INTRODUCTION TO PSYCHOLOGY

2nd Edition

Joseph G. Johnson, Ph.D.
Miami University
Oxford, OH

Ann L. Weber, Ph.D.
University of North Carolina at Asheville
Asheville, NC

Contributing Editor
Kevin Filter, Ph.D.
Minnesota State University
Mankato, MN

Collins
An Imprint of HarperCollinsPublishers

An American BookWorks Corporation Production

HarperCollins books may be purchased for educations, business, or sales promotional use. For information please e-mail the Special Markets Department at SPsales@harpercollins.com.

Library of Congress Cataloging-in-Publication has been applied for.

ISBN: 13: 978-0-06-088152-8
ISBN: 10: 0-06-088152-6

15 16 17 18 19 RRD 10 9 8 7 6 5 4 3 2

Contents

Preface to the 2nd Edition

If you were to meet a psychologist, you may expect him or her to either "tell me what you're thinking," look at you and identify your personality traits, or interpret the dream you had last night. Yes, some psychologists do indeed study topics such as these. However, you may be surprised (even disappointed?) to find out that many psychologists "only" study the method you use to make a decision, the path through the brain that visual information travels en route to perceiving a face, the impact on your behavior of an observing crowd, or your ability (or struggles) to learn a second language. Whereas the purview of physics or chemistry is well defined and generally understood by most people, the same is not often said about psychology. Psychology, the science of behavior and mental processes, is not even so much a single discipline as it is a spirit common to many different fields of study; it bonds together the other social sciences: sociology, anthropology, economics, and political science. There are psychological aspects to history, art, music, and how they are experienced. Psychology emerges from the natural sciences and illuminates how they are understood; it is a central concern of much of philosophy and theology. It crosses cultures and spans millennia—the first humans undoubtedly wondered about one another's behavior, and may well have wondered about the very process of wondering.

As an outline text, this book was based on the excellent work of other scholars whose introductory psychology texts deserve careful appreciation. This book was not written to stand alone, although it should serve as a useful and concise review for an experienced psychology student. It is written to be a comprehensive summary of the highlights most often covered in a typical introductory course in psychology. As such, it will be a helpful supplement to any recent introductory text, especially in an active studying program that involves writing and discussing ideas with others. It is assumed that the reader will consult another source if more detailed coverage of specific topics is desired.

Revisions and Updates to the 2nd Edition

This edition retains some of the content—not to mention the spirit—of the 1st Edition. However, there is a substantial proportion of new material, and some significant changes and revisions to mention as well. Nearly fifteen years have passed since the 1st Edition, and substantial progress in a number of areas is reflected in this edition. For example, the growing interest and importance of biopsychology and neuroscience warrants the space devoted in this edition to a survey of imaging techniques, and to behavioral genetics. Emerging themes in modern psychology have also been incorporated, such as the appreciation of multiple biological and environmental influences on most psychological phenomena, and the importance of studying and considering these phenomena across the life span and across diverse cultures. The chapter organization has been restructured for this edition to coincide largely with the most recent outline for the College Board's Advanced Placement (AP) examination in psychology. Outdated (or now-auxiliary) terms and concepts have been removed or replaced, and the suggested readings have been updated as well. A key new feature of this edition is the section at the end of each chapter that provides review questions (both multiple choice and short essay).

Tips for Reading, Study, and Critical Thinking

We who teach psychology courses have found that successful students tend to follow a few general strategies. These ideas are summarized as follows.

First, it is important to understand the concepts not just by memorizing definitions, but by thinking about how the concepts are applied. For example, beyond memorizing what a specific neuroimaging technique or research design is, you should understand its advantages and disadvantages, or in what situations it is best applied.

Second, you will gain the most out of the material presented in this book if you can think about how to integrate ideas by drawing connections across chapters. How did the history of the general atmosphere of psychology contribute to the approaches to treating psychological disorders? How can principles of learning be applied to understanding social phenomena? What role do certain biological processes play in development and the expression of various behaviors?

Third, we mention some of the pioneers—as well as notable contemporaries—in the respective fields of each chapter. It is important that you recognize these names and associate them with the theories, concepts, or developments for which they are responsible. Oftentimes, important ideas are referred to by the name of their originator, rather than by some other label. Try not to gloss over the names as irrelevant or secondary—each good idea is the result of somebody's hard work!

Finally, and most important, you should never assume that what you read in the following pages is the definitive answer to any question, the best method to study a certain behavior, or the end of the story concerning any debate. Like any good science, psychology is dynamic, and what may be today's "accepted wisdom" could very easily become passé folklore tomorrow. Instead, seek out the latest information on any topic in which you are interested, to get an appreciation for the state of the art. The best teachers empower students to learn; the best texts equip the student to ask questions, to look for more. This review text is a step in that direction.

Acknowledgments

From Joseph:

I would like to thank Jerry Busemeyer for rescuing me from the "real world" and providing me with a better graduate education and experience than I could have imagined; without him I can certainly say I would not be where I am today. I would also like to thank my wife, Jeane, for her support and patience. She is more delighted than I to see this project come to fruition, such that she no longer has to compete with "the book" for my attention.

I would like to thank Fred Grayson for providing me with the opportunity to write this revision, trusting my professional facility, and putting up with my preoccupations and general flakiness. Due credit should also be given to Dr. Kevin Filter and other support personnel. I also would like to acknowledge the work of Daniel DeCaro, who researched and compiled an excellent bibliography as well as the glossary.

Psychology: History and Approaches

The term **psychology** was first coined in sixteenth-century Germany as a combination of two Greek root words: *psyche* (soul or mind) and *logos* (study). Its original use suggested "the study of the mind," something as old as the human race itself. In recent centuries, this interest in human nature has been honed into a systematic discipline. Today, psychology is defined as the science of behavior and mental processes, with the goal of understanding, predicting, and controlling behavior and mental processes. There are many different approaches toward psychological science; each approach focuses on particular means and methods to achieve these goals. Also, the scope of psychology includes many different fields, distinguished by interest in different psychological processes, different populations, and different levels of analysis.

"Psychology has a long past, but a short history."
—Herman Ebbinghaus (1850–1909), pioneer of memory research

■ ROOTS OF PSYCHOLOGY

Psychology has long been a common human interest, but it has been considered a formal scientific discipline only since the late nineteenth century. Several perspectives and disciplines contributed to the origin of psychology as a science. Most notably, these include early physiological and philosophical perspectives.

Physiology and Medicine

Before 500 B.C. in the Western world, medical practices were largely controlled by priests, who explained both mental and physical illnesses in terms of divine causes.

Hippocrates (460–377 B.C.) rejected mystical and superstitious explanations for bodily processes. He argued that physical well-being, illness, and healing were natural processes. In *The Art of Healing*, Hippocrates described behavior patterns recognizable to modern psychologists as behavioral disorders.

The Nature of Man contains his theory that the natural elements—earth, air, fire, and water—combine to form bodily humors or natural fluids like blood, black bile, yellow bile, and phlegm. Any imbalances among these four humors would result in illness or disease.

Galen (A.D. 130–200), a physician in Imperial Rome, extended Hippocrates's ideas by suggesting a better understanding of human nature and emotions. Galen emphasized the usefulness and effectiveness of the parts and processes of human anatomy. He further argued that imbalances among the bodily humors would result in extremes or disorders of temperament. Too much blood would make a person "sanguine" or cheerful; excessive yellow bile would make one "bilious" or angry; too much black bile led to "melancholia" or sadness; and too much phlegm, of course, made one "phlegmatic" or lethargic and sluggish.

These early ideas of influences on behavior, while obviously crude and simplistic by today's standards, have persisted in our language (for example, a "sense of humor") and our ongoing interest in how bodily processes affect thought, emotions, and action. In fact, recently there has been increasing interest in biological implications for behavior.

Philosophy

Psychology has also been influenced by basic arguments about the very nature of reality. Ancient cultures believed that all which exists is of one nature; such notions are collectively referred to as **monism**. Later, religiously popularized recognition of two kinds of reality (that is, **dualism**) influenced philosophical thought. Both monism and dualism have left undeniable marks on the modern science of psychology.

Dualism

Dualist ideas about human nature were first detailed by the Greek philosopher Aristotle (384–322 B.C.), who conceived of the soul as the animator of all beings, including humans. According to Aristotle, humans have rational (reasoning) souls. Humans' ability to reason makes human thought abstract, separate from the material world. Thus a human being has a material body but a rational (reasoning) mind, and is governed by two systems of nature. Aristotle's dualism explains human thought and action as unique in all existence.

Thomas Aquinas (A.D. 1227–1274) extended Aristotle's dualistic view of human nature with the argument that, because human thought is rational, human action is freely decided rather than compelled by natural forces. This is the essential argument in favor of free will. Whether human will is free or not is an important consideration in determining the morality of human action.

The most articulate proponent of the dualism of human nature was French philosopher Rene Descartes (1596–1650). Famous for the dictum *Cogito ergo sum* ("I think, therefore I am"), Descartes distinguished between the free will that governs the rational human soul and the physical "passions" (appetites) and "emotions" (excitements) that govern the material body. Further, Descartes saw the relationship between body and soul as a conflict, an ongoing struggle for control of one's actions.

Modern psychologists continue to debate the nature of human behavior, with strong arguments both for forms of "free will" and for a more mechanical understanding of psychological processes.

Monism

Some of the earliest systems of philosophy were monistic philosophies, advocating that all of reality has but a single nature. One form of monism, idealism, argues that all of reality exists only in the mind,

as ideas, and thus things are "real" only to the person who is presently experiencing them. One extension of this idealism is that, for things to continue when no one is thinking about them, they (and we) must all be figments of a supreme being's imagination—ideas of God, for example.

Another form of monism is materialism, arguing that the single nature of reality is matter. If all of reality is matter, then all that exists must be governed by the laws of matter, or the laws of mechanics. This view, known as mechanism, can be applied to human nature if one accepts that human beings, like all else in reality, are purely material beings, and thus human action is governed by the physical laws of mechanics. Mechanism has had an enduring influence on the science of psychology, especially in early theories about the relationship between bodily (physical) events and mental experiences.

Determinism

One implication of mechanism is that, according to the laws of mechanics, physical forces cause specific changes in other physical objects. Causes determine effects in the physical world. If one wishes to understand the present condition of an object or event, one must examine the events (causes) that led up to (determined) it. This understanding—that present conditions can be understood if one examines past influences—is known as **determinism**. It is a critical assumption in any science.

Empiricism

Another essential tenet of science is the reliance on observable events as evidence of reality. Instead of imagining how things "must" be, a scientist observes how they are, or rather how they look, sound, feel, taste, or smell. This reliance on the evidence of one's sensory experiences is known as **empiricism**.

Empiricism is such a familiar and commonsensical part of the scientific method that it is difficult to remember that it was once a new concept. Ancient and medieval scholars often argued that one could "reason" one's way to the truth or be informed through revelation, prophecy, or inspiration.

The English scholar Roger Bacon (1214–1292) argued that empirical observation was essential to the scientific method. Later, John Locke (1632–1704) asserted that empirical (sensory) experience was the basis for all knowledge. Locke maintained that the human mind at birth is a *tabula rasa* (blank slate) on which experience alone can inscribe knowledge.

■ HISTORY AND DEVELOPMENT OF PSYCHOLOGICAL SCIENCE

The early contributions of physiology and philosophy had an undeniable influence on the development of psychology as a distinct scientific discipline. It is difficult to pin down an exact date of birth for psychology. It is more important to gain an appreciation of the evolution of psychology as a scientific discipline, which is characterized by periods of specific schools, or systems of belief, thought, and study.

Body and Mind

Some of the earliest methods of psychology focused on the relationship between body and behavior. This orientation grew from philosophical debate about the appropriate conceptualization of body and mind, coupled with physiological study of physical symptoms and influences on behavior. Thus, early psychology

included popular, largely nonscientific pursuits such as physiognomy and phrenology, as well as more rigorous scientific methods including psychophysiology and psychophysics.

Physiognomy

Physiognomic explanations for human behavior argued that it was possible to "read" one's character in his or her physical features. An early system of this was popularized by Johann Kaspar Lavater (1741–1801), and its effects can still be read in nineteenth- and early twentieth-century literature, where physical descriptions are supposed to indicate certain personality traits, for example, a "nobles" brow, a "weak" chin, or a "generous" mouth. Lavater's ideas were later extended by an Italian criminologist who described the shifty-eyed, sneering "criminal type."

Phrenology

Franz Joseph Gall (1758–1828) popularized **phrenology** (literally from the Greek for "study of the personality"), a technique for inferring character from the shape and form of the skull. Phrenologists assumed that certain personality traits and mental faculties were revealed in the bumps and dents they could feel through patients' scalps. Though ultimately discredited, phrenology enjoyed immense popularity and success, and offered a simple (though invalid) way to predict behavior on the basis of a few observations.

Psychophysiology

In the nineteenth century, researchers began systematic experiments nn how physical events are psychologically experienced. The first experiments in the relationship between physiological processes and psychological experience (**psychophysiology**) focused on the functioning of the senses, especially sight, sound, and touch.

Johannes Müller (1801–1858) established the first institute for the study of physiology in Berlin. Although favoring a mechanistic view of human nature, he also believed in vitalism, a conviction that all living beings were animated by a "life force" that was ultimately impossible to analyze.

One of Müller's students was Hermann L. von Helmholtz (1821–1894). Helmholtz rejected Müller's belief in vitalism and instead refined a mechanistic explanation of behavior in terms of the physical and chemical processes of the nervous system. In Helmholtz's experimental approach to the nervous system, he charted distances between stimulation and response points along the nerve fibers of frogs, demonstrating that behaviors could be evaluated by measuring reaction time, the interval between a stimulus and a response.

Psychophysics

Another approach to understanding the body-mind connection was taken by the psychophysicists. Psychophysics as a discipline focused on the relationship between the physical and environmental changes (stimuli) and the sensory processes that they trigger. Gustave Feodor Fechner (1801–1889) had been a confirmed mechanist who later in life softened his mechanism in a quest for a more spiritual understanding of experience. In his 1860 work *Elements of Psychophysics*, Fechner argued that because matter and mind must be related, research must focus on how physical stimuli are related to the mental experiences they produce.

Ernst Heinrich von Weber (1795–1878) was a colleague of Fechner's who, in 1834, had published a study of the sensory processes involved in touch. Weber's experimentation with people's judgments about the heaviness of hand-held weights led him to develop Weber's Law, a mathematical summary of how changes in sensory qualities are perceived. In brief, according to Weber's Law, the ability to detect change in a stimulus depends on the magnitude of that stimulus. For example, if a person has lost five pounds, will weight loss be noticeable? Yes, if the person previously weighed only 90 pounds. No, if the person previously weighed 300 pounds. One pound less than 90 is more noticeable than one pound less than 300.

Is psychophysics part of psychology or part of physics? Until the late nineteenth century, most "psychological" research was really focused on medicine, physiology, or physics rather than on psychological processes. This changed, however, as a body of work emerged that was distinctive of psychology, rather than the domain of other disciplines.

Behavior and Mental Processes

The "birthday" of psychology depends on exactly what body of work is considered psychological. However, the date of birth usually assigned to the demarcation of modern psychological research—the study of behavior and mental processes—is 1879. In that year, the first scientific laboratory for psychological research was established. In the early years, the approaches to studying psychology closely paralleled the natural sciences as psychologists searched for credibility while trying to establish a unique scientific identity.

Wundt's Structuralism

Wilhelm Wundt (1832–1920), a German professor of philosophy, founded the first laboratory for the scientific study of psychology at the University of Leipzig in 1879. Unlike his predecessors in psychophysics, Wundt was interested in decidedly psychological processes like consciousness, thought, and emotions. The "laboratory" Wundt established consisted of a group of people interested in these same phenomena, all of whom intended to study these processes scientifically. Just as Wundt's contemporaries studying purely physics attempted to break down the physical world into component parts (for example, atoms), Wundt tried to do the same with consciousness.

The "scientific" technique Wundt employed was **introspection** (literally, "looking within"), the common practice of considering one's own actions and reactions, and self-consciously trying to analyze their sequence and components. For example, in order to understand the tactile sensation of "wetness," Wundt would ask a subject to immerse his hands in water, and describe his various sensations separately. "Wetness" might equal a combination of the tactile sensations of "coolness" plus "smoothness." Wundt hoped thus to identify the basic components of more complex conscious experiences.

Wundt's work was extended in the United States by his student Edward Bradford Titchener (1867–1927), who emphasized the study of sensations as the building blocks of the content of consciousness, without concern for the processes or goals of consciousness. Because Titchener's and Wundt's perspective emphasized analysis of the structure of consciousness, this school of thought came to be known as **structuralism**. Structuralist assumptions are very common. They can be seen in action when a child tries to understand a new toy by taking it apart, or when an adult enjoys a meal and inquires about the ingredients. The structuralist perspective assumes that psychological experience is better understood only when the content of that experience has been analyzed and identified.

James' Functionalism

A very different point of view was espoused by William James (1842–1910), whose 1890 book *Principles of Psychology* is considered the first text in psychology. James himself is usually referred to as the father or founder of American psychology. Trained as a physician, James was a professor of physiology, psychology, and philosophy at Harvard. His interests in psychology were broad and his influence on the new discipline enormous.

James favored a school of psychology termed **functionalism**. A functionalist perspective assumes that the products of psychological processes—behaviors, emotions, and thoughts—must serve some function, or they would be changed or lost. The way to understand psychological processes, therefore, is not to analyze their structure, but rather to identify their goals. Whereas a structuralist looks at a behavior and asks, "What are the components of that behavior?" a functionalist asks, "What purpose does that behavior serve?" Also, whereas structuralism is identified with physics, principles of biology—especially evolution and adaptation—are apparent influences on the functionalist school of thought.

Functionalist assumptions emerge whenever researchers question the usefulness or origins of a cross-cultural behavior pattern. For example, why do people in all parts of the world smile when they are happy? Because smiling is universal, it is probably built-in rather than acquired through learning. The functionalist question is: What purpose does smiling serve? Smiling must be useful; it must increase the chances of the smiler's survival. It must have at least one important survival function.

German Gestalt Psychology

Gestalt is a German word that translates roughly to mean "form," "shape," or "pattern" in English. In the early twentieth century, Gestalt psychologists in Germany studied perceptual phenomena that caused them to doubt the usefulness of structuralist assumptions. Specifically, whereas structuralism concerns dissecting concepts into components, Gestalt psychologists stress the importance of the concept as a whole. Max Wertheimer (1880-1943), Kurt Koffka (1886–1941) and Wolfgang Köhler (1887–1967) found that arrangements of perceptual stimuli close together in time or space created illusions of connections between the stimuli. For example, if blinking lights were positioned closely beside each other, a subject viewing them experienced the sensation that a single glowing light seemed to be "moving" from one light fixture to the next and the next—such as many modern-day marquees.

Wertheimer, Koffka, and Köhler dubbed such "apparent movement" the phi phenomenon. They observed that human perception seemed particularly prone to such illusions and speculated that it is more meaningful to connect close-together events than to keep them artificially separate.

Gestalt psychologists focused on identifying the principles of perception and the conditions under which these principles apply. They concluded that the human mind imposes an order or "meaning" of its own, rather than passively absorbing the content of sensory experiences. More recently, Gestalt psychology has influenced both approaches to psychotherapy and the modern development of cognitive psychology. With its emphasis on the importance of meaning in human perception and behavior, Gestalt psychology contributes distinctively to psychological theories of human nature.

Freud's Psychoanalysis

The Viennese physician Sigmund Freud (1856–1939) developed an early interest in neurology into a system of treatment for psychological disorders. His system of therapy was known as **psychoanalysis**,

because it emphasized the importance of analyzing the psyche in order to gain insight into psychological conflicts. Psychoanalysis has also come to be known as a "theory" of personality and a perspective on human nature.

Psychoanalysis assumes that psychological experiences are caused by biological drives and instincts. Living in civilized society inevitably frustrates many biological drives, but most of the resultant conflict is kept hidden from one's conscious mind. Conflicts and anxiety in one's unconscious can sometimes manifest themselves in disguised forms, safely in dreams or more dangerously in physical symptoms. Such symptoms can be crippling unless the sufferer, through psychoanalytic therapy, achieves insight into the original conflict, and the symptoms become unnecessary.

Although the principles of psychoanalysis have captured the public imagination, they defy empirical testing. Scientific theories are formed, tested, modified, and sometimes rejected on the basis of empirical (experience-based) observations. Yet psychoanalytic concepts like that of the unconscious mind cannot be tested, confirmed, or rejected through observation. Thus psychoanalysis cannot accurately be called a "theory." In this respect, Freud's work differed greatly from his contemporaries such as Wundt and James. Nonetheless, the concepts of psychoanalysis are well known world-wide, and the application of psychology in the treatment of mental and physical illness has been shaped by many psychoanalytic ideas.

Watson's Behaviorism

Structuralism, functionalism, and Gestalt psychology all seek to understand human experience by looking at mental processes, and psychoanalysis views behavior in terms of underlying (subconscious) elements. However, like the subconscious, mental processes (for example, sensation, perception, and cognition) are internal and cannot be directly observed. They are all examples of the perspective known as **mentalism**, the study of mental events and processes. Mentalism has long been criticized as a contradiction of the empirical basis of the scientific method. Science relies on empirical (sense-experienced) observations of real events. If a researcher cannot see, hear, or feel another's thoughts or hidden emotions, these processes cannot be studied scientifically.

Behaviorism is the alternative to mentalism. Behaviorism is a perspective in psychology that emphasizes the need to study only what is observable. Mental events are not observable; behaviors are observable. One cannot observe thought processes, but only the resulting behaviors, the environment in which they are embedded, and the consequences of such behaviors. Thus, it is argued, behavior and its consequences are the appropriate foundation for scientific psychology.

The father of behaviorism was John B. Watson (1878–1958). Watson originally trained in physiology but turned to a stronger interest in comparative psychology, the study of the behavior of nonhumans. Watson observed that although the rats he studied could not introspect or offer self-reports of their behavior, they could still behave, and their behavior could be objectively observed and measured. Watson's heir apparent as champion of behaviorism was undeniably B. F. Skinner (1904–1990), who became best known for his studies of animal learning and what it can teach humans about better ways to live and function.

Behaviorism in its most extreme form rejects the examination of any unobservable process. For example, consider a psychological experience defined by a stimulus (S) that excites the sensory processes of an organism (O), which consequently makes a response (R) leading to some consequence (C). In strict behaviorist terms, one might observe the S, R, and C, but not the processes occurring within the O. A

behaviorist rejects as impossible and irrelevant questions such as "Did the *O* make the *R* deliberately?" or "How does *O* feel about the *C*?"

Actually, very few psychologists today adhere to this strict view of behaviorism. **Neobehaviorists** (new behaviorists) introduced the concept of intervening variables—changes in processes within the organism that cannot be observed but that can be used to explain *S-R* patterns. One such neobehaviorist was Clark L. Hull (1884–1952), whose 1943 work *Principles of Behavior* listed a series of postulates or rules regarding the effects on behavior of such intervening variables as drive and habit strength.

Another neobehaviorist, Edward Chace Tolman (1886–1959), found it necessary to hypothesize that learning can take place even when it is not observable. Tolman allowed rats to explore mazes without offering them any rewards for being fast or accurate. The rats showed no signs of having learned the maze—until a later time when they were rewarded for their maze-running efforts. At that time the rats learned the maze faster than rats who had not explored the maze before. Obviously, the experienced rats had learned something, although their learning had remained latent (hidden) until it was useful. Tolman developed the somewhat mentalist concept of latent learning while he conducted traditional behaviorist research on rats' performance times.

The Cognitive Revolution

Behaviorism was by far the dominant school of psychological thought, at least in America, in the first half of the twentieth century. However, not everyone agreed with the behaviorists. Noam Chomsky (born in 1928), a linguist at MIT, argued that language cannot be explained through a stimulus-response process as championed by behaviorists. He directly challenged Skinner's book on verbal behavior in a 1959 issue of the journal *Language*. He illustrated the complexity of language acquisition and production, and he maintained that purely behavioral explanations could not convincingly explain these complexities. For example, Chomsky pointed out that theories based solely on stimulus-response-consequence relationships cannot account for creativity in language use (for example, by poets). Furthermore, if language is acquired solely through such interaction with the environment, it would be largely dependent on one's specific environment—a curious hypothesis considering that all humans learn language at about the same age.

Chomsky's review, if not marking the birth of cognitive psychology, is often cited as starting a cognitive revolution. He viewed the transformation from internal thoughts and ideas to verbal language as a cognitive process. Soon thereafter, researchers in other domains followed his lead to examine the role of cognitive processes in other human behaviors. This theoretical impetus was aided by technical innovation.

After World War II, problem-solving machinery and information technology combined to produce artificial intelligence, the software and hardware we take for granted today as computers. Because to some extent computers simulate many human-like cognitive processes (like thinking, remembering, and problem solving), the study of artificial intelligence can yield some answers about the dynamics of human cognition. Going a step further, many cognitive psychologists viewed the computer as an analogy for the working of the mind—receiving input, transforming and manipulating the input, and storing and retrieving information. Alan Newell (1927–1992) was an influential mathematician who saw these links between artificial intelligence and human cognitive functioning.

Cognitive psychology has been officially recognized as a discipline for forty years, dating back to Ulric Neisser's (born in 1928) landmark book, *Cognitive Psychology*, in 1967; and the introduction of the field's own journal in 1970. These publications helped to define a burgeoning field, both at the time of

their publication and still today. Neisser has also been influential in developing a model of human cognitive processes as actively involved in seeking information and meaning. **Cognitive psychology**—the study of the psychological processes involved in cognitive functions—combines time-honored Gestalt principles of perception with an interest in information processing, the sequence of cognitive operations whereby sensory experiences are meaningfully interpreted and acted upon.

Neuroscience: Body and Mind Revisited

The history of psychology began with a focus on the brain and body as determinants of human action. It then witnessed a shift toward the study of behavior and mental processes—which still today are evident in the commonly accepted definition of psychology. However, the importance of the body and brain in guiding behavior has recently been resurrected. In fact, George H. W. Bush (born in 1924), as president of the United States, declared the 1990s as "the decade of the brain." Today, an increasing number of major universities have centers devoted to brain investigation techniques and have established programs in **neuroscience**, a term broadly referring to scientific study of the nervous system and encompassing biological psychology, neuroanatomy, neurobiology, and so on.

If the digital computer was a key contributor to the cognitive revolution, the development of increasingly sophisticated techniques of studying the brain and nervous system has helped to advance the biological study of the mind. Physiologists were not silent during the reign of earlier schools of thought and had come a long way from studying bumps on the head. For example, Camillo Golgi (1843–1956) discovered staining methods that allowed for visualization of individual neurons and was awarded the Nobel Prize in 1906, jointly with another pioneer of neuroscience, Santiago Ramón y Cajal (1852–1934). Cajal proposed the Neuron Doctrine, which established the neuron as the fundamental unit of the nervous system and outlined the basic principles of their interaction. More recently, computerized techniques such as PET and MRI have afforded an incredible level of detail in anatomical and functional study of the brain and nervous system.

Contemporary Approaches to Psychological Science

The history and development of psychology is characterized by a great deal of diversity and the contributions from many different disciplines and schools of thought. Is a certain behavior the result of subconscious desires, the product of stimulus-response mappings, the attempt to perform a particular function, or a specific pattern of neural firing? Given any particular psychological phenomenon, there are a number of different interpretations. As a result, contemporary psychological science is not described by adherence to one certain method and theoretical framework, but rather a collection of various approaches.

Behavioral Approach

The **behavioral approach** includes behaviorists and neo-behaviorists, whose orientation toward psychological research was described earlier in this chapter. These psychologists are primarily concerned with the stimulus-response-consequence patterns, or learning history, of individuals in explaining behaviors. For example, a behaviorist studying emotions might suggest that the emotional response toward a stimulus is learned through previous reinforcement of the response.

Biological Approach

Biological psychologists (or **neuropsychologists**) study the biological bases of behavior, usually concentrating on the nervous system (the brain and other nervous tissue) and the biochemical processes underlying behavior. This approach thus assumes that behaviors are the end result of distinct biological processes. For example, biological psychologists studying emotions would be primarily concerned with the genetic predispositions, physiological dynamics, and brain areas associated with the expression of emotions. The impact of biological psychology is pervasive and ever-increasing.

Cognitive Approach

Cognitive psychologists study people's perception, transformation, representation, processing, storage, and retrieval of information. That is, the cognitive approach considers how behavior arises as the result of mental processes. To explain an emotional reaction, a cognitive psychologist may focus on how the stimulus was perceived and represented, or determine if memories were accessed in forming a response. In contrast to behaviorists, cognitive psychologists maintain that although internal psychological processes are not directly observable like behaviors, they are indirectly accessible and thus a proper focus for scientific psychology.

Humanistic Approach

Psychologists in the humanistic tradition emphasize the uniqueness and autonomy of the individual. That is, they frame behavior in terms of each individual's unique perceptions of the world, and suggest behavior is determined by each person's capacity to think, decide, and act for oneself. For example, different people's emotional reactions to the same event would depend on each person's unique perception of the event. Humanistic psychologists assume that people are essentially motivated to be productive and healthy, and need guidance only when circumstances have impeded their natural progress toward realizing their own potential (self-actualization). Notable humanistic psychologists include Abraham Maslow (1908–1970) and Carl Rogers (1902–1987).

Psychodynamic Approach

The **psychodynamic approach** is based on the work of Freud, although the influence of the original psychoanalytic techniques and premises is greatly diminished today. Still, researchers adopting the psychodynamic approach focus on the innate, pervasive, and mostly unconscious desires and conflicts of the individual. From this perspective, emotions are interpreted as the consequence or expression of these internal struggles, such as inconsistent desires or the suppression of instinctive behaviors to conform to societal expectations.

Sociobiological Approach

The sociobiological approach, also known as evolutionary psychology, is relatively new but has experienced rapid growth and increased popularity. This approach applies evolutionary concepts like natural selection and adaptation to human behavior and social interaction. It focuses on the functional development of the mind, in the context of the (social) environment—that is, how the mind has evolved as the result of pressures in the environment. However, opponents and critics view this approach as an extreme form of determinism, and portray some research of evolutionary psychologists as politically

incorrect (for example, claiming evolutionary research on gender differences as sexist). However, researchers embracing the sociobiological approach have shed light on behaviors such as parenting, sexual development, cooperation, and altruism. These researchers might claim that emotions have evolved due to the adaptive function that they serve.

Sociocultural Approach

The **sociocultural approach** to psychology studies how thinking and behavior vary across cultures and in different situations. It emphasizes the role of situational influences on individuals in certain places, conditions, and times. Furthermore, this approach appreciates the cultural diversity in the human population and attempts to understand how cultural influences help to shape behavior. From this perspective, the study of emotion might be focused on the situations where each emotion is conveyed, as well as the cross-cultural similarities and differences in emotional expression.

Important Subfields in Psychology

There are many ways to categorize research and application of psychological science. While the preceding divisions are currently considered the primary perspectives describing the way psychologists approach problems, there are many subfields in psychology that are often distinctly recognized and represent a substantial number of research psychologists. Three important subfields are comparative psychology, developmental psychology, and personality psychology.

Comparative Psychology

Comparative psychologists study physiological effects on behavior by specifically studying nonhumans, in an effort to make comparisons between nonhumans and humans. These psychologists can work from many different perspectives, depending on their specific domain. For example, while one comparative psychologist studies problem solving in chimpanzees, another may examine their social behaviors, while another focuses on the adaptive value of their behavior, while yet another is concerned only with their learning of stimulus-response pairs.

Developmental Psychology

Developmental psychologists study the changes in psychological function as an organism grows and ages. Developmental psychology adopts a life span perspective, focusing on the influences on behavior and mental processes of changes that occur from conception and birth, through infancy and childhood, to adolescence, adulthood, old age, and death. Developmental psychologists may also adopt any of the approaches mentioned in the preceding sections.

Personality Psychology

Personality psychologists specialize in the study of individual differences, how and why individuals differ from one another. Personality psychologists also work to develop techniques for assessing personality characteristics among different individuals. Again, these psychologists may be influenced by any combination of the primary approaches, each of which endorses a unique explanation for the construct of personality.

Specialized Fields in Applied Psychology

Basic research addresses fundamental questions about the nature of things, while **applied research** attempts to solve immediate practical problems. Examples of basic research in psychology include investigations of the nature of learning and memory, of how the ear analyzes sound and the eye light, how deeply our opinions are influenced by those of others, what needs are met by sleep, and many more. Examples of applied research include investigations of the most effective ways to teach particular topics such as geography, how to effectively select applicants for a particular type of job, and how to design an airplane instrument panel to be used easily and without mistakes.

Although much research that is well funded is applied, advances in fundamental knowledge and major leaps in technology usually come from basic research. In addition, most applied research relies strongly on the information already yielded by basic research. Each specialized area of psychology also generates a unique set of findings that further inform applications of psychological research. Some modern specializations are introduced in the following sections, but note that this survey is by no means comprehensive.

Clinical and Counseling Psychology

Counseling psychologists provide guidance and therapy to normal individuals with adjustment problems. **Clinical psychologists** diagnose and treat the more severe problems of clinical populations, individuals who need in-patient care in institutions (like hospitals) or regular out-patient therapy through mental health clinics. Note the distinction between these specialists and psychiatrists, which are medical practitioners, not psychologists.

Educational Psychology

Educational psychologists are experts in the processes of teaching and learning, and they conduct applied (practical) research to identify questions and answers in these processes. For example, these psychologists might determine optimal methods of instruction or assessment.

Environmental Psychology

Environmental psychologists study how the physical environment, broadly defined, shapes mental processes and behavior. For example, they may study the effects of weather on depression, the effects of population density (crowding) on aggressive tendencies, or the effects of isolation or sensory deprivation in general.

Forensic Psychology

Forensic psychologists work at the intersection of psychology and the law. Their work may include developing criminal profiles to aid law enforcement or evaluating mental competence of defendants in trial settings.

Health Psychology

In recent years, the distinct field of **health psychology** has emerged as a special focus on the psychological processes involved in wellness and illness, both physical and psychogenic (originating in the mind). This includes not only the effects of behavior and mental processes on wellness, but also vice versa.

Human Factors Psychology

After World War II, **human factors psychology** developed as a special application of psychology to the relationship between human workers or equipment operators—like airplane pilots—and the machines and equipment they operate. It derives its name from its focus on the human factor in the person-machine relationship, and is sometimes called **ergonomics** (from the Greek *ergo* for "work") because of its applications to work environments. Human factors psychologists' contributions range from training programs so that people can operate equipment more effectively to designing easy-to-read, mistake-proof control panels and signs.

Industrial and Organizational Psychology

Industrial psychologists work within industrial or employment settings to study and improve the relationship between workers and their jobs and workplace. Organizational psychologists more specifically study the relationship between the employee and his or her employing organization, focusing on group dynamics, leadership, management, and communication. Many professional psychologists have developed expertise in both these fields, and are known as industrial-organizational, or I/O, psychologists.

School and Community Psychology

School psychologists provide advice and guidance within schools and school systems, concentrating on the needs of the student within the educational environment. **Community psychologists** work toward preventing (or minimizing) psychological disorders by getting help to those who need it, such as through community programs, and by advocating changes to social systems.

Sports Psychology

Sports psychologists study various aspects of sports-related behavior, from perception-action and movement processes, to the effects of accountability and competition, to the learning of strategies and behaviors, to the psychological benefits of sports and exercise.

Psychology is the science of behavior and mental processes. It has philosophical roots in dualistic concepts of rational thought and free will, as well as monistic concepts of determinism and empiricism. The first laboratory for the scientific study of psychology was founded in 1879 by Wilhelm Wundt, who employed introspective techniques to understand the structure of consciousness. Functionalists like William James favored a goal-analysis of behavior, while Gestalt psychologists focused on the importance of holistic meaning in human perception. Behaviorist John B. Watson rejected the mentalism of the schools of structuralism, functionalism, and Gestalt psychology. Behaviorism concentrates on observable stimuli and responses and connections between them. More recently, psychology has emphasized the role that cognitive processing plays in various behaviors.

In conjunction with the theoretical and experimental development of psychology as a science, biological study of the human brain has advanced our understanding of the mechanisms underlying behavior. Early attempts, such as physiognomy and phrenology, spurred later interest in more advanced technique such as direct nerve stimulation and the brain imaging techniques of today.

The diverse contributions to psychological science have produced a variety of perspectives on the study of mental processes and behavior. These include traditional behavioral, biological, humanistic, and psycho-

dynamic approaches, as well as more recently developed cognitive, sociocultural, and sociobiological approaches. These approaches define ways of thinking, rather than specific topics of study. That is, any and all of these approaches can be used to study specific phenomena, such as vision, personality, movement, attitude formation, or memory. In fact, the number of specialized fields in psychology is constantly growing, and includes both basic and applied research.

KEY CONCEPTS

applied research	environmental psychology	organizational psychology
basic research	ergonomics	personality psychology
behavioral approach	evolutionary psychology	phrenology
behaviorism	forensic psychology	physiognomy
biological approach	functionalism	psychoanalysis
clinical psychology	Gestalt	psychodynamic approach
cognitive approach	health psychology	psychology
community psychology	human factors psychology	psychophysics
comparative psychology	humanistic approach	psychophysiology
counseling psychology	industrial psychology	school psychology
determinism	introspection	sociobiological approach
developmental psychology	mentalism	sociocultural approach
dualism	monism	sport psychology
educational psychology	neobehaviorist	structuralism
empiricism	neuroscience	

KEY PEOPLE

Thomas Aquinas	Hermann L. von Helmholtz	Alan Newell
Aristotle	Hippocrates	Carl Rogers
Roger Bacon	Clark L. Hull	B. F. Skinner
Santiago Ramón y Cajal	William James	Edward Bradford Titchener
Noam Chomsky	Wolfgang Köhler	Edward Chace Tolman
Rene Descartes	Kurt Koffka	John B. Watson
Gustave Feodor Fechner	Johann Kaspar Lavater	Ernst Heinrich von Weber
Sigmund Freud	John Locke	Max Wertheimer
Galen	Abraham Maslow	Wilhelm Wundt
Franz Joseph Gall	Johannes Müller	
Camillo Golgi	Ulric Neisser	

Selected Readings

Fancher, R. E. (1996). *Pioneers of psychology, 3rd Ed.* New York, NY: Norton, W. W. & Company, Inc.

Hock, R. R. (2004). *Forty studies that changed psychology: Explorations into the history of psychological research, 5th Ed.* Prentice Hall.

Kimbal, G. A., & Wertheimer, M. (2003). *Portraits of Pioneers in Psychology, Vol. 5.* American Psychological Association.

Munger, M. P. (2003). *History of psychology: Fundamental questions.* Oxford University Press.

Wertheimer, M., & Bjorkman, M. (1999). *Brief History of Psychology, 4th Ed.* Belmont, CA: Wadsworth.

Test Yourself

1) Which of the following is a common definition of psychology?
 a) the study of unconscious causes of conscious behavior
 b) the science of behavior and mental processes
 c) the study of organisms and their responses to stimuli
 d) the science of mental phenomena

2) Which two disciplines were most influential in the early development of psychology?
 a) physics and philosophy
 b) physiology and philosophy
 c) biology and sociology
 d) physics and biology

3) The first psychological laboratory was founded in 1879 by whom?
 a) Sigmund Freud
 b) William James
 c) John Watson
 d) Wilhelm Wundt

4) Who is most likely to agree with the saying that "the whole is greater than the sum of its parts?"
 a) a structuralist
 b) a functionalist
 c) a Gestalt psychologist
 d) a behaviorist

5) Who is most likely to claim that only directly observable phenomena should be studied?
 a) John B. Watson
 b) Noam Chomsky
 c) Sigmund Freud
 d) none of the above

6) Which of the following explanations might a cognitively-oriented psychologist most likely propose?
 a) Stress results from an individual's perception and failure to realize one's potential.
 b) Stress is the result of a chemical imbalance in the brain.
 c) Stress is the result of excessive demands on the ability to process information.
 d) Stress is an adaptive response to situations which has evolved over time.

7) Which approach to psychology emphasizes the role of the situation and best appreciates the diversity in the human population?
 a) behavioral approach
 b) cognitive approach
 c) humanistic approach
 d) sociocultural approach

8) Which of the following is *not* a specialized field of psychology?
 a) psychiatry
 b) forensic psychology
 c) sports psychology
 d) ergonomics

9) Briefly explain the similarities and differences between structuralism and functionalism, including the definition of each in your answer.

10) Suggest how a psychologist adhering to each of the cognitive, psychodynamic, and sociobiological approaches might explain "forgetting."

Test Yourself Answers

1) **b.** Psychology is defined as the science of behavior and mental processes. The other definitions are inaccurate or describe particular approaches to psychology.

2) **b.** Physiology and philosophy are most often credited with influencing the establishment of psychology as a distinct scientific discipline.

3) **d.** Wilhelm Wundt founded the first psychological laboratory at the University of Leipzig, Germany.

4) **c.** A Gestalt psychologist concentrates on the holistic representations of stimuli and how these give rise to meaning.

5) **a.** John B. Watson was the father of behaviorism, an approach that focuses on observable stimuli and responses. The other approaches are concerned with mental processes that are not directly observable.

6) **c.** A cognitively oriented psychologist, who is concerned with the perception, manipulation, storage, and retrieval of information, might suggest stress is the result of excessive demands on the ability to process information. The other hypotheses align with (a) the humanistic approach, (b) the biological approach, and (d) the sociobiological approach.

7) **d.** The sociocultural approach studies how thinking and behavior vary across cultures and in different situations.

8) **a.** Psychiatry is a branch of medicine, not psychology, involved in the treatment of psychological disorders.

9) Structuralism and functionalism are both types of mentalism, studying mental events and processes. However, they differ in their approach. The structuralist perspective seeks to understand behavior by examining its components or ingredients. A functionalist perspective assumes that behaviors must serve some function, or they would cease to exist. In other words, structuralism is concerned with what processes are involved in a particular behavior, or what is required for a behavior to occur; whereas functionalism is concerned with what goals are being served by a particular behavior. A structuralist asks, "What are the components of that behavior?" when a functionalist asks, "What purpose does that behavior serve?"

10) A cognitive psychologist studies mental processing and the handling of information, and might therefore suggest that forgetting is a failure in the storage and/or retrieval of information. A psychologist trained in the psychodynamic approach would view forgetting as a mechanism that reduces internal conflict, especially by repressing painful or embarrassing memories. An evolutionary psychologist might claim that the mind has evolved to forget information, because this is an adaptive function that improves behavior (such as by avoiding a "cluttered" mind full of useless past information).

Research Methods in Psychology

This chapter presents an overview of the basic methods of research that characterize psychology. It begins with an introduction to the scientific method that guides research in many disciplines. It also introduces key statistical concepts that are used to assess research findings, as well as a discussion of research ethics. As a science, psychology depends on a variety of research methods for its accumulated knowledge. To appreciate the findings of psychology, to evaluate their strengths and weaknesses, it is necessary to understand these methods.

■ THE SCIENTIFIC METHOD

The **scientific method** is not unique to psychology, but describes a process or cycle that characterizes "good science." In fact, this method dates back to the work of Aristotle (384–322 B.C.), although these days, it has changed somewhat. By systematically adhering to the scientific method, research on a particular topic is guided by a process of self-correcting theory development, testing, and improvement.

Theory Development

The scientific method is concerned with theory development, testing, and refinement. A **theory** is a set of integrated principles and assumptions that organizes data, explains behaviors, and makes testable predictions. Unfortunately, the term "theory" in common usage has taken on a more imprecise meaning that often refers to a guess or hunch. In science, theories are not just educated guesses of what will happen, but systematic formalizations of how and/or why things happen. A conjecture about who committed a crime or what will happen when you microwave some random object, is not a theory. However, a coherent system for explaining differences and relationships between living organisms from today and millions of years ago (for example, evolution) is an established theory. For instance, a theory in psychology of altruistic (helping) behavior may explain such behavior by the desire to look good or give a favorable impression to others.

Forming Hypotheses

Psychological theories are used to form **hypotheses**—testable predictions about behavior, mental events, or other phenomena. A hypothesis is stated before research is conducted and formalizes what to expect based on the theoretical principles under examination. A hypothesis derived from the example theory of altruistic behavior might predict that an individual is more likely to help out when others are around to witness the act.

Hypothesis Testing

After formulating a hypothesis, it must be subject to empirical testing. That is, one must determine whether the hypothesis is supported by actual data (for example, real behavior). There are many methods for testing hypotheses, each with its own strengths and weaknesses. Testing the hypothesis about altruistic behavior could involve conducting an experiment, or simply watching people in natural settings, and comparing behavior in the presence or absence of others.

Reporting and Refining

After testing hypotheses, research psychologists disseminate their findings to colleagues through journals, books, and conferences. Academic environments and the networks they comprise have always provided important avenues of communication among researchers and theorists. Researchers seldom work alone, and the very act of publishing one's findings or theories invites others' comments and contributions. If hypotheses are confirmed, this advances support for the theory; otherwise, it suggests the need for refining the theory in light of the new data. In this case, the cycle begins anew—the polished theory is used to derive new hypotheses, which are subsequently tested and reported.

■ IDENTIFYING RELATIONSHIPS: CORRELATIONAL METHOD

The correlational method is one of two general ways that psychologists collect information in hopes of supporting their theories about behavior and mental processes. The other, the experimental method, is covered in the next section.

The correlational method is used as a broad term that encompasses several distinct research methodologies. This term is used because these methods seek to find consistent relationships, or **correlations**, between variables of interest. They frequently make use of statistical correlation coefficients (see the "Descriptive Statistics" section, later in this chapter), as well. The most common correlational methods are discussed here.

Surveys

In a **survey**, also called a poll, one or more questions are asked of a relatively large number of people. Political polls ask people, for example, about their preferences toward particular candidates or governmental policies, while consumer polls ask about shoppers' needs and preferences. Surveys may utilize questionnaires (lists of questions) to allow respondents to answer sets of questions that can cover a range of topics, or they may use interviews to obtain detailed information in a more flexible format.

The benefit of using a survey is that it is a relatively easy and inexpensive way to collect data on a large number of people. However, the survey method does not provide a good degree of control over respondents, which may introduce misunderstanding or dishonesty. Also, the way questions are asked has a large impact on survey results. The same underlying question asked different ways, or with different response options, can lead to widely disparate conclusions.

It is rarely practical to question everyone of interest, for example, all Americans of voting age. For this reason, the survey usually must select a smaller number of individuals whose answers can be taken to represent the larger group. This smaller group is termed the **sample**, and the larger group they represent is termed the **population**. The population, in fact, can be fairly small. A marketing study of an exclusively priced men's cologne, for example, is directed only toward men with a high income, and perhaps only executives among these. The sample must be chosen carefully, therefore, to provide an unbiased representation of the target population; otherwise, serious errors can occur in drawing any conclusions.

Random Sampling

Avoiding bias can usually be accomplished by drawing the sample at random from the population, so that each of its members is equally likely to be chosen. That is, once the population is identified, the survey respondents are selected randomly, such as by selecting names randomly from a phone book.

Stratified Sampling

In reality, the goal of selecting at random from the entire population can be difficult to achieve, so researchers often use **stratified sampling** procedures. This requires that a predetermined number of people be drawn from various sectors, or strata (layers) of the population. To be useful, a political poll, for example, may seek to include a number of professional people and a number of nonprofessional people, a number of uneducated and a number of highly educated people, a certain number of people from various races and religions, and so on.

Case Studies

Case studies are intensive investigations of single situations, incidences, or people. For example, a case history focuses intensively on the life of a single individual. Clinical psychologists often use this method to deepen their understanding of unique or instructive cases; all of Freud's early clinical investigations were case histories that he published along with his observations. The case study method is not designed to eliminate alternative explanations for findings. As a result, it often leaves many questions unanswered but is a rich source of ideas for future research.

Naturalistic Observation

The method of **naturalistic observation** focuses on behavior in its natural setting rather than in the controlled environment of the laboratory. It differs from a case study in that the researcher does not interact with the subject of investigation. For example, watching how people behave in a shopping mall or observing the daily life of an African tribe are both examples of naturalistic observation. Such studies can involve animal populations as well. Because the investigator does not interfere with the natural behavior, this method provides an excellent opportunity to study individuals or groups as they really behave. However, this also means that certain questions may not be answered; investigators must take what they get.

Longitudinal versus Cross-Sectional Designs

Longitudinal studies follow individuals for significant periods of time. Such studies are important in developmental psychology, where psychologists monitor developmental processes for substantial periods. Likewise, questions regarding the success of various types of psychotherapy, or the effectiveness of teaching methods, are often approached through longitudinal studies. Another design that is particularly useful for answering developmental questions is the **cross-sectional study**, which includes different groups at one period in time. Where a longitudinal study may measure behavior in a single group of students when they are in each of the first, third, and fifth grades, a corresponding cross-sectional study would measure separate groups of first, third, and fifth graders at one time.

■ DETERMINING CAUSATION: EXPERIMENTAL METHOD

While psychologists utilize correlational research methods in many situations, the experimental method, when applicable, is considered the most desirable. This is because the experiment allows a greater degree of control over the research situation than any other method. Second, under ideal conditions, such control lets the researcher establish clear causal relationships. No other method offers the researcher the possibility of being able to specify without question the cause of a psychological event, even though some methods provide very helpful suggestions.

The basic idea of an **experiment** is to perform a manipulation upon some system of interest and observe the results. For example, a physicist might subject a bar of iron (a very simple "system") to a magnetic field and observe the results (the bar becomes magnetized). Unlike the bar of iron, organisms and particularly human beings are very complex systems, ones that are not passive but are constantly interacting with their environments. As a result, the simple method of choosing a natural environment and introducing a manipulation (or treatment) and observing the results is unsatisfactory in the behavioral sciences.

Variables

To formalize concepts into measurable factors, it is often necessary to rely on an **operational definition**. For example, in order to measure the amount of altruistic behavior one exhibits, it is necessary to create a measure of this concept, such as whether or not someone picks up a stranded motorist, or the amount of money donated to a charity. The exact operational definition for any concept will depend on the nature of the experiment.

The factors in an experiment are properly called **variables**, and are classified in two main categories. The **independent variable** is the manipulation or treatment itself. In the experiment on altruistic behavior, this would be the presence or absence of others. The **dependent variable** is the measurement of interest, such as the extent of altruistic behavior (for example, amount of money donated). In psychological research, the dependent variable is usually a measure of behavior, mood, or cognitive function.

The dependent variable derives its name from the fact that it is dependent upon the independent variable, which in contrast can be manipulated independently from other factors. For example, it might turn out that the altruistic behavior is indeed dependent upon the presence of others: Without others around to observe a charitable act, one does not perform the act. It is precisely this dependence of the dependent variable on the independent variable that gives the experimental method the power to identify causal relationships.

It should be noted that other classifications of variables exist as well, although they are not usually of primary interest in an experiment. In fact, these variables are often seen as nuisances that may have an impact on the dependent variable, or the relationship between the independent and dependent variables. Extraneous variables are those that may be influencing the dependent variable in an experiment that are not measured or manipulated as independent variables. Moderator variables are those that affect or control the degree of the effect of the independent variable on the dependent variable.

Designing Experiments

The main purpose of a psychological experiment is to isolate specific causes of behavior, so experiments are designed with this purpose in mind. Although there are different types of experimental designs, they share some common features. Experiments involve the manipulation of relevant independent variables, or **factors**, such as the amount of a drug, the length of a word list, or the presence of others. Then the behaviors under examination are measured to determine whether the factor is a significant cause of the behavior.

Experimental psychologists attempt to achieve the greatest possible degree of **control**, or holding constant factors that are not under investigation. Control is essential to guarantee that any results are due to the hypothesized factor(s), and not merely to chance differences between the groups or their situations. Good control also helps to minimize the possible influence of extraneous variables that are not of direct interest.

Groups and Assignment

A typical experiment in the behavioral sciences utilizes at least two groups of participants, termed the **experimental group** (experimental condition) and the **control group** (control condition). The participants are treated exactly the same in both groups, except that those in the experimental group receive the factor, or manipulation, while the others do not. Thus, the measured behaviors (for example, altruism) can be compared between the experimental and control groups, and any differences in this measure are attributed to the manipulated factor (such as presence of others). There may be more than one group of each type, such as multiple experimental groups that each receive a different **level** of a particular factor (for example, presence of few, several, or many others).

With systems as complex as human beings it is virtually impossible to find or create groups that are literally equal in all respects aside from the manipulated factor (for example, equal abilities or qualities). For this reason, an important component of experimental design is **random assignment** of each participant to a particular group. This means that in choosing participants for each condition, the researcher assures that each participant will have an equal chance of being assigned to either condition (such as by drawing names). If we have reasonably large numbers of participants, individual differences will average out equally between the groups. This helps to ensure that only the factor under investigation is implicated as a cause of the behavior.

In some experimental designs, participants serve as their own controls, providing another means for excluding irrelevant factors. For example, a single participant may be given a memory test both before and after administration of a drug that claims to improve memory. In this case, a participant's memory before drug administration (control condition) can be compared to the same participant's memory afterwards (experimental condition). This is called a **within-subjects design**, or repeated measures design,

because the independent variable is manipulated within each participant, and measurement of the dependent variable is repeated for each participant. In the more typical **between-subjects design**, each participant receives only one condition.

Sampling also plays an important part in the experimental method. An experimenter may want to understand the behavior of one population but have convenient access to only an unusual or specialized sample of people from which to select experimental participants. This is especially true in most major universities where participants are typically drawn from introductory courses or campus advertisements.

Other Aspects of Experimental Research

In conducting experimental research, once we determine the variables of interest and select and assign participants, then we are almost prepared to "run the experiment." However, there are a few additional issues that often need to be considered.

Placebos

Consider an experiment designed to test the hypothesis that sugar causes hyperactivity in children. It probably comes as no surprise that passing out candy to children could affect their behavior, even if it contains no sugar at all. Aside from the excitement of receiving the candy, some of the children may have been told by their parents that candy makes them hyperactive. For these children, the candy may have a **placebo effect** due to such expectations.

Placebo is Latin for "I will please," and represents the first line in a medieval healing prayer. The term placebo was originally used to refer to medicines, such as pills, that actually have no active or effective substance. Such a "medicine" can render dramatic effects if the user has strong expectations for it. The disappearance of a headache, for example, after taking such a pill is referred to as the placebo effect.

The placebo effect can have serious implications for experiments involving drugs, or any other treatment for which participants already have well-developed expectations. In an experiment with candy, it would be wise to have an additional **placebo group** made up of children who receive candy with no sugar. For this to be effective, the placebo candy must be indistinguishable from the regular candy, so that the children themselves do not know which they have received. (Indeed, it is best not to mention the presence of the placebo at all.) Now we have three groups: an experimental group receiving candy with sugar, a control group with no candy, and a placebo group receiving candy without sugar. Differences in activity levels due to sugar alone should appear in the experimental group alone, but differences due simply to receiving candy, regardless of sugar content, will appear between the control group and the two candy groups.

Bias versus Objectivity

Experiments in psychology can become very complex, in part because experimenters themselves are not perfectly objective observers. Ambiguities are often present in experiments, even in the best observational situations. The researcher may then be forced to make subjective judgments during the experiment.

For example, a researcher may see a child with his or her arms around another child in such a way that it is not clear whether they are wrestling, hugging, or simply reaching around for drawing materials. An experimenter that knows the child has had candy with sugar may be inclined to interpret the behavior as wrestling, in line with the hypothesis under investigation. On the other hand, if the child did not

receive candy with sugar the experimenter may look more closely at the situation before forming a conclusion, discovering that the child actually was only reaching for a crayon.

Because it is so natural to have expectations affect our perceptions, even the best-intentioned investigator can exhibit such **experimenter bias** in making judgments during an experiment. The only solution is to be sure that the person who collects the data, that is, who actually observes the activity of the children, does not know to which group each child belongs.

Blinds

For reasons of control, reducing unexpected placebo effects, and reducing experimenter bias, it is desirable to keep participants and investigators blind to the exact conditions and assignments of an experiment. Participants who do not know which conditions they are in—control versus experimental group—are said to be **blind** to their assignments. This helps to avoid, reduce, or eliminate the effect of any preconceived expectations or attempts to perform a certain way. A researcher may have someone other than himself or herself collect the data in order to keep measurement more objective. A data-collector who does not know which treatments are real and how participants are assigned is said to be blind as well. For this reason, a study where neither the participants nor the observers know the group assignments is called a **double-blind** procedure. Although difficult to set up, such devices are necessary to obtain unbiased results in many areas of psychology.

Limitations of Experimentation

Although the experimental method is the most powerful research tool available to psychologists, it has limitations. Many questions cannot realistically be put into an experimental framework. Even among questions that can be addressed experimentally, there are ethical limitations on what manipulations psychologists can do. For example, questions regarding the effects of malnutrition on the development of the human infant brain, or the impact of life-threatening stress, cannot be answered by imposing these afflictions in controlled experimental situations. In some cases, experimentation is one of many options, the use of which must be carefully considered by weighing potential risks and benefits.

It has been common in both psychological and medical research to study nonhumans in cases where using human subjects would be inappropriate. However, the use of animals as subjects is strictly constrained by guidelines for their ethical treatment in experiments. Abiding by these guidelines can add to the expense and complexity of experimental research. When an experiment cannot feasibly be performed, researchers are forced to rely on other methods, such as those discussed earlier in this chapter.

■ STATISTICAL ANALYSIS

After conducting research and obtaining measurements and data, psychologists use various procedures for analyzing the data to describe results and test hypotheses. The results of a psychological study can be qualitatively descriptive (for example, verbal), as is often the case with naturalistic observations. Where possible, however, psychologists prefer quantitative, or numerical, results. These allow a more objective analysis and provide for a number of useful statistical procedures. **Statistics** are numbers, like sums or ratios, representing information about samples of events or individuals. In order to describe sample characteristics and test hypotheses, psychologists rely on descriptive statistics and inferential statistics, respectively.

Descriptive Statistics

Descriptive statistics serve the important function of characterizing or summarizing large amounts of data so that they can be readily comprehended. There are four common types of descriptive statistics: frequencies, measures of central tendency, measures of variability, and measures of covariance.

Frequencies

In many situations psychologists are interested in how many times certain events—including specific values of a variable—occur. Sometimes, such as with naturalistic observation, this is the primary data of interest. The **frequency** of an event is simply this count of occurrences. If several different events are of interest, psychologists may explore the **frequency distribution** of the data. For example, if test scores range from 0 to 100, then a frequency distribution may illustrate how many scores fall within certain ranges, such as 80–89, corresponding to the "event" of a B grade. One then may also be interested in the relative frequency, such as a proportion or percentage, of how often each event occurs (for example, 33 percent, or one-third, of the class received a B grade).

Central Tendency

The first type of descriptive statistic characterizes the central tendency of a set of data. The most common measures of central tendency are the mean, the median, and the mode of a distribution of data (for example, scores on a test, or amount of charitable donations).

The Mean

The most frequently used statistic of this type is the **mean**, or average, a single value that characterizes a potentially large number of cases or scores. For example, the mean (average) height of male students at a particular university might be 5'10". This mean is a single value that represents the center of all the values representing the heights of each and every male student. It is calculated by simply adding up all of the values in the sample (all male students' heights) and dividing by the sample size (the number of male students).

The Median

Another measure of central tendency is the **median**, the score that appears exactly in the middle of a rank-ordered distribution of scores. For example, in the distribution 2, 3, 3, 5, 5, 5, 8, the median is 5, the fourth number in an ordered list of seven scores. The median is useful because it characterizes a "real" score rather than a numerical average that might not be one of the scores (for example, the mean score of 4.43 in the preceding sample). It also helps to divide the distribution into an upper and lower half. For example, if the median height in the male student sample above is 5'11" inches, then half the students are that height or taller, and half are that height or shorter.

The Mode

A third measure of central tendency is the **mode**. The mode is simply the most frequently occurring single score. For example, in the above distribution of scores, the mode would be 5, because this number appears more often than any other. The modal height of male students at a university is 5'9" if there are more males with this height than any other height.

The median and the mode are relatively unaffected by the presence of a few scores that are extremely large or small, such as the presence in the population of a small number of unusually tall or short males. The mean, on the other hand, can be markedly affected by such extreme values. For example, adding two scores of 20 to the distribution {2, 3, 3, 5, 5, 5, 8} would dramatically affect the mean of those scores, but would not change the median or mode at all. Also, for variables taking only discrete values (for example, whole numbers), the mean may not be appropriate—it makes more sense to say that the average family has a median of two children than a mean of 1.7 children, because the latter cannot exist. Such points should be considered when selecting an appropriate statistic for central tendency.

Variability

The second common type of descriptive statistic characterizes the **variability** in a sample, which is the spread or dispersion of a distribution of values. In other words, it characterizes the degree to which individual values differ from the central value.

Range

The most easily understood of these is the **range**, which simply gives the highest value minus the lowest value. For example, in a distribution of test scores wherein the highest score obtained was a 96 and the lowest a 54, the range is (96–54), or 42.

Standard Deviation and Variance

In statistical analyses, a more common measure of variability is the **standard deviation**. The meaning and computation of the standard deviation are fairly complex, but essentially the standard deviation is a single value calculated to represent the average fluctuation of scores around the mean score. For a normal population, about two-thirds of the population fall within one standard deviation on either side of the mean. For example, if the mean height of college males is 5'10", and the standard deviation is 1", then about two thirds of college males are between 5'9" and 5'11" tall (the mean of 5'10", plus and minus one inch). Oftentimes, the variance is used in statistical calculations. The **variance** is interpreted in a similar manner as the standard deviation, because it is simply the standard deviation squared.

Covariance (Correlation)

Measures of central tendency and variability describe the scores for a single variable. One other common descriptive statistic signals the relationship between two different variables. The **correlation** represents the degree to which two variables change together, and is measured by the correlation coefficient.

The correlation coefficient is usually expressed as a decimal form of a ratio (for example, 0.45). It ranges in value from 0 to 1 to indicate the relationship strength, and can be positive or negative to indicate relationship type. A positive correlation (direct relationship) means that variables change in the same direction: As one variable increases, the other increases as well. A negative correlation (inverse relationship) means that increasing one variable tends to occur with decreases in the other. A correlation coefficient is said to be "high" if it approaches (is near) the value of +1.00 or –1.00. The relationship between variables is said to weaken as the correlation coefficient approaches 0.

We might expect that height and weight in the above group of college males, for example, would yield a fairly positive correlation coefficient. In other words, the taller they are, the more they are likely

to weigh. In contrast, if height is inversely related to body fat, then there would be a negative correlation between these two measures—taller people tend to have less body fat. Finally, we might guess that a student's height is unrelated to his or her grade point average, so that correlating these two variables would yield a correlation coefficient near 0.

Inferential Statistics

Whereas descriptive statistics describe a sample in terms of the variables or scores of interest, **inferential statistics** provide measures of the comparison between groups and help researchers to draw conclusions. For example, we would use inferential statistics to measure the difference in the activity levels of the control versus experimental groups in the experiment studying the effects of sugar on school children's behavior.

Chance and Significance Testing

Inferential statistics help researchers make decisions as to whether or not their findings are reliable, or in statistical terms, **significant**. Suppose, in a study of the effects of sugar on children, that the experimental group (which received candy with sugar in it) produced a higher mean activity level than the two control groups (which received either placebos or nothing). Before jumping to any conclusions about the relationship of sugar to activity in children, the experimenter must first ask whether this difference is reliable—whether it could be repeated—or whether it is instead probably due to chance alone.

An inferential procedure such as the analysis of variance (commonly abbreviated ANOVA) would indicate whether or not the difference is reliable (significant), and the extent of the reliability. Essentially, such routines give an indication of how likely the effect (difference between groups) is to occur by chance alone. As the likelihood that the results are due to chance decreases, the likelihood that the results are due to the experimental manipulation (the independent variable) increases. Thus, inferential statistics are a measure of the weight of the "evidence" in favor of a particular conclusion about the causal relationship between variables.

Drawing Conclusions; Making Errors

Inferential statistics can be used to draw tentative conclusions about the hypotheses under examination. If an inferential statistic suggests that there is "less than a 5 percent possibility" that the effect is due to chance alone—a **significance level** of 95 percent—the researcher still must make a decision about whether to accept or reject the hypothesis. As the significance level increases, the researcher can be more confident about the decision. Note that there is no such thing as a sure thing in hypothesis testing; no inferential test produces a significance level of 100 percent, and no hypotheses are ever "proved."

Even with a very high significance level, there is always the chance of making an error in interpreting results in favor of (or against) hypotheses. A researcher may make a **false positive** claim, or Type I **error**, by suggesting a relationship exists when it in fact does not. Alternatively, a **false negative** claim, or Type II error, occurs when one rejects a hypothesis which is in fact true. There is a balance to be found when interpreting inferential statistics, depending on one's willingness to accept each type of error.

■ GENERALIZABILITY AND APPLICATION

A danger of conducting research is the possibility that conclusions will be drawn too hastily, or applied to generally. This could lead to undesirable consequences, especially in applied settings where research is used as justification for policy measures, drug therapy, organizational changes, and so on. It is therefore important to qualify the results of psychological research, and understand their application.

Causation versus Correlation

It is important to distinguish between causation and correlation in the design, conducting, and interpretation of psychological research. Only the experimental method can support hypotheses of causation. Thus, if one desires to test a hypothesis of causation, one must devise an experiment to do so. Furthermore, when reading about research in an academic publication or the popular press, one should always keep in mind this distinction. Be wary of claims that "X causes Y" when an experiment was not performed, or when only correlations are reported in support of the claim.

Replication

Despite the assurance of statistical significance, replication is an invaluable part of the scientific process. Replication refers to the fact that research findings will not be considered established until they are shown to be repeatable (replicable). If a particular experimental effect cannot be replicated, one must question whether there is an alternative explanation for the effect, such as idiosyncratic procedures at an institution, or the particular sample of participants.

Application: Choosing the Right Tool for the Job

Psychologists have a variety of useful and scientific methods at their disposal. These methods can be applied to topics across virtually any psychological domain. However, it is important that psychologists understand the problem they are tackling and choose an appropriate design accordingly. Similarly, it is crucial to know in advance what analyses will be applied to a particular study. Although many different methods and statistics exist in the psychologist's toolbox, one cannot just choose any method, such as the easiest or most convenient. A number of questions must be considered. Am I seeking to determine causation or correlation? Am I able and willing to manipulate the factors I want to study? Do I need to worry about controlling for participant or investigator expectations?

■ ETHICAL ISSUES IN PSYCHOLOGICAL RESEARCH

There is extensive opportunity for psychological research to influence and shape many aspects of our lives. Indeed, the impact of psychological research on areas such as health, society, and politics is undeniable. However, with this great influence comes great responsibility, and the ethical guidelines for psychologists are a serious and pervasive part of the field. These guidelines are formalized in the *Ethical Principles of Psychologists and Code of Conduct* of the American Psychological Association, and are also considered in publication and funding decisions.

Protecting Participants

One of the chief ethical concerns of psychologists conducting research on humans and nonhumans is the protection of research participants. This includes minimizing any potential risk or discomfort—whether physical, emotional, or psychological—of human participants as well as humane treatment of nonhuman subjects. These days, the use of deception in research is also strongly discouraged and must be justified as the only possible means to study an important problem. In fact, psychologists are required to disclose a reasonable amount of information regarding the study to participants prior to their participation. This allows participants to give **informed consent**, or agreement to participate based on sufficient information about the study. After a study, participants are **debriefed** by the investigator, who reveals any relevant information that was withheld and corrects any intentional misdirection as well as any unintentional participant misunderstandings.

Fairness, Honesty, and Accuracy

It is incumbent on psychologists to portray their research results fairly, accurately, and honestly. Although researchers are free to determine what topics to study, and what research results are worthy of dissemination, they are not supposed to knowingly withhold information. For example, it is poor practice to publish only those results from a study that confirm one's hypotheses, or include in an analysis only those participants who exhibit a predicted effect. More severe infractions include fabrication and plagiarism. **Fabrication** refers to making up research results, or saying that results were obtained that were not. **Plagiarism** is the act of presenting the work of others, whether ideas or words, as one's own. Violations of scientific integrity by one researcher could tarnish the image of the field as a whole, and is therefore seriously enforced.

Review Boards and Peer Review

Psychological research also benefits from a fair amount of oversight to preserve and safeguard these ethical principles. Colleges and universities have institutional review boards that aid researchers in considering ethical issues, and these boards must approve research designs before they are implemented. Research results are also not widely dispersed without external (to the researcher) evaluation. The peer review process, where colleagues review and critique the work that is presented for publication, is used by most academic journals to control the quality of the research and uphold the principles of "good science."

Both basic and applied psychological research rely on the scientific method of conducting research and interpreting the data yielded by such research. This involves a cycle of theory development, forming hypotheses, testing hypotheses, and refining theories in light of empirical results. The particular research methodology may be either correlational or experimental. Correlational research seeks to identify relationships between concepts or behaviors. The most common form of correlational research is the survey, which polls a large number of people and relies on representative samples to make claims about a certain population. Case studies study one individual in detail, and thus provide depth rather than breadth. Naturalistic observation is set in the field, rather than in the laboratory, and involves observation rather than interaction.

Experimental methods provide greater control over the research situation and allow for causal infer-ences. A manipulation or treatment is applied to one group of participants, the experimental group, and withheld from a comparison group, the control group. Representative sampling is also important in exper-iments, as is random assignment of participants to groups. In conjunction with other design features such as blind procedures or placebos, these characteristics attempt to minimize alternative explanations for the observed effects. Every experiment utilizes dependent and independent variables, which must often be operationally defined for a particular experiment. The dependent variable (usually a behavior) is assumed to depend on changes in the independent variable (the treatment).

Once data are collected, they can be analyzed descriptively and/or inferentially. Descriptive statis-tics summarize data, using both measures of central tendency, like the mean, median, and mode; and measures of variability, like the range and standard deviation. Inferential statistics measure the results of comparisons between groups, and provide an index of the significance or reliability of research findings. These assist researchers in drawing conclusions from data, with the understanding that there is always the likelihood of committing errors. An important quality of inferential research is replication, or repeti-tion of findings in similar studies. It is also important to always be cautious in generalizing or applying research findings.

An important aspect of psychological research is adherence to ethical standards. This involves the way human participants and nonhuman subjects are treated before, during, and after a research study. Also, the manner in which research is conducted and reported should conform to ethical guidelines. Institutional review boards and the peer review process help to ensure the integrity of psychology as a scientific discipline.

Key Concepts

between-subjects design	false positive	population
blind	frequency	random assignment
case study	frequency distribution	random sampling
control	hypothesis	range
control group	independent variable	replication
correlation	inferential statistics	sample
cross-sectional study	informed consent	scientific method
debriefing	level	significance level
dependent variable	longitudinal study	standard deviation
descriptive statistics	mean	statistics
double-blind procedure	median	stratified sampling
experiment	mode	survey
experimental group	naturalistic observation	theory
experimenter bias	operational definition	variance
fabrication	placebo effect	within-subjects design
factor	placebo group	
false negative	plagiarism	

Key People
Aristotle

SELECTED READINGS

Shaughnessy, J. J., Zechmeister, E. B., & Shaughnessy, J. S. (2005). *Research methods in psychology*. The McGraw-Hill Companies.

Hogan, T. P. (2003). *Psychological testing: A practical introduction*. John Wiley & Sons, Inc.

Davis, S. F., & Smith, R. A. (2004). *An introduction to statistics and research methods: Becoming a psychological detective*. Pearson Education.

Campbell, D. T., & Stanley, J. C. (1963). *Experimental and quasi-experimental designs for research*. Chicago: Rand-McNally.

Cohen, B. H., & Spata, A. V. (2004). *Explaining Psychological Statistics with Research Methods: Science and Diversity*. Wiley, John & Sons, Inc.

Test Yourself

1) Which of the following is not a step in the scientific method?
 a) theory development
 b) forming hypotheses
 c) proving hypotheses
 d) theory refinement

2) A(n) _____ provides a basis for deriving testable _____.
 a) experiment; variables
 b) theory; experiments
 c) operational definition; statistics
 d) theory; hypotheses

3) _____ is a type of_____ method that is set in the field, not the laboratory.
 a) An experiment; correlational
 b) Naturalistic observation; correlational
 c) An experiment; inferential
 d) Naturalistic observation; experimental

4) Which of the following can a psychologist use to determine causal relationships?
 a) naturalistic observation
 b) correlational methods
 c) experimental methods
 d) all of the above

5) Research results are summarized using _____statistics, and _____ statistics are used to judge significance and draw conclusions.
 a) general; specific
 b) correlational; experimental
 c) inferential; descriptive
 d) descriptive; inferential

6) If appetite increases as the number of thoughts about food increases, which statement is most accurate?
 a) Thinking about food is positively correlated to appetite.
 b) Thinking about food is negatively correlated to appetite.
 c) Thinking about food is inversely related to appetite.
 d) Thinking about food causes increases in appetite.

7) Which of the following necessarily employs a repeated measures design?
 a) an experiment
 b) a longitudinal study
 c) a cross-sectional study
 d) all of the above

8) Which of the following is the most ethical procedure?
 a) debriefing
 b) plagiarism
 c) fabrication
 d) deception

9) Briefly define each of these terms with respect to the following experiment: control group, experimental group, placebo group, independent variable, and dependent variable.

 Dr. Smith is interested in the effects of violent video games on aggressive behavior in children. She randomly divides a class of fourth graders into three groups. The first group plays with assorted toys for thirty minutes, while the second group plays violent video games, and the third group plays nonviolent video games. Then,

all the children are allowed to play together on the playground and the number of aggressive acts (for example, pushing and fighting) performed by each child is recorded.

10) Define three measures of central tendency, and give their values for the following distribution of test scores: 7, 8, 9, 7, 7, 9, 8.

Test Yourself Answers

1) **c.** The scientific method involves testing hypotheses in conjunction with the other steps listed, not proving hypotheses. Hypotheses can be supported to various degrees but cannot be proven.

2) **d.** A theory is a framework for understanding phenomena and provides a basis for deriving testable hypotheses, or predictions.

3) **b.** Naturalistic observation is a type of correlational method that is set in the field, not the laboratory.

4) **c.** Only experimental methods can determine causation. Correlational methods, of which naturalistic observation is an example, can only suggest relationships.

5) **d.** Research results are summarized using descriptive statistics, and inferential statistics are used to judge significance and draw conclusions. Answers (a) and (b) do not contain legitimate types of statistics.

6) **a.** If appetite increases as the number of thoughts about food increases, then thinking about food is positively correlated to appetite. This is an example of a direct relationship, not an inverse relationship. Based on this information one cannot claim causation—perhaps having an appetite causes the thoughts about food, rather than vice versa.

7) **b.** A longitudinal study employs a repeated measures design, because the same participant is studied at different points in time.

8) **a.** Debriefing is the ethical procedure of revealing all relevant information after a research study. Although deception may technically be justified if there is no feasible alternative, it is discouraged (and must subsequently be revealed during debriefing).

9) Dr. Smith has performed an experiment so that she may determine whether violent video games cause aggressive behavior. In her experiment, the students who played violent video games were in the experimental group, because they received the manipulation of interest. Those students who played with toys were in the control group, because they did not receive this manipulation. The children who played nonviolent video games were in the placebo group, which was included to determine whether playing video games at all (violent or not) contributed to aggressive behavior. The independent variable was playing violent video games, and the dependent variable was the number of aggressive acts on the playground, which was used as the operational definition of aggressive behavior.

10) The mean is a measure of central tendency that is the average of all values or scores, obtained by summing all scores and dividing by the number of scores, which is $55 \div 7 = 7.86$ for the given sample. The

median is the middle score when they are rank-ordered, or arranged lowest to highest; this is the fourth score in a series of seven, or the value 8. The mode is the most frequently occurring value in the distribution of scores, which is the value 7, occurring three times.

Biology, Brain, and Behavior

Study of the biological mechanisms serving overt behaviors contributes to a greater understanding of virtually every psychological process. This chapter serves as a primer for the biological bases of human behavior. There are two major systems that serve as the body's communication pathways, the nervous system and the endocrine system. The nervous system is introduced here by beginning with the neuron, or nerve cell, followed by a taxonomy of the nervous system. The principles of electrical and chemical communication between neurons are also introduced. Then an overview of the endocrine system, which uses hormones to guide biological processes, is presented. A large part of this chapter is devoted to a detailed look at the brain, including its anatomical and functional structure. The chapter also describes the methods of neuroscience by which we have been able to learn so much about the nervous system. In conclusion, it provides brief coverage of behavioral genetics, which has helped us to understand the extent of (inherited) biological influences on mental events and behavior.

■ THE BODY'S BUILDING BLOCKS

The cell is the basic anatomical unit that makes up the human body. There are cells of many different types, such as blood cells, skin cells, bone cells, muscle cells, and so on. The nervous system in particular comprises two basic types of cells. These are **neurons**, or nerve cells, which are most important in the function of the nervous system, and **glial cells** (also called glia), which provide nutrition, support, and insulation to the neurons.

Neuronal Anatomy

There are three parts or regions to each neuron: the dendrites, the cell body, and the axon (see Figure 3-1). The **cell body**, sometimes called a soma, is composed of a **cell membrane**, or wall, that is filled with a fluid called **cytoplasm**. It also contains the cell **nucleus**, where the genetic material for the cell is found, and the cell's energy producers, **mitochondria**. Most neurons have many **dendrites** that radiate and branch like roots from the large central cell body. Also extending from the cell body is a single **axon**,

a long thin tube or fiber that may be up to several centimeters, and sometimes even a meter or more, in length.

Dendrites

Dendrites carry electrochemical signals into the cell body, which in turn may send signals to other cells via the axon. That is, dendrites are the means by which neurons receive the majority of signals *from* other neurons.

The Axon

The axon, on the other hand, carries signal impulses out of the cell; it is the means by which a neuron communicates to other neurons. Axons can carry signals large distances through the body, allowing the brain to control the body's muscles. They also carry sensory signals from the senses to the brain for processing. The axons of many neurons are wrapped in specialized glial cells that form a **myelin sheath**. This is essentially a blanket of fat that allows for faster conductance of signals.

Synapses

Neurons are not physically connected, but are separated by microscopic gaps. These gaps, between the axon of one neuron, that send a signal, and the dendrites of another neuron that is receiving the signal, are called **synapses**. The term synapse is also sometimes used as a verb, basically meaning "functionally connects to," such as when saying that one neuron synapses on another. Indeed, most neurons in the brain synapse onto countless other neurons in the brain.

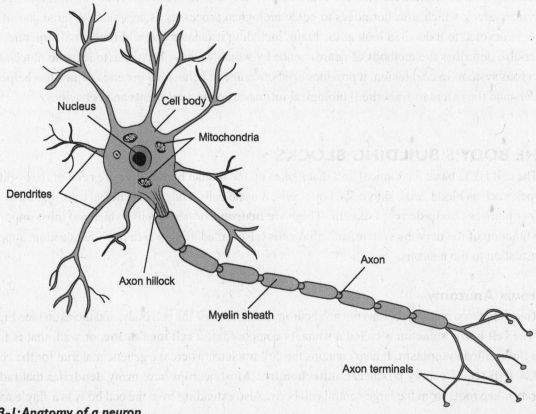

Fig. 3-1: Anatomy of a neuron

Types of Neurons

Nerve cells that send information outward to control the muscles are termed **motor neurons** (or efferent neurons, from the Latin for "carrying outward"). Those that bring signals in from the senses are termed **sensory neurons** (or **afferent** neurons, from the Latin for "carrying toward"). A third type of neuron is the class of **associative neurons**, which provide linkages among other neurons in the brain. Outside the central nervous system axons typically form bundles, each surrounded by a sheath. These are termed nerves or nerve fibers. Each contains several dozen to several thousand axons.

Neural Communication

Neural communication is the basis of thought and initiator of action. For example, answering a question is, technically, the result of sums of neurons that determine which response to produce, as well as the transmission of this desired response to the appropriate muscles of the mouth, tongue, jaw, and throat. A single neuron receives messages almost exclusively from its dendrites, and these incoming messages are accumulated in the cell body. Then, if appropriate, the message is transferred down the axon of the neuron to transmit the message to neighboring neurons. Neurons use two general means to communicate, electrical impulses within a neuron and chemical messages between neurons.

Electrical Communication

Although the science behind electrical transmission within a neuron is rather complex, the gist can be understood as follows. The balance of ions, or electrically charged particles, gives neurons a negative electrical charge when in a resting (noncommunicating) state. However, signals from other neurons can cause changes in the cell body that increase this charge (make it less negative). If this increase in electrical charge is sufficient—such as if many neurons send signals at about the same time—then an **action potential** occurs in a neuron. This refers to a sudden influx of positive ions that give the neuron a net positive charge, which spreads through the inside of the neuron down the axon. The occurrence of an action potential is what is commonly meant when one speaks of a neuron "firing." When the action potential reaches the end of the axon, or **terminal button**, it causes the release of chemical messengers that send the signal to neighboring neurons.

Chemical Communication

The synaptic gap that separates neurons prevents the electrical signal from one neuron to be directly transmitted to the next neuron. Instead, chemical substances called **neurotransmitters** are used to send messages between neurons. The action potential terminating at the end of an axon in one neuron releases neurotransmitters that reach neighboring neurons. Many transmitter substances have been found in the nervous system. Among the better studied to date are norepinephrine, serotonin, GABA, and acetylcholine.

Each neuron has specialized **receptors** that absorb only specific neurotransmitters. When an appropriate neurotransmitter molecule binds to one of a neuron's receptors, it causes channels, or gates, in the cell membrane to open and allow certain ions to enter the cell. This usually causes an increase in the electrical charge of a neuron, or **excitatory postsynaptic potential** (EPSP). If many of these channels open within a short time span, the charge increases enough to cause an action potential, and the signal continues. Less numerous are neurotransmitters that open channels causing a decrease in the electrical charge, or an **inhibitory postsynaptic potential** (IPSP).

■ THE NERVOUS SYSTEM: ANATOMICAL AND FUNCTIONAL OVERVIEW

The neurons introduced in the preceding section are connected in a complex, fascinating system that relays messages all over the human body. These include messages within the brain, producing thought, as well as messages to the body (such as those producing movement) and from the body (such as those producing sensations). The nervous system is conceptually divided into two major parts, the central nervous system and the peripheral nervous system. The **central nervous system** includes the brain and spinal cord enclosed in the bony protective sheaths of the skull, as well as the spinal column. The **peripheral nervous system** extends throughout the body outside the brain and spinal cord.

Central Nervous System

The brain is the most important single structure in the nervous system, and is discussed in detail in the "THE BRAIN: A DETAILED LOOK" section later in this chapter. However, the brain does not work in isolation; instead, it relies on a complex system to transmit information from the body for processing and to the body for action. The spinal cord is the highway on which this information begins or ends its journey.

The **spinal cord** is actually a downward extension of the brain. In cross-section, it is seen to contain a butterfly-shaped central gray region, composed of cell bodies. It also contains a surrounding white region of sensory axons carrying signals toward the brain and motor axons carrying signals out toward the muscles of the body. The spinal cord also controls a variety of reflexes (responses that are automatic or "hard wired") that regulate posture when the body is stationary. Such reflexive adjustments are also continuously made when the body is in motion. The cord is the source of thirty-one pairs of spinal nerves that connect with it through openings between the vertebrae (segments of bone or cartilage that form the spinal column).

Peripheral Nervous System

The peripheral nervous system comprises all parts of the nervous system outside of the brain and spinal cord. It consists of two major functional units: the **somatic nervous system** for voluntary actions, and the **autonomic nervous system** for self-regulating actions.

Somatic Nervous System

The somatic nervous system consists simply of the motor (efferent) nerves that supply the muscles of the body, and the sensory (afferent) nerves that carry signals to the central nervous system from the senses such as the eyes, the ears, the tongue, and the skin. Thus, the somatic nervous system is involved in every move that you make, as well as in every sensation you experience.

Autonomic Nervous System

The autonomic (from autonomous, or "self-governing") nervous system is essential to maintaining any organism's survival. The autonomic nervous system is divided into two major branches, termed the **sympathetic nervous system** and the **parasympathetic nervous system**. These two operate in opposite but complementary ways in the regulation of many of the biological functions of the body. Because they

have opposite effects on many organs, such as the heart, they are often said to be antagonistic. In reality, the sympathetic and parasympathetic branches of the autonomic nervous system interact in an exquisitely complex and highly coordinated fashion in the regulation of actual physiological events.

Sympathetic Branch

The sympathetic nervous system is responsible for arousal. It is also known as the fight-or-flight system, because when it dominates, it tends to prepare the organism for high levels of activity. Its effects include increasing blood pressure, accelerating the heart, stimulating the release of adrenaline into the bloodstream, and many others.

Parasympathetic Branch

The parasympathetic nervous system is responsible for relaxation. When dominant, it tends to move the body toward energy conservation by decreasing blood pressure, lowering the heart rate, and so on.

■ THE ENDOCRINE SYSTEM

The endocrine system is the second method of communication in the human body. It is a system of ductless **glands** that control many internal biological functions of the body by releasing small quantities of chemicals known as **hormones** directly into the blood, where they influence target organs such as the heart. The major endocrine glands include the pituitary gland, the thyroid gland, the adrenal glands, the pancreas, and the gonads (testes in men and ovaries in women).

Hormones and Regulation

The endocrine system does its job by controlling the release of hormones to regulate the internal state of the body. Because hormones travel through the bloodstream, endocrinal communication does not rely on connections to specific cells. The endocrine system is thus able to produce a variety of effects. It is most commonly referred to as a regulatory system, because it maintains a stable internal state. For example, it controls the metabolism of sugar to provide a consistent level of insulin. Failure of endocrinal components, such as in diabetics, can result in great (and potentially dangerous) fluctuation of internal states.

The endocrine system is also responsible for significant departures from steady states, as well as for controlling long-term processes in the body. For example, the endocrine system releases adrenalin in conjunction with the transitory fight-or-flight response. Different hormone levels are associated with different behavioral states, such as emotions and levels of arousal. Also, the endocrine system is responsible for enduring processes such as growth and sexual development. Each of these processes is a chemical reaction to hormones, each of which affects only specific target organs, and which are controlled by specific glands.

Glands

We have seen that the endocrine system uses hormones in the bloodstream as its method of sending messages. The release of these hormones are controlled by various glands responsible for specific functions.

Pituitary Gland

Sometimes called the master gland because of its pervasive influence over the other endocrine glands, the **pituitary gland** is embedded in the bone of the skull under the hypothalamus (a brain structure discussed in the "Hypothalamus" section later in this chapter). Its close association with the hypothalamus forms a major connection between the rapid-acting nervous system on the one hand, and the slower-acting endocrine system on the other.

The pituitary gland is actually two glands. These are the posterior pituitary gland in back, and the anterior pituitary gland in front. Under control of the hypothalamus, the anterior and posterior pituitary glands secrete small quantities of a wide variety of hormones that stimulate the other endocrine glands into activity. The posterior pituitary, for example, produces ADH, which regulates the salt level of the blood and thus the retention of water in the body. It also produces oxytocin, important in childbirth. The anterior pituitary produces at least three hormones that regulate the sex glands and also regulates the adrenal glands and thyroid gland.

Adrenal Glands

A key function of the **adrenal glands** is activation of the body during states of alarm signaled by the sympathetic nervous system. They also regulate salt and carbohydrate metabolism and release corticosteroids, hormones associated with muscle strength and long-term maintenance of stress.

Thyroid Gland

The **thyroid gland**, located in the neck in front of the windpipe and below the vocal cords, regulates the metabolic rate of the body. Activity in the thyroid has also been implicated for some personality characteristics. Overproduction of hormones by the thyroid is associated with excitability and nervousness. An underactive thyroid produces lethargy and in infants has been linked to deficiencies in nervous system development and mental retardation.

Other Endocrine Glands

The **pancreas** regulates sugar metabolism by controlling levels of insulin and glucagons in the bloodstream. The **gonads**—testes in men and ovaries in women—are responsible for the development and maintenance of secondary sexual characteristics as well as reproductive functions proper.

■ THE BRAIN: A DETAILED LOOK

The brain is the most wondrous element of biological design, and is the major organ of the central nervous system. In order to understand the brain, it is necessary to orient oneself by learning the key anatomical structures. To better appreciate the operation of the brain, it is also important to understand key organizing principles of the brain.

Key Structures

The brain is, in reality, a mass of neurons without discrete physical sections. There is often no anatomical border where one area of the brain ends and another begins. However, the brain can be conceptually divided into its major components, which are determined as much by function as by physiology. Here, we

adopt a common division into the forebrain, the midbrain, and the hindbrain. The major brain structures are outlined in Figure 3-3 and described in the following sections.

The Hindbrain

The **hindbrain** includes the lower physical areas of the brain, in part a continuation of the spinal cord and the area where signals first enter the skull and reach the brain via the brainstem. This portion of the brain is also the oldest in terms of our evolutionary development (phylogeny). Many basic and vital life-maintenance functions are controlled in these areas, such as respiration and circulation.

Pons and Medulla

The upper portion of the hindbrain is termed the **pons** (from the Latin for "bridge"), and its lower portion is termed the **medulla** (meaning "core"). These form the site where several cranial nerves originate, and they serve in part as a relay center between the spinal cord and the rest of the brain. The medulla also controls a number of vital functions such as blood pressure, heart rate, and respiration, as well as other involuntary functions such as coordination of the two eyes.

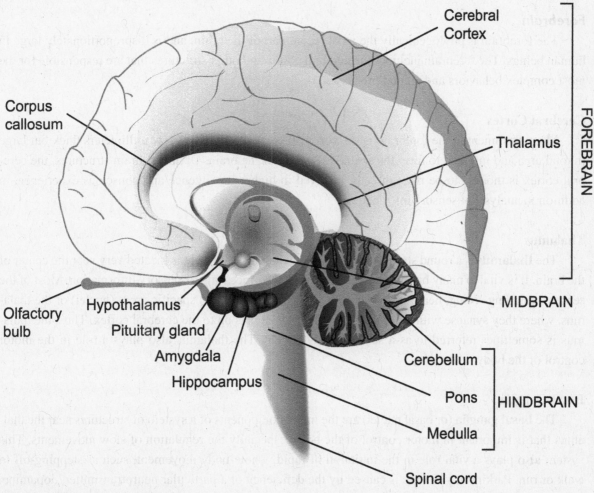

Fig. 3-2: Major brain structures

Reticular Formation

The **reticular** (netlike) **formation** forms a cylindrical core through the mid- and hindbrain. It is important in the regulation of arousal and attention, as well as overall states of activity of the brain such as sleeping and waking. During sleep, it controls the occurrence of dream and nondream sleep.

Cerebellum

The **cerebellum** (or little brain) is also part of the hindbrain, although it is located above its main axis. Connected to the pons, the cerebellum plays a vital role in the production of coordinated, rapid, and whole-body movement, such as walking and jumping, and in well-learned or automatic behavioral sequences.

The Midbrain

The **midbrain** is a small region under the forebrain and above the hindbrain. The reticular formation continues through this region, and other important nuclei are contained here. One such nucleus is the **substantia nigra** (black substance), which is responsible for smoothing the beginning of movements. The midbrain also contains nuclei for auditory and visual reflexes.

Forebrain

The forebrain is phylogenically the most recent part of the brain, and is disproportionately large in human beings. The forebrain includes the cerebral cortex and other structures that are responsible for the most complex behaviors and mental processes.

Cerebral Cortex

Most prominent in the forebrain is the **cerebral cortex**. It is only a few millimeters thick but large in total area and infolded to form the wrinkled surface of the brain. Of all the brain structures, the cerebral cortex is thought to be most directly involved in higher intelligence and conscious experience, in addition to analysis of sensory information.

Thalamus

The **thalamus** is a round structure roughly an inch in diameter that is located very near the center of the brain. It is vital to many brain functions, including the processing of sensory information. Most of the senses, including seeing, hearing, and the skin senses, send axons to specific areas (nuclei) of the thalamus, where they synapse with other neurons that carry signals on to the cerebral cortex. Thus, the thalamus is sometimes referred to as a sensory relay station. The thalamus also plays a role in the motor control of the body.

Basal Ganglia

The **basal ganglia** (or basal nuclei) are the major components of a system of structures near the thalamus that is important in motor control of the body, especially the regulation of slow movements. This system also plays a vital role in the initiation of rapid, whole-body movement, such as stepping-off to walk or run. Parkinson's disease is caused by the deficiency of a particular neurotransmitter, dopamine, in this area.

Hypothalamus

The **hypothalamus** is a small structure near the lower surface of the brain, beneath the thalamus. It is important for drive states such as hunger, thirst, and sexual arousal. It also plays an important role in the expression of emotions. The hypothalamus is directly connected to the pituitary gland, and thus exerts a strong influence on the endocrine system. The hypothalamus is part of a set of structures that are collectively referred to as the **limbic system**. This system is implicated in emotion and memory, and also includes other forebrain structures such as the hippocampus, amygdala, septum, and others.

Hippocampus

Also part of the limbic system, the **hippocampus** is most often associated with memory formation. Damage to the hippocampus prevents the creation of new memories, but not memories already stored.

Amygdala

The **amygdala** is a limbic system structure that serves a variety of purposes. It is often implicated in emotional responses, such as aggression and fear, and also integrates information across sensory modalities.

Corpus Callosum

The **corpus callosum** is a large region of myelinated axons in the forebrain that transmits information between the two (left and right) hemispheres of the cerebral cortex.

Principles of Organization

Beyond the functional and anatomical division of the brain, it is important to appreciate some general organizational principles that characterize the brain.

Cellular Organization

The cerebral cortex is gray in appearance (called **gray matter**) because it contains many cell bodies and synaptic connections. Beneath it is a thicker region formed mostly of the axons of cortical cells. This region is termed **white matter** because of the white appearance of the myelin sheaths of glial cells around these axons. Beneath this region are found a variety of structures that form the core or the forebrain.

Cortical Lobes

The cerebral cortex is divided into four areas or lobes (Figure 3-4). The **frontal lobes**, covering more than a third of the frontal-most region of the forebrain, are involved in planning future behavior and in initiating behavior. They also are involved in short-term memory and in the regulation of emotion. The back edge, or strip, of the frontal lobes is an important area for the motor control of the body (motor cortex). The **temporal lobes**, beneath the temples, are important for hearing (audition) and for memory. The **occipital lobes**, at the back of the forebrain, are involved almost entirely in vision. The **parietal lobes**, above the temporal lobes and in front of the occipital lobes, are important for body sense (touch) and object recognition.

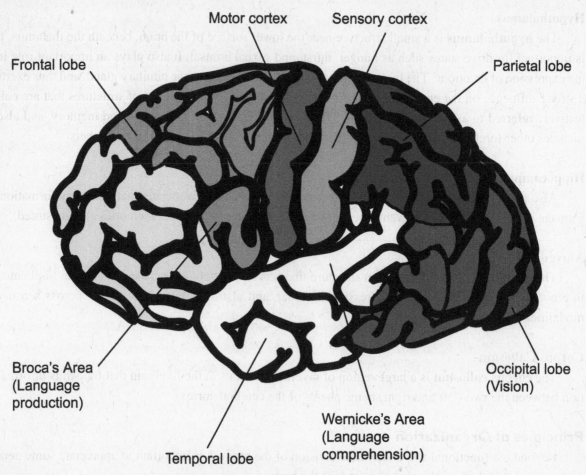

Fig. 3-3: Lobes of cerebral cortex. Shown for left hemisphere.

Cortical Hemispheres

There are actually two of each type of lobe—for example, a left and a right temporal lobe. This is because the cerebral cortex is formed into two large cerebral hemispheres (half-spheres) that are connected by the **corpus callosum**. For most behaviors and mental events, the processing of both hemispheres is involved. However, for many functions, the left and right hemispheres are like functional mirrors, whereby the left hemisphere is responsible for the right side of the body or environment, and vice versa. For example, the motor cortex in the left hemisphere controls the right side of the body, and the right occipital lobe contains a map of the left visual field.

Some distinct functions take place in each hemisphere as well. In most people, the left hemisphere is important for language abilities and logical, analytic thinking. For example, the left temporal lobe in most persons is vital to both language production and interpretation. The right hemisphere is important for spatial thinking, and perhaps intuitive and creative thought as well as art and music. There is, however, a great deal of individual difference in lateralization, or hemispheric specialization. For example, although the left hemisphere is responsible for language in around ninety-five percent of right-handed individuals, the right hemisphere at least partially controls language abilities in nearly half of left-handed individuals.

Specialized and Hierarchical Processing

Differential processing across lobes and/or hemispheres represents functional specialization of the brain. That is, the brain utilizes a sort of divide-and-conquer strategy, whereby certain areas are assigned specific tasks. However, a particular behavior often recruits several brain areas. For example, naming a picture of an object requires areas for vision, object recognition, speech production, and motor control. A similar concept applies within a certain processing region. Specifically, much of the brain's processing can be characterized as **hierarchical**, or structured in levels of increasing detail or complexity.

In many functional areas of the brain, information (that is, neural activation) progresses through distinct pathways. Often, processing along this pathway results in increasingly complex representations, formed by integrating information from preceding levels of processing. For example, as discussed in Chapter 5, the properties of a visual stimulus or scene are broken down by features. Perception of a red square with a black border is actually the integration of perceptions involving two vertical lines in certain locations, two horizontal lines in certain locations, and a region of red space.

■ METHODS OF NEUROSCIENCE

How do we know so much about the anatomical and functional properties of the nervous system? Neuroscientists use a variety of techniques, each with particular advantages and disadvantages, which allow them to study the nervous system in varying degrees of detail.

Primitive Techniques

Perhaps the term "primitive" sounds like the techniques here are unrefined or outdated. In fact, they are still very useful in helping to draw conclusions about form and function in the brain.

Staining

Staining refers to injecting nontoxic chemicals into cells, which dyes them and allows for observation. These methods provide only anatomical information, but allow for observation of single neurons as well as larger networks of proximate neurons.

Lesions

To **lesion**, or destroy, part of the brain is an invasive method that has contributed a great deal of knowledge about the functions of specific brain areas. The rationale is that by observing what deficits are introduced through removal of specific brain structures (also called ablation), one can determine what functions were served by the removed structure. These methods have been applied experimentally to animals, but also therapeutically to humans, such as to reduce or eliminate epileptic seizures.

Electrical Techniques

Electrical techniques have been used to investigate the brain in two basic ways. First, we can draw conclusions about neuron function by observing behaviors that result from direct stimulation of neurons. Second, we can observe the patterns of natural electrical activity that correlate with specific behaviors.

Direct Stimulation

Because neurons use electrical signals to communicate, it is possible to simulate this electrical signal experimentally to cause neural firing. Specifically, minute electrodes are used to introduce an electrical charge in a neuron, causing an action potential. This may produce a cascading effect among populations of neurons that allows investigators to witness anatomical connections (that is, which other neurons fire) and functional properties (that is, what is the resultant behavior).

EEG and ERP

The electrical activity in neurons also gives rise, across the brain's billions of neurons, to electrical fields that produce regular waves of electrical current across the surface of the brain. These brain waves are measured, amplified, and displayed through the use of an **electroencephalogram** (EEG). This noninvasive technique involves distributing multiple electrodes across the scalp. Alternatively, invasive minuscule electrodes placed at individual neurons can be used for **single cell recording**, or in combination, groups of these electrodes allow **multiple cell recording** from clusters of neurons.

The advantage of the EEG is its precise temporal resolution, or the ability to discern the timing of brain activity in milliseconds. For example, by using EEG recording during an experiment, manipulations or stimuli can be matched to the changes in electrical activity, or **event-related potentials** (ERPs), that they produce. However, what EEG recording gains in temporal resolution it lacks in spatial resolution, or the ability to localize brain activity, for which it can only provide broad regional measures.

Imaging Techniques

A variety of innovative noninvasive imaging techniques have recently been developed that allow for increased spatial resolution over electrical recording techniques. These include techniques that provide anatomical and functional data, using a variety of methods.

CAT

The **computerized axial tomography** (CAT) scan is essentially an X-ray photograph of the brain. This provides a detailed look at anatomical structure and can be used to determine brain damage or atrophy. However, it does not provide any insight into functional analyses.

PET

Positron emission tomography (PET) scans provide an anatomical view, but also allow for functional and biochemical analyses. PET takes advantage of two principles: the fact that cells consume more energy (in the form of glucose) as a function of increased activity; and the fact that radioactive substances emit positrons that can be measured. Thus, by injecting a radioactive form of glucose, measuring positron emissions gives an idea of the activity level of different brain regions.

This technique has also recently been developed using radioactive forms of other substances, such as specific neurotransmitters or drugs, which allow for many different useful biochemical analyses. However, the advantages of PET must be weighed against the risks of using radioactive substances. Furthermore, the timing precision of PET is relatively poor, on the order of approximately thirty seconds.

MRI and FMRI

The **magnetic resonance imaging** (MRI) technique takes advantage of a different property of neurons. MRI immerses the brain in a strong magnetic field and measures radiofrequency waves. This method provides a very high resolution image of the brain, surpassing that of PET (fractions of millimeters). The **functional MRI** (fMRI) technique involves performing MRI scans in quick succession. This allows for observation of changes in blood oxygenation levels (BOLD) that indicate neuronal activity.

The use of MRI and fMRI has increased dramatically since their development. This is because they provide both excellent spatial resolution as well as timing precision (effectively on the order of a few seconds). The use of fMRI scans overlaid on a high resolution MRI scan allows for excellent anatomical and functional analyses. Furthermore, these techniques do not require exposure to the radiation that PET does.

MEG

The **magnetoencephalogram** (MEG) is based on principles similar to EEG and MRI. It detects the magnetic fields produced by the electrical activity in neurons. This allows for localizing brain activity. It does not provide a good anatomical portrait, and is thus often used in conjunction with a high resolution MRI scan. Although it provides temporal resolution superior to fMRI (similar to EEG), and high spatial resolution of cortical activity, this spatial resolution is greatly diminished for subcortical structures.

■ BASIC BEHAVIORAL GENETICS

Perhaps the most pervasive debate in psychology is that between the role of biological (genetic) influences and environmental influences in shaping behavior, personality, and so on. This nature-versus-nurture debate dates back at least to 1874, with the publication of Sir Francis Galton's (1822–1911) book, *English Men of Science: Their Nature and Nurture*. These days, such questions are examined by psychologists in the field of **behavioral genetics**, which is the study of how genes and heredity affect behavior. A basic understanding of genetics and hereditary influences on behavior helps to illuminate this debate.

Genetics: The Biology of Inheritance

The human body is composed of trillions of its basic building blocks, cells. Each cell (except red blood cells) contains twenty-three pairs of chromosomes, with one chromosome of every pair coming from each parent. These chromosomes contain DNA, of which a small fraction is composed of **genes** that guide the development of an individual via protein production. Most characteristics, both physical (for example, eye color) and psychological (for example, susceptibility to stress) are **polygenic**, meaning they are influenced by more than one gene. Recently, the Human Genome Project has successfully "cracked the genetic code" in determining DNA segments that contribute to individual differences.

A person's unique set of genes determines his or her **genotype**, which interacts with the environment to determine the expressed **phenotype**. For example, identical twins share the same genetic blueprint, and thus have the same genotype. However, due to environmental influences from the womb onward, they do not look exactly alike or have the same personality characteristics; they each have a unique phenotype.

Behavioral Genetics in Psychological Research

Galton originally concluded that heredity was the dominant influence on psychological characteristics, based on the study of intelligence within families. His logic was that **family studies** can help to determine whether a trait is genetic, by seeing if the incidence of a trait runs in the family, or if closely related family members are more similar than distantly related or unrelated individuals. However, families share not only genetic influences but also common environments. More recently, psychologists have therefore additionally used twin and adoption studies. **Twin studies** compare identical and fraternal (nonidentical) twins, with the assumption that greater similarities among identical twins suggest a genetic influence, whereas larger differences between identical twins implicate environmental factors. **Adoption studies** take advantage of opportunities to study adopted children that can be compared to both their biological parents and their adoptive parents, where similarities to the former point to a genetic component, and similarities to the latter suggest a role of the environment.

The Nature-versus-Nurture Debate Today

Behavioral geneticists study, and reach conclusions about, not only genetic influences but also the role of the environment. As a result of their work, it is almost unanimously accepted in the research community that both genetics and environment contribute to most psychological characteristics. Thus, the nature-versus-nurture debate these days is not a question of "which one," but rather "how much of each."

Behavioral geneticists study the extent to which traits differ among individuals or groups, and why; they do *not* study the determinants of a trait or behavior within any particular individual. In this sense, they examine the extent to which variability of a trait in a given population is attributable to genetic versus environmental factors. For example, it seems that around eighty percent of variability in the height of human beings is genetically determined. In contrast, less than half of personality characteristics seem to come from heredity. This does not mean, of course, that eighty percent of one individual's total height, or forty-five percent of his or her personality traits, are due to genetics.

The most fruitful applications of behavioral genetics in psychology are in the areas of where individual differences are most likely to be evident. Although some functions, such as vision, are essentially identical across individuals, factors such as personality, mental abilities, and psychological disorders are not. Understanding the influence of genetic and environmental influences in these areas may lead to improvements in testing, teaching, and therapeutic applications.

Humans and other organisms are composed of trillions of cells, including neurons that comprise the nervous system and the glial cells that support them. Neurons receive signals via their dendrites, integrate signals in their cell bodies, and transmit signals via their axons. Intricate electrical and chemical processes allow communication within and between neurons, respectively. The communication pathway of neurons is collectively referred to as the nervous system. The nervous system is divided into the central nervous system (brain and spinal cord) and the peripheral nervous system. The peripheral nervous system is then divided into the somatic nervous system and autonomic nervous system; the latter of which is further divided into sympathetic (arousing) and parasympathetic (relaxing) branches.

The other major communication system in the body is the endocrine system. This system uses the pituitary gland and other glands to release hormones into the bloodstream. These chemical messengers control and regulate many bodily functions, such as the metabolism of sugar and salt, as well as growth

processes, emotion, and sexual development. The endocrine system also interacts with the nervous system, such as by regulating the release of adrenaline through the adrenal glands as a result of signals from the sympathetic nervous system.

The brain is the key component of the nervous system. It is conceptually divided into three regions. The hindbrain controls many basic functions, such as respiration and circulation, and includes the cerebellum that coordinates movements. The midbrain includes nuclei for sensory reflexes, as well as part of the reticular formation, a structure beginning in the hindbrain that regulates activity states (for example, waking and sleeping). The forebrain includes important structures including the brain's main relay station, the thalamus, and the structures of the limbic system (the hypothalamus, amygdala, hippocampus, and others) that are important for emotion and memory. The forebrain also includes the cerebral cortex, which is divided into four lobes in each hemisphere. The brain processes information in a specialized and hierarchical manner, recruiting many areas for a particular task and integrating information across them.

So much is known about the nervous system thanks to the work of neuroscientific study methods. These methods can be classified on various dimensions, such as their spatial and temporal resolution, or whether they are invasive or noninvasive. They include staining and lesion techniques, electrical recording techniques such as EEG, and neuroimaging techniques such as CAT, PET, MRI, and fMRI.

An important implication of the biological component of psychology is the influence of inherited genes on behavior. The field of behavioral genetics studies this influence, as well as that of environmental features. They use family, twin, and adoption studies to examine the relative contribution of these factors, which have changed psychology's historical nature-versus-nurture debate into a question of "how much of each" rather than "which one."

Key Concepts

action potential
adoption study
adrenal gland
associative neurons
autonomic nervous system
axon
basal ganglia
behavioral genetics
brain
cell body
cell membrane
central nervous system
cerebellum
cerebral cortex
computerized axial tomography (CAT)
corpus callosum
dendrite

electroencephalogram (EEG)
endocrine system
event-related potentials (ERPs)
excitatory postsynaptic potential (IPSP)
family study
forebrain
frontal lobe
functional MRI (fMRI)
gene
genotype
gland
glial cells
gonads
gray matter
hierarchical processing

hindbrain
hippocampus
hormone
hypothalamus
inhibitory postsynaptic potential (IPSP)
lesion
limbic system
magnetic resonance imaging (MRI)
magnetoencephalogram (MEG)
medulla
midbrain
mitochondria
motor neurons
multiple cell recording
myelin sheath

neurons

neurotransmitter

nucleus

occipital lobe

pancreas

parasympathetic nervous

 system

parietal lobe

peripheral nervous system

phenotype

pituitary gland

polygenic

pons

positron emission

 tomography (PET)

receptor

reticular formation

sensory neurons

single cell recording

somatic nervous system

staining

substantia nigra

sympathetic nervous system

synapse

temporal lobe

terminal button

thalamus

thyroid gland

twin study

white matter

Key People

Francis Galton

SELECTED READINGS

Carlson, N. R. (2003). *Physiology of behavior, 8th Ed.* Allyn & Bacon, Inc.

Gazzaniga, M. S. (1997). *Conversations in the cognitive neurosciences.* Cambridge, Mass.: MIT Press.

Pinel, J. P. J., & Edwards, M. E. (1997). *A colorful introduction to the anatomy of the human brain: A brain and psychology coloring book.* Allyn & Bacon, Inc.

Rosenzweig, M. R., Breedlove, S. M., & Watson, N. V. (2004). *Biological psychology: An introduction to behavioral and cognitive neuroscience.* Sinauer Associates, Inc.

Slaughter, M. M. (2001). *Basic concepts in neuroscience: A student's survival guide.* The McGraw-Hill Companies.

Test Yourself

1) Neurons receive messages primarily via their _____, and transmit messages primarily via their _____.
 a) electrical impulses; chemicals
 b) axons; dendrites
 c) dendrites; axons
 d) synapses; dendrites

2) What is the sudden, positive electrical charge often referred to as a neuron "firing?"
 a) an action potential
 b) an electrical potential
 c) electrical transmission
 d) a neural spike

3) The _____ branch of the autonomic nervous system prepares the body for action, whereas the _____ branch relaxes the body.
 a) somatic; arousal
 b) arousal; somatic
 c) sympathetic; parasympathetic
 d) parasympathetic; sympathetic

4) While the spinal cord acts as an information highway to carry signals to and from the brain, which system then disperses signals throughout the body?
 a) the limbic system
 b) the peripheral nervous system
 c) the central nervous system
 d) the distributing nervous system

5) The endocrine system employs various _____, such as the pancreas, to release _____ that regulate many bodily functions.
 a) organs; neurotransmitters
 b) organs; hormones
 c) glands; neurotransmitters
 d) glands; hormones

6) Although it is difficult to pinpoint a single brain structure responsible for complex phenomena like emotions, which area is typically associated with their regulation?
 a) the limbic system
 b) the cerebellum
 c) the reticular formation
 d) parietal cortex

7) Which statement best describes the organization of the brain?
 a) Behaviors and mental events are the result of processing that is almost exclusively localized to one particular processing region.
 b) Behaviors and mental events rely on integrating information from different regions, each performing specialized tasks in a hierarchical manner.
 c) Processing in the brain is performed by highly specialized regions, which are distributed primarily throughout the frontal cortex.
 d) For most behaviors and mental events, the processing of only one hemisphere is involved, but some tasks require communication across hemispheres.

8) Which neuroimaging technique offers the best temporal resolution?
 a) CAT
 b) EEG
 c) fMRI
 d) PET

9) List the four lobes of the cerebral cortex and give an example of a function associated with each. Why are there actually eight distinct cortical lobes?

10) Describe the field of behavioral genetics, including what is studied, some of the methods used, the psychological debate to which they contribute, and the current status of this debate.

Test Yourself Answers

1) **c.** Dendrites are the many small branches that receive signals, whereas (most) neurons have only one axon that sends signals.

2) **a.** An action potential refers to the sudden, positive electrical charge, often called the "firing" of a neuron, that travels down the axon and causes neurotransmitter release.

3) **c.** The sympathetic branch of the autonomic nervous system prepares the body for action, whereas the parasympathetic branch relaxes the body.

4) **b.** The peripheral nervous system comprises all parts of the nervous system outside of the brain and spinal cord, and it disperses signals throughout the body.

5) **d.** The pancreas is not actually an organ, but a large gland; one of many which the endocrine system employs to release hormones and regulate bodily functions. Neurotransmitters are the messengers of the nervous system, not the endocrine system.

6) **a.** The limbic system, including structures such as the amygdala and hypothalamus, is often regarded as the primary regulator of human emotions.

7) **b.** Behaviors and mental events rely on integrating information from different regions, each performing specialized tasks in a hierarchical manner. Functional areas for the majority of mental processing are not localized to a single hemisphere or to particular regions such as the frontal cortex.

8) **c.** Functional MRI (fMRI) offers the best temporal resolution of the neuroimaging techniques listed (CAT and PET); EEG offers better temporal resolution than fMRI but is not a neuroimaging technique.

9) The frontal lobes are involved in planning future behavior, initiating behavior, short-term memory, emotion, and many other higher-order functions. Motor cortex is also located in (the rear of) the frontal lobes. The temporal lobes are important for hearing and memory. The occipital lobes are involved almost entirely in vision. The parietal lobes are implicated in object recognition and also contain the sensory cortex that provides for the sense of touch. Because of the symmetry of the brain across two hemispheres, there are actually two of each lobe (for example, left frontal lobe and right frontal lobe).

10) Behavioral genetics involves the study of the influences of heredity and the environment on psychological traits and human behavior. Behavioral geneticists use studies such as family studies, twin studies, and adoption studies that compare individuals with varying degrees of genetic and environmental features in common. They have contributed knowledge to the long-standing nature-versus-nurture debate in psychology, an argument over whether the heredity or the environment are responsible for personality, mental abilities, mental disorders, and other characteristics and behaviors. These days, researchers recognize the influence of both factors on nearly every phenotypic trait, although to varying degrees.

Consciousness

Ne hundred years ago, William James observed that ordinary consciousness is but one of many potential types of consciousness which surround it, separated from it by the thinnest of veils. Some of these other types of consciousness, such as dream sleep, are relatively well-known, while others, such as mystical states, are not so well understood. Much of what is known by psychologists about consciousness is, in fact, the result of research focused on so-called altered states or alternative modes of consciousness, such as sleep, hypnosis, meditation, and the effects of psychoactive drugs. Research on these altered states allows us to infer what is normal in unaltered states of consciousness.

■ LEVELS OF CONSCIOUSNESS

Consciousness is typically defined as awareness of one's own mental activity as well as the external environment. Although consciousness was a key concept in early psychology, its influence on psychological research waned during the reign of behaviorism. John B. Watson himself proclaimed, "Psychology must discard all reference to consciousness." In the past thirty years or so, however, there has been a resurgence of the study of consciousness and mental states, with the advent of techniques for studying brain activity.

Psychologists often draw distinctions between various levels of consciousness. For example, any experience of which one is aware is said to occur at the **conscious level**. In contrast, experiences of which one cannot become aware, such as activity of the autonomic nervous system, are said to occur on a **nonconscious level**. Unlike nonconscious experience, some experiences can potentially become conscious, even though they are not currently; these are said to be at a preconscious level. Finally, the **subconscious level** (or unconscious level), refers to a level of mental activity that is not conscious, but nevertheless influences conscious thought or activity. Although this concept enjoys popular usage, it is not accepted by many psychologists.

Besides levels of consciousness, psychologists often recognize different states of consciousness. A **state of consciousness** is a stable configuration or pattern of psychological processes such as mood,

memory, ability to reason, body sense, sense of self, and so on. Sometimes it is hard to define distinct states; the remainder of this chapter discusses some that are widely accepted.

■ SLEEP

Sleep is one of several types of daily rhythm, also known as **circadian rhythm**, seen in the human body (from Latin *circa*, "about," and *dies*, "a day"). Other rhythms involve the body temperature, which peaks for most people between in the early evening and is lowest in the early morning. When a person moves to a new activity cycle—such as when switching work schedules from a day shift to a night shift, or flying to a new time zone—it can take several days to completely readjust. During this time, someone is said to experience jet lag, a feeling of general fatigue accompanied by decreased efficiency, difficulty with sleeping, or even digestive disorders.

Stages of Sleep

Psychologists distinguish between two major categories of sleep: dream sleep and non-dream sleep. Subjects who are observed to experience rapid eye movement (REM) during sleep are most likely to report dreaming. Thus while REM and dreaming are not the same thing, REM is generally interpreted as a sign of dreaming, and non-REM (NREM) sleep is generally expected to be non-dream sleep.

Much of what is known about sleep has been learned through the study of the small continuous electrical signals recorded from the cortex. These are recorded by an EEG (see Chapter 3) that depicts arousal patterns in a waveform graph. Psychologists can learn a lot by noting properties of these waveforms. One key measure of these waveforms is the amplitude, or height of the wave, which indicates the power (voltage) of the energy source—in this case the electrochemical activity of the brain. A second measure is the **frequency**, a unit of waveform energy speed measured in cycles per second, or Hz (pronounced hertz), named after Heinrich Hertz, the electromagnetic physicist who identified this unit of measurement.

A number of distinct EEG patterns, or rhythms, are commonly recognized as characterizing the stages of sleep (see Figure 4-1). The EEG pattern that characterizes ordinary wakefulness is the **beta rhythm**, a low amplitude pattern of fast activity of 12 or more Hz. With the onset and deepening of sleep, the EEG patterns change from fast rhythms of low amplitude (small voltage) to slow rhythms of high amplitude (relatively high voltage).

NREM Sleep

Upon first going to sleep, we usually enter non-dream or **NREM sleep**. This is also sometimes called slow-wave sleep because of the associated EEG patterns. There are four levels or stages of NREM sleep. Typically, we progress in order through these four stages during the first thirty to forty-five minutes of sleep. After that, we move between them throughout the night, spending proportionately larger amounts of time in the middle two stages.

Stage One

This most superficial stage of sleep is not actually sleep at all in the usual sense but simply the first stage of relaxing into sleep. It is characterized by a passive, restful, state of mind. The EEG is dominated by **alpha rhythms** in the range of 8 to 12 Hz.

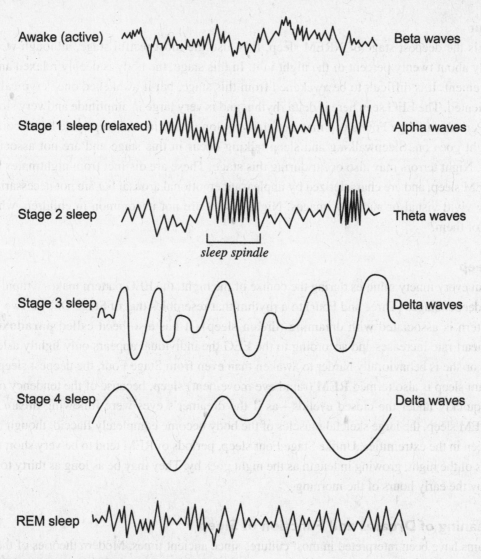

Fig. 4-2: EEG patterns of different stages of sleep

Labels within figure:
Awake (active) — Beta waves
Stage 1 sleep (relaxed) — Alpha waves
Stage 2 sleep — Theta waves
sleep spindle
Stage 3 sleep — Delta waves
Stage 4 sleep — Delta waves
REM sleep

Stage Two

This stage carries a feeling of drifting off to sleep. There may be a pleasant sense of falling, or the presence of hypnogogic images: vivid but usually stationary images that drift before the mind's eye. These are not dreams, which are much more complex than hypnogogic images. The EEG in Stage Two sleep exhibits slower and larger **theta rhythms**, ranging from about 4 to 7 Hz. The presence in the EEG record of brief bursts of high amplitude activity called **sleep spindles** indicate that the person is drifting into the deeper stages of sleep.

Stage Three

This is considered an intermediate level of sleep. It is during this stage that most large body movements occur during the night. The EEG pattern seen in this stage is termed the **delta rhythm**. Delta rhythm can range from 1 to 3 Hz, but tends toward 2 to 3 Hz in Stage Three.

Stage Four

This is the deepest stage of NREM sleep. It is also the most restful stage, although we typically spend only about twenty percent of the night in it. In this stage, the body is deeply relaxed and there is little movement. It is difficult to be awakened from this stage, but if awakened one is typically groggy and disoriented. The EEG seen here is delta rhythm and is very large in amplitude and very slow—close to 1 Hz. Periods of Stage Four sleep may be relatively long early in the sleep cycle but become shorter as the night goes on. Sleepwalking and sleep talking occur in this stage and are not associated with dreaming. Night terrors may also occur during this stage. These are distinct from nightmares that occur during REM sleep, and are characterized by unpleasant emotional arousal but are not necessarily accompanied by vivid visual or auditory images. Night terrors are not uncommon in children, who usually grow out of them.

REM Sleep

About every ninety minutes during the course of the night, the EEG pattern makes a rapid transition from the deeper stages (Three and Four) to a rhythm that resembles that of Stage One or Two. This new sleep pattern is associated with dreaming (dream sleep). It has also been called **paradoxical sleep** because heart rate increases and according to the EEG the individual appears only lightly asleep, while in fact he or she is behaviorally harder to awaken than even from Stage Four, the deepest sleep.

Dream sleep is also termed **REM** (rapid eye movement) **sleep**, because of the tendency of the eyes to move quickly under the closed eyelids—as if the dreamer's eyes were following dream activities. During REM sleep, the large skeletal muscles of the body become completely flaccid, though movement may be seen in the extremities. Unlike Stage Four sleep, periods of REM tend to be very short during the first hours of the night, growing in length as the night goes by. They may be as long as thirty to forty-five minutes by the early hours of the morning.

The Meaning of Dreams and Function of Sleep

Dreams have been interpreted in most cultures since ancient times. Modern theories of the meaning of dreams began with Sigmund Freud. In his great work *The Interpretation of Dreams* (published in 1900), he suggested that the manifest content of a dream (the dream events as experienced) conceal a hidden or latent content that expresses some form of wish fulfillment—often dealing with sex or violence—that is not acceptable to the conscious mind. Other psychoanalytic dream theorists, such as Carl Jung (1875–1961), believe that dreams are the symbolic language of the unconscious mind, communicating to the conscious mind.

At the opposite pole, some brain scientists suggest that dreams have no meaning at all, but represent random activity of the cortex during sleep. A variation on this view is offered by Nobel Prize-winning scientist Francis Crick (among others), who argues that dreams are the accidental by-products of the fine-tuning and review that the brain undergoes while we sleep. One implication of this **activation-synthesis theory** is that the meanings or stories we find in our dreams are actually interpretations we impose (synthesis) on the otherwise random bits and pieces of information and memory our brains are reviewing (**activation**), all in a night's work. Perhaps the most balanced view is to recognize that dreams are a basic biological event, but that their content reflects major psychological issues of the dreamer.

The activation-synthesis theory of dreams is one that attempts to explain the functional role of sleep. A more detailed hypothesis along these lines is that sleep gives the brain a chance for updating and expanding neural connections in the brain. One example of this is evidence for memory consolidation during REM sleep. That is, during REM sleep, memories and experiences are moved from a temporary to permanent status, links are made associating long-term memories, and unnecessary memories are cleared out. Sleep, in general, is also seen as a time for the brain to reset or prepare the body and brain for the following day's activity. This assumption suggests why sleep deprivation and fatigue can be handicapping or even debilitating. Other basic functions include growth, as evidenced by activity of the pituitary during sleep, and energy conservation due to lower body temperatures during sleep.

Sleep Disorders

Most people will experience some type of sleep disorder at some point in their lives. These can range from relatively mild symptoms to major disorders that impair one's daily life. Sleep disorders are distinguished, however, from fleeting or even long-lasting periods of inadequate sleep. Many college students and new parents may not get eight hours of sleep, but this is not necessarily the result of a sleep disorder.

Insomnia

Insomnia is the pervasive inability to fall asleep or remain asleep during the night, which then also leads to decreased performance and fatigue during the day. This is not simply inadequate sleep, or the temporary inability to sleep due to anxiety, excitement, or nervousness. Insomnia is also correlated with mental disorders, especially anxiety disorders and depression. There are behavioral changes, such as modifying daily routines and relaxation techniques, that can help with insomnia. Ironically, some common treatments for insomnia, such as sleeping pills, can actually exacerbate the problem as a result of their role in decreasing REM sleep.

Narcolepsy

Narcolepsy is a rare (around one in one-thousand people suffer) but more severe sleep disorder in which a person will suddenly transition from a conscious, waking state into REM sleep. This may occur at very inopportune times, and its onset is often associated with a highly emotional state. Because muscle tone decreases with REM sleep, narcoleptics are also rendered immobile, which can be especially dangerous. Although the causes are not certain, there seems to be a chemical basis, which may make specific drugs an effective treatment.

Sleep Apnea

Sleep apnea is characterized by brief, but persistent, periods where the inflicted individual stops breathing during sleep. The individual wakes long enough to resume breathing before continuing sleep. As a result of these repetitive interruptions in sleep—hundreds of times a night—the individual experiences increased fatigue and decreased attention. Because sufferers of sleep apnea (around one in twenty-five people) do not recall the awakenings, they are often unaware they have the disorder, although their sleep partners may complain about their loud snoring.

Sleep Paralysis

Sleep paralysis, as the name suggests, involves paralysis of the body at sleep onset or upon awakening. It is probably related to the natural state of paralysis associated with REM sleep. Although it is not dangerous in itself, it can be quite frightening for those who experience it. It is often accompanied by hallucinations, and is more frequent in those who suffer from narcolepsy or some personality disorders.

Sudden Infant Death Syndrome

In the United States, sudden infant death syndrome (SIDS) strikes around two in every one thousand infants, usually between the ages of two and four months. This unfortunate disorder refers to instances in which apparently healthy babies stop breathing during sleep and die as a result. The causes are not well known, but various factors such as brain abnormalities, cigarette smoke, and genetics have been suggested. Many instances of SIDS may actually be the result of accidental suffocation, the majority of which can be prevented by appropriate infant care (for example, ensuring that infants sleep on their backs).

■ HYPNOSIS

Hypnosis is not well understood, though it has been known in one form or another for almost two hundred years. It appears to be a state of deep relaxation, brought about by special techniques, in which the subject is highly susceptible to suggestions made by the hypnotist. Ernest Hilgard, a leading researcher of hypnosis, describes characteristic changes that occur under hypnosis. Hypnotized individuals tend not to initiate action, except at the hypnotist's direction, and attend only to the hypnotist's voice and toward whatever the hypnotist directs attention. Hypnosis also increases fantasy and role playing, while diminishing the questioning of the validity of statements or reality of events. Many individuals also experience posthypnotic amnesia, the inability to recall what happened during hypnosis even when informed of what happened. Not all people can be hypnotized; rather, people have differential hypnotic susceptibility.

Explanations for Hypnosis

Some researchers view hypnosis as a trance state while others have analyzed it in terms of classical or instrumental conditioning. Social psychologists have discussed it in terms of modeling or role playing, suggesting that hypnotized individuals are simply acting out the behaviors expected of them. As evidence for this role theory, they point out that most if not all of the feats performed under hypnosis can be performed just as well when the subject is not hypnotized. Some people may be simply pretending.

Hilgard advocates a dissociation theory, whereby consciousness itself is capable of division into distinct streams. The hypnotized individual experiences a passive state of deep relaxation, while a deeper or separate aspect of consciousness, called the hidden observer, witnesses all that transpires with the first part but is usually not accessible unless called out under hypnosis. Yet, the social role is a part of Hilgard's theory as well, because he suggests that hypnotized individuals are engaging in a social agreement to allow the hypnotist to control thoughts and actions.

Applications of Hypnosis

Whatever its origins, hypnosis has long been effectively used for pain control in surgery and dental procedures, as well as for relief from chronic pain. It is also found by many psychologists to be a useful adjunct to psychotherapy, such as the use of posthypnotic suggestion to modify behaviors occurring after hypnosis. However, some applications of hypnosis are quite contentious, such as the use of hypnosis to aid in memory recall. Research has shown that an individual's expectations and the hypnotist's suggestions are largely responsible for "facilitation" of recall under hypnosis. The same may be true for hypnotic age-regression as a means of reconstructing one's childhood.

■ OTHER STATES OF CONSCIOUSNESS

Some states of consciousness are not so easy to identify or classify as those discussed up to this point. Many times, this is the result of continued debate about the perception of some states by the research community.

Meditation

Meditation is best defined as a self-induced process of relaxation providing heightened awareness, tranquility, and opportunities for internal reflection. Since its wide-scale introduction in the West during the 1960s, meditation has been the source of considerable research and controversy among psychologists, who have been interested in it primarily as a method of relaxation and stress management. Research suggests that, while useful in these ways, meditation is perhaps no better than other methods—such as progressive relaxation, exercise, and biofeedback, in which patients learn to monitor their own physical processes (such as heart rate or muscle tension) and control them.

Meditation has been practiced in a variety of forms in many cultures, both in the East and the West, for thousands of years. Its traditional contexts have been religious or spiritual, or having to do with personal growth. There are many forms of meditation; some are active, such as dancing, but most are passive. The latter seem to fall into two general categories.

One form of passive meditation, concentrative meditation, includes forms of meditation that develop a concentrated focus of attention. This may be, for example, on one's own breathing, as in Zen meditation, or on a mantra (a word or phrase selected for this purpose), as is common in Indian practices. Another form of passive meditation, termed opening-up meditation, develops an unencumbered, objective observation of oneself. The latter is common in many Buddhist traditions.

Daydreaming and Fantasy

Nearly everyone has at some point experienced daydreams or waking fantasies. Such behavior does not necessarily need to involve some grand illusions or escape from reality. Daydreams may often involve rather mundane events, such as merely imagining alternate courses of action, mentally trying solutions to a problem, or contemplating things that could have been said or done differently. Daydreams and fantasies may be more than just a way to relieve boredom. They may relieve stress or tension, enhance creativity, improve memory through mental rehearsal, or play a role in reducing the tendency to actually engage in impulsive behaviors by mentally simulating them instead.

Near-Death Experiences

Interviews of patients who were close to death but survived produce estimates of the occurrence of mystical near-death experiences as high as thirty to forty percent. These experiences typically involve such formulaic experiences as inviting visions of bright lights (often at the end of tunnels), replay of old memories ("life flashing before one's eyes"), and out-of-body sensations.

There is no consensus response or explanation by psychologists to such claims. In fact, such phenomena are a point of controversy between monists and dualists regarding the nature of mind and body. However, some near-death phenomena can easily be explained by hallucination caused by oxygen deprivation to the brain. The experience may thus be manufactured in the same sense that dreams synthesize otherwise incoherent neural activity.

■ DRUG-INDUCED STATES

Drugs are chemicals that affect the body in deliberate ways. **Psychoactive drugs** in particular affect the nervous system, producing psychological changes in the persons who take them. Americans are the consumers of a remarkable number of both legal and illegal drugs. Perhaps the most common of these are alcohol and tobacco. Both have had very destructive consequences on individuals who abuse them, and to others as well (for example, victims of the consequences of others' altered behavior). Other highly addictive drugs have recently become widely available, with major negative social consequences. Ironically, the widespread use of drugs other than alcohol and tobacco began in the 1950s with the development of powerful psychiatric drugs such as tranquilizers and antidepressants. Within a decade, recreational drug use came to be commonplace.

Psychopharmacology

Psychopharmacology is the study of psychoactive drugs and their effects. Chapter 3 describes how communication across neurons depends on specific neurotransmitters (NTs). Psychoactive drugs primarily affect the brain by altering the natural release and binding cycles of these NTs. There are three primary mechanisms by which this occurs. First, drugs may bind to a neuron's receptor sites for specific NTs and mimic the effect of the NT; such drugs are called **agonists**. Second, when drugs called **antagonists** bind to receptor sites, they do not mimic the NT effect, but rather prevent the natural NT from producing the effect. Finally, some psychoactive drugs prolong or curtail the duration of the NT effect by prohibiting or initiating the release of an NT from a receptor site.

Two important characteristics of psychoactive drugs are whether they lead to increased tolerance and physiological dependence. Increased **tolerance** is the tendency to need more and more of the drug to produce the same effect. Alcohol and tobacco both produce this effect, while tranquilizers and antidepressants, taken in moderate doses, do not.

Psychologists generally prefer the term **physiological dependence** to the term addiction in accurately describing certain effects of psychoactive drugs. Physiological dependence is the tendency to acquire a physical need for the drug so that withdrawal from it is uncomfortable, painful or even dangerous. Again, alcohol and tobacco produce this result, while tranquilizers and antidepressants, in moderate doses, do not. Some psychologists also speak of **psychological dependence**, alternatively referred to as habituation, as

the tendency to become psychologically dependent on a drug, even in the absence of physiological dependence. Some people, for example, might be said to be psychologically dependent on a particular soft drink. Evidence suggests that heavy marijuana users become psychologically dependent upon this drug.

Types of Drugs

There are many different types of drugs, and many different ways by which they can be classified. We follow a scheme here that focuses on how each type of drug affects the nervous system.

Depressants

Depressants are called such because they reduce or inhibit the activity of the nervous system. Two of the most common depressants are alcohol and barbiturates. Both of these depressants work by increasing the activity of a specific NT called GABA, which naturally inhibits neural activity.

Alcohol

Alcohol affects specific brain regions, producing characteristic effects. For example, alcohol hinders cortical areas, which results in reduced inhibitions, cognitive impairments, and emotional changes (for example impulsivity, aggression, moodiness, and so on). Alcohol also causes memory problems because it impairs the hippocampus and hinders motor coordination through its impact on the cerebellum.

Barbiturates

Barbiturates, often called downers, cause relaxation, mild euphoria, decreased attention, and loss of muscle coordination in small doses. Increased doses cause deep sleep, and further increases in dosage can be fatal. Barbiturates are among the most addictive psychoactive drugs, with some of the most acute withdrawal symptoms, including death.

Stimulants

Stimulants are psychoactive drugs that increase activity in the nervous system and sometimes overt behavioral activity as well. This class covers a range of specific drugs, including nicotine, caffeine, cocaine, amphetamines, and MDMA.

Nicotine

Nicotine, the psychoactive drug in cigarettes, is an agonist for the primary NT of the autonomic nervous system, and also increases the release of the primary excitatory NT in the brain. Nicotine produces physical effects as well as heightened mood and increased attention. Nicotine creates physiological and psychological dependence, which makes smoking a difficult habit to break, involving withdrawal symptoms including craving, irritability, and weight gain.

Caffeine

Caffeine, perhaps the most popular drug in the world, is found in coffee and chocolate, as well as many teas, colas, and other drinks. In low doses, it causes physical effects such as reduced drowsiness, increased urination, and physical stamina, as well as psychological effects such as enhanced problem

solving. In larger doses, it can cause anxiety and physical tremors. There are moderate symptoms of caffeine withdrawal, including headaches, fatigue, tremors, and craving.

Cocaine

Cocaine is powerfully addictive, due to its strong and fast-acting effects. Cocaine stimulates the brain by increasing norepinephrine and dopamine activity, causing pleasurable sensations such as euphoria, optimism, confidence, and a sense of well-being. However, the negative effects of continued use are numerous, including paranoia, nausea, insomnia, depression, and sexual dysfunction.

Amphetamines

Amphetamines intensify dopamine and norepinephrine activity by increasing their release and prolonging their binding to receptors. Amphetamines, also known as uppers or speed, affect the sympathetic branch of the autonomic nervous system, thereby accelerating heart rate, increasing blood pressure, and suppressing appetite. They also increase alertness and can decrease response time. Prolonged use produces effects similar to those of cocaine abuse, and is sometimes reminiscent of paranoid schizophrenia, a dire mental disorder that also implicates dopamine.

MDMA

MDMA is an abbreviation of the chemical name for the drug that goes by the name ecstasy. This is a third psychoactive stimulant that increases dopamine release, and also functions as an agonist for the NT serotonin, which may explain its hallucinogenic properties. Tolerance decreases its positive effects with continued use, while the negative effects persist. MDMA is especially dangerous in that it permanently destroys neurons that use serotonin, causing sustained memory impairment even after discontinued use, as well as panic disorder in some instances.

Narcotics

Narcotics are also referred to as opiates, because they are primarily derivatives of (or synthetic forms of) opium, which comes from the poppy plant. Besides opium, this class includes heroin, morphine, and codeine. Narcotics are known for their sleep-inducing and pain-relieving properties. They primarily function as endorphin agonists and cause both inhibiting and excitatory effects on the nervous system. Narcotics are highly addictive, in part because they are thought to alter the physical structure of some neurons so that they require the drugs to function.

Hallucinogens

Hallucinogens, or psychedelics, are named due to their production of hallucinations in the drug user. They also have a wide range of other effects, often creating a distortion of reality and identity, as well as dramatic changes in mood, emotion, perception, and thought. This class of drugs includes lysergic acid diethylamide (LSD) and tetrahydrocannabinol (THC), the psychoactive ingredient in marijuana. Increased research has begun to isolate the neural causes of the effects of these potent drugs. For example, LSD seems to stimulate serotonin receptors in the forebrain, and receptors to which THC binds have also been identified. Abuse of these drugs can have long-lasting effects on personality and cognitive ability, even though they are not typically thought to be physically addictive.

Therapy and Abuse

There is an obvious distinction between the use of psychoactive drugs in a therapeutic setting and the recreational use and abuse of these drugs. The majority of psychoactive drugs were initially used for therapeutic applications, and many still are today. Narcotics are used worldwide for pain relief in hospitals and are available on a prescription basis for this purpose. Cocaine can be used as an anesthetic, and the medicinal use of marijuana has become an increasingly prominent political issue. Ketamine is used by veterinarians for its anesthetic properties, but has recently become popular as a recreational drug due to its hallucinogenic effects. Thus, while it is difficult (if not impossible) to broadly declare that psychoactive drugs are "good" or "bad," it is easy to distinguish between their practical use and their naïve misuse.

Consciousness refers to a stable pattern of psychological processes and exists on many levels. Much of what is known about consciousness is, in fact, a result of research focused on altered states of consciousness, of which the most thoroughly studied is sleep. Sleep is a type of circadian rhythm that has been categorized as either dream sleep (REM) or non-dream (NREM) sleep, depending on whether or not rapid eye movements have been observed in these periods. Most sleep research involves the use of electroencephalogram (EEG) records that indicate arousal or brain wave activity at various stages and times. Specifically, there are four stages of NREM sleep, characterized by progressively slower EEG waveforms. Brain waves during REM sleep resemble "light" sleep, but one is in fact deeply asleep (that is, hard to awaken) during this paradoxical stage. Dreams also occur in this stage, and theories abound about whether dreams have meaning and what that meaning might be. Psychoanalytic theories favor interpretation of dreams in terms of unconscious processes, whereas modern biological theories argue that dreams appear only to have meaning because the dreamer imposes meaning on random mental activity.

Hypnosis is a familiar but hard-to-explain altered state of consciousness. A deeply relaxed, suggestible state, it has been defined as a trance, a learned behavior pattern, and a social role. Dissociation theory argues that hypnosis is one of many separate, parallel streams of consciousness, all of which can be tracked by one's own "hidden observer." Hypnosis has been found to have useful applications in pain control and psychotherapy.

Meditation is a self-induced altered state thought to have benefits in terms of relaxation, heightened awareness, and internal reflection. Meditation can be active or passive, with passive forms involving either concentration (for example, focusing on breathing or on a mantra) or opening up (objective self-observation). Daydreaming and near-death experiences are other altered states of consciousness.

Psychoactive drugs affect the nervous system and produce psychological changes in drug takers. Psychopharmacology, the study of these drugs and their effects, has provided an idea about how these drugs work by mimicking, blocking, or otherwise affecting natural neurotransmitters. Psychoactive drugs, including depressants, stimulants, narcotics, and hallucinogens, can produce serious side effects in the form of increased tolerance, physiological dependence, and psychological dependence. Recreational drug use can be traced to the popularization of therapeutic drugs like tranquilizers and antidepressants.

Key Concepts

activation-synthesis theory
agonists
alpha rhythm
antagonists
beta rhythm
circadian rhythm
conscious level
consciousness
delta rhythm
depressants

hallucinogens
hypnosis
insomnia
meditation
narcolepsy
narcotics
nonconscious level
NREM sleep
physiological dependence
psychoactive drugs

psychological dependence
REM sleep
sleep apnea
sleep paralysis
sleep spindles
state of consciousness
stimulants
subconscious level
theta rhythm
tolerance

Key People

Francis Crick
Ernest Hilgard
Carl Jung

SELECTED READINGS

Blackmore, S. J. (2003). *Consciousness: An introduction.* Oxford University Press.

Ellman, S. J., & Antrobus, J. S. (2001). *The mind in sleep: Psychology and psychophysiology.* Wiley, John & Sons, Inc.

Farthing, G. W. (1992). *The psychology of consciousness.* Prentice Hall.

Piero, S., & Ficca, G. (2002). *Awakening and sleep-wake cycle across development: Advances in consciousness research.* Benjamins, John Publishing Company.

Steriade, M. M., & McCarley, R. (2005). *Brain control of wakefulness and sleeping.* Springer-Verlag New York, LLC.

Test Yourself

1) Which of the following terms best describes processes or experiences that cannot be brought into awareness?
 a) conscious
 b) nonconscious
 c) subconscious
 d) preconscious

2) Which of the following best defines circadian rhythms?
 a) brain waves that occur during REM sleep
 b) brain waves that occur during NREM sleep
 c) the habitual patterns characteristic of psychoactive drug abuse
 d) various regular body cycles occurring on a twenty-four-hour schedule

3) Which EEG waveform rhythm is not usually characteristic of sleep?
 a) alpha
 b) beta
 c) delta
 d) theta

4) Which of the following best describes the activation-synthesis theory of dreams?
 a) Dreams are an attempt to make sense out of random neural activity.
 b) Dreams are the result of repressed desires.
 c) Dreams are an attempt to rehearse the day's activities to remember them.
 d) Dreaming is an adaptive response to the survival pressures of our ancestors.

5) Which of the following statements regarding hypnosis is true?
 a) Anybody can be hypnotized, with sufficient practice.
 b) Under hypnosis, one can be made to do whatever the hypnotist wishes.
 c) Modern psychologists disagree on the mechanisms underlying hypnosis.
 d) Hypnosis is essentially the same as meditation, or a light stage of sleep.

6) Meditation is a(n) _____ state of consciousness, with the most consistent result being _____.
 a) unintentional; stress relief
 b) self-induced; relaxation
 c) unofficial; tranquility
 d) abnormal; skepticism

7) Drugs that mimic neurotransmitters are called _____, and those that keep neurotransmitters from binding to receptor sites are called _____.
 a) agonists; antagonists
 b) antagonists; agonists
 c) agonists; placebos
 d) imitators; obstructers

8) Requiring increasing amounts of a drug in order to feel its effect describes the development of which of the following?
 a) physiological dependency
 b) psychological dependency
 c) tolerance
 d) resistance

9) Briefly describe the main characteristics of each stage of NREM sleep and discuss how EEG brain waves change as one progresses deeper through these stages.

10) Briefly describe the four main classes of psychoactive drugs, the primary effect(s) of each class on the nervous system, and one example from each class.

Test Yourself Answers

1) **b.** Nonconscious events, such as the brain's regulation of bodily functions, occur without awareness, regardless of efforts to bring them into consciousness. Subconscious and preconscious events are not currently conscious, but they can be at some point.

2) **d.** Circadian rhythms are the various regular body cycles occurring on a twenty-four-hour schedule, such as sleep and body temperature.

3) **b.** Beta rhythm (12+ Hz) is indicative of a normal, waking state, not sleep. Alpha rhythm, delta rhythm, and theta rhythm characterize progressively slower waveforms associated with successively deeper stages of sleep, respectively.

4) **a.** The activation-synthesis theory suggests that dreams are an attempt to make sense out of random neural activity. Psychoanalysts may suggest dreams are the result of repressed desires.

5) **c.** Modern psychologists disagree on the mechanisms underlying hypnosis, with theories such as state theory, role theory, and dissociation theory. Not everyone is susceptible to hypnosis, and those hypnotized cannot be made to do literally anything.

6) **b.** Meditation is a self-induced state of consciousness, with the most consistent result being relaxation. It is neither unintentional nor abnormal, and it is indeed a state recognized by psychologists; although no states are either official or unofficial.

7) **a.** Drugs that mimic neurotransmitters are called agonists, and those that keep neurotransmitters from binding to receptor sites are called antagonists. Placebos are not psychoactive drugs, but inert substances.

8) **c.** Tolerance refers to the requirement of increasing amounts of a drug in order to feel its effect. Dependencies refer to the physical or psychological need for a drug.

9) There are four stages of NREM sleep, and brain waves recorded via EEG become larger (increased amplitude) and slower (decreased frequency) as one progresses from Stage One to Stage Four. In Stage One, the mind is in a passive, restful state, and one is not even technically asleep, but preparing to fall asleep. In Stage Two, the individual drifts off to sleep. Vivid images called hypnogogic images may occur during this stage, as well as short bursts of neural activity called sleep spindles. During Stage Three is when most large body movements occur. Stage Four is the deepest stage of sleep, where the body is deeply relaxed and difficult to awaken. However, sleepwalking, sleep talking, and night terrors may also occur during Stage Four.

10) The four classes of psychoactive drugs are depressants, stimulants, narcotics, and hallucinogens. Depressants, such as alcohol and barbiturates, reduce or inhibit mental and behavioral activity. In contrast, stimulants increase or stimulate activity. Examples of stimulants include caffeine, nicotine, cocaine, and amphetamines. Narcotics, or opiates, such as opium,

morphine, and heroin, induce sleep and have powerful pain-relieving properties. Hallucinogens, such as LSD and THC (marijuana), have wide-ranging effects distorting reality and identity.

Sensation

B asically everything we know about the world comes to us through our senses. These include vision, audition, the skin senses such as touch and sensitivity to heat and cold, the chemical senses of taste (gustation) and smell (olfaction), as well as internal senses dealing, for example, with nutrient and salt levels of the blood and the angles of the joints (proprioception).

■ BASIC PRINCIPLES

Each sensory organ (for example, the eye, ear, skin, nasal passage, or tongue) and its corresponding information pathway is uniquely structured to receive a particular form of physical energy, translate it into the electrochemical energy of neural impulses, and transmit this information to the brain. The field of **psychophysics** (see also Chapters 1 and 6) has taught us a great deal about how physical energy is related to psychological experience. First, we cover here some principles that apply across sensory modalities, before examining each sense in more detail.

From Physical to Psychological

The first step for any sensory modality is the transformation of physical signals into neural signals, the language of the nervous system; this process is called **transduction**. For example, the ear and auditory system turn physical vibrations into psychological sounds, while the eye and visual system turn physical light into psychological images. Each sensory system is equipped with specialized **receptors** (sensory neurons) that detect a particular form of energy or chemical. Sensory neurons are essentially the first link in the chain of sensory information, receiving signals from the physical world rather than via dendrites from other neurons. Furthermore, receptors and other neurons have specific **receptive fields**, which are regions of the physical or chemical spectrum that cause a receptor to be optimally active. For example, many neurons in the visual system respond optimally only to light in a certain place, neurons in the auditory system are tuned to specific frequencies, and taste receptors respond to particular molecules.

Information travels from the sensory organ along a particular pathway, ultimately arriving at a specific cortical location for detailed processing. A key role in the transmission of sensory information from the sensory organs to the brain is played by the thalamus. As we saw in Chapter 3, the thalamus is a sort of relay station for sensory information, which has specific neural clusters or nuclei responsible for transmitting neural signals to and from most sensory organs.

Thresholds and Adaptation

An important concept in understanding how the nervous system interprets sensory information is the threshold, which is often distinguished into two types. An **absolute threshold** is the minimal amount of physical intensity that is required to allow detection, such as how faint a sound one can hear. A **difference threshold** (also called a **just noticeable difference**, or jnd) refers to the minimal amount of change in intensity that is necessary to allow detection of a change. A light may become slightly brighter, without being noticeable—this increase is thus below the difference threshold for brightness (about 1.5 percent in humans). Research on thresholds has traditionally focused on identifying the minimal stimuli that a given sensory system (vision, audition, touch, smell or taste) can detect. Many of these threshold findings have been published in tables of norms (comparison standards) listing the minimal stimulus strengths, or stimulus differences, that most people can detect.

Although nerve cells have thresholds that determine what stimuli will be noticed, this sensitivity diminishes with constant exposure to the stimulus. When jumping into a swimming pool, it may seem extremely cold—but only for a few minutes. Driving past a farm, with its high amount of manure, may be almost unbearable to one's sense of smell, but farmers living there don't seem fazed at all. **Sensory adaptation** refers to this property of sensation; that is, the decrease in sensitivity to a constant sensory stimulus. This is actually an important and adaptive benefit of our sensory systems, allowing us to focus on novel stimuli rather than being overwhelmed by the flood of sensory input we experience, such as various odors, crowd noise, clothes on our skin, and so on.

■VISION

Vision is undoubtedly the most important sense, at least for human beings. The majority of information we receive about the world is visual. Some estimates suggest that almost one-third of the cortex is devoted to some sort of processing of visual information, and that three-quarters of sensory neurons are located in the eyes. Vision is also the sense that has received the most thorough research attention, and so we are provided with a great deal of knowledge about the psychological experience of sight.

Transduction of Light

Sight depends upon information conveyed by light, a form of electromagnetic radiation. Two key properties of electromagnetic waves are the distance between the peaks (or troughs) of each wave, called the **wavelength**, and the **amplitude** or height of a wave. Electromagnetic waves are classified along an infinite spectrum defined by the wavelength, ranging from very short waves such as X-rays, to longer waves such as radio waves, with many other well-known waveforms in between (for example, microwaves, ultraviolet waves, infrared waves). Visible light is actually a very small portion of the known electromagnetic spectrum, but this coincides with the wavelengths emitted by the sun and other stars.

The wavelength of light determines the **hue**, or color, that we experience, ranging from shorter blue and violet waves to longer waves of orange and red light. The amplitude determines the **intensity** of the experience (related to brightness). These properties are picked up by a specialized and fascinating optical instrument: the human eye.

Anatomy of the Eye

The eye itself is a spherical structure bounded by a tough protective covering of tissue termed the sclera layer (see Figure 5-1). Light enters the eye through the transparent **cornea**, an extension of the sclera layer. From there, it passes through a variable-sized opening called the **pupil**, which is controlled by the colored portion of the eye, a muscle called the **iris**. Then it passes through the optical (crystalline) **lens** and on through the fluid of the eye (vitreous humor) to the inner light-sensitive surface of the eye. On this surface, termed the **retina**, the light forms an image of the object seen.

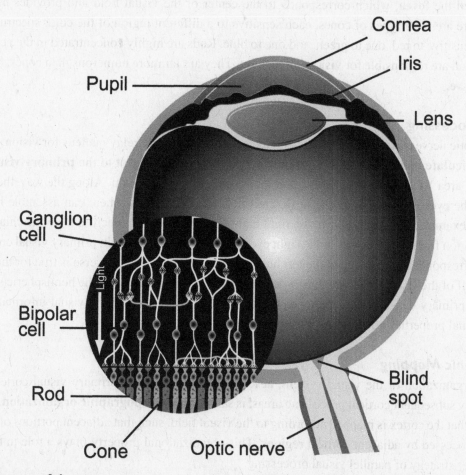

Fig. 5-1: Anatomy of the eye.

The retina is composed of more than 120 million light sensitive cells or photoreceptors called **rods** and **cones** (due to their respective shapes) as well as many other nerve cells. These receptors synapse onto bipolar cells, which then activate ganglion cells. The **ganglion cells** are responsible for carrying the information from the eye to the brain using electrical communication (action potentials). The axons of the ganglion cells

converge to form a bundle called the **optic nerve** to carry this information to the brain. Because there are no receptors at this single location where the optic nerve leaves the eye, there exists a corresponding blind spot in the field of vision.

The Lens and Visual Acuity

Accurate visual focus is termed **visual acuity**, the responsibility of the lens. Muscles in the eye adjust the thickness of the optical lens according to the distance of the object seen. When these eye muscles are relaxed, the eye is naturally focused on objects in the distance. Nearby objects require the lens to become thicker (an adjustment termed **accommodation**).

The Retina and Visual Sensitivity

Of the light sensitive cells of the retina, the cones are found predominantly near the center in a region called the **fovea**, which corresponds to the center of the visual field and provides high acuity vision. There are three types of cones, each sensitive to a different region of the color spectrum. One is primarily sensitive to red, one to green, and one to blue. Rods are highly concentrated in the periphery of the retina, and are responsible for vision in low light. They are far more numerous than cones, but are not color sensitive.

Visual Processing

The optic nerve carries information from the eye to the thalamic relay nucleus for vision, called the **lateral geniculate nucleus**, or LGN. From there, the information is sent to the **primary visual cortex** (also called area V1), located in the occipital lobe at the back of the brain. Along the way, the information from the eyes is portioned at the **optic chiasm** so that each hemisphere can assemble half of the image. For example, information from the right half of the left eye is sent across the optic chiasm to join the information from the right half of the right eye in the right LGN and right primary visual cortex. Note that this corresponds to the image in the left half of the visual field. The converse is true for the image in the right half of the visual field, which is processed in the left LGN and V1. The hemispheric specialization of the primary visual cortex continues through further processing of the visual information; other organizational properties hold as well.

Topographic Mapping

The organization of the visual system, at least through the LGN, primary visual cortex, and the immediately subsequent cortical processing areas, is said to follow **topographic organization**. This simply means that the cortex is mapped according to the visual field, such that adjacent portions of the visual field are processed by adjacent cortical regions. This organizational property plays a role in the divide-and-conquer strategy of parallel visual processing.

Parallel Processing

An entire visual scene is not processed by a single cluster of connected neurons, but rather the visual system assigns different cortical regions to different tasks. First, regions are location-specific, following the topographic organization discussed in the preceding section. Furthermore, the visual pathway is organized

into at least two distinct pathways that process certain elements of a visual scene in parallel (at the same time). For example, the information in one area of the visual field is processed in distinct areas along separate pathways: one for form and color (the "what" pathway) and one for location and movement (the "where" pathway).

Hierarchical Processing

In Chapter 3, we discuss the hierarchical nature of neural processing. The processing of visual information is an excellent example of this property. In particular, the visual system is said to consist of thousands of specific **feature detectors**, or cells that respond only to a specific feature of an object. For example, one cell in the visual system may respond only to a point of red light in a specific place. These feature detectors are linked through successively higher levels of visual cortex to neurons with increasingly larger receptive fields responsible for increasingly complex forms. That is, another feature detector may be activated only when three neighboring point feature detectors are activated, and thus respond to a short line segment in a certain orientation. Feature detectors later in the visual system may then respond only to combinations of line-segment feature detectors producing simple or complex shapes.

Color Vision

The first significant theory of color vision was the **trichromatic theory** based on work by Herman von Helmholtz, who built on the theory of the English physicist Thomas Young (1773–1829). The word trichromatic means "three color," which describes their basic premise involving the three primary colors of light: red, green, and blue—not to be confused with the three primary colors of pigment, red, yellow, and blue—that could be combined to produce any color of light. So, they surmised that the retinal cones that correspond to these three primary colors were responsible for producing color vision.

Indeed, the retinal cones do seem to be responsive to one of three primary colors of light, but Austrian physician Ewald Hering (1834–1918) suggested this was not the whole story. He cited the example of afterimages, such as when one stares for some time at the color red, then "sees" the color green when looking at a white space. Hering proposed the **opponent-process theory** of color, which implies two distinct color processes, one for red and green, the other for blue and yellow. Indeed, six types of **opponent-process neurons** in the ganglion cells and thalamus have been identified that respond optimally to either red or green, either blue or yellow, and either black or white; these cells are then inhibited when the opponent color is present.

Thus, both theories contribute to the ultimate perception of color in the brain. It seems the color information that leaves the retina is attributable to the three types of cones. This information is then coded on the way to visual cortex by many opponent-process cells, allowing for discrimination of millions of different colors.

Vision Disorders

There are many types of disorders that range in type and severity. Some people have poor or cloudy vision, some cannot discern certain types of stimuli (e.g. color), and some have partial or total lack of visual ability altogether.

Poor Acuity

In some eyes, the relaxed lens does not focus the image of a distant object onto the retina itself, but to a point somewhere in front of or behind it. In the first instance, the eye is said to be **myopic**, or nearsighted, and in the more common latter case, the eye is said to be **hyperopic**, or farsighted. Both can be corrected by appropriate corrective lenses.

Colorblindness

About one in fifty people have a deficit in sensing colors, with more afflicted males than females (as a genetic defect, it is linked to gender). These people are not actually color *blind*, but rather one or more types of cones do not function properly, hindering discrimination of the corresponding colors. For example, someone with defective red cones would not be able to code longer wavelengths in the retina, which would thus not give information to red-green opponent-process cells, resulting in poor discrimination between the colors red and green.

Blindness

Blindness can occur for a variety of underlying pathologies (reasons), and approximately 50,000 Americans annually become blind. Two of the leading causes are cataracts (damage to the lens) and glaucoma (poor drainage of the fluid in the eye, causing pressure and distortion). Brain trauma can also cause blindness if it affects areas responsible for visual processing. Blindness resulting from damage or deficits in the eye may be able to benefit from the potential of recent remarkable research on artificial vision. This research has led to devices that take the place of the photoreceptors in the eye and send information directly to the primary visual cortex. However, blindness due to brain trauma or cortical deterioration cannot take advantage of these scientific advances.

■ AUDITION

Audition is the experimental psychologist's term for hearing, or the psychological interpretation of sound. This is another extremely helpful and finely tuned sense in humans. Although we are best able to detect and discriminate sounds in the range of the human voice, we are also able to sense very faint sounds. As with vision, the question is how we transform the physical energy of sound into a psychological experience.

Transduction of Sound

Sound is another type of wave transmitted through the air at a speed of about 1,100 feet (thirty meters) per second. The frequency (wave cycles per second; see also Chapter 4) of a sound determines its **pitch**; low frequencies produce low-pitched tones, and high frequencies produce high-pitched tones. The healthy human ear hears an enormous range of frequencies, around 20 to 20,000 Hz. **Loudness** is determined by the amplitude (size of the waves), and is measured in decibels (dB), where 1 dB is equal to the human difference threshold for loudness. The decibel range increases exponentially; for example, if a sound increases by 10 dB, it actually becomes ten times louder. Normal conversation (about 60 dB) is thus 100 times louder than a whisper (about 40 dB).

The Ear

The structures of the ear, depicted in Figure 5-2, can be seen to channel sound energy progressively from the outside world closer and closer to the nervous system that detects it. The tasks of these auditory structures can be understood by examining the structure and function of three stages in this progression: the outer ear, the middle ear, and the inner ear. The outer ear includes the visible portion of the ear, called the **pinna**, which initially collects sounds and funnels them down the auditory canal. At the end of the auditory canal is the **eardrum** (tympanic membrane), which separates the outer ear from the middle ear.

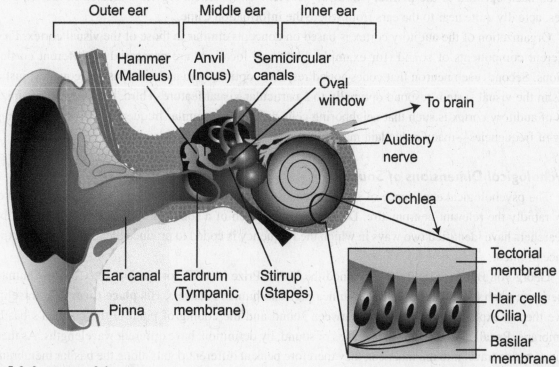

Fig. 5-2: Anatomy of the ear.

The Middle Ear

The fluctuations in air pressure that accompany sound waves cause the eardrum to move back and forth like a drumhead. Connected to the inner surface of the eardrum are three of the smallest bones of the human body, known by both their common names and the Latin equivalents: the **hammer** (malleus), **anvil** (incus), and **stirrup** (stapes). Together, they form a set of levers that amplify the vibrations of the eardrum en route to the small membrane (oval window) that transfers sound vibrations into the inner ear.

The Inner Ear

The inner ear is contained in a fluid-filled, cartilage spiral termed the **cochlea**, imbedded in the bone of the skull. The vibratory action of the middle ear bones is converted, in the inner ear, into traveling waves that flow the length of the cochlea. They set in motion two membranes extending the length of the cochlea, one stretching above the other. Resting on the **basilar membrane** are specialized receptor cells

for hearing. These neurons have small **cilia** (hairs) that extend into the **tectorial membrane** above them. When traveling waves set the two membranes into motion, a shearing stress is created between the membranes, bending the hairs of these cells. This is the stimulus that activates the hair cells, which in turn produces neural activity in cells whose axons become the **auditory nerve**. This bundle of axons carries information on to the brain, leading to the experience of hearing.

Auditory Processing

The auditory nerve of each ear carries information inward to the thalamus, which relays the information back outward to the **primary auditory cortex**. This cortical region is located in the temporal lobes, actually quite near to the ears from where the information came.

Organization of the auditory cortex is based on concepts similar to those of the visual cortex. First, different components of sound (for example, pitch and location) are processed in different cortical regions. Second, each neuron that codes sound responds optimally to a characteristic frequency, just as cells in the visual system respond optimally to a particular visual feature. Third, the physical organization of auditory cortex is such that neighboring cells are tuned to similar frequencies, producing a mapping of frequencies—many redundant mappings, in fact.

Psychological Dimensions of Sound

The psychological experience of sound intensity (loudness) is quite straightforward. It is based on how rapidly the relevant neurons fire. Determining the pitch of a sound is a bit more complicated, but researchers have identified two ways in which the frequency is coded to produce the psychological experience of pitch.

Georg von Békésy (1899–1972) earned the Nobel Prize in 1961 for his discovery of how humans experience pitch, based on his study of guinea pigs and human cadavers. His **place theory**, or traveling wave theory, explains the connection between sound and the coding of pitch in the cochlea's basilar membrane. Recall that different frequencies of sound, by definition, have different wavelengths. As these various waves travel into the inner ear, they therefore peak at different points along the basilar membrane. The brain interprets the location of these peaks through neural activity—because hair cells at a certain location correspond to a certain frequency. The result is the psychological experience of pitch.

One problem with place theory, however, is that it does not account for the fact that humans can hear very low frequencies, because there are no auditory nerve cells that respond optimally to these frequencies. It seems a second principle, described by **frequency-matching theory**, allows us to hear these frequencies. Simply enough, this theory suggests that the firing rate of neurons in the auditory nerve matches the frequency of the sound: If a sound has a frequency of 50 Hz, the neurons fire fifty times per second. Because neurons cannot fire faster than around 1,000 times per second, frequencies above this are coded by neurons that are synchronized, but offset. Think of it like soldiers who fire while their neighboring comrades are reloading, allowing a near-continuous volley of shots. This analogy may help to remember the other common name for frequency-matching theory, which is volley theory.

Sound Localization

One important contribution of our sense of hearing is that it grants us the ability to locate objects by the sounds they make. This skill is attributed directly to the fact that we have two ears. Both ears receive

the vibrations (sounds) from the world around us. However, each ear receives these sounds at a different time, and with a different intensity. For example, sounds to the right of us will be picked up by the right ear first, and the sound will also be louder in the right ear. The brain uses this differentiation to accurately locate sounds.

Hearing Disorders

An estimated twenty-one million Americans suffer from some type of hearing loss, including a quarter million who were born deaf. There are actually two distinct types of deafness. **Conduction deafness** occurs when some elements of the ear fail to operate properly, such as if the bones of the middle ear do not vibrate, or the eardrum is punctured. This can be partially alleviated by the use of a hearing aid that helps in amplifying sounds for the inner ear to register.

Most types of hearing loss involve insensitivity to higher frequencies like violins or birds chirping rather than lower frequencies like drumbeats or bass. This is the result of **nerve deafness**, or damage to the cochlear hair cells, corresponding to particular frequencies. This hearing loss is associated with some degenerative diseases and aging, but also a great degree to prolonged exposure to sound levels greater than about 90 dB (for example, rock concerts and jet planes). There is recent evidence to suggest that regeneration of hair cells, long thought impossible in humans and other mammals, may be a possibility. For deaf children, some parents opt for cochlear implants, which translate the sound waves into neural impulses much like artificial vision methods translate light. However, these devices are somewhat controversial, because they are seen by some as a failure to embrace deaf culture.

■ CHEMICAL SENSES

Vision and hearing can be termed mechanical senses because they rely on the translation of physical energy in the form of waves. Other senses rely on the detection of particular chemicals in the world around us. While some animals do not have a sense of vision and/or hearing, they all have some form of chemical senses. Humans have a sense of smell, called **olfaction**, and a sense of taste, called **gustation**. Unlike other sensory receptors, the chemical receptors for these senses are continuously regenerating.

Smell

Olfaction occurs in the **olfactory area** in the uppermost part of the nasal cavity, where odor molecules arrive primarily from the nostrils, but also through the back of the mouth. Approximately a thousand different types of odor receptors—in stark contrast to the four distinct receptors for vision—extend into the olfactory area on the dendrites of sensory neurons (cilia). Binding of odor molecules to the receptors causes the neurons to fire, and the distinct odors we experience are the result of the response pattern across these various receptor types.

Olfaction is the only sense that does not relay its messages through the thalamus. Rather, the axons from sensory neurons in the olfactory area synapse onto a brain structure called the **olfactory bulb**, which extends to just above the olfactory area from near the hypothalamus. Signals pass from the olfactory bulb to olfactory cortex, where odors are processed, but also to the hypothalamus, amygdala, and other structures implicated in emotion. This underscores the connection between olfaction and emotional memories.

In some species, there is a subsystem of olfaction that is responsible for detecting **pheromones**. Pheromones are special chemicals transmitted among animals that impact the recipient's physiology and/or behavior, such as sexual drive and menstrual cycles. There is still debate about the extent to which pheromones influence modern-day humans, but one acknowledged example is menstrual synchrony. This tendency for females who live together to menstruate at the same time is attributed to pheromonal signals secreted through perspiration.

Taste

Gustation is the work of specialized receptors in the mouth called **taste buds**, which are grouped into structures called papillae. Although most taste buds are on the tongue, there are also taste buds on the roof of the mouth and the back of the throat. These taste buds have small pores for catching molecules of chemicals in food dissolved in saliva, which are sensed by small fibers in the pores. There is actually a wide variety across individuals in the number of taste buds, which can range from hundreds to thousands.

There are only a few distinct taste sensations, the most well-known of which are sweetness, saltiness, sourness, and bitterness. These tastes are produced neurally in different ways; sweet and bitter sensations occur when molecules bind with particular receptors, whereas salty and sour chemicals work directly on the ion channels in neurons.

Most people realize—especially when they have a stuffy nose—that the taste buds alone do not create the flavors that we experience in foods. Olfaction contributes a great deal (in fact, the majority) to the experience of flavor, thanks to the pathway from the back of the mouth to the olfactory area. Olfactory and taste information, as well as signals from other senses including sight and the feel of foods in the mouth, converges in the orbitofrontal cortex. Here, along with information about current states of hunger (or lack thereof), is where researchers believe the experience of flavor is created.

■ SOMATIC SENSES

Small specialized organs and free nerve endings (dendrites) located in the tissues beneath the skin are the source of the skin senses, which include sensitivity to pressure, warmth, cold, and pain. Other touch experiences, such as texture, tickling, itching, or wetness, are created from some combination of these basic four sensations. These tactile (touch) senses, in addition to senses that monitor the position of the body, are collectively referred to as the somatic (bodily) senses.

Touch, Pressure, and Temperature

The skin is the largest organ of the human body, covering more than five square feet of surface area. Distributed across this area, either embedded in or directly below the skin, are receptors that respond to pressure. This pressure occurs either directly on the skin or is conducted through the hairs in the skin. The neural mechanics of transduction underlying the sense of touch are not well understood. Part of the mystery is that there are many types of receptors involved, but the sensation produced is not directly attributable to the receptor type. These receptors are on axons of **somatosensory neurons** (which have no dendrites) that split and project both to the skin and to the spinal cord. From here, information about the intensity (or weight) and the location of a stimulus—coded by the firing rate and

distribution of activated neurons, respectively—is transmitted through the thalamus to the somatosensory cortex.

Not all of the receptors along the skin respond to simple contact or pressure. Some respond instead (or in addition) to changes in temperature. For example, there are nerves that show increases in activity for temperatures around 95°F to 115°F, as well as those that respond to a wide range of cool temperatures.

Pain

Some free nerve endings are responsible for the transmission of a sensation of pain from the body to the brain. Neurons that code for pain send information to the spinal cord in two distinct types, one for sharp pains and one for dull pains or aches. These neurons also return information to the skin region where the pain occurs. Higher-order processing of pain, such as in the cortex and other brain regions, is still under exploration. There seem to be cognitive as well as emotional components to the degree of pain and the exact experience associated with painful stimuli.

Pain can be adaptive in many ways, such as a learning mechanism and to prevent more substantial bodily harm. However, fortunately, the body also has mechanisms for controlling pain. An early **gate-control theory** of pain control has turned out to be slightly inaccurate, but the basic premise—that the spinal cord can block pain signals being sent to the brain—seems to have some merit. Also, the brain can release some **analgesic** (pain-relieving) neurotransmitters, such as serotonin and endorphins, which block pain signals traveling upward through the spinal cord.

Proprioception and Balance

Specialized sensory systems throughout the body provide a sense of body position, or **proprioception**. In particular, the **vestibular sense** informs the brain about the position and movement of the head. This is provided by the **semicircular canals** and related structures of the inner ear, conveying a sense of balance, acceleration, and orientation as the head moves. This helps explain why infections of the middle and inner ear can result in difficulties with balance. The sense of the position of other parts of the body, and their relation to one another, is called **kinesthesia**. Organs associated with the joints contribute this information, through the spinal cord and thalamus, to the cerebellum and somatosensory cortex. This sense is important for all movement and motor skill.

Each of our senses is the result of specialized receptors that perform transduction, the conversion of external physical energy into neural information. This information is transmitted along distinct pathways, almost always through the thalamus, to cortical areas devoted to a particular type of sensory processing. In order to sense a stimulus, it must be above an absolute threshold; to detect a change in stimulus, the change must exceed a difference threshold. For example, the absolute threshold for frequency is around 20 Hz, whereas the difference threshold is less than one percent of the frequency (but varies considerably depending on frequency). Changes, however, are critical in detecting stimuli due to sensory adaptation. Vision and audition are the primary human senses, giving us the most information and possessing the most cortical area devoted to their processing; these are also the best understood.

Vision is afforded to us by the work of the eye, which uses the lens to focus light received through the pupil on the retina. The receptors for vision, photoreceptors, are embedded in the retina and respond to

different types of incoming light energy. Rods are photoreceptors that respond to low levels of light, whereas three types of photoreceptors (cones) respond to approximately red, green, and blue wavelengths of light. This information is transmitted through the thalamus to the primary visual cortex and beyond. Visual cortex is characterized by topographical organization and parallel, hierarchical processing. Different regions process elements such as color, movement, and form using increasingly complex assemblies of feature detectors. Our sense of color is explained by a combination of the trichromatic theory and the opponent-process theory. Different visual disorders can result depending on the location and type of abnormality or damage in the visual system.

Audition, our psychological sense of hearing, is the result of processing in the auditory cortex in the temporal lobes. The ear performs the transduction of sound waves into the neural signals this area understands. Specifically, the outer ear funnels sound waves to the middle ear, which amplifies them for the receptors in the cochlea of the inner ear. These receptors each respond optimally to a particular frequency based on their location along the cochlear (basilar) membrane. In conjunction with frequency-matching theory, this explains our ability to discriminate frequencies ranging from around 20 to 20,000 Hz. Hearing loss can be due to failures in the amplification of the middle ear (conduction deafness) or in the transduction of sound into neural signals (nerve deafness).

Our other senses are also important to our normal and satisfying functioning as human beings. The two chemical senses, olfaction (smell) and gustation (taste) work in concert to deliver a sense of flavor. These chemical senses function when specific molecules dissolve in bodily fluids (mucous or saliva) and bind to specialized receptors. The senses of touch, including pressure, temperature, and pain, allow us to interact with the world of our own volition, rather than passively. Another somatic (bodily) sense is proprioception, which gives us information about the position of our head (vestibular sense) and body (kinesthesia), allowing for bodily control and coordinated movements.

Key Concepts

absolute threshold	fovea	loudness
accommodation	frequency-matching theory	myopic
amplitude	ganglion cells	nerve deafness
analgesic	gate-control theory	olfaction
anvil	gustation	olfactory area
auditory nerve	hammer	olfactory bulb
basilar membrane	hue	opponent-process theory
blind spot	hyperopic	optic chiasm
cilia	intensity	optic nerve
cochlea	iris	pheromones
conduction deafness	just noticeable difference	pinna
cones	(jnd)	pitch
cornea	kinesthesia	place theory
difference threshold	lateral geniculate nucleus	primary auditory cortex
eardrum	(LGN)	primary visual cortex
feature detectors	lens	proprioception

psychophysics
pupil
receptive fields
receptors
retina
rods
semicircular canals

sensory adaptation
somatosensory cortex
stirrup
taste buds
tectorial membrane
topographic organization
transduction

trichromatic theory
vestibular sense
visual acuity
wavelength

Key People
Georg von Békésy
Herman L. von Helmholtz
Ewald Hering
Thomas Young

SELECTED READINGS
Carlson, N. R. (2003). *Physiology of behavior, 8th Ed.* Allyn & Bacon, Inc.
Goldstein, E. B. (2003). *Sensation and perception.* Wadsworth.
Levine, M. W. (2000). *Fundamentals of sensation and perception.* Oxford University Press.
Matlin, M. W., & Foley, H. J. (1996). *Sensation and perception, 4th Ed.* Allyn & Bacon, Inc.

Test Yourself

1) The field of _____ has taught us a great deal about the transformation of physical signals into neural signals, called _____.
 a) psychosomatics; adaptation
 b) psychophysics; transduction
 c) psychosomatics; conversion
 d) psychophysics; accommodation

2) Stimulus intensity below the _____ will not be detected; neither will a change in intensity smaller than the _____.
 a) benchmark; difference threshold
 b) difference threshold; just noticeable difference
 c) absolute threshold; difference threshold
 d) perceptual limit; just noticeable difference

3) Which of the following sequences best describes the path of light and/or neural signals in the visual system?
 a) lens, retina, optic chiasm, optic nerve, LGN, primary visual cortex
 b) retina, lens, optic nerve, optic chiasm, LGN, primary visual cortex
 c) lens, retina, optic nerve, optic chiasm, LGN, area V1
 d) lens, retina, optic chiasm, optic nerve, thalamus, area V1

4) Which property best describes the functioning of the visual cortex?
 a) topographic organization
 b) parallel processing
 c) hierarchical processing
 d) all of the above

5) Which of the following sequences best describes the path of sound and/or neural signals on the way to the auditory cortex?
 a) outer ear, eardrum, middle ear, cochlea, auditory nerve, thalamus
 b) outer ear, middle ear, eardrum, cochlea, auditory nerve, thalamus
 c) outer ear, eardrum, middle ear, cochlea, thalamus, auditory nerve
 d) none of the above

6) Which of the following sequences best describes the path of olfactory information to the brain area that determines the psychological experience of flavor?
 a) odor receptors, olfactory bulb, thalamus, temporal cortex
 b) odor receptors, olfactory bulb, thalamus, orbitofrontal cortex
 c) olfactory bulb, odor receptors, thalamus, temporal cortex
 d) odor receptors, olfactory bulb, orbitofrontal cortex

7) Which of the following best describes the location of taste buds in the mouth?
 a) the tongue
 b) the tongue and gums
 c) the tongue and roof of the mouth
 d) all of the above

8) _____ refers to the sense of the position and activity of the body parts, including the _____ sense for the head in particular.
 a) Proprioception; kinesthesia
 b) Proprioception; vestibular
 c) Kinesthesia; proprioceptive
 d) Vestibular; proprioceptive

9) What are the four basic primitives for different tactile (touch) senses? How are location and intensity of these primitives coded? What cortical area is responsible?

10) Briefly describe how both the trichromatic theory and the opponent-process theory contribute to our understanding of the experience of color (including black and white). Include in your answer sufficient description of the four types of photoreceptors in the retina.

Test Yourself Answers

1) **b.** The field of psychophysics has taught us a great deal about the transformation of physical signals into neural signals, called transduction. Psychosomatics is a branch of medical science not discussed in this book, and accommodation is an adjustment of the lens in the eyeball.

2) **c.** Stimulus intensity below the absolute threshold will not be detected; neither will a change in intensity smaller than the difference threshold. The difference threshold is also referred to as the just noticeable difference (jnd), but this answer was matched with incorrect terms.

3) **c.** The proper order for the given structures of the visual system is lens, retina, optic nerve, optic chiasm, LGN, area V1. Although the optic nerve continues also after the optic chiasm, information first enters the optic nerve before the optic chiasm. Note that this distinction, not the use of thalamus (where the LGN resides) or primary visual cortex (synonymous with area V1), eliminates options (A) and (D).

4) **d.** All of the above options, topographic organization, parallel processing, and hierarchical organization, are indeed characteristic of the visual cortex.

5) **a.** The proper order for the given structures of the auditory system prior to arriving in the auditory cortex is outer ear, eardrum, middle ear, cochlea, auditory nerve, thalamus.

6) **d.** The proper order for the given structures on the path of olfactory information to the brain area responsible for flavor is odor receptors, olfactory bulb, orbitofrontal cortex. Recall that olfactory information is the only sense which bypasses the thalamus, and flavor is interpreted in the orbitofrontal cortex with additional information such as taste and hunger. The temporal cortex processes auditory information.

7) **c.** Taste buds in the mouth are located on the tongue and roof of the mouth, but not on the gums.

8) **b.** Proprioception refers to the sense of the position and activity of the body parts, including the vestibular sense for the head in particular. Note that proprioception encompasses the term kinesthesia; the latter could be justified in the first blank, but only vestibular fits in the second blank.

9) Somatosensory receptors under the skin are sensitive to pressure, warmth, cold, and pain. Although the transduction involved is unclear, the location of tactile input is determined by which neurons are activated, and the intensity of the input is a function of how strongly they are activated (that is, the firing rate). This information is processed in the somatosensory cortex, which is located in the forward portion of the parietal lobes.

10) The retina is composed of four types of photoreceptors. Rods do not sense color, whereas the three types of cones are most sensitive to red, green, and blue

wavelengths. Trichromatic theory explains how these photoreceptors help to code color information. Opponent-process theory explains how ganglion cells and neurons in the LGN and visual cortex code color. In particular, different neurons are tuned to optimally fire in response to a particular color in a pair of opponent colors, and to be inhibited by the other color; the color pairs are red-green, blue-yellow, and black-white.

Perception

Perception is usually taken to mean the final, organized, and meaningful experience of sensory information. The difference between sensation and perception is one of degree of understanding. Sensation (from a Latin word meaning "to feel") involves the neural stimulation of sensory systems by physical changes, as we saw in Chapter 5. **Perception** (from the Latin *per* or "thorough" and *capio* or "grasp") involves recognizing the meaning of what has been sensed. Basically, sensation is detecting a stimulus, whereas perception is recognizing a stimulus. That is, when one senses a stimulus, one is aware of it, but when one perceives that stimulus, one understands what it is.

■ STUDYING PERCEPTION

The study of perception has been guided by different approaches to exactly what the nature of perception is. To a large degree, the study of perception has also been defined by the formal quantitative framework used to analyze perceptual performance. These concepts are introduced here to lay the foundation for the remainder of the chapter.

Approaches to Perception

There are three primary approaches that describe psychologists who study perception. The ecological approach, founded by James J. Gibson (1904–1979), focuses on the interactions with the environment, in particular how we perceive the cues in the environment that help us to perform specific actions. The constructivist approach is mainly concerned with perceptual inference, or how we use incomplete sensory information to form mental representations. These approaches have contributed a great deal to the more recent computational approach, which attempts to understand the exact computations that a perceptual system performs.

Psychophysics Revisited

We discuss a bit about the historical contributions of psychophysics in Chapter 1 and the application of psychophysics to sensation in Chapter 5. Classical psychophysical studies have examined absolute **thresholds** (the minimum energy needed to sense a stimulus) as well as difference thresholds (the minimal stimulus change that can be recognized, or jnd). These studies have led not only to a better understanding of human sensation, but formal quantitative analyses of perception as well.

Weber's Law

The earliest formalization of a psychophysical relationship is considered to be **Weber's Law**, after its formulator E. H. von Weber. According to Weber's Law, the noticeability of a change in stimulus strength depends on the magnitude of the stimulus before the change. Weber's Law is often written:

$$jnd = I \times K$$

which states that the just noticeable difference in stimulus intensity (*jnd*) is equal to some constant fraction ($K < 1$) of the original intensity (*I*). Loosely translated, this means that, for a given sensory system (vision, touch, and so on), a noticeable change in the intensity of a stimulus must be proportional to (that is, depends on) the already-present stimulus intensity. Each sensory system will have its own specific value for the Weber fraction, K.

For example, the noticeability of an increase in the light in a room depends on how much light is available before the increase. If the room is dark, even a very faint increase in light will be noticeable; if the room is already well lit, however, an increase in light—even a bright increase—may not be noticeable against the bright background. Specifically, the brightness in a room must increase by around two percent of the original brightness to notice a change. Another example of Weber's Law is the noticeability of a dieter's weight loss. The noticeability of, say, a five-pound weight loss depends on how much the individual weighed before the loss. A five-pound loss will be more noticeable on a 100-pound person than on a 200-pound person.

Weber's Law provides a practical insight into human perception because it characterizes the relationship between psychological experience (for example, vision) and physical stimulus (for example, brightness of light) as one of proportion. In other words, we do not see exactly what is actually changing in light energy. Instead, we see a meaningful proportion or percentage of the change, always automatically comparing it to the background. This is an early identification of the enormous adaptability and flexibility of human perception.

Signal Detection Theory

The threshold theories formulated by early psychophysicists relied on the assumption that sensory systems like eyes and ears will be "activated" by any stimulus strong enough to enter the system. But a self-reflection exercise suggests that sensation and perception are not so simple: If someone in the same room with you whispers to you, will you hear it? Modern psychophysicists point out that the answer to this is, "It depends." Whether you hear the person's whisper can depend on several factors: how noisy the room already is; whether you are preoccupied with other matters; whether the person whispers your name or some less meaningful word. In essence, modern theorists argue, perception depends not so much on the strength of the stimulus as on your ability to detect the stimulus amidst all the noise in the environment and in your own system.

This characterization of perception as a decision about whether you really heard something or not is the essence of **signal detection theory**, the favored approach of modern psychophysicists. Signal detection theory, sometimes referred to as the theory of signal detection and therefore often abbreviated **TSD**, was originally developed to explain the pattern of responses radar operators made when vigilantly monitoring wartime radar screens. When a blip (flash of light) appeared on the screen, was it really an enemy aircraft, or just a cloud formation? TSD focuses on one's ability to detect a signal in a background of noise. The **signal** includes the stimuli of interest and stimulus changes (for example, aircraft). **Noise** refers to any nonsignal event, whether internal (for example, preoccupation or fatigue) or external (for example, cloud formations or a flock of birds). TSD emphasizes the judgment criteria of the observer in the experimental setting. This includes, for example, the importance and probability of making correct responses as well as different types of errors (for example, false negatives and false positives).

The signal detection approach formalizes perception with the following assumptions:
- The judgment criteria of the subject must be taken into account.
- There is actually no such thing as an exact absolute threshold.
- Signals always occur against a noise background.
- The determining variable is not the signal's intensity but the ratio of the signal to the noise. The higher the signal to noise (signal:noise) ratio, the stronger the signal stands out against the noise background and the easier the detection process will be. The lower the signal:noise ratio, conversely, the harder it is to detect the signal, even if a signal is there.

Instead of threshold values for various sensory systems, the signal detection approach measures **sensitivity**, or the ability of the observer to detect the signal.

■ THE ROLE OF ATTENTION

With the influx of sensory information that continually bombards our senses, how is it that we are able to actually perceive anything without being overwhelmed? The answer lies in attention. **Attention** is the process of controlling and focusing mental resources to enhance perception and behavior. Attention serves many functions, including the direction or orientation of sensory systems to specific stimuli, the selection of relevant information for further processing while ignoring other information, and the allocation and continuous regulation of mental resources for processing.

Attention also helps us to perform better in many situations. For tasks that are even somewhat challenging or demanding, we are able to do better if the task "has our full attention." However, focusing attention, especially for long periods of time, can also be mentally draining. There are some other aspects of attention to consider as well.

Selective Attention

An important characteristic of attention is that it is limited. Therefore, it is necessary to prioritize which sensory information will be processed, or which tasks will be performed. **Selective attention** refers to the fact that, at any given moment, attention is focused only on a particular subset of all available information. For example, consider the cocktail party effect, or the ability to selectively attend to one voice among many in order to follow a single conversation in a noisy environment.

In some cases, it is possible to allocate attention to two different tasks, or to allocate some specific resources to one task, and other resources to another task. In this case, one can exhibit **divided attention** to different types of information. Sometimes it is even more difficult to focus attention rather than have it be divided. The ability to utilize divided attention depends in large part on the nature of each task, such as how much thought each requires, or whether they demand the same type of mental resources.

Voluntary and Involuntary Attention

You have probably heard or used the phrases "give attention" and "grab attention." You may give a specific task or person all of your attention, or something in the environment may grab your attention. These phrases allude to two different types of attention, voluntary and involuntary. Voluntary or goal-directed attention refers to instances where your attention is under conscious control, allowing one to purposefully guide attention to accomplish a particular task. In contrast, involuntary attention occurs when attention is unintentionally diverted, usually to salient stimuli such as lighting changes, movement, and unusual or novel stimuli. Marketing and advertising firms take advantage of these properties when designing advertisements to draw your attention.

■ PERCEPTUAL PROCESSES AND ORGANIZATION PRINCIPLES

The majority of perception research, much like research on the senses, has focused on visual processing. This research has led to a good understanding of how we perceive the form, location, distance, and motion of objects in the environment.

Form Perception

Perceiving distinct forms in the world is often taken for granted, but it is actually a curiosity that we somehow interpret the light that is reflected into our eyes as distinct forms. We must somehow carve boundaries between adjacent light sources to determine (perceive) distinct forms. Early in this century, the Gestalt school of psychology emphasized the holistic nature of perception (see Chapter 1 for a review of Gestalt influences in the history of psychology). Gestalt psychologists emphasized that perception is not a passive translation of sensation into ideas but rather an active process of seeking meaning. Meaning could be inferred in perceived stimuli by means of several Gestalt principles that have contributed to our understanding of form perception, including figure-ground relationships and grouping principles.

Figure-Ground Relationships

The Gestalt psychologists stressed the dynamic aspect of perception, noting that a perceived form always appears as a vital figure against a broader or open background (ground). Thus, they stressed the **figure-ground relationship** in perception.

Grouping Principles

Gestalt psychology provided a number of grouping principles (or Gestalt principles) that help in defining distinct forms (Figure 6-1). In other words, it suggests properties that are used to determine whether a collection of objects or events are considered together or separate.

- **Proximity** suggests that objects or events occurring close to each other belong together—those seated at a single table at a diner are likely to be acquaintances dining together.
- **Similarity** refers to the tendency for similar objects to form groups. For example, looking on a football field, we know that those wearing similar jerseys are on a single team.
- The concept of **closure** means that we tend to perceive complete figures, though in fact part of the figure may be hidden from view or missing altogether. For example, at the dentist's office, we don't assume that the receptionist is missing the bottom half of his body.
- **Continuity** suggests that figures that appear to create a continuous form belong together. For example, "X" in Figure 6-2 is not perceived as two separate angles.
- **Common** fate implies that objects in common motion—for example, the same direction and speed, such as a flock of birds or a marching band—are seen as a unit.
- **Connectedness** refers to the tendency to perceive as a group those elements of a scene that are connected by other elements, such as the cars of a train.

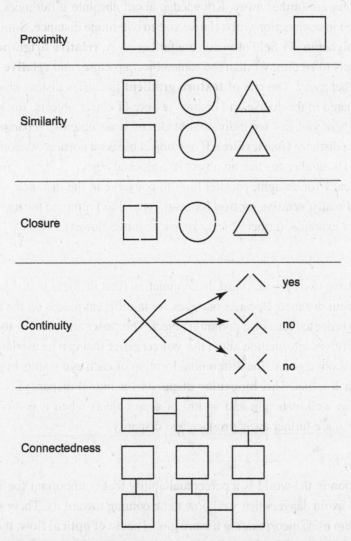

Fig. 6-1: Gestalt grouping principles. Different principles determine how the collection of lines and/or shapes in each row are organized into groups.

Perceiving Location and Distance

An important perceptual feat is the ability to judge location and distance of objects in the environment. In Chapter 5, we describe how the auditory system localizes sound sources based on the differences between the two ears of the sound's intensity and timing. In addition, information about where the image falls on the retina, as well as information about the head's current orientation, are all used together to identify the location of objects.

Our ability to perceive distance, **depth perception**, has long been an area of research interest for perception psychologists. An abundance of research has identified many different cues that we use to determine the distance of an object. These can be grouped into **monocular cues** (those available to each eye separately) and **binocular cues** (those requiring inputs from both eyes).

Monocular Cues

The cue of **relative size** suggests that, if two images are assumed to be the same size, images that are smaller on the retina are further away. Knowledge about absolute differences in size between two objects can also be used in conjunction with relative size to determine distance. Similarly, **relative height** suggests that objects higher in our field of vision are farther away, **relative brightness** describes the tendency for distant objects to be dimmer than the same object up close, and **relative clarity** suggests that hazier objects are farther away. The cue of **texture gradient** identifies distant objects by their finer or grainier texture, compared to the coarse and distinct texture of closer objects. Imagine looking across a large field of grass, where you can see individual blades of grass up close (coarse texture) but only an indistinct green sea at a distance (fine texture). If one object blocks a portion of another object, this **interposition** (or occlusion) is another cue that an object (the blocked object) is further away. **Linear perspective** refers to the tendency for straight, parallel lines to converge in the distance, such as when looking down railroad tracks. Finally, **relative motion** (or motion parallax) refers to the use of objects' speeds to determine distance (for example, farther objects appear to move slower).

Binocular Cues

The fact that we have two eyes that work in conjunction (that is, focus on the same object) provides two additional cues about distance. Because our eyes are in different places on the head, they each must turn slightly inward in order to focus on a common object. The closer an object is, the more the eyes must converge. The brain receives information about this **convergence** that can be used to assist depth perception. Similarly, despite convergence, the differential location of each eye results in projection of slightly different images on each retina. This **binocular disparity** (or retinal disparity) is used by the brain to determine the depth (as well as height and width) of seen objects when it combines the two images. Specifically, images that are further away produce less disparity.

Perceiving Motion

Recognizing motion in the world is a perceptual ability that is important for a number of reasons, such as allowing us to avoid dangers that we know to be coming toward us. There seem to be a number of cues the visual system uses, incorporating a more global sense of **optical flow**, the changes in the retinal image across the entire visual field. An object that changes location in the visual field is likely to be

moving, and the rate of change in the retinal image can be used to determine its speed. There are cells in the visual cortex that respond to motion in their assigned area of the visual field. In fact, separate cells respond optimally to motions of different speed and direction, for a given location. These cells are located primarily in **area MT** (also called area V4) in the occipital lobe. Again, the brain must also take into account the orientation and movement of the head, which it is afforded through its vestibular sense.

The brain sometimes also perceives motion when there is in fact none, called **apparent motion**. One example of apparent motion is the phi phenomenon described in Chapter 1, involving a series of blinking lights. As another example, consider the powerful illusion of **stroboscopic motion** in movies: When a series of still photograph frames are projected in quick succession, one sees not separate frames but continuous motion of the characters and action on the screen.

Perceptual Constancy

The complex combination of cues available to the eye allows us to see an object as composed of constant perceptual characteristics despite changes in the retinal image itself.

- **Size constancy** refers to the fact that objects do not appear to change in size when they come nearer the eye (producing a larger retinal image) or farther from it (producing a smaller image).
- **Shape constancy** refers to the fact that the apparent shape of an object does not change as it rotates or moves in space, although, in fact, it produces altered retinal images.
- **Color constancy** and **brightness** (or lightness) **constancy** refer to the steady appearance of an object's color and brightness despite changes in lighting conditions.

■ RECOGNITION OF PATTERNS AND OBJECTS

The ability to recognize patterns and objects in the world for what they are is beyond merely detecting the object, or perceiving its form, distance, color, and so on. Recent research has implicated the **inferotemporal cortex (area IT)**, at the bottom of the temporal lobe, in processing that leads to object recognition. But how exactly is this done? Although this is not yet fully understood, there are many theories. The processes in these theories can be classified into three categories.

Bottom-Up Processing

Our discussion of the visual system up to this point has provided a description of so-called bottom-up processing. In models of object recognition based on **bottom-up processing**, information travels up from the sensory receptors to the brain, where it is passively interpreted. By the time information reaches area IT, the brain is processing complex shapes and distinct objects, rather than just simply points of light or line segments such as edges or corners. Yet, this simpler information, all received from photoreceptors, is where the processing began. If object recognition relies solely on bottom-up processing, the perceptual system must run through all possible objects to locate (recognize) the correct choice. This is like reviewing all of the faces that are stored in one's memory to locate a correct match with the one seen. Consider also a beginning reader, or someone learning a foreign language, who must laboriously construct the correct sound and meaning of written words.

Top-Down Processing

Top-down processing refers to recognition that is guided by higher-order cognitive processes and existing knowledge. In a top-down model, the brain sends down important information—like preliminary guesses about what is seen—to the sensory system as it collects information. For example, a top-down model may identify the important features of the object seen and narrow the search among possible objects to only those possessing these features. Evidence shows that expectancies and previous experiences influence perception and object recognition (see the following section); this is due to the influence of top-down processing. Contrast the performance of a fluent reader, or the native speaker of a language, with a novice reader or someone new to a language. The experts can make use of contextual information and past occurrences to aid in recognizing written words.

Network Processing

Whereas top-down processing aligns with the constructivist approach, and bottom-up processing is most likely to be seen in models from the ecological approach, recent research in the computational tradition has begun to explore an elegant new class of models. These **connectionist models** (or neural network models) attempt to explicitly model the architecture of the recognition system by specifying the distinct units involved and the connections among them. Another name for these models—parallel distributed processing models—relates two of their key characteristics. That is, processing occurs simultaneously in neural units that are widely distributed, yet interconnected.

A connectionist model of word recognition may begin with units for different letters of the alphabet. These units could be connected in various ways to other units, representing phonemes. For example, the unit for *h* may be connected (along with *s*) to a unit representing *sh*, as well as to a unit representing *ch*. There would also then be a unit for the sound *ay*, which would be connected to different units, or combinations of units, that produce this sound, such as *a, ai, ay, ea,* and so on. An important concept in most connectionist models is that the strength of the connections depends on the frequency with which the units are activated together. The more often *a* and *i* occur together to form the sound *ay*, the stronger the connection between each letter unit and the *ay* phoneme unit. Finally, there may be still other units that represent entire words, such as the *chair* unit with connections to the *ch*, *ay*, and *r* units.

Connectionist models exhibit attributes of both bottom-up and top-down processes. For example, in the example of connecting letters, presentation of the individual letters may activate the appropriate word. In one sense, this model relies on bottom-up processing because it is presentation of the stimuli (letters) that guide processing. However, top-down processes are also involved, because it is through these processes (for example, prior experience) that the connections among various units are strengthened. Furthermore, top-down processing could also be incorporated by exerting an influence directly on the word units from units representing the context of the particular situation. Thus, whereas presentation of *c-h-a-i* may lead to equal activation of the words *chair* and *chain* through bottom-up processing, the context may determine which of these words best fits the particular situation.

■ SHAPING PERCEPTIONS

Regardless of one's approach to studying perception, or how one views perception as proceeding, an undeniable empirical fact is that perceptions are not always stable and uniform across time, situations, or people. They can be affected by contextual information and individual experiences.

Illusions

Illusions, such as commonly encountered optical illusions, are erroneous perceptions. They are the result of complex interactions of visual cues and are not in all cases well understood. Often they seem to occur when there are few cues upon which to base a perceptual judgment, and one or more are supplying misinformation. When the brain is presented with seemingly contradictory information, it must somehow reconcile this information in order to form a perception. Two of the most common illusions, the Ponzo illusion and Müller-Lyer illusion, are shown in Figure 6-2. These illusions, and many others, have been used by researchers to study perception. By examining what kind of mistakes occur in the perceptual system, we have gained a better understanding of the underlying principles on which perception is based.

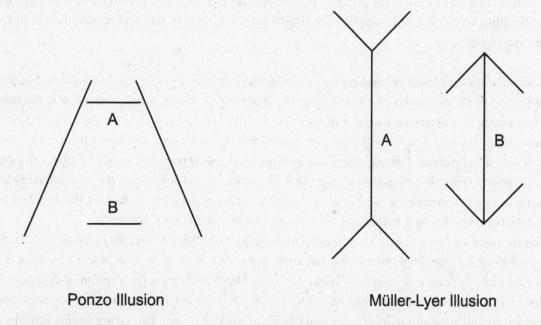

Ponzo Illusion Müller-Lyer Illusion

Fig. 6-2: Ponzo and Müller-Lyer illusions. Is line A longer? Despite the appearances, for each illusion the lines A and B are the same length.

Expectations, Experience, and Culture

Some evidence suggests that perceptual processes are innate, or inborn, rather than learned. For example, depth perception is evident very early in human development, as illustrated by research using the visual cliff. In these studies, infants are urged to crawl across a sturdy transparent bridge over a several-foot drop in a floor. The infants have little experience with substances like glass, but have also seldom fallen. Nonetheless, eager as they are to crawl across the glass bridge, the babies become distressed when they see the depth of the visual cliff, and are reluctant to take the risk of crossing it.

Although perceptual processing may seem to be hard-wired in the nervous system, there can actually be a great degree of individual variability in perception based on expectations and contexts. One may have preconceived notions about what one is going to experience; these expectations are referred to as one's **perceptual set**. This can result in the differential perception across individuals of the same stimuli, such as the predisposition to recognize clouds as UFOs. Even within an individual, the context or past experiences can greatly influence one's perceptions, especially of ambiguous stimuli. This can make all the difference between perceiving an approaching stranger as threatening (at night when alone) versus just lost (in a crowd during the day). Motivation may also shape perceptions, such as whether an ambiguous shape is identified as food depending on one's state of hunger, or whether someone else's actions are perceived as flirtatious.

One's culture may also play a role in how different objects are perceived or recognized. For example, many popular textbook illusions, such as in Figure 6-2, feature straight-lined figures like arrows and lines. Research suggests that in nomadic non-Western cultures, where natural surroundings offer few examples of straight lines (for example, curved huts instead of skyscrapers or a lack of railroads), natives have not developed a perceptual set about straight-lined figures and thus are not fooled by such illusions. Other cultures that do not use many pictorial representations (for example, pictures and paintings) have more difficulties in judging distances that are illustrated using relative size and relative height in two-dimensional pictures.

Although they are closely related, there is a distinction between sensation and perception. Sensation typically refers to the awareness of a stimulus, or its input for processing; perception refers to the subsequent processing that determines what a stimulus is. An important prerequisite for (most) perception is attention, which is limited and highly selective. Sometimes voluntary and sometimes involuntary, one's attention may also be divided among stimuli. In studying perception researchers often adopt a constructivist, a computational, or an ecological approach. Historically and still today, the specialized field of psychophysics has contributed a great deal to the formal study of perception, such as Weber's Law and signal detection theory, which build upon the concept of a threshold (see Chapter 5).

Perception of the form of an object is guided by principles identified by Gestalt psychologists, including several grouping principles (proximity, similarity, and so on). Perception of an object's location is the result of auditory cues as well as retinal image location. Depth perception (perception of distance) is a complex ability that utilizes many monocular (for example, relative height, interposition, linear perspective, and so on) and binocular (convergence and binocular disparity) cues. Perceiving motion involves the brain's processing of optical flow, and calls on specialized cells in area MT (or V4). Object recognition occurs primarily in brain area IT, and theories for pattern and object recognition can be classified according to whether they suggest bottom-up, top-down, or network processing.

With the great variability in information that our brain receives, the degree of perceptual constancy—such as size and form constancy, despite changing retinal images—in our perceptual system is somewhat amazing. However, the brain is also susceptible to various illusions, resulting from conflicting information from various cues that must be reconciled. One's expectations, motivation, experience, and culture can also greatly influence perceptions, as can the context in which stimuli are experienced.

Key Concepts

apparent motion
area MT
attention
binocular cues
binocular disparity
bottom-up processing
brightness constancy
closure
color constancy
common fate
connectedness
connectionist models
continuity
convergence
depth perception

divided attention
figure-ground relationship
illusions
inferotemporal cortex
 (area IT)
interposition
linear perspective
monocular cues
noise
optical flow
perception
perceptual set
proximity
relative brightness
relative clarity

relative height
relative motion
relative size
selective attention
sensitivity
shape constancy
signal
signal detection theory
similarity
size constancy
stroboscopic motion
texture gradient
top-down processing
Weber's Law

Key People

Ernst Heinrich von Weber
James J. Gibson

SELECTED READINGS

Geissler, H., Townsend, J., & Link, S. W. (1992). *Cognition, information processing, and psychophysics: Basic issues.* Lawrence Erlbaum Associates, Inc.

Gescheider, G. A. (1999). *Psychophysics: The fundamentals.* Lawrence Erlbaum Associates, Inc.

Goldstein, E. B. (2003). *Sensation and perception.* Wadsworth.

Levine, M. W. (2000). *Fundamentals of sensation and perception.* Oxford University Press.

Matlin, M. W., & Foley, H. J. (1996). *Sensation and perception, 4th Ed.* Allyn & Bacon, Inc.

Test Yourself

1) _____ is regarded as our awareness of stimuli, whereas _____ concerns subsequent processing for understanding a stimulus.
 a) Perception; sensation
 b) Sensation; perception
 c) Perception; object recognition
 d) Perception; illusions

2) Psychophysics has contributed a great deal to our understanding of perception, such as _____, a property of difference thresholds?
 a) signal detection theory
 b) Weber's Law
 c) relative size
 d) relative clarity

3) The fact that, at any given moment, one focuses only on a particular subset of all available information best describes what concept?
 a) divided attention
 b) perceptual set
 c) involuntary attention
 d) selective attention

4) Which of the following is *not* a perceptual organization principle associated with form perception?
 a) form constancy
 b) proximity
 c) closure
 d) connectedness

5) Motion perception occurs primarily in brain area _____, and is susceptible to the illusion of _____.
 a) IT; optical flow

 b) MT; motion parallax
 c) IT; apparent motion
 d) MT; stroboscopic motion

6) Object recognition occurs primarily in brain area _____, and is influenced in part by one's _____.
 a) IT; optical flow
 b) MT; culture
 c) IT; expectations
 d) MT; human factors

7) Which of the following is *not* a type of perceptual constancy?
 a) color constancy
 b) size constancy
 c) time constancy
 d) all of the above are types of perceptual constancy

8) Which of the following does *not* influence perceptions?
 a) context
 b) culture
 c) expectations
 d) all of the above influence perceptions

9) Differentiate between bottom-up, top-down, and network models of processing. Include how each mode would assume recognition of a street sign.

10) Give the difference between monocular cues and binocular cues for depth perception, citing at least two examples (with definitions) of each.

Test Yourself Answers

1) **b.** Sensation is regarded as our awareness of stimuli, whereas perception concerns subsequent processing for understanding a stimulus. Object recognition would also be valid in the second blank, but perception does not fit in the first blank.

2) **b.** Weber's Law states that the difference threshold (jnd), or perceived change in stimulus intensity, is a constant proportion of the absolute stimulus intensity.

3) **d.** Selective attention refers to the fact that, at any given moment, one focuses only on a particular subset of all available information. The other terms involving attention may contribute in determining what exactly is in the subset.

4) **a.** Form constancy is not a perceptual organization principle, but rather a perceptual constancy referring to our consistent perception of form despite changing retinal images.

5) **d.** Motion perception occurs primarily in brain area MT, and is susceptible to the illusion of stroboscopic motion. Motion parallax, or relative motion, is a cue for depth perception, not an illusion.

6) **c.** Object recognition occurs primarily in brain area IT, and is influenced in part by one's expectations.

7) **c.** Time constancy is not a type of perceptual constancy discussed in this chapter. In fact, one's perception of time is not constant or invariant.

8) **d.** All of the above influence perceptions, especially interpreting ambiguous stimuli.

9) In models that assume bottom-up processing, information travels up from the sensory receptors to the brain, where it is passively interpreted. Recognizing a street sign begins with seeing the sign's features, which are then constructed into a representation, which is in turn recognized (for example, matched to possible street signs in memory). Top-down processing refers to recognition that is guided by higher-order cognitive processes and existing knowledge. This type of model would suggest that the street sign for which one is looking would influence recognition, by the brain's signals to the sensory system about what information to seek. Network processing models specify the distinct units involved and the connections among them. These models allow for both bottom-up and top-down influences. Recognizing a street sign in a network model might presume activating specific units based on the sensory input, which would in turn lead to identification of a particular type of sign based on connections formed through prior experience.

10) Monocular cues for depth perception are available independently to each of the two eyes, whereas binocular cues are computed by using information from both eyes. Monocular cues include relative size, relative height, relative brightness, relative clarity, and relative motion. These cues suggest that images that are smaller, higher in the visual field, dimmer, less clear, and slower-moving tend to be further away.

Other monocular cues involve using texture or coarseness (texture gradient); interposition of one object blocking another; and the tendency for straight, parallel lines to converge in the distance (linear perspective). One binocular cue is convergence, or information the brain receives about how much the eyes must turn inward to focus an object. Another binocular cue is binocular disparity, or the difference between the retinal image between the eyes.

Learning

Learning is one of the most remarkable abilities exhibited by humans—and also (in some form) in every animal species studied in the laboratory. It is an important aspect that allows organisms to adapt to their surroundings and survive. Learning can occur from a variety of processes, ranging from simple processes occurring on the cellular level to forming associations between behaviors and their consequences to witnessing others and behaving accordingly. Learning can also be used in therapeutic and other applied settings.

■ LEARNING AND ADAPTATION

Learning is defined as a relatively permanent change in behavior and understanding due to experience, which cannot be explained by instinct, maturation, or temporary states of the organism. The key word in the definition of learning is experience. Notice that instinct and developmental changes are excluded from the definition of learning. Instinctual behaviors are those that occur because of the inherited nature of an organism. Maturational changes are those that develop from growth due to developmental processes. Behavioral changes resulting from temporary states, such as illness and drug-induced changes, are also excluded from the definition of learning.

Learning is the primary route by which an organism exhibits adaptation. **Adaptation** can actually refer to a couple of different concepts. In a learning context, or in biology and physiology, it describes the beneficial changes in behavior in response to changes in the environment. That is, adaptation is the ability to change to fit with one's surroundings. Evolution is adaptation that is carried across generations. In this sense, learning is adaptation occurring across the life of an organism, while evolution is adaptation occurring across generations of a species. Also, adaptation can refer to decreased responsiveness, such as sensory adaptation discussed in Chapter 5.

Psychologists have long been interested in learning from experience and adapting to one's environment; the history of learning theory spans most of the twentieth century.

Early learning theorists worked in the behaviorist tradition. Hence, their learning research emphasized the scientific analysis of behavior change as a result of experience. Much of the work was done in

laboratories with nonhuman animals. Furthermore, researchers in other fields have contributed to our understanding of these processes. For example, biologists have examined various species to discover that some simple forms of learning and adaptation take place even in relatively simple organisms. In more recent times, learning theorists have applied their findings to human behavior, and especially to the therapeutic treatment of people with psychological disorders. The most fundamental distinction between types of processes that can accurately be classified as learning is between nonassociative and associative learning. Of the latter, there are two basic paradigms, called classical conditioning and operant conditioning. A third type of associative learning is observational learning, involving a process called modeling.

Nonassociative learning involves learning about one particular stimulus and the direct relationships involved with that stimulus. There are two common types of nonassociative learning. First, **habituation** refers to the process of adapting to a stimulus that remains constant, or unchanging. It is the process of getting used to something, and this type of learning is evident in many different animal species. In fact, a simple neural substrate for this type of learning, called long-term potentiation, has been identified that suggests simple learning can occur in even low-level life forms. Second, **sensitization** refers to a heightened response to unexpected stimuli. This tendency is especially relevant for potentially dangerous or threatening stimuli, or when an organism is in an elevated (aroused) state. For example, if you are watching a scary movie, you are probably sensitized to loud, unexpected noises or a surprising touch on your shoulder.

■ CLASSICAL CONDITIONING

Associative learning involves not just learning about a single stimulus, but learning associations or connections between multiple stimuli and/or behaviors. The first type of associative learning paradigm is called **classical conditioning**, or Pavlovian conditioning, after Ivan P. Pavlov (1849–1936), the Russian scientist who is almost unanimously credited with its discovery and initial investigation.

Pavlov's Experiments

Pavlov was awarded the Nobel prize in 1904 for his work on the physiology of digestion. In his laboratory he used dogs as subjects. Pavlov developed a research program to investigate the parameters of the salivary reflex in dogs. He planned a number of experiments to try to understand the stimulus-response relationship between food and salivation. Work with new dogs went as expected at first. Food was presented to a dog restrained in a harness, and the salivation response was measured. However, with experience, dogs salivated at the sight of the harness apparatus. Sometimes in their home cage they salivated at the sight of a laboratory assistant. Pavlov realized that these salivary responses had been learned. He proceeded to study this type of learning, and in 1927 reported his findings in a lengthy book titled *Conditioned Reflexes*.

To examine whether the dogs were indeed learning these responses, Pavlov presented the dogs with a series of learning trials. On each trial a neutral stimulus—for example, a tone—was paired with a biologically important stimulus, food. Specifically, Pavlov would sound the tone for a short time and then present the dogs with food. On early trials, the dog salivated only when the food was presented; this was, of course, the natural response of the dog. On later trials, the dog salivated when the tone was presented, before seeing the food. Pavlov proposed that the dog had learned to associate the sound of the tone with the impending food, and therefore also with the salivation response for food.

Definition of Terms

Pavlov chose the terms used in his paradigm carefully and purposefully. He used the word "unconditioned" for stimuli and behaviors in naturally occurring (unlearned) relationships. The **unconditioned stimulus** (UCS) is the stimulus that naturally brings about a particular response, the **unconditioned response** (UCR). In Pavlov's experiments, salivation was the UCR in relation to the presentation of the UCS, food. Pavlov used the label "conditioned" to express the learned relationship between stimulus and response. Specifically, a **neutral stimulus** that did not naturally produce a response became a **conditioned stimulus** (CS), or stimulus that produced a learned response, called the **conditioned response** (CR). Note that the tone began as a neutral stimulus but became a CS through learning; also, the salivation response began as an UCR to food but then became *also* a CR to the tone.

The Sequence of Events

Before conditioning occurs, the UCS causes the UCR, and the potential CS is a neutral stimulus (technically, not causing the CR, but usually causing no significant response). The **acquisition** phase of classical conditioning consists of the development of the CR as trials proceed. On each trial, the neutral stimulus (potential CS) is paired with the UCS. For early trials, the animal does not make CRs. Then the first CRs appear, but they are small. As the trials proceed, the CRs rapidly become stronger. Finally, the CRs reach their maximum strength, called the asymptote. This growth and leveling off of the CR is collectively referred to as a learning curve (see Figure 7-1). A steeper learning curve represents a behavior learned relatively quickly; a shallower learning curve represents a more difficult behavior to learn.

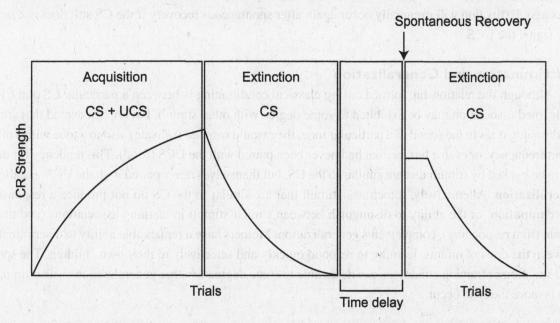

Fig. 7-1: Time course of classical conditioning. The strength of the conditional response (CR) changes over time based on the presence or absence of the conditioned stimulus (CS) and unconditioned stimulus (UCS).

The presentation order is crucial for determining how strong the conditioning effects are, and sometimes whether learning occurs at all. Of particular importance is whether the CS appears before the UCS (forward conditioning), or the two stimuli appear at the same time (simultaneous conditioning), or the CS

appears after the UCS (backward conditioning). Forward conditioning is the most successful method of classical conditioning, because it allows the CS to signal the UCS. You may notice your pet responds to the sound of the can opener rather than waiting for a call of "come and get it!" after preparing the food. An especially effective way to condition an organism is to have a waiting period between CS and UCS presentation. This waiting period is called the **interstimulus interval** (ISI); the optimal ISI depends on the UCS, CS, and CR.

Extinction and Reconditioning

After conditioning has been successful, the CS will produce the CR even though it is no longer paired with the UCS. However, one cannot expect a learned relationship to last forever. Eventually **extinction**, or the gradual disappearance of the CR in the presence of the CS, will occur as the organism disassociates the CS and UCS (see Figure 7-1). It is not functional for learned relationships to be forgotten immediately; in practice, the time until extinction depends on the stimuli and response.

It is also not always functional for learned relationships to be forgotten permanently. Perhaps there is a span of time where the CS does not signal the UCS, but then it regains this functional antecedent property. If this is the case, then quick relearning of a conditioned relationship after extinction, called **reconditioning**, occurs much faster than in the original acquisition phase. Another phenomenon, called **spontaneous recovery**, may occur after extinction if the CS is presented following a brief pause. In this case, the CS elicits the CR even in the absence of the UCS (see Figure 7-1). This could occur even after a long delay—such as the emotional response to smelling the perfume one associated with a lover from years ago. Extinction will eventually occur again after spontaneous recovery if the CS still does not reliably signal the UCS.

Discrimination and Generalization

Although the relationship formed during classical conditioning is between a particular CS and CR, the learned association may be exhibited to some degree with other stimuli. Pavlov discovered that after conditioning dogs to the sound of a particular tone, they would respond (salivate) also to a tone with a different frequency, or even a buzzer, that had never been paired with the UCS (food). This tendency for the CR to be evoked by stimuli that are similar to the CS, but themselves never paired with the UCS, is called **generalization**. Alternatively, sometimes stimuli that are similar to the CS do not produce a response. **Discrimination**, or the ability to distinguish between similar stimuli in learning associations (and thus refrain from responding), complements generalization. Mothers have a remarkable ability to discriminate between the cries of infants, learning to respond quickly and selectively to their own children. The specific situation or training conditions can determine to some degree whether generalization or discrimination is more likely to occur.

Higher-Order Conditioning

There is nothing that prevents the learning of relationships beyond those pairing a CS and a UCS. In fact, if a CS reliably signals a UCS, it may itself play the role of the UCS by forming higher-order relationships. That is, **higher-order conditioning** occurs when a neutral stimulus is paired with a strong CS, in the absence of a true UCS, to produce the CR; over time, the neutral stimulus becomes a second CS.

Many children develop conditioned fears of doctors, simply because they associate them with the delivery of past pain (for example, immunization shots). In this case, the doctor is a CS that is paired with the pain of a shot (UCS). Furthermore, children may also then become apprehensive just at the sight of the doctor's waiting room (a second CS) because it is, in turn, associated with the doctor.

Applications of Classical Conditioning

There are a number of therapeutic applications that involve principles of classical conditioning. For example, knowledge of this paradigm has helped counselors provide guidance to drug addicts and alcoholics, such as avoiding situations and people that they associate with their drug/alcohol use. Other therapists may hold the view that emotional reactions are conditioned responses, and act accordingly in treating patients. Some of these applications are discussed further in Chapter 15; here, some other applications are briefly mentioned.

Taste Aversion Conditioning

In **taste aversion conditioning** a novel taste (for example, saccharin) is paired with stomach illness. With rats, the illness is typically caused by injection of a small dose of poison. Before conditioning, the injection (UCS) leads to illness (UCR). During conditioning, the saccharin (CS) is paired with the injection (UCS). The result of this procedure is that when saccharin (CS) is presented to the rat, the rat avoids it (CR). People experience taste aversion if they consume a distinctively flavored food and later become ill from an unrelated virus like influenza (the flu). Although they know it was not the food that caused the illness, they still have an aversion to the taste of the food.

Systematic Desensitization

Systematic desensitization was developed by the therapist Joseph Wolpe (1915–1997) as a treatment for phobia (irrational fear) in humans. Wolpe believed that such fears were learned through classical conditioning, and therefore they could be treated with this method. The treatment involves two components of classical conditioning: extinction of the fear response to the phobic stimulus, and acquisition of a calming response to the stimulus. The former is achieved by presenting the phobic stimulus in a controlled situation that is certain not to bring harm. The latter is achieved through instruction on relaxation techniques that are then followed during stimulus presentations, after the fear response is extinct. This technique usually involves progression through a hierarchy of successively more acute fears (for example, from climbing stairs to flying) to conquer phobias.

Eye-Blink Conditioning

In eye-blink conditioning, the subject is fit with a helmet that can measure the eye-blink reflex. During the conditioning trials a neutral stimulus, such as a dim yellow light presented on a panel, is paired with the presentation of a puff of air to the eye. Before conditioning, the puff of air (UCS) causes an eye-blink response (UCR). During the conditioning trials, the dim yellow light (CS) is paired with the puff of air (UCS). After conditioning has occurred, the dim yellow light (CS) leads to an eye-blink response (CR). Recent research has linked impairment of the eye-blink response with susceptibility to Alzheimer's disease, thus providing a diagnostic tool for identifying at-risk individuals.

■ OPERANT CONDITIONING

Operant conditioning (also instrumental conditioning) is based on a contingency (causal connection) between a response and the consequence that follows the response. Contingencies can be expressed as if-then statements: If the response occurs in the presence of certain stimuli, then the consequence follows. Thus, whereas classical conditioning involves learning associations between stimuli and responses, operant conditioning concerns learning associations between responses and their consequences.

Thorndike's Law of Effect

Edward L. Thorndike (1874–1949) was an early pioneer in conditioning research. He studied the behavior of cats in a chamber called the puzzle box. The cat was confined inside the chamber, which had various devices inside including rings, loops of wire, and panels. The cat's task was to learn to escape from the box, which could be accomplished only by pulling a particular device. Because there were several devices, the task was difficult; but the cat usually escaped after a number of minutes. As trials proceeded, the escape response occurred more quickly. The learning was gradual and orderly, rather than occurring abruptly as a sudden stroke of insight.

Thorndike concluded that the cats did not use reasoning to solve this problem but rather slow trial-and-error learning. He stated this formally as the **law of effect**. This law, also known as Thorndike's Law, suggests that responses followed by a satisfying state of affairs (pressing the correct device to escape) would be more likely to occur in subsequent situations; responses followed by an annoying state of affairs (pressing incorrect devices to no avail) were gradually eliminated from the animal's behavior. Because Thorndike viewed responses as important to the extent that they were instrumental in producing rewards, he used the term **instrumental conditioning** to describe the learning paradigm.

Skinner's Experiments

Before his death, B. F. Skinner (1904–1990) was considered the most influential living psychologist. In the second half of the twentieth century, he was the leading advocate for behaviorism, and is the founder of the operant conditioning paradigm. An operant is a voluntary behavior that a person or animal emits in response to its environment (stimuli). This illuminates the key difference between instrumental conditioning and operant conditioning. **Operant conditioning** is a learning paradigm in which the organism learns to respond to the environment in a way that produces desirable consequences. Instrumental conditioning relies on the experimenter to allow the organism to respond, and measures the response latency (the time until a response occurs). In contrast, the organism is under voluntary control of its own response in operant conditioning, and the rate of response is typically the dependent variable of interest.

Skinner developed an experimental chamber to study learning in laboratory rats. He always called this an operant conditioning chamber, but others refer to it as a Skinner box. The Skinner box included a lever attached to the front wall, a food dispenser, metal rods embedded in the floor allowing the experimenter to deliver a mild electric shock, and lights and speakers allowing the experimenter to administer visual and auditory stimuli. Skinner trained his rats to earn the reward of food pellets, or avoid the electric shock, by pressing the lever in response to stimuli (for example, when lights came on or a tone sounded). After many various experiments using the chamber, Skinner formalized operational definitions of discriminative stimuli, reinforcement, punishment, shaping behavior, and schedules of reinforcement.

Principles of Reinforcement

The essence of operant conditioning as evident in Skinner's experiments can be explained in a three-term contingency involving a stimulus, a response, and a reinforcer. In the presence of a significant environmental event, which an organism learns to identify as a **discriminative stimulus**, an organism may learn to make a specific response if this response is sufficiently reinforced.

Types of Reinforcement

Generally speaking, a **reinforcer** is an event that increases the likelihood that the immediately preceding response (operant behavior) will occur again. There are many different ways to classify reinforcers, but it is important to remember that what they have in common is their tendency to promote or strengthen the associated behavioral responses. A common distinction is that between positive and negative reinforcers. **Positive reinforcers** promote behaviors through addition of a desirable consequence; this is essentially a reward. **Negative reinforcers** strengthen behavioral responses by removing an aversive stimulus. If pushing the lever gave the rat food pellets, the food pellets are positive reinforcers; if pushing the lever turned off the electric shock to the floor, the removal of shock is negative reinforcement.

Another common way to classify reinforcers is whether they are primary or secondary. **Primary reinforcers** are those that are naturally reinforcing to an organism, including basic needs such as food and water, or the removal of painful stimulation. **Secondary reinforcers** are those that an organism must learn. Money and good grades are excellent examples of secondary reinforcers in humans. Note the similarities between these types of reinforcement and the concepts of UCS and CS, respectively, from classical conditioning; in fact, secondary reinforcers are often referred to as conditioned reinforcers.

Schedules of Reinforcement

Skinner did not always give his rats food pellets (or remove the electric shock) every time they pushed the lever. That is, rather than using **continuous reinforcement** by reinforcing every instance of the desired response, he adopted various **intermittent reinforcement** (also called partial reinforcement) schedules that dictated reinforcers only on some of the learning trials. These schedules are labeled according to whether reinforcers are delivered based on the number of trials or amount of time, and whether they do so in a fixed or flexible manner (see Figure 7-2).

Fixed-Ratio Schedule

Fixed-ratio schedules provide reinforcement after a certain number of responses. A rat may receive food pellets after every tenth lever press, or a factory worker may get paid for every five cars assembled. This schedule generates a high rate of responding, because reinforcement is directly related to the response rate.

Variable-Ratio Schedule

Variable-ratio schedules also provide reinforcement after some number of responses; however, the number required to receive reinforcement varies between reinforcement administrations. A rat may receive food pellets after the tenth lever press, and then after eight more, and then after another thirty-three, and so on. A slot machine provides positive reinforcement on a variable-ratio schedule, sometimes after the first token played, sometimes only after very many. This schedule also generates a high rate of responding, because of the direct dependence on the response rate.

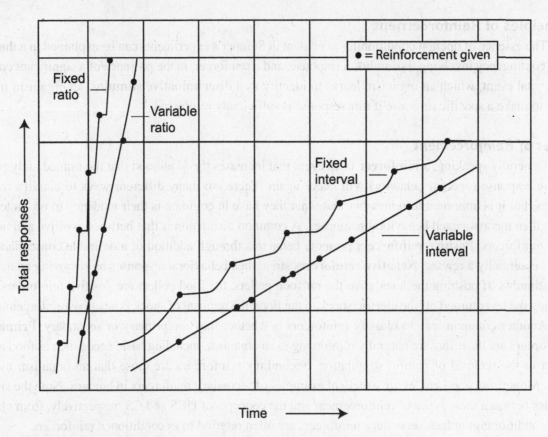

Fig. 7-2: Reinforcement schedules in operant conditioning. The rate and pattern of responding (lines) depends on the reinforcement schedule (points indicate reinforcement).

Fixed-Interval Schedule

On a **fixed-interval schedule**, behavior is reinforced after a fixed amount of time has elapsed since the previous reinforcement. A rat may receive food pellets on the first lever press following every thirty second pause, regardless of whether ten lever presses or one hundred have occurred. This schedule eventually produces choppy start-stop behavior, where the response rate increases steadily as the fixed interval duration approaches (see Figure 7-2).

Variable-Interval Schedule

A **variable-interval schedule** reinforces the first response following a variable elapsed time since the previous reinforcement. So, a rat may receive food pellets on the first lever press after ten seconds have passed, and then on the first lever press after an additional seventeen seconds have passed, and so on. This schedule produces a steady response rate, by virtue of the unknown reinforcement time.

Punishment

Upon first exposure to the concepts of operant conditioning, many people are confused by the meaning of negative reinforcement. Because positive reinforcers are essentially rewards, people tend to think negative reinforcers are punishments. This is incorrect; negative reinforcers are also rewards, but they are rewards in the sense of removing an aversive stimulus rather than adding a

desirable one. In contrast, **punishment** refers to removal of a desirable stimulus or addition of an aversive one. Administering punishment intends to decrease the likelihood of behaviors, whereas giving reinforcement (positive or negative) aims to strengthen behaviors. A great deal of research has attempted to discover how and when punishment is best utilized. Punishment is most effective when it is immediate and consistent (occurs every time the unwanted response does). One drawback of punishment is that it does not encourage the correct behavior, only suppresses—that is, it does not necessarily eliminate—the undesirable behavior. Furthermore, it only does so in the presence of a discriminative stimulus that is perceived as a punishment threat (for example, parents, police patrols, and so on).

Conditioning Concepts Revisited

Many of the concepts that apply in the classical conditioning paradigm are relevant in operant conditioning as well. For example, discrimination is important in determining specifically which responses will be rewarded. However, if similar responses are also rewarded, generalization may occur. One interesting study involved both these concepts in training birds to recognize certain works of art. The birds were able to discriminate between the impressionist painter Picasso and the cubist painter Monet, because they were only rewarded for responding to one artist's work. However, when later shown works by other impressionist and cubist painters, the birds generalized the response rules they had previously learned.

Extinction also occurs in operant conditioning, when a particular behavioral response is no longer reinforced. The delay before extinction occurs is a function of the details of the conditioning procedure. In particular, the reinforcement schedule has much to do with extinction. Responses learned via intermittent reinforcement are less susceptible to extinction than those that are continuously reinforced. Furthermore, variable schedules delay extinction, compared to fixed schedules, because the organism is not aware of which particular response should be reinforced, and thus cannot identify as accurately when reinforcement has ceased. Finally, spontaneous recovery and rapid relearning of associations are also possible with operant conditioning.

Applications of Operant Conditioning

Operant conditioning techniques are more widespread than may seem at first glance. Even superstitions can be interpreted as the result of intermittent reinforcement of operant behavior—such as if you usually get good grades whenever you wear your "lucky" shirt on exam days. There are a number of therapeutic applications as well as avenues for applying these concepts at home, work, and school.

Shaping and Behavior Modification

One can use positive reinforcement to train an animal by waiting for the desired response and immediately rewarding the animal. But this may involve a long period of waiting. **Shaping** is a process that speeds up the training process by reinforcing the animal for increasingly specific steps that lead toward the desired behavior. For example, a dog can be trained to roll over first by learning to lie down; then to lie down and roll onto one side; and ultimately to lie down, roll onto one side, and then over onto the other. Because of the step-by-step procedure, shaping is also called the method of successive approximations. Shaping is one of many ways that operant conditioning can be applied to teach people or animals to modify their behavior, either globally or in particular situations.

Escape and Avoidance Conditioning

Negative reinforcement can be used in specific operant conditioning paradigms called escape conditioning and avoidance conditioning. **Escape conditioning** involves training an organism to perform so as to stop an aversive stimulus, such as a rat escaping an electric shock, or a parent stopping a child's crying. **Avoidance conditioning** involves training an organism to perform so as to prevent an aversive stimulus from occurring in the first place, such as learning to evacuate a building when a fire alarm sounds. Note that avoidance conditioning also entails classical conditioning, because one must learn to associate the stimulus (for example, fire alarm) with a conditioned response (for example, evacuation). Avoidance behaviors can be quite pervasive, especially in the sense that they prevent one from learning to break the avoidance response. That is, by avoiding something (for example, harmless spiders), one does not have the opportunity to learn that the stimulus does not necessarily need to be avoided (for example, learning that the spider is indeed harmless).

Learned Helplessness

One clinical application of operant conditioning is the work of Martin Seligman (born in 1942) and others, which has led to a theory of depression. Seligman's work began with dogs exposed to electric shocks (signaled by a preceding light) using escape and avoidance conditioning procedures. Dogs learned to escape fairly quickly, and most learned to avoid the shock with extensive practice. However, Seligman was disappointed with the slow avoidance learning. He tried a different procedure with some new dogs. These animals were first restrained in a harness and given several light-shock pairings. Seligman thought that this might teach them the significance of the light as a signal for shock, and that this might speed up avoidance learning. To the contrary, these dogs performed poorly: when the light was presented they acted afraid. Although unrestrained, the animals lay on the floor and whimpered when the shock was presented.

After thinking about this result, Seligman realized that the training with light and shock in the harness had taught these animals that they could not do anything about the delivery of shock. He called this phenomenon **learned helplessness**. Seligman and colleagues have performed many additional studies, demonstrating learned helplessness in cats, rats, and humans. According to Seligman, the key factor in the development of learned helplessness is the experience of having a lack of control over the environment. Further, he has theorized that several such experiences of lack of control, and the accompanying feeling of helplessness, is the cause of human depression. He has pointed out that loss of a spouse or relative are cases where one may perceive a lack of control. These situations lead to helpless feelings and thus depression. This view has implications for therapy with depressed clients. Seligman has proposed that depressed clients should be encouraged to engage in activities that will lead to success and a perceived sense of control over the environment.

Educational, Domestic, and Industrial Applications

Educators and administrators have applied research on operant conditioning in classrooms and other settings. Even if they haven't read the research articles and consciously applied certain principles—although many have—the effects of different reward and punishment styles are evident to any parent or teacher who tries to teach children appropriate and inappropriate behaviors in many settings. These principles are also applied in industrial settings, where different reinforcement schedules and punishments are used to promote efficient workplace habits and productivity.

■ INFLUENCES ON ASSOCIATIVE LEARNING

There are a number of influences that can tweak the strength of an association learned via classical or operant conditioning techniques. One important factor is motivation, discussed in Chapter 10. Those discussed here can be grouped into biological factors, cognitive processes, and dependence on the particular learning context.

Biological Factors

There is some evidence that individuals may have particular biological predispositions toward forming certain associations. It was long believed by some of the pioneering researchers who used conditioning paradigms, such as Skinner and Watson, that virtually any stimulus (or reinforcer) could be associated with any response. However, work by researchers such as John Garcia (born in 1917) has forced these researchers to reconsider such claims.

Garcia used a classical conditioning paradigm to instill taste aversions in rats, and made a surprising discovery. Although rats could be trained to learn that particular tastes signaled nausea and illness, the same could not be learned about lights and sounds. It seemed the rats were biologically inclined to develop taste aversions, a natural and adaptive ability, but were not capable of forming such associations between other artificial stimuli and the nauseous feelings. Additional evidence comes from research showing that humans are easily conditioned to fear some natural stimuli (for example, harmless snakes and spiders) than others (for example, flowers).·

Biofeedback refers to the use of information about the body's state to guide behavior. In this sense, the body provides information that serves as additional cues in an attempt to learn behaviors. In conjunction with principles of conditioning, biofeedback techniques have seen increasing popularity in therapeutic settings, such as in physical therapy. Often, a goal of biofeedback is self-control over one's physiologic responses. Modern researchers believe we have much more control over supposedly involuntary bodily functions than was once thought.

Context Factors

There are many particulars about the learning stimuli and environment that can moderate the strength of learned associations, the speed by which they are learned, and other factors such as discrimination and generalization. For example, in both types of conditioning, the size of the stimulus (UCS or reinforcer) influences the ability to learn the association; stronger stimuli facilitate quicker and deeper learning. A larger reward will better encourage learning through operant conditioning, and a more painful shock will expedite classical conditioning.

The environment in which the learning paradigm is embedded can also play a key role in learning. Some environments may be more conducive to learning particular types of associations, or exhibiting the learning at a later time. For example, environments offering a clearer link between stimulus and response, or between response and reinforcement, promote learning of the critical associations. If the environment does not foster developing such clear associations, such as if the appropriate discriminative stimuli are difficult to identify, learning is more difficult as well.

Cognitive Factors

Skinner and other behaviorists would argue that there is no cognitive component to associational learning, and view cognitive research with some disdain. To them, such research is no better than introspective conjecture. However, recent research has shown that, indeed, cognitive processes do seem to play an important role in learning.

For example, one phenomenon that supports the cognitive aspect of learning is the **overjustification effect**. This refers to when giving rewards for doing an activity actually decrease one's desire to perform the activity. In particular, if one has an intrinsic desire to perform a certain behavior, rewarding the behavior interferes. It's as if the reward is cognitively processed as a signal that one should not want to do the task for its own sake, but must be bribed into doing it. The reward, rather than the enjoyment of the task itself, becomes the motive for performing the task. In some cases, for example, rewarding children for activities they already enjoy doing anyway can backfire. The application of operant conditioning principles to these phenomena is not straightforward.

Attention

Because any learning environment consists of an abundance of cues, some of which may be unrelated to the association being learned, attention plays a key role in learning. Granted, context-dependence in learning suggests that even factors outside of our direct attention may become part of the learned association. Nevertheless, the stimuli that receive one's direct attention are those that stand the highest chance of being related to the accompanying response.

Learning As Information Processing

Robert Rescorla (born in 1940) is a modern scientist producing important research and theory regarding classical conditioning from an information-processing perspective. According to Rescorla, a participant in classical conditioning attempts to learn patterns of stimuli. Rescorla has shown that pairing a CS with a UCS is necessary but not sufficient for classical conditioning to occur. In one of Rescorla's experiments, he found that stronger CRs were learned when the UCS and CS always occurred together, compared to cases where the same number of CS-UCS pairings occurred but the UCS was sometimes also presented alone (without the preceding CS). Based on this research, Rescorla suggests that the predictability, or reliability, of the association is important for learning, rather than mere co-occurrence.

Latent Learning

The stereotypical psychology experiment of rats running mazes has contributed to yet another cognitive aspect of learning. The standard procedure is to reward rats for successfully navigating mazes, thus reinforcing their learning of the correct path. However, this type of learning is not the simple product of association learning. It seems rats develop a **cognitive map**, or a mental representation of the layout of the maze. This occurs even if their learning is not reinforced. Thus, learning the maze layout is not a simple associative process, but the cognitive map is stored for later use. This results in **latent learning**, or learning that occurs but is not exhibited until there is an incentive involved.

■ OBSERVATIONAL LEARNING

The cognitive component of learning behaviors is especially evident in the context of **observational learning**, or learning how to do something by watching others do it. This involves cognitive processing rather than conditioning, because one does not receive any reinforcement or punishment, and is not exposed to a UCS, but still learns behaviors. A particular form of observational learning is called **vicarious conditioning**, or the learning of a conditioned response by witnessing (or hearing about) others being conditioned. The process by which this occurs is often referred to as **modeling**.

The researcher whose name is synonymous with this type of learning is Albert Bandura (born in 1925), who examined learning in young children in the 1960s. While the child was playing alone, an adult entered the room and displayed verbal and physical aggression to a plastic punching-bag clown (Bobo) doll. Later, the child was frustrated by being shown some highly attractive toys but being allowed to play with them only for a few minutes. Then the child was left alone with the Bobo doll and watched through a one-way mirror. Children displayed aggression toward the doll, in many cases mimicking the behavior of the adult model of aggression. Children who were frustrated in the same way, but who had not seen the adult model of aggression, did not act so aggressively. In other research, Bandura and colleagues found that children could learn aggression by observing the behavior on a cartoon. These results have caused some psychologists to caution parents about television and movie violence that children observe.

Social and Cultural Learning

Observational learning is also referred to as social learning because it applies especially to learning about appropriate behaviors toward others. In fact, social learning theory explains behavior patterns as having been learned through a process of operant conditioning and observational learning. According to social learning theorists, the reinforcement, punishment, and models are provided by the social environment. For example, the children in studies such as those above were also able to learn about the reinforcement (or punishment) that the model received after interacting with Bobo, even though the children themselves were not rewarded or punished. Social learning theories of human aggression have analyzed the many rewards (reinforcement), direct and indirect, for behaving aggressively in our society. Moreover, ironically, many authorities' and parents' attempts to discourage aggressive behavior by punishing aggressive offenders results in the provision of models for further aggressive behavior. Social learning theories do argue in favor of the power of positive models as well as the obvious antisocial or aggressive examples. Some research has indicated that televised or publicized examples of prosocial (helpful) behavior are much more influential than comparable examples of antisocial or aggressive modeling.

Observational learning also provides a method whereby individuals can learn about the appropriate behaviors particular to their individual culture. They can thus learn cultural rules and norms merely by observing the behavior of others, and the consequences of such behavior. This type of learning helps shed light on many cultural differences, such as the low incidence of aggressive behavior in some cultures.

Skill Learning

The learning of certain **skills**—the complex sequences of actions that together achieve a specific goal—comprise a large part of the type of learning that occurs every day. These skills may range from tying one's shoes to flying an airplane. They develop through a process involving observational learning as well as associative learning. A key element required for successful skill learning is practice, which is

the repetitive performance of a skill. Furthermore, feedback about one's performance is essential to understand if one is performing a skill correctly, and how to adjust one's behavior if one is not.

Learning is an important and ubiquitous concept in humans as well as other organisms, allowing for adaptation to one's environment. Simple forms of learning include nonassociative learning such as habituation and sensitization. These produce heightened or diminished responses to stimuli, respectively. Another type of learning, associative learning, involves learning about relationships between stimuli. Classical conditioning and operant conditioning are the two primary types of associative learning.

Classical conditioning was originally discovered by the Russian physiologist Ivan Pavlov, who found that reflexive responses like salivation were also made due to other stimuli as a result of learning. In classical conditioning, repeated pairing of a conditioned stimulus (CS) with an unconditioned stimulus (UCS) results in a response to the CS alone. Pavlov's research identified the conditions under which the conditioned response (CR) is acquired, extinguished, reacquired, generalized, discriminated, and spontaneously recovered. The classical conditioning sequence has been applied to both humans and nonhumans and can explain such diverse phenomena as phobias and taste aversions.

Early research on operant conditioning was conducted by Edward L. Thorndike, who studied the law of effect. Later research by B. F. Skinner identified conditions in which rats' behaviors changed in Skinner boxes. Both positive and negative reinforcement result in increasing the corresponding behavior, whereas punishment decreases its incidence. Behavior can also be shaped if successive approximations of the criterion behavior are reinforced. Reinforcement can also be either continuous or partial, with the latter applied according to either ratios or intervals of responses, on either a fixed or variable schedule. Applications of operant conditioning to human experience include behavior modification and research on learned helplessness as a source of depression.

There are a number of influences on both types of associative learning, including biological, cognitive, and context factors. Biological factors include biological predispositions to forming certain associations. Many different context aspects are relevant for learning associations, including the strength of stimuli and the match between learning context and performance context. Cognitive processes also play a major role in associative learning. Effects such as overjustification and latent learning suggest that learning is more than forming deterministic associations, but also involves active information processing.

Observational learning occurs when behavior changes to imitate that of models. Work by Albert Bandura and colleagues has shown the power of both live and media models. Social learning theories have argued that behavior patterns in general are learned as a result of social reinforcements, punishments, and models. Learning of social roles and norms is also explained by observational learning, as are cultural differences and skill learning.

Key Concepts

acquisition	classical conditioning	discrimination
adaptation	cognitive map	discriminative stimulus
associative learning	conditioned response (CR)	escape conditioning
avoidance conditioning	conditioned stimulus (CS)	extinction
biofeedback	continuous reinforcement	fixed-interval schedule

fixed-ratio schedules
generalization
habituation
higher-order conditioning
instrumental conditioning
intermittent (partial)
 reinforcement
interstimulus interval
latent learning
law of effect
learned helplessness
learning

modeling
negative reinforcers
neutral stimulus
nonassociative learning
observational learning
operant conditioning
overjustification effect
positive reinforcers
primary reinforcers
punishment
reconditioning
reinforcer

secondary reinforcers
sensitization
shaping
spontaneous recovery
systematic desensitization
unconditioned response
 (UCR)
unconditioned stimulus
 (UCS)
variable-interval schedule
variable-ratio schedules
vicarious conditioning

Key People

Albert Bandura
John Garcia
Ivan P. Pavlov
Robert Rescorla
Martin Seligman
B. F. Skinner
Edward L. Thorndike
Joseph Wolpe

SELECTED READINGS

Domjan, M. (2003). *The principles of learning and behavior.* Wadsworth.

Klein, S. (2001). *Learning: Principles and applications, 4th Ed.* The McGraw-Hill Companies.

Ormrod, J. E. (2003). *Human Learning, 4th Ed.* Prentice Hall.

Schwartz, B., Wasserman, E. A., & Robbins, S. J. (2001). *Psychology of learning and behavior, 5th Ed.* Norton, W. W. & Company, Inc.

Test Yourself

1) Two types of nonassociative learning include _____, or decreased response to an unchanging stimulus; and enhanced responses to unexpected stimuli, called _____.
 a) adaptation; habituation
 b) habituation; sensitization
 c) adaptation; overreaction
 d) habituation; overjustification

2) In Pavlov's experiments, which of the following terms could be used to label the salivation in dogs?
 a) CR
 b) UCR
 c) neither of the above
 d) both of the above

3) Which of the following terms is *not* associated with application of classical conditioning principles?
 a) learned helplessness
 b) taste aversion
 c) eye-blink conditioning
 d) systematic desensitization

4) Classical conditioning involves associations between _____, while operant conditioning concerns contingencies between _____.
 a) stimuli and responses; responses and consequences
 b) stimuli and responses; organisms and environments
 c) responses and consequences; stimuli and responses
 d) behaviors and consequences; cause and effect

5) Which of the following terms from the chapter describes a learning paradigm that rewards the first correct response after ten seconds, and then the first correct response after an additional twenty seconds?
 a) fixed-interval schedule
 b) variable-interval schedule
 c) double-interval schedule
 d) variable-ratio schedule

6) Strengthening behaviors through an incentive that removes an unpleasant event is called _____; discouraging behavior by administering an unpleasant event is called _____.
 a) positive reinforcement; negative reinforcement
 b) negative reinforcement; extinction
 c) positive reinforcement; shaping
 d) negative reinforcement; punishment

7) Which of the following is *not* an example of evidence for the cognitive influence on learning?
 a) shaping
 b) insight
 c) latent learning
 d) overjustification

8) Which name is most closely associated with observational learning and social learning theory?
 a) Thorndike
 b) Pavlov
 c) Bandura
 d) Skinner

9) A researcher notices that a loud bang startles dogs and causes them to become anxious. She conducts a series of learning

trials by ringing a bell before firing off a cap gun. After many such trials, the dogs become anxious merely by the sound of the ringing bell. After some time, when she rings the bell (without firing the cap gun) the dogs do not become anxious. However, one week after this occurs, she rings the bell and they become anxious once again. What type of conditioning paradigm is this? Describe how each of the following terms is represented in this experiment: CS, UCS, CR, UCR, acquisition, extinction, and spontaneous recovery.

10) A researcher wants to teach people to press one button when a vowel is flashed on a computer screen, and a different button when a consonant is flashed. Briefly describe an example of positive secondary reinforcement and negative primary reinforcement that could be used in this experiment; also state how the first reinforcer could be given according to the four different partial reinforcement schedules.

Test Yourself Answers

1) **b.** Two types of nonassociative learning include habituation, or decreased response to an unchanging stimulus; and enhanced responses to unexpected stimuli, called sensitization.

2) **d.** Both of the above terms could be used in conjunction with the salivary response in Pavlov's dogs. This was an unconditioned response (UCR) to food and became a conditioned response (CR) to the tone sounded.

3) **a.** Learned helplessness was a concept developed by Seligman using an operant conditioning—not classical conditioning—paradigm.

4) **a.** Classical conditioning involves associations between stimuli and responses, while operant conditioning concerns contingencies between responses and consequences.

5) **b.** A variable-interval schedule provides reinforcement after different amounts of time; a fixed-interval schedule reinforces behavior after a consistent amount of time (for example, either ten or twenty seconds). A double-interval schedule was not mentioned in the chapter, and ratio schedules are based on the number of responses, not elapsed time.

6) **d.** Strengthening behaviors through an incentive that removes an unpleasant event is called negative reinforcement; discouraging behavior by administering an unpleasant event is called punishment. These terms are easily confused; practice

them until the difference between them is clear.

7) **a.** Shaping is the learning of a behavior by reinforcing successive approximations to the target behavior; this is an application of operant conditioning, not a cognitive influence on learning as the other terms are.

8) **c.** Albert Bandura is the researcher best known for his work on observational learning and social learning theory. Thorndike, Pavlov, and Skinner used instrumental, classical, and operant conditioning paradigms, respectively.

9) The experiment described is an example of classical conditioning, because it involves associative learning between stimuli responses and their consequences. The loud bang that naturally startles the dog is the unconditioned stimulus (UCS), and the anxiety is the unconditioned response (UCR) to this stimulus. The ringing bell becomes the conditioned stimulus (CS) that produces anxiety, which in this case is now also a conditioned response (CR). Acquisition is when the bell (CS) reliably produces anxiety (CR) without the loud bang (UCS). Extinction occurred when the bell no longer produced anxiety on its own. However, spontaneous recovery occurred one week later, when the bell again elicited an anxious response.

10) Positive reinforcement gives a pleasant consequence, and a secondary reinforcer is one that must be learned (that is, it is not a natural or primary reinforcer). Money is

the most common positive secondary reinforcer for humans. A negative reinforcer removes an aversive stimulus. A primary negative reinforcer could be stopping an irritating tone when a correct response is given. A monetary payment could be given according to one of four schedules, such as after: every ten correct responses (fixed-ratio); different numbers of correct responses (variable-ratio); each correct response after every ten seconds have elapsed (fixed-interval); or correctly responding after a varying amount of time has passed (variable-interval).

Cognition I: Memory and Knowledge

Psychologists consider memory to be a different process from learning, although the two are closely related. Whereas learning refers to the acquisition of new behaviors, memory refers to the process of saving or storing information so that it might be available when needed. Thus, for example, extinction, which refers to the loss of a stimulus-response connection, is not the same as forgetting, the loss of the ability, or potential, to recall information. Moreover, memory is discussed in the parlance of cognitive psychology (derived from computer studies and artificial intelligence engineering) rather than that of behavioral psychology. The use of cognitive rather than behavioral terminology means that memory is described in terms of processes that are not directly observable. Memory researchers speak of encoding, storage, retrieval, and information processing. Here, we generally observe a distinction between the processes (memory) and the information (knowledge) involved, although the terms are often used interchangeably.

■ STUDYING MEMORY

In order to study memory, it must first be made clear what one wants to study. Is it the process of remembering something? Is it the actual physical storage of the information? The term memory means different things to different people. Early memory research was led by such pioneers as William James, the learning researchers introduced in Chapter 7, and German psychologist Hermann Ebbinghaus (1850–1909). Ebbinghaus essentially founded the scientific study of memory and developed a technique (learning and retention of nonsense syllables) and a measurement method (learning/forgetting curves) that are still widely used today. The work of Ebbinghaus and other early memory researchers focused on the associations formed in memory, such that remembering accurately was viewed as a correct response to a stimulus.

In the middle of the twentieth century, this behaviorist view was gradually replaced by a more cognitive focus on the processes that underlie memory tasks. Borrowing the metaphor from computer sciences, memory research began to focus on the relevant information processing that is involved. In

particular, much like the operation of a computer, emphasis was placed on how the mind encodes, stores, and retrieves information. **Encoding** refers to the transformation of incoming information for storage, such as the way a computer encodes all its information using 1s and 0s. **Storage** is simply retaining the information, potentially for later use, such as in the memory chips or RAM of the computer, which physically store the sequences of 1s and 0s. **Retrieval** is the process of moving the information out from storage and essentially reversing the encoding process so that the information can be used.

■ ENCODING AND REPRESENTING INFORMATION

In order to accurately study knowledge and the processes by which we memorize and remember it, it is important to first understand precisely the types of information with which we are working. In other words, how is sensory information encoded by the brain? How is lasting knowledge represented in the brain?

Automatic versus Effortful Processing

There is a basic distinction to be made between automatic and effortful processing of information. Some mental tasks can be accomplished automatically, whereas others require substantial cognitive effort. In the context of memory and knowledge that is the focus of this chapter, the distinction describes how information is encoded.

Automatic processing occurs without our awareness, thus allowing one to focus attention and mental effort elsewhere. Some types of automatic processing come naturally, such as encoding spatial information. During an exam, in an attempt to recall a definition, you may be able to "see" where on the page the term appeared, although you did not specifically attempt to learn this information. Some automatic processing may come only after a fair amount of practice. When first learning a foreign language, you may have to effortfully translate one word at a time by mentally looking up the translation in your native language. However, with time, this process is replaced by an automatic encoding of the appropriate concept when the foreign word is encountered. A good deal of context is encoded automatically, which can influence subsequent recollection of material embedded in the context, as you will see in the "Cues and Context" section, later in this chapter.

Effortful processing, as the name suggests, involves a more concentrated attempt to encode information. First and foremost, this process requires attention. As we have seen, selective attention serves as a way to focus on a particular subset of all available information for more effortful processing. In the remainder of this chapter, we see how some particular types of effortful processing, such as rehearsal and mnemonic strategies, become important when determining how well things are remembered.

Encoding Modalities

Another way to describe how information is encoded is the modality that is involved. In other words, information can be encoded as visual information, auditory information, information regarding meaning, as some abstract "feeling," and so on. That is, the modality describes *what* type of information is encoded. The three primary encoding modalities are visual and acoustic encoding, and encoding of meaning (semantics).

- **Visual encoding** refers to the encoding of information about how a stimulus appears, or the image it suggests.
- **Acoustic encoding** describes encoding of how a stimulus sounds, or for what sounds it might be responsible.
- **Semantic encoding** of a stimulus means that the meaning of the stimulus is encoded.

Research has shown that semantic encoding generally produces better memory than acoustic encoding of the same stimulus, which is in turn usually better than memory created by visual encoding.

It is important to note that these modalities are distinct from the stimuli that are encoded. In other words, stimuli presented as printed words could be encoded by the way they sound, or words presented through speakers could be encoded by their meaning, and so on. The stimulus "BRAIN" could be encoded in all three modalities if one registers that it is in all capital letters, that it rhymes with "train," and that it is a part of the body.

Knowledge Representation

The information processing approach to memory and knowledge—indeed, to cognition more generally—has led to a great deal of research into how knowledge is represented and organized in the mind. Such concerns are the topic of entire volumes, but in this section, we only briefly introduce some general, extensive principles.

Concepts and Categories

The word "concept" may seem very commonplace, and has been used quite a bit informally up to this point. However, **concepts** refer to the fundamental units of thought and knowledge representation. A concept is essentially a mental grouping or category of properties into a coherent representation of people, places, things, events, and ideas. The distinction is often made between **formal concepts**, which are defined by specific rules or properties, and **natural concepts**, or those that resist formal definition but instead are described by characteristic features. For example the concept of "equilateral triangle" is a formal concept defined by three connected line segments at equal angles, whereas it is more difficult to make strict rules about inclusion in (or exclusion from) the natural concept of "bird" (ostriches don't fly, but a bat isn't a bird, and so on). For natural concepts, one may often have in mind a particular **prototype**, or characteristic member of the concept category. For example, a sparrow is more likely than an ostrich or penguin to be one's idea of a typical bird.

Schemas and Scripts

Schemas refer to more comprehensive representations than concepts. A **schema** includes the knowledge, beliefs, and expectations about a particular concept. So, for example, whereas the concept of "tiger" may help to define what animals belong to the category with this label, one's "tiger" schema involves elements of knowledge (carnivorous), belief (dangerous), expectations (will attack), and other mental reactions (fear). If a schema is about a particular event or sequence of events, such as familiar activities, then it is referred to as a **script**. You may have a script for getting ready for school, which describes your actions and expectations for this activity. Schemas and scripts are powerful organizing principles for one's knowledge. For example, they can greatly influence how incoming information is perceived, as we discuss in Chapter 6.

Hierarchies

The units of knowledge, such as concepts, schemas, and scripts, are often organized into mental hierarchies. That is, rather than being stored as a large collection of distinct bits of knowledge, this information is further organized into meaningful structures. For example, the concept "animal" may be divided into subordinate categories such as "mammal," "bird," "fish," and so on; these may in turn be divided into more precise concepts. A particular concept may be a member of several different hierarchies, which provides connections or associations among concepts as well. The term "doctor" will likely appear under concepts such as "hospital" and "jobs," but would also appropriately fall under the heading "human," and thus "mammal" and "animal." Although one may be quicker to respond when asked if a doctor belongs in a hospital than when asked if a doctor is an animal, the concept nevertheless falls under both hierarchies. The nature of hierarchies and the relationships among concepts can also play a role in determining how information is processed. Recent evidence suggests that these principles also describe the way that knowledge is stored in the mind.

Effective Encoding

According to the levels-of-processing approach, the encoding of information plays the largest role in all subsequent memory processes. Researchers in this tradition have contributed to our understanding of how the depth of processing relates to memory. In other words, material that is considered more intensely, such as through concerted study efforts rather than by fleeting attention, is more likely to be encoded well, and as a result more likely to be retrieved.

Memory as a Network

Modern research in cognitive psychology has examined exactly how knowledge is represented and organized in the mind. Network models, discussed briefly in Chapter 6, have become increasingly popular in cognitive psychology in general, and memory research in particular. These models build on the hierarchical organization principle in supposing a dense network of associations among related concepts. Furthermore, the strength of these associations depends on the degree to which they are related. In this sense, learning and experience lead to semantic memories by creating and strengthening associations. For example, "doctor" would be more strongly connected to "hospital" than to "animal." Retrieval is then a matter of spreading activation throughout this network until the response concept is found, or activated. These theories have exciting potential, and have already been applied in explaining many phenomena.

■ STORAGE OF INFORMATION

For many years, researchers have suspected that memory is not a single process, but involves more than one stage and thus more than one type of memory. Based on these thoughts, cognitive researchers Richard Atkinson (born 1929) and Richard Shiffrin (born 1942) proposed in 1968 what was to become one of the most successful theoretical models in the field of psychology. According to the Atkinson-Shiffrin model, memory is functionally divided into two stages, short-term memory and long-term memory. Subsequent research has led to the inclusion of a third stage, called a sensory store. Information

moves successively through these three stages if attention (focused awareness) is given to it. In the absence of attention, information tends not to move further into the system.

Sensory Storage

The **sensory store** holds direct impressions of sensory events for short periods of time. There are different, specific sensory registers for each of the senses. The visual register is termed the **iconic memory store,** and the auditory register is termed the **echoic memory store**. Although the iconic memory lasts only about half a second, the echoic memory lasts several seconds or longer. Consider taking class notes, where one is able, in a sense, to hear a sentence said by the instructor for several seconds after it is actually spoken, and is able to write it down. If the student involuntarily hears something else the instructor (or a classmate) says in the meantime, however, the echoic memory of the first sentence is lost. Thus, sensory memory can easily be written over by new information. In fact, most information that enters the sensory registers is lost, otherwise one would be overwhelmed. What we attend to, however, moves on to the next stage of memory.

Short-Term Storage and Working Memory

The **short-term store** (STS), also commonly referred to as short-term memory, has been called the desktop of the mind because it closely corresponds to conscious experience, and in particular to one's thoughts. Although the STS is often considered synonymous to the term working memory, most modern researchers draw a distinction between the two. The STS is considered a repository for information, which has been transferred from the sensory store, retrieved from long-term memory, or temporarily stored while being actively processed. In contrast, **working memory** typically refers to the active processing that recruits the STS for storage purposes, but also manipulates or transforms information therein. In any case, there are a few key properties of the STS, including limitations in storage space and duration.

Limited Capacity

The STS is very limited in capacity, able to hold only about five to nine (the magic number seven, plus or minus two) units of information at once. A seven-digit phone number, for example, is within this five-to-nine item capacity. If the number of units goes higher, new information displaces, or writes over, existing units. Thus, it is easy to remember a seven-digit number long enough to dial the phone, but if someone asks us for a street address at the same time (requiring that we handle several more digits), we exceed our short-term memory capacity and lose at least part of the phone number. If the number of information units is limited, one way to effectively increase STS capacity is to increase the size of each unit. This tactic, called **chunking**, refers to grouping information into meaningful units for storage rather than storing each bit of information separately. While it is difficult to remember a string of letters such as:

ETNRQKADMILEUCEIR

it is much easier to remember all of the letters when they are regrouped as follows:

NICKEL DIME QUARTER

The first string exceeds the capacity of STS, whereas the second string takes advantage of organizing the letters into meaningful chunks of information.

Limited Duration

Information remains only briefly in short-term memory if it is not in use. In order to retain information such as a phone number for any length of time, it is necessary to repeat it to ourselves, a process termed **rehearsal**. From a cognitive point of view, this amounts to reentering the information more quickly than it can fade from memory. In **maintenance rehearsal**, information is merely repeated so that it is maintained in short-term memory until it is needed. For example, a phone number is repeated until the phone is dialed. This type of rehearsal requires little attention and is not likely to lead to long-term memory. Although one might repeat a phone number many times in attempting to dial past a busy signal, once the call has been made one is not likely to remember the phone number even a short time later. Most research on short-term memory has been done with auditory material, especially spoken words of one type or another, which coincides with the primarily verbal nature of maintenance rehearsal.

Long-Term Storage

The **long-term store** (LTS), or long-term memory, is generally considered to be practically unlimited and relatively permanent. Information can remain in the LTS even when it is not being consciously attended. In colloquial terms, when people talk about "memory," they are usually referring to long-term memory, the process of retaining and retrieving information anywhere from minutes to years, even a lifetime, after first encoding it. A common misconception is that everything one has ever encountered is stored somewhere in the LTS. Actually, the transfer of information into the LTS requires attention and additional processing. A second form of rehearsal, **elaborative rehearsal**, involves deeply examining information, turning it over in one's mind and giving it special attention. This type of rehearsal tends to put information into long-term memory.

When memory researchers refer to the LTS as unlimited, they are relating the fact that one never seems to run out of space, or fail to create new memories (barring trauma, disease, and so on). A limited capacity in the LTS would suggest that current memories would need to be erased to make room for new memories, which does not seem to be the case. Characterizing the LTS as permanent implies that information is never lost from this store. This may not be entirely accurate, but studying memory loss is difficult because the inability to report information that was once present in the LTS may not be due to a loss of the stored information. Instead, it may simply be due to the inability to retrieve the information from memory (see the "FAILURES IN MEMORY" section).

Relations Among Memory Stores

Contemporary memory research acknowledges the interaction between the three memory stores, rather than supposing only a serial progression from sensory registers, to the STS, to the LTS. Information being in a sensory register could also be interpreted as the knowledge in the LTS that is activated by sensory signals, just as the knowledge in the LTS that receives current attention could describe information in the STS. The fact that existing knowledge can affect perception and the processing of information in working memory is further evidence of the interaction between stages.

■ RETRIEVAL OF INFORMATION

We may effectively encode information and store it accurately. However, this information is not of much use to us unless it is accessible. That is, we need to retain information so that we are able to retrieve it when we want to apply it.

Measuring Retention Through Retrieval

Memory researchers typically distinguish between three main types of tasks that are considered measures of retention (memory performance). The type of retrieval depends on whether one is requested to freely produce information (recall), asked to make a judgment or identification about presented information (recognition), or required to relearn material that has since been forgotten.

Recall

Recall refers simply to remembering or producing spontaneously the information requested, as must be done for an essay test. In responding to an essay item, one must search one's available recollections for the necessary information. Likewise, when encountering a new acquaintance, one must search one's past associations with the person to produce his or her name.

Recognition

Recognition is the ability to recognize correct information, as on a multiple-choice test, or features of a particular item, such as whether something has been seen before. In choosing the correct answer on a multiple-choice test, one must scan the choices and identify the one that matches one's knowledge about this item. Thus, in recognition, two processes are undertaken and compared: a review of what is being perceived, and a review of what is remembered. When a match is found, we say recognition has occurred. Recognition is also necessary in such mundane tasks as identifying the correct coat in a full closet and such unusual tasks as eyewitness identification of crime suspects in a police lineup.

Relearning

Relearning requires that material actually be relearned, for example, learning again a list of forgotten names. When the method of relearning is used, psychologists look for a savings score, measuring the extent to which the material is relearned more quickly than it had been originally learned. For example, the less time one needs to relearn a list of names, the more of the list one must have remembered from the first lesson. The time saved represents one form of savings evident in relearning.

Cues and Context

When new information is learned (encoded), it is stored in the context of other information. For example, we saw that knowledge in the LTS can be characterized as a hierarchical network of associations among bits of information which are related to varying degrees. Therefore, it is often helpful to use **cues**, or stimuli that promote more effective retrieval of information. In recall tasks, these cues often refer to features of the environment in which the information was originally encoded and stored. The **encoding specificity principle** states that the effectiveness of a cue depends on the degree to which it provides a signal to the information. For instance, the recall of terms learned in a psychology class is best done in the room where the class is held and not, say, at the beach in the summertime. The

classroom itself is a cue to effective retrieval. In other words, as we discuss about learned associations in Chapter 7, memories also exhibit context dependence. Furthermore, even one's mood or state of mind can serve as cues, leading to **mood-congruence** and **state-dependence** in memory, respectively. Finally, the transfer-appropriate processing model suggests that memory is facilitated by the correspondence between the process used to encode and retrieve information. For example, if a list of concepts is learned by viewing pictures (visual encoding), later recognition is better when using pictures rather than spoken labels.

Recognition performance is also affected by the use of cues. In recognition tasks, cues are presented that serve as pointers or guides to the desired information in the network of knowledge discussed earlier. That is, **priming** can occur in recognition tasks, where cues facilitate quicker recognition performance (compared to recognition without cues). Priming may occur consciously, with the presentation of a cue to help jog your memory. More often priming occurs implicitly, such as in lexical priming tasks, where one is quicker at deciding whether a string of letters forms a legitimate word (SPOON) if the preceding letter string formed a related concept (FORK).

Even without the use of explicit cues, context can be an important factor in the subsequent retention of information. For example, when learning a list of words, two very robust findings are types of serial position effects, meaning that retention is a function of the word's position in the list order. Specifically, these tasks show strong **recency effects**, where the most recently learned words (those at the end of the list) are remembered better than words in the middle of the list. Similarly, **primacy effects** describe the improved memory for words at the beginning of the list.

■ TYPES OF MEMORY AND KNOWLEDGE

Psychologists often distinguish between different types of memory and knowledge; more precisely, they refer to the nature of the information or material that is encoded, stored, and recalled. One classification that is often used is that of implicit and explicit memory, each of which is further divided into distinct types of knowledge. These divisions are not only theoretical but also are supported by evidence of memory loss for only one type of knowledge, while other types are spared. However, whereas there may be specific types of memory, associations still undoubtedly exist among the different types in one's knowledge network. For example, although knowledge of facts and events may be considered distinct, one may associate a particular fact (why zebras have stripes) with the event of learning (a trip to the zoo).

Implicit Memory

Implicit memory processes are applied to information or events that are somehow stored or influential, but without direct or conscious access. Such information is also referred to as **nondeclarative knowledge**, because the knowledge cannot be overtly stated. Implicit memory of prior experiences exert an unintentional influence on subsequent behavior. One may have very little (if any) concrete, verbalizable knowledge from early childhood, but research suggests that implicit memory from this time impacts many aspects of life. One distinct type of implicit memory is procedural memory. **Procedural memory** refers to storing, encoding, and retrieving (applying) knowledge about performing certain (often complicated sequences of) actions, such as riding a bike or driving a standard transmission automobile. These actions can be performed almost effortlessly, but they are hard to describe in verbalizable rules.

Explicit Memory

Explicit memory refers to the direct or conscious access of information. The corresponding information is also referred to as **declarative knowledge**, because the information can be directly stated or declared. Note that although knowledge for some actions may seem like the product of procedural memory, if it can be directly stated then it would technically be classified under explicit memory. Explicit memory can be further divided by the type of material involved; a common distinction is that between semantic and episodic memory. **Semantic memory** deals with general knowledge information, such as specific facts, that constitutes the bulk of our LTS. This includes everything from our own name, to the phone number where we work, to the name of the ocean on the western shore of the United States. **Episodic memory** is a record of specific events experienced and remembered. These include any episode that one can recall from his or her own life, including the events of the past few hours and days.

Episodic knowledge tends to fade, and in fact forms only a small part of the total information available in permanent memory. Although most if not all information may at one time have been associated with a particular learning episode, the latter has long since been forgotten, leaving only the objective information. For example, you may not remember when you learned the significance of the year 1776 in American history, but this failure in episodic memory does not bar the semantic memory of knowing what is significant about that year.

■ BIOLOGICAL BASES OF MEMORY AND KNOWLEDGE

The process of memory formation has been studied intensively at a number of biological levels. These range from the study of individual molecules implicated in memory, to the relationships among neural networks that may be responsible, to brain structures where memory processes seem to be concentrated.

Neural Mechanisms

Recent evidence suggests that the formation of permanent knowledge (in LTS) involves the creation of new connections in networks of neurons (what physiological psychologist Donald Hebb has termed cell assemblies) by the growth and alteration of synaptic connections. Hence, a common phrase in neuroscience classes when discussing this type of Hebbian learning is, "Neurons that fire together, wire together." Furthermore, unlike in other brain areas, new neurons are formed throughout the life span in the hippocampus, a brain area often implicated in creating new knowledge. One specific process that has given memory researchers some insight into what neural substrates might underlie memory processes and knowledge creation is called long-term potentiation.

Although some memory is the product of the creation of new synapses—indeed, sometimes even entirely new neurons—it is also possible for existing neural connections to be modified. **Long-term potentiation** (LTP) describes an enduring increase in the neural firing potential of a neuron or group of neurons resulting from repeated activation. That is, repeated stimulation of a neuron results in long-lasting (or permanent) biochemical changes at synapses with other neurons, such as increased neurotransmitter release. This strengthens connections between neurons and results in more efficient neural circuits. For example, if two neurons repeatedly activate a third neuron, eventually this latter neuron will be more responsive to activation of either of the first two neurons alone. This type of sensitization process—which

was discovered in the sea slug, a relatively simple organism—is often cited as biological evidence for Hebbian learning and the creation of permanent knowledge.

Brain Areas

Various areas of the brain have been found to be important for memory processes and the formation of permanent knowledge. The hippocampus, part of the limbic system, is the single structure most often associated with the creation of new knowledge. Specifically, it seems to be responsible for explicit memory (declarative knowledge) in LTS. Other structures that are implicated for various memory tasks include the amygdala (connected to the hippocampus and also part of the limbic system), the thalamus, and the cerebellum (for procedural memory). Although these structures are often cited as helping to create or code knowledge, it seems that most information is actually "stored" in dispersed cortical regions. Also, the prefrontal cortex is often implicated in working memory and the STS. Depending upon its extent and location, damage to these areas can cause memory failure.

■ FAILURES IN MEMORY

The processes of encoding, storage, and retrieval are anything but simple. There are many ways in which one or more of these stages can break down and produce behavioral deficits in memory, or instances where information is not available.

Forgetting

There are many theories of why forgetting occurs, ranging from commonsense explanations to those more solidly supported by research. A common explanation for forgetting is the notion of decay, which states that if information is not used it is gradually lost. One problem with this theory is that one frequently remembers events from one's past or information learned long ago and not thought of since. Thus, disuse alone cannot explain why certain knowledge fades forever while other information seems to be produced after long periods in well-preserved form. Early and recent biological theories have attributed the decay of some knowledge to the slow loss of the actual brain substrate (the memory trace), thought to be responsible for memory storage. According to these theories, some knowledge (called flashbulb memories) is retained though not retrieved for years because, when originally stored, they were exceptionally vivid and thus left stronger biological traces, which were more easily aroused many years later.

This account of forgetting suggests that it is the result of a failure in the storage of information. Forgetting, in a sense, can also occur by failure in encoding, when information that was in the STS is not reliably transferred to the LTS. That is, although the information was once known because it was in the STS, it was forgotten because it was not transferred to the LTS (or degraded when it was stored). Finally, forgetting can also be due to failures in retrieval, such as through interference.

Interference

The basic idea of interference is that knowledge is not lost so much as it is inhibited, or interfered with, by memory for other knowledge. There are two types of such interference, termed retroactive interference and proactive interference. Depending on the process assumed to be taking place, they are sometimes referred to respectively as retroactive inhibition and proactive inhibition.

Retroactive Interference

Retroactive interference occurs when information acquired later interferes, as if retroactively (acting backward), with previous information. For example, suppose that on Monday one studies Spanish and on Tuesday studies Italian. During a Spanish test taken on Wednesday intrusions are experienced from Italian words. Retroactive interference suggests our inability to recall older information is due to competition from newer information.

Proactive Interference

Proactive interference occurs when earlier information interferes proactively (acting forward) with subsequent information. Proactive interference explains one's inability to acquire new knowledge or habits because of the powerful competition of existing knowledge. Persistent habits provide good examples of proactive interference. Suppose one moves after living for several years in an apartment with one kitchen drawer next to the sink where the tableware is always stored. The new apartment, however, has a bigger kitchen and the tableware is now stored in the drawer next to the stove. When hurried or preoccupied, one forgets this new plan and habitually seeks knives and forks in the wrong drawer (by the sink) corresponding to the old storage place.

Amnesia

Popular media and fiction frequently feature **amnesia,** or memory loss, as a disorder that complicates characters' lives. In nonfictional life, amnesia (from the Greek *amnasthai*, "not to remember") is rare but fascinating. There are many forms of amnesia, but few are well understood. There are also cases of amnesia for different types of specific memory (for example, semantic but not procedural memory), as well as for combinations of knowledge types. Two general classes of amnesia are retrograde amnesia and anterograde amnesia.

Retrograde Amnesia

Retrograde amnesia is the loss of knowledge (or recall ability) for events just prior to any event that disrupts ongoing neural activity (such as a sudden blow or a mild electrical shock to the head). This loss commonly covers only about a minute prior to the traumatic event, suggestive of the idea that only short-term memory is disrupted. Other cases, however, can include longer periods prior to the event, sometimes half an hour, but in some cases as much as several hours or even days. Retrograde amnesia usually encompasses loss of knowledge about events (episodic memory), rather than the amnesic's general knowledge (semantic memory).

Anterograde Amnesia

Anterograde amnesia is seen in certain instances of brain damage. Newly acquired knowledge fades rapidly and is often lost within half an hour, if not sooner, though those formed prior to the damage remain unaffected. This suggests that it is not memory storage but the process of memory formation (encoding) that is affected in anterograde amnesia. Strangely, anterograde amnesia often seems to involve only declarative memory, so that the same individual who cannot remember having practiced a skill (for example, a video game) will nonetheless continue to improve at it daily, suggesting that procedural memory is intact.

■ APPLICATIONS OF MEMORY RESEARCH

Beyond a better understanding of how the mind works, knowing about the basics of memory can help us in a number of applied situations. These include educational settings, clinical applications, and legal implications, among others.

Repressed and Constructed Memories

Up to this point, we have studied the various processes of memory encoding, storage, and retrieval. We have also explored failures in these processes, which lead to forgetting or amnesia. However, applied research in clinical and legal settings considers other aspects about the fallibility of memory, such as the functional benefit of forgetting or the caution in relying on accurate recall.

Repressed Memories

While memory seems useful and forgetting a nuisance, it is important to consider the special case of memory for unpleasant knowledge. In these instances one might be motivated to forget or be unable to retrieve certain information or events to conscious review. Freud, for example, considered such motivated forgetting to be an example of **repressed memory**, a psychic defense mechanism that can occur when knowledge is painful or threatening. Repression is a process whereby unpleasant ideas—real knowledge as well as shameful fantasies—are moved from conscious consideration to storage in one's unconscious mind, where they will be unavailable to conscious efforts at retrieval. Recently, there has been increased debate about whether such knowledge is actually repressed, or whether it is in fact constructed at the time when they surface.

Constructed Memories

Although memory for information and events, especially when vivid, carries a strong feeling of authenticity, considerable evidence suggests that, in fact, memory can be altered significantly by experiences that occur after the original formation of knowledge. For example, suggestions made by other people can be incorporated into memory without one's knowing it. How confident can one be that one's earliest recollection was not, in fact, something that was originally related by a parent, or dreamed, or simply experienced later than in early infancy? The episodic details of the encoding may be lost, while the semantic substance of the memory is retained. Well-established schemata can also play a role in memory distortion, causing one to recall things the way they are expected to be instead of the way they actually are.

Observations of distortions, misrecollections, and bias in recall have led psychologists to conclude that much of long-term memory may be constructive. This means that later events and knowledge can influence what one remembers or what one believes happened. For example, in answering the question, "What were you doing at 3:30 P.M. on January 3, 2004?," one might first use a calendar to reconstruct the information that the date was a Saturday during semester break, count forward from an event such as New Year's Day, and so on, in order to "remember" what one "must have" been doing at that date and time. Research suggests that even recall of particularly vivid or dramatic events turns out to be incorrect when subject to verification.

An important domain where psychologists have studied this constructive aspect of memory is in how it affects eyewitness testimony in the courtroom. Such testimony is invaluable to the legal process, but it

is important to bear in mind that it is far from reliable. Such factors as emotionality, distraction, and the wording of police questioning have all been shown to have a reconstructive (distorting) effect on eyewitness memory for detail and recognition.

Improving Memory

Another practical application of memory research is in helping people to improve their memory capabilities. We have seen how methods such as focusing attention, rehearsal, chunking, and using cues can help to encode and retrieve information. One can also take advantage of encoding specificity to create powerful cues for specific items of information that one desires to memorize. Such strategies for memory are termed **mnemonics**, from the Greek word *mnemon*, or "mindful." Ancient Greek orators, for example, used the **method of loci**. They would imagine themselves walking through familiar places (in Latin, *loci*) like a building or garden. While memorizing, they would associate each object or room encountered in the building with a point to be made in their speech. Later, while giving the speech, they would imagine retracing their walk through the building and encountering these objects, reminding them of the points they wished to make. A common mnemonic method used today is to think of silly rhymes, phrases, or absurd images to associate with items in a list that must be set to memory. How do you remember the names of the planets in our solar system, in order of increasing distance from the sun?

Early research considered memory as learned associations, whereas modern cognitive psychology distinguishes between learning (acquiring new behaviors) and memory processes (saving information for later use). That is, a behavioral approach was replaced with the view of memory as information processing. In particular, memory involves encoding, storage, and retrieval processes. More recent research has updated this approach, providing more detail about the memory processes involved and the organization of knowledge.

Encoding can occur automatically, or it can be effortful with directed attention. Different modalities of encoding information can occur, including visual, acoustic, and semantic encoding. This information encoding ultimately determines the way knowledge is represented. In particular, information becomes specific concepts, both natural and formal, which produce schemas and scripts. These different units of information are organized into hierarchical networks, or associations among concepts of varying strength.

The process of storing knowledge is divided into the storage of sensory information, short-term storage, and long-term storage. The sensory register stores incoming sensory information for very brief instants. Information remains relatively longer (but still not very long) in the short-term store, and this store also has limited capacity (around seven pieces of information). The amount stored can increase through techniques such as chunking, and can remain longer by maintenance rehearsal. Through attention and elaborative rehearsal, information moves from the short-term store to the long-term store. The long-term store is essentially unlimited and permanent.

The retrieval process is what is meant by remembering information, and is usually separated into different tasks when assessing retention. Recall refers to freely producing stored knowledge, recognition involves identifying stimuli as present in stored knowledge, and relearning involves memorizing again forgotten knowledge. The ability to accurately recall knowledge and recognize stimuli is greatly affected by cues presented, contextual information, and one's mood and state of mind.

Research has identified different types of memory and knowledge. These include implicit memory (nondeclarative knowledge) and explicit memory (declarative knowledge). The former includes procedural memory, or knowledge how to perform certain tasks or actions; the latter is often divided into knowledge about facts (semantic memory) and storage of specific events (episodic memory). These different types are supported by research on the biological aspects of memory, such as long-term potentiation, patterns of activity among groups of neurons, connections between neurons, and specific brain areas.

Failures in memory processes can occur at any stage (encoding, storage, or retrieval). Forgetting was once attributed to decay from storage, but is often seen as a failure in retrieval of stored knowledge. Interference can inhibit retrieval and result in forgetting; it is classified as either retroactive (new knowledge interferes with old knowledge) or proactive (old knowledge prevents learning new knowledge). Amnesia is another type of memory failure, or memory loss. Two types of amnesia are anterograde and retrograde amnesia, which are often the result of brain damage, disease, or aging.

Researchers also studied the extent to which memory is a constructive process. They also explore whether some knowledge, especially that which is painful or unpleasant, is repressed. Finally, some research has looked into improving memory processes and the retention of information through various techniques.

Key Concepts

acoustic encoding	long-term potentiation	rehearsal
anterograde amnesia	(LTP)	relearning
automatic processing	long-term store (LTS)	repressed memory
chunking	maintenance rehearsal	retrieval
cues	method of loci	retroactive interference
declarative knowledge	mnemonics	retrograde amnesia
echoic memory store	mood-congruence	schema
effortful processing	natural concepts	script
elaborative rehearsal	nondeclarative knowledge	semantic encoding
encoding	primacy effects	semantic memory
encoding specificity	priming	sensory store
principle	proactive interference	short-term store (STS)
episodic memory	procedural memory	state-dependence
explicit memory	prototype	storage
formal concepts	recall	visual encoding
iconic memory store	recency effects	working memory
implicit memory	recognition	

Key People

Richard Atkinson
Hermann Ebbinghaus
Richard Shiffrin

SELECTED READINGS

Baddeley, A. D. (1997). *Human memory: Theory and practice, Revised Edition.* Pearson Education.

Cohen, H., & Lefebvre, C. (2005). *Handbook of categorization in cognitive science.* Elsevier Science & Technology Books.

Feuerstein, R., & Hoffman, M. B. (1995). *Teacher's guide to categorization, Vol. 1.* SAGE Publications.

Tulving, E., & Craik, F. I. M. (2005). *Oxford handbook of memory.* Oxford University Press.

Neath, I., & Surprenant, A. M. (2002). *Human Memory.* Wadsworth.

Test Yourself

1) The encoding of information can be
 _____, which does not require
 direct attention, or _____,
 which does require attention.
 a) declarative; nondeclarative
 b) accidental; explicit
 c) implicit; elaborative
 d) automatic; effortful

2) The basic units of knowledge are
 _____, which are commonly
 thought to be organized in a
 _____.
 a) ideas; chunk
 b) concepts; chunk
 c) concepts; network
 d) schemas; network

3) Which of the following is *least* associated
 with the short-term store?
 a) limited capacity
 b) elaborative rehearsal
 c) limited duration
 d) maintenance rehearsal

4) Which of the following techniques helps
 improve one or more memory processes?
 a) chunking
 b) mnemonics
 c) cues
 d) all of the above

5) Determining whether presented
 information matches existing knowledge is
 best described by which term?
 a) recognition
 b) recall
 c) relearning
 d) retrieval

6) Which brain structure is most closely tied
 to memory formation, especially semantic
 knowledge?
 a) prefrontal cortex
 b) hippocampus
 c) amygdala
 d) cerebellum

7) When new information inhibits the
 retrieval of previous knowledge, it is
 referred to as what?
 a) proactive interference
 b) retroactive interference
 c) retrograde amnesia
 d) anterograde amnesia

8) A great deal of research suggests that
 memory is often _____, under
 the influence of context, schemas,
 distortions and biases.
 a) repressed
 b) constructive
 c) fake
 d) unverifiable

9) Briefly describe the distinction often made
 between short-term memory and working
 memory. Include an example, such as
 adding two numbers on a piece of paper.

10) Describe the different types of memory and
 knowledge covered in the chapter. Mention
 one way in which researchers have
 supported these theoretical distinctions.

Test Yourself Answers

1) **d.** The encoding of information can be automatic, which does not require direct attention, or effortful, which does require attention. The other terms are types of knowledge or rehearsal, not encoding.

2) **c.** The basic units of knowledge are concepts, which are commonly thought to be organized in a network. Schemas are more comprehensive (less basic) than concepts.

3) **b.** Elaborative rehearsal is used to transfer information into the long-term store; the other terms describe features of the short-term store.

4) **d.** All of the techniques listed help improve memory: chunking increases STS capacity, mnemonics is an encoding method to aid retrieval, and cues aid retrieval as well.

5) **a.** Identifying presented material is referred to as recognition. Although this involves a retrieval process, retrieval can also refer to recall and thus is not the best choice.

6) **b.** Although all of the listed structures are implicated in some type of memory process, the hippocampus is often cited as being responsible for creating new semantic knowledge.

7) **b.** Retroactive interference refers to situations where new information interfered with the retrieval of previous information. Proactive interference refers to the inhibition of learning new information due to old information, whereas amnesia is memory loss.

8) **b.** Research suggests that memory is often constructive, under the influence of context, schemas, distortions, and biases.

9) Short-term memory, or the short-term store (STS), refers only to information storage, while working memory includes also manipulation of information. STS may contain information that has been transferred from the sensory store or retrieved from long-term memory. Working memory recruits the STS, meaning that the STS is the storage site for the information currently being processed by working memory. For example, two numbers on a piece of paper would move from the visual sensory register into the STS, and then working memory would add the numbers and place the sum in the STS. Then, perhaps, maintenance rehearsal keeps the sum intact until it is written down.

10) Implicit memory (nondeclarative knowledge) is for information and events that cannot be consciously accessed. This includes procedural knowledge about performing actions and complex tasks. Explicit memory, or declarative knowledge, refers to information that is directly accessible. That is, unlike implicit memory, it can easily be put into words. This includes semantic knowledge about specific facts and episodic memory for past events. Amnesia for only certain types of knowledge provides support for these distinctions.

Cognition II: Language and Thinking

In Chapter 8, we introduce the information processing approach to memory and knowledge, describing how cognitive psychologists view the acquisition of knowledge, how it is represented, and how it is stored and retrieved. This chapter deals with higher-order cognitive processes, which involve manipulation and use of knowledge. We begin with an introduction to the production and comprehension of language, which has received considerable attention in cognitive psychology. We then briefly survey other cognitive processes, such as reasoning, problem solving, and decision making.

■ THINKING AND COGNITION

The information processing approach that characterizes cognitive psychology views brain activity as a series of operations that use and manipulate information. In Chapter 8, we explore the way that information is represented and the processes used to store and retrieve knowledge. We discuss that concepts are the building blocks of knowledge and memory, and of cognition in general. Concepts represent specific objects or ideas, which are often assembled into other mental representations such as schemas and scripts. These are the basis for many forms of cognitive processes, which transform and use this information for different purposes.

Types of Thinking

Many different psychologists have made distinctions between types of thinking, or processing. The first type, for which we use the label **convergent thinking**, is focused, deliberate, directed thinking; it is also referred to as analytic thinking. It is the kind of thinking we undertake in order to recall an elusive idea, solve a problem, or make a choice. The term "convergent" implies that, although we may approach an issue from many different directions, eventually all these approaches converge—come together—on the same final solution or response.

Divergent thinking characterizes undirected thinking, such as brainstorming and creativity. The term "divergent" implies that, from one starting point, subsequent thought processes may continue in different

directions and culminate in different conclusions. Creativity is the ability to produce novel and unique ideas, and creative problem solving relies on divergent rather than convergent thinking. For example, creativity is demonstrated by coming up with many different uses for a simple object, like a brick or a toothpick. There is little clear relationship between creativity and performance on most intelligence tests. Formal education may inadvertently discourage creativity by emphasizing convergent thinking in a traditional curriculum.

Cognitive Models and Artificial Intelligence

The increase in computing power, and the use of computers in research, has dramatically influenced every scientific discipline. This is especially true in the field of cognitive psychology. Modern cognitive theories do more than just describe relations among cognitive phenomena, they propose specific models of how these cognitive processes operate. Some examples are the neural network or connectionist models discussed in Chapter 6 and Chapter 8. Other examples include many current applications to **artificial intelligence** (AI), the use of computers to imitate human perception and cognition. AI work has explored language recognition and production; problem solving of both a general and specific nature; reasoning and logic, and making optimal decisions. In the remainder of this chapter, we review some research on how humans perform these various cognitive tasks.

■ LANGUAGE

Perhaps the best single example of a cognitive phenomenon—and one that has undoubtedly received ample attention in research—is language. (See Chapter 11 for discussion of language development.) **Language** is the mechanism by which we communicate our internal thinking to others. Language is also, in essence, nothing more than the manipulation and understanding of a symbolic system. That is, any language is completely described by the symbols used to convey information, and the rules, or **grammar**, that exist for using the symbols.

Elements of Language

When you read or speak a sentence, you are implicitly taking in a wealth of information about the symbols you encounter. In terms of the symbols or elements of language, a sentence is composed of a meaningful series of smaller units. The smallest linguistic unit is the **phoneme**, or basic unit of sound. These are basically what you may think of as syllables, where English has around forty different phonemes. These are used to construct **morphemes**, which are the smallest units of a language that have any meaning on their own. Morphemes are anything that carry meaning, and can thus consist of only a phoneme or two, such as *un-*, or enough phonemes to constitute a whole word, such as *dog*. Morphemes are used to construct words, phrases, and sentences according to **syntax**, which is the portion of grammar (the set of rules) that dictates valid ways to form these structures. For example, English syntax dictates that a sentence requires a subject and a verb. Even if a sentence has proper syntax, it must also follow the **semantics** of language, or rules for deriving meaning.

Structure of Language

The elements of language given in the preceding section describe technically how different elements of language are used to compose increasingly complex symbols (for example, words or sentences) used

for communication. This was a sufficient basis for the study of language for quite some time. However, a linguist named Noam Chomsky (born in 1928) dramatically changed the way that linguistic research is approached. He advocated a more abstract analysis of the way language is used, rather than in a formulaic approach that focused on combining ingredients. He proposed that we should consider the **deep structure**, or abstract representations and meanings conveyed in a sentence, rather than on the **surface structure**, or actual sentence that was produced. Essentially, Chomsky's revelation moved the study of language from the voice box to the mind.

Linguistic Tasks

There are two fundamental tasks that are involved when considering a language as a vehicle for communication. First, one person must use the language to construct a meaningful message; this is called **language production**. For this to be of any use, it must be understood by the recipient of the message. This understanding of the meaning and purpose of language produced by another is termed **language comprehension**. In order to be understood, it is important that the language that is produced incorporates the appropriate surface structure that represents the intended deep structure, and also that the surface structure is received and interpreted to represent the same deep structure.

■ REASONING AND JUDGMENT

Philosophical approaches to human thought often identified human mental faculties or sets of abilities. Thomas Jefferson, for example, identified the three major human faculties as memory, imagination, and reason. He organized his personal library to represent corresponding sections (for example, history, art, and science). Most broadly, reasoning is the process by which we develop and evaluate arguments, and how we draw conclusions based on these arguments. Whether we realize it or not, much of the everyday logic that we apply, especially when learning about new situations, involves reasoning.

Formal Reasoning

Formal reasoning relies on forms of logic, a system of rules for making correct inferences. **Inferences** are conclusions or judgments that are derived from statements that are known or assumed to be true, rather than from directly observed evidence. The two best recognized types of formal reasoning are deductive and inductive reasoning. Generally speaking, the difference between these is whether one reasons about specific cases from general statements (deduction), or vice versa (induction). For example, the former is used when we want to know about one specific object or event when we know the class to which it belongs; the latter is used to make judgments about broader principles (such as class inclusion) of a specific object or event.

Deductive Reasoning

Deductive reasoning begins with general principles and applies these to particular cases. For example, you know that in spring birds begin to build nests, and that today is the first day of spring. You might then deductively reason that a particular bird you see in your neighborhood is commencing to build a nest somewhere. Deductive reasoning is more conservative than inductive reasoning and generally more reliable. This type of reasoning is also used when attempting to determine possible effects of actions or events.

Inductive Reasoning

Inductive reasoning, or inference, begins with specific facts or experiences and concludes with general principles. For example, one day you observe a particular bird, a blue jay, building a nest. You next observe another kind of bird, a robin, also building a nest nearby. You might then inductively reason that all local birds have begun to build nests today. Since inductive reasoning makes inferences about an entire class based on only a few members of that class, it is an expedient but risky form of reasoning. This type of reasoning is used to infer causes for known actions or events.

Judgment

A particular type of inductive reasoning involves determining the likelihood of certain events; this task is most commonly referred to as **judgment** or estimation. Essentially, this refers to assigning some numerical value, such as probability of occurrence or believability based on the available evidence. Although there are mathematical formulas that can be used to find correct answers to many such problems, people generally do not know these rules or do not apply them. Alternatively, most people turn to the use of **heuristics**, general solution strategies like rules of thumb. These are usually much easier to use than complicated formulas, and often—but not always—work just as well. Much has been learned about the way people approach judgment tasks by the evidence for individual heuristics they seem to employ. For example, Amos Tversky (1937–1996) and Daniel Kahneman (born in 1934) have done extensive research examining heuristics and the biases they produce; their research has had a dramatic impact on decision research and earned Kahneman the Nobel Prize in 2002. Three of their most widely studied examples of heuristics are introduced here.

Anchoring

Anchoring is a heuristic whereby one uses some value (such as a given value, or a value used in previous situations) as a starting point when trying to solve a judgment task. In this case, the final answer that is given is biased toward the value of the anchor, compared to cases where no anchor was used and the answer was developed from scratch. That is, individuals tend to be reluctant to make dramatic adjustments in a value that they have already adopted to some degree, or one that has been introduced. This heuristic can work well because values or solutions that were appropriate in the past may very well be applicable again, in which case anchoring essentially points one in the right direction.

Availability

When people are judging the likelihood of some event, often they must generate the relevant information from which they must make an inference. They may anchor on some value that they know. When generating subsequent information, people often rely on the **availability heuristic**, by which the information they consider is that which can most easily be brought to mind—that which is mentally most available. This heuristic can also work well, because information that can be easily recalled is generally more frequent, and thus more likely. However, it can also lead to biases, such as the common belief that driving is safer than flying, even though more deaths occur on our highways than in the skies. The mental availability of airborne fatalities, a product of media coverage and the magnitude of airplane crashes, can lead to inflated judgments about the likelihood of being involved in an airplane accident.

Representativeness

Sometimes people are required to determine if one object, or concept, is the member of a particular class of objects, or category. In this case, people may rely on the **representativeness heuristic**, basing their judgments largely on the degree to which the object is similar to the category prototype, or typical member of the class. For example, Tversky and Kahneman told people that Linda is an outspoken, very bright woman, and that she majored in philosophy, was deeply concerned with issues of social injustice and discrimination, and participated in demonstrations. Most people judged Linda to be more likely to be a bank teller involved in the feminist movement, than to be just a bank teller. This violates formal logic, because the probability of a conjunction of two events cannot be more likely than the probability of either event alone. However, these people may have used representativeness to judge Linda, who seemed more similar to the label "feminist bank teller" than "bank teller."

Analogical Reasoning

An **analogy** is an inference that two things or ideas that are similar in some ways share other qualities as well. Analogical reasoning involves forming a concept about something new based on its similarity to something familiar. For example, in the analogy, "tines are to fork as teeth are to comb," one must first understand the relation between teeth and comb—that "teeth" are the serrations in a comb—in order to conclude that "tines" must be the word for the prongs of a fork. Analogical reasoning takes commonplace forms as well. For example, if you turn down a friend's request to borrow your car because "the last time you borrowed something of mine you ruined it," you are drawing an analogy between the old behavior and the new request, and making your decision by carrying the inference forward.

■ PROBLEM SOLVING

Problem solving is one of the most obvious functions of thinking. However, despite its ubiquity, there really is no standard definition for problem solving, or standard all-inclusive typology for classifying different problems. Here we include some useful classifications and general approaches toward problem solving.

Types of Problems

One way to talk about what type of problem that faces you is whether or not there is certainty in the given information, the valid operations on this information, and the goal or desired end state. If all these things exist, one is faced with a **well-defined problem**, such as trying to find two whole numbers that are multiplied to produce 35. If any of this critical information is missing, such as knowing that a correct solution exists and how to know if it is obtained, the problem is said to be **ill-defined**; for example, when writing a paper for a course, there is no specified method to follow, or way of knowing that one has achieved an "A" paper.

Another way to classify problems is by the general type of operations that are expected. For example, arrangement problems require one to rearrange given information to produce some result, such as solving anagrams. Transformation problems require manipulation and changing of given information, such as in mental rotation tasks (where one is asked to identify valid depictions of a given figure from a different angle). Problems of inducing structure are common on exams such as the SAT, where one is asked to complete a sequence or identify the missing elements in a sequence.

Approaches to Problem Solving

As we have seen with other mental phenomena such as perception (Chapter 6), and indeed with psychology in general (Chapter 1), there are many different ways to approach research. Here, we consider two influential approaches to solving problems.

The Gestalt Approach

The Gestalt approach to perception emphasizes the search for meaningful patterns and interpretations in collected data or elements (see Chapter 6). Similarly, the Gestalt approach to problem solving emphasizes the role of perception and interpretation in finding solutions. According to the Gestalt principle of reorganization, the solution to a problem depends on perceiving new relationships among its elements. Many paper-and-pencil brain-teasers are easily solved only when one eliminates assumptions about how lines must be drawn or how objects should be used.

Gestalt theory also distinguishes between productive and reproductive thinking in problem solving. **Productive thinking** involves producing a new organization of a problem's elements, such as reorganizing letters to solve a word puzzle. **Reproductive thinking** applies past solutions to new problems. For example, having once learned to assemble sticks to form a rake, a caged chimpanzee might next reproduce this strategy by stacking boxes in a cage to reach a goal, when each box by itself is too short to do the job.

One problem with reproductive thinking can be the development of a **set effect**, a tendency to solve new problems by applying past habits and assumptions. A set effect can prevent one from perceiving a simpler solution than the familiar, tried-and-true but more cumbersome approach. One type of set effect is **functional fixedness**, a perception that elements of a problem have fixed or inflexible functions and cannot be combined in new ways. For example, if you don't have a candle holder, how else can you safely prop up a lit candle? If you have aluminum foil handy, you can mold a sheet of it into a cuplike holder for a candle. But if your functional fixedness only allows you to think of aluminum foil as a covering or a wrapping, not a moldable substance, you will fail to find this solution.

The Gestalt psychologist Wolfgang Köhler (1887–1967) studied primates by historical accident, while he was confined to a British-controlled island during World War I because he was a German visiting there when the war broke out. Specifically, Köhler studied the practical problem solving of chimpanzees. For example, a chimpanzee inside a cage reached without success for a banana out of reach just beyond the bars. There were two short hollow sticks, one thin and one thick, inside the cage, but neither was long enough to rake in the banana. Suddenly the chimpanzee seized the two sticks, assembled them by pushing the thin one partly into the thick one, and successfully used this new long tool to retrieve the banana. Köhler characterized the chimpanzee's problem solving discovery as an example of **insight**, the perception of a problem in a new way leading to sudden recognition of a solution. Insight is often described as sudden or surprising, which explains some common names for insight such as the "aha" phenomenon, or exclaims of "Eureka," meaning "I've found it."

The Information-Processing Approach

The information-processing approach analyzes problem solving as a series of steps in a sequential process. Research suggests that problem solvers pursue their tasks one strategy at a time. One strategy for problem solving involves using a procedure or formula guaranteed to produce a solution, known as an

algorithm. For example, to calculate the area of a rectangle, multiply the length by the width. Like all formulas, this one for quadrangle area is an algorithm. Algorithms are sure but not always expedient. For example, the algorithm for reassembling the anagram CINERAMA into another word would be to try every possible combination of letters until one makes sense. This would be a time-consuming procedure compared with the relatively quick payoff provided by the perception that the solution is the common term for a citizen of the United States.

Working Backward

The strategy of working backward entails doing exactly that. That is, if one knows what the goal or solution to a problem is, it is often easier to begin with this goal in mind and proceed backward to determine where to start in accomplishing the goal. This can sometimes be more productive than working "forward," from given information or resources to the solution, because one is less likely to head down the wrong path.

Means-End Analysis

Another strategy for problem solving is **means-end analysis**, a process of repeatedly comparing the present situation with the desired goal and reducing the difference between the two. This is the usual strategy for solving household problems like how to do laundry, how to prepare a meal, or how to dress a child.

■ DECISION MAKING

Another higher-order cognitive process is that of decision making. Decision making is another process that is hard to define. Depending on one's definition, decision making may include almost every action that is undertaken. In this section, we discuss some basic classes of decisions, and discuss some issues in decision making that have been researched by cognitive psychologists.

Types of Decisions

Decisions come in many different forms and serve many different purposes. On a low level, one can consider the decision to allocate attention to a particular location or resource. Perceptually, decisions are made about what we have seen or heard. When cognitive psychologists speak of decision making, they are usually referring to preferential **choice**, or the selection of an option or action from among an available set, based on one's subjective **utility**, a measure of personal value or liking. Often, decision researchers make the distinction between decisions under risk, where outcomes of possible actions are characterized by probabilities, or decisions under uncertainty, where the likelihoods of (at least some) decision outcomes are unknown.

In the parlance of decision researchers, the options or actions from which one chooses are called alternatives, and the information that describes each alternative is referred to as the various attributes of the option. Decisions can range from simple choices among two alternatives, each described by a single attribute, to more complicated multiattribute decision-making tasks. In this case, the decision may be quite difficult if it is necessary to make trade-offs, such as if one alternative excels on one attribute but is poor on another, and a second alternative has converse attribute values.

Optimal Decisions and Rationality

For preferential choice, it is difficult to identify an "optimal" or "correct" way of making decisions. It is almost a circular argument, because it seems that what one person chooses is what he or she deemed to be "optimal" at the time. One of the most heated debates among cognitive psychologists and others who study decision making is the definition of rationality in decision making. Some argue that rationality requires following rules of logic and probability, whereas others take a more ecological view, regarding rationality as defined by good choices in particular environments.

For better or for worse, decision research has used a particular benchmark for decision optimality, called the **expected utility** model. This model suggests that a decision should be made by:

- Determining the weight or importance that should be given to each attribute
- Determining the subjective value or utility that each attribute possesses
- Multiplying the attribute weight with the attribute value, across all attributes for an alternative

This model provides a measure of the utility one can expect to receive by choosing an option, where optimal choice suggests one should select the option with the highest expected utility (so as to maximize the expected utility).

Heuristics and Biases in Decision Making

Many responses require making choices without prior experience or sufficient information to guarantee satisfaction. If there are many alternatives described by many attributes, perhaps one is not able to perform expected utility calculations. Sometimes perhaps one just doesn't want to perform complex computations when a "good enough" choice will suffice. Decision-making strategies provide shortcuts and guidelines in such situations as these. In particular, much research has shown that people employ various heuristics to make many types of decisions (see also the discussion of heuristics in the "Judgment" section earlier in this chapter). Rather than trying to determine the optimal decision to be made in a given situation, one may employ a simpler, less effortful strategy. For example, one may use a strategy where they consider the attributes in (decreasing) order of importance, eliminate alternatives that do not meet some minimum level on each attribute, and select from among the remaining alternatives; or choose the first alternative encountered that meets minimum requirements on all attributes.

We identified a few heuristics in discussing judgment tasks, and described what types of biases these could introduce in people's judgments. A great deal of research has also considered how these biases, and others, may be manifest in preferential choice. For example, research suggests people may "overweight" small probabilities in making decisions. Some biases concern inherent evaluation, not the use of information. For example, people seem to be "loss averse," where they evaluate a particular loss more strongly than a gain of the same magnitude. Some researchers argue that although these biases may paint a picture of error-prone or flawed decision making, this is not necessarily the case. The types of mistakes people make can be considered in a different light, as adaptive methods for making the types of decisions that naturally occur in our environment.

Framing

Decisions involve making choices among a set of alternatives. The alternatives may be presented in a biased or persuasive comparison, known as a frame. **Framing effects** refer to situations where logically equivalent choices are presented in different ways. Such differences in presentation often result in differ-

ential processing and/or different choices. For example, consider the different impressions conveyed by these two alternatives:

- **Alternative A:** Would you invest $1,000 in a new business if it had a fifty percent chance of succeeding brilliantly?
- **Alternative B:** Would you invest $1,000 in a new business if it had a fifty percent chance of failing miserably?

The success frame in A makes it seem more appealing than the failure-framed B, although the probability of success versus failure is the same for both. This may lead some to choose to invest in A, but forego the opportunity in B.

A similar dependence on framing involves whether outcomes are presented in gains or losses. Kahneman and Tversky presented people with a hypothetical decision about which policy to adopt to combat the outbreak of a strange disease. When the policy was phrased in terms of the number of lives saved, it was chosen more frequently than when the same outcomes were phrased in terms of potential lives lost, supposedly as a result of loss aversion.

In Chapter 8, we discuss memory and knowledge primarily from an information processing perspective. It is this viewpoint, where cognitive processes are viewed as the manipulation and use of information, that has guided research on higher-order cognitive phenomena such as language, reasoning, problem solving, and decision making. These days, many researchers take advantage of the available computing power, and in many cases, the analogy of the mind as a sort of computer, to develop cognitive models and explore computer programming of cognitive functioning (AI).

Language is a good example of a cognitive task, because it is essentially nothing more than a collection of symbols and the rules for using and manipulating them. The symbols can consist of phonemes, morphemes, words, phrases, and sentences, and the rules are dictated by grammar, syntax, and pragmatics.

Reasoning is another type of thinking, or cognitive process, and it involves tasks such as evaluating evidence and drawing conclusions. Formal reasoning is based on rules of logic and includes deductive and inductive reasoning. In particular, inductive reasoning about the likelihood of different hypotheses or events is sometimes referred to as judgment. Sometimes, humans use heuristics or shortcuts for making judgments, which can provide a quick means to solutions but can also introduce idiosyncratic biases.

Problem solving actually covers a broad range of tasks, and it is hard to define. Researchers have studied solving problems through insight, as well as various strategies for solving problems, such as using prescribed algorithms or other strategies including working backwards and means-ends analysis. Decision making is often considered within problem solving, but is actually quite distinct. Most decision-making research has studied how people choose from among a set of options or actions. Although there is no truly objective way to define a correct decision in this case, the expected utility model has served as a benchmark for analyzing human decisions. Often, people will employ heuristics when they do not have the time, information, awareness, or computational ability to apply the expected utility model. Decision making is also susceptible to particular biases, especially when heuristics are used or information is framed in a particular way.

Key Concepts

algorithm	functional fixedness	morphemes
analogy	grammar	phoneme
anchoring	heuristics	productive thinking
artificial intelligence (AI)	ill-defined problem	representativeness heuristic
availability heuristic	inductive reasoning	reproductive thinking
choice	inference	semantics
convergent thinking	insight	set effect
deductive reasoning	judgment	surface structure
deep structure	language	syntax
divergent thinking	language comprehension	utility
expected utility	language production	well-defined problem
framing effects	means-end analysis	

Key People

Noam Chomsky

Daniel Kahneman

Wolfgang Köhler

Amos Tversky

SELECTED READINGS

Border, G. J., Harris, K. S., & Raphael, L. J. (2002). *Speech science primer: Physiology, acoustics and perception of speech.* Lippincott Williams & Wilkins.

Connolly, T., Hammond, K. R., Baron, J., Arkes, H. R., & Lopes, L. (Eds.). (2000). *Judgment and decision making: An interdisciplinary reader.* Cambridge University Press.

Hardman, D., & Macchi, L. (2004). *Thinking: Psychological perspectives on reasoning, judgment and decision making.* Wiley, John & Sons, Inc.

Koehler, D. J., & Harvey, N. (2004). *The Blackwell handbook of judgment and decision making.* Blackwell Publishers.

Pisoni, D. B., & Remez, R. E. (Eds.). (2004). *The handbook of speech perception.* Blackwell Publishers.

Test Yourself

1) Deliberate, analytic, directed thinking is called _____ thinking, whereas it is called _____ thinking if it is more undirected and creative.
 a) formal; informal
 b) deductive; inductive
 c) divergent; convergent
 d) convergent; divergent

2) Which of the following is the most basic unit of a language that conveys meaning?
 a) phonemes
 b) morphemes
 c) words
 d) sentences

3) Which of the following refers to the underlying meaning of a sentence, as opposed to the mechanical or symbolic aspects that are actually produced?
 a) pragmatics
 b) surface structure
 c) deep structure
 d) grammar

4) Which of the following is *least* likely to have an objective, identifiable, correct answer?
 a) a judgment
 b) a choice task
 c) a well-defined problem
 d) none of the above

5) _____ reasoning involves drawing general conclusions from given arguments, whereas _____ reasoning begins with general principles and applies them to specific cases.
 a) Analogical; deductive
 b) Inductive; deductive

c) Deductive; inductive
d) Formal; analogical

6) Which of the following is a specific strategy that will find the correct solution to a problem, if there is one?
 a) a heuristic
 b) an algorithm
 c) a bias
 d) anchoring

7) Which of the following is indicative of a mental set?
 a) a schema
 b) insight
 c) heuristics
 d) functional fixedness

8) Which of the following statements best describes optimal decision making, as discussed in the chapter?
 a) Expected utility is the accepted definition for optimal decision making.
 b) Heuristics cannot be optimal because they are naïve shortcuts.
 c) Human decision making cannot be optimal because it is prone to biases.
 d) There is no objective way to determine an optimal decision.

9) Compare and contrast the different types of thinking introduced in the chapter: convergent, divergent, productive, and reproductive.

10) Describe how the three different heuristics discussed in the chapter might occur when someone is asked to estimate the crime rate in a large city.

Test Yourself Answers

1) **d.** Deliberate, analytic, directed thinking is called convergent thinking, whereas it is called divergent thinking if it is more undirected and creative. The other options involve types of reasoning in particular, not thinking in general.

2) **b.** Morphemes are the most basic unit of a language that conveys meaning. Phonemes are the units of sound, not meaning, and the other options are more general than morphemes.

3) **c.** Deep structure refers to the underlying meaning of a sentence, as opposed to the mechanical or symbolic aspects that are actually produced (surface structure). Pragmatics and grammar refer to the social and construction rules of language, respectively.

4) **b.** A preferential choice task is not likely to have an objective correct answer, although the expected utility model is often invoked to establish an "optimal" decision.

5) **b.** Inductive reasoning involves drawing general conclusions from given arguments, whereas deductive reasoning begins with general principles and applies them to specific cases. Analogical reasoning involves analogy, or comparison.

6) **b.** An algorithm is a specific strategy that will find the correct solution to a problem, if there is one. Anchoring, a type of heuristic, may produce an incorrect answer.

7) **d.** Functional fixedness is a mental set where one cannot imagine new uses for familiar objects.

8) **d.** There is no objective way to determine an optimal decision, according to the discussion in the chapter. Expected utility, although a common benchmark, is not a definition of optimality, and heuristics (and human decision making in general) can indeed lead to optimal decisions.

9) Convergent thinking is focused, deliberate, directed thinking, and may be expected to follow a certain method or routine. Divergent thinking, in contrast, is undirected "free" thinking that leads to creative solutions. This latter type of thought is related to productive thinking, which involves producing a new organization of a problem's elements. Reproductive thinking involves applying past solutions to new problems, a directed method that would be more in line with convergent thinking.

10) If one is asked to judge the crime rate in a large city, they may first rely on anchoring. That is, if they know the crime rate in another city, they may use this as a starting point for determining their estimate. They may also rely on representativeness, where the crime rate in the target city will depend on how similar it is to the city for which they know the crime rate. However, due to availability, they may inflate the crime rate because news reports of murders and muggings in large cities come easily to mind.

Motivation, Emotion, and Stress

A central question for both professional and amateur psychologists concerns why people behave as they do. An interest in this question has led to research and theory about motivation, the process of energizing and directing goal-oriented behavior. A related interest in less observable processes has developed work on emotion, a state of personal feeling. Motivation and emotion are related in that emotion includes in part the subjective experience of motivation, the feeling that accompanies motivation, and the stress resulting from conflicting motives.

Both motivation and emotion are constructs, processes that cannot be directly observed or studied but whose antecedent conditions (causes) and consequences (outcome behaviors) can be researched. Many other topics—such as learning, cognitive processes, and perception—are also constructs in the sense that they cannot be directly studied, but they can be inferred to occur as processes between the factors that cause them and the behaviors they bring about.

■ MOTIVATION

Motivation is a process that both energizes and directs goal-oriented behavior. Broadly defined, **motivation** refers to the factors that define goals, influence the initiation of goal-directed behavior, and determine the persistence and vigor of such behavior. The study of motivation involves identifying different sources and types of motivation, developing theories about motivation, and researching specific motivators in an attempt to better understand human behavior.

Sources and Types of Motivation

As with many psychological constructs, there are many different ways we can classify the things that motivate our behavior. Here, we discuss a few different ways that have been useful in organizing motives for discussion and research.

Primary and Secondary Motives

One way to classify specific motives, such as hunger or the desire to be accepted, is by recognizing whether they are primary or secondary motives. Like the classification of reinforcers discussed in Chapter 7, **primary motives** are biological motives that provide a natural or innate source of goal-direction and prompt behavior. In contrast, **secondary motives** are cognitive, social, psychological, or environmental factors that provide motivation, and must be learned. Both types of motivation can be quite powerful; an individual may deny oneself food (a primary motive) in order to obtain a positive evaluation of body image from one's peers (a secondary motive).

Intrinsic and Extrinsic Motivation

A second way to distinguish between different types of motives is whether the motivation comes from the environment, or from within the individual. **Intrinsic motivation** describes motives that come from within, such as desires, self-esteem, or feelings of satisfaction or accomplishment. **Extrinsic motivation** comes from the environment, such as praise from a parent or teacher, money, or escape from a threatening situation. Notice that any particular motive (for example, hunger) can be classified according to different methods (for example, primary and intrinsic). There is no right or wrong way to describe motives, and many behaviors are the result of multiple types of motives anyway. For example, the motivation to catch a fish could be driven simultaneously by primary motives (hunger), intrinsic secondary motives (self-esteem), and extrinsic secondary motives (praise from one's parent).

Maslow's Hierarchy of Motives

Humanistic psychologist Abraham Maslow (1908–1970) suggested a coherent structure as one way to organize the various motives of human behavior. Maslow had originally been enthusiastic about behaviorism, but he became disillusioned with its limited view of human aspirations. His conception of human motivation exceeded a purely biological or survival-oriented view. For Maslow, although biological (primary) motives were clearly essential to survival, secondary motives were just as essential to ultimate human development and productivity. He ranked human motives in a hierarchy of motives, an ordering of needs that must be satisfied in human behavior. One property of Maslow's hierarchy (see Figure 10-1) is that primary motives take precedence over secondary motives.

As depicted in Figure 10-1, this hierarchy of motives is usually arranged as a pyramid, with the most basic physiological needs, such as hunger and thirst, at the bottom. After these are satisfied, safety needs take precedence, including physical security and freedom from pain and fear. Next in importance are belongingness needs: needs to be accepted and loved by others, and to have a place or territory of one's own. Beyond these are the esteem needs, including both the esteem (appreciation) of others and self-esteem. At the top of the pyramid, Maslow placed the need for self-actualization, the motivation to live up to (actualize) one's potential to be fully human.

Theories of Motivation

A number of theories have been developed since the early years of scientific psychology to explain how behavior is both initiated and directed. Theories of motivation have been developed and modified to reflect prevailing assumptions about human nature and the effects of the environment on behavior. These theories differ primarily in where they place the locus of motivation, and what goals they see motivation

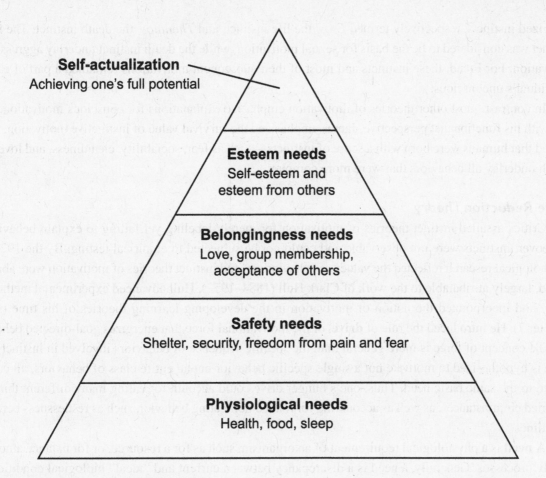

Self-actualization
Achieving one's full potential

Esteem needs
Self-esteem and
esteem from others

Belongingness needs
Love, group membership,
acceptance of others

Safety needs
Shelter, security, freedom from pain and fear

Physiological needs
Health, food, sleep

Fig. 10-1: Maslow's hierarchy of motives.

as serving. Each theory is useful in explaining some properties of human motivation, but none can account for how and why we do everything that we do.

Instinct Theory

The influence of dualism on early psychology provided a temptingly simple answer to the question of why people behave as they do. Because dualist views of human nature supported the idea of free will, the dualist theory of motivation succinctly asserted that people choose their courses of action. This view presented problems for scientific psychologists, especially as research identified indisputable environmental influences on behavior. Given the mechanistic influences on early psychology, a more appealing theory of motivation explained human behavior as being, like animal behavior, governed by instincts. **Instincts** are innate, goal-directed sequences of behavior; they are more complex than simple reflexes but are impervious to the influence of learning and experience. The concept of instinct enjoyed great popularity and support in the late nineteenth century. Two very different instinct theories of motivation were developed by the psychoanalyst Sigmund Freud and the functionalist William James.

Freud considered the notion of instincts to be very broad, almost on the order of the later concept of a drive (see the following section). In Freud's view, human behavior was motivated by two biologically

energized instincts, respectively termed *Eros*, the life instinct, and *Thanatos*, the death instinct. The life instinct was considered to be the basis for sexual motivation, while the death instinct underlay aggressive motivation. For Freud, these instincts and most of their subsequent motivations remained a part of each individual's unconscious.

In contrast, most other theories of motivation emphasize explanations for conscious motivation. In line with his functionalist perspective, James emphasized the survival value of instinctive motivation. He argued that humans were born with a score of instincts—such as fear, sociability, cleanliness, and love—which underlay all behaviors that were more complex.

Drive Reduction Theory

Critics assailed instinct theories of motivation for merely labeling yet failing to explain behavior. Moreover, instincts were not observable and could not be subjected to empirical testing. By the 1920s, psychological research reflected the values of behaviorism, and instinct theories of motivation were abandoned, largely attributable to the work of Clark Hull (1884–1952). Hull advanced experimental methodology and incorporated the notion of motivation in the developing learning theories of his time (see Chapter 7). He introduced the role of **drive**, or the motivational force that energizes goal-directed behavior. The concept of force is more general than the specific sequence of behaviors involved in instinct. A drive is hypothesized to motivate not a single specific behavior but an entire class of behaviors, all connected to the same basic need. Thus, one's hunger drive could account for eating many different things in varied circumstances, as well as accounting for related non-eating behavior, such as restlessness before mealtimes.

A **need** is a physiological requirement of an organism, such as for a resource, or for balance among bodily processes. Generally, a need is a discrepancy between current and "ideal" biological conditions for an organism. That is, needs are driven by the desire to maintain **homeostasis**, a consistent internal state. An animal that needs food (that is, it is surviving below the ideal level of food) will experience the hunger drive, and this will motivate eating behavior until the drive is reduced. The experience of a need is hypothesized to be unpleasant, and the drive produced by this need would act as a signal for behavior to gratify the need. Thus drive theory explains behavior in terms of a motivation for drive-reduction. The link to learning theory emerges when one considers that behaviors that reduce needs can also be learned as reinforcers.

Hull incorporated this need-produced concept of drive into an equation for motivated behavior. In Hull's equation, the probability of a given behavior is a function of three factors:

- The drive the organism experiences as a result of a need state
- The incentive; the value of the external stimulus that will reduce the need state
- Habit strength; the organism's practice or past experience with, or ability to perform, the behavior

Hull assumed that the behavior was a multiplicative product of these three factors. This suggests that the stronger these three factors are, the greater will be the likelihood that the organism will perform the behavior in question; and also that if any of these factors drops near zero in strength, so will the likelihood of the given behavior.

Hull's view of motivation is considered neobehaviorist rather than strictly behaviorist, because it relies on the operation of intervening variables like drive, incentive, and habit strength, instead of observable conditions and responses. Each intervening variable is assumed to be determined by an

observable antecedent condition (a stimulus or influence). Likewise, the result of the interaction of the intervening variables is assumed to be an observable, measurable aspect of behavior.

Arousal Theory

Some modern theories of motivation focus on the concept of arousal, suggesting that one is motivated to perform in order to be aroused. **Arousal** is basically considered to be some general, overall level of physiological activation, although it is closely linked to concepts of emotion discussed in the "EMOTION" section later in this chapter. Arousal theories of motivation suggest that there is some optimal level of arousal that results in maximum performance for a given individual in a given situation. In other words, there is not a strictly increasing relationship between arousal and performance—continued increases in arousal do not always result in continued increases in performance. Rather, the relationship between arousal and performance can be described by the **Yerkes-Dodson Law**, named after its developers in animal research. When arousal is too low or too high for a particular task, performance suffers.

The Yerkes-Dodson law suggests that the effects of arousal will vary with the nature of the task and performance in question. In general, the optimal level of arousal to motivate good performance is greater for simple tasks than for complex tasks. This explains why mild fear, such as of an approaching deadline, might motivate one individual to do a better job than otherwise on a familiar (simple) assignment, while causing another to work more slowly and make more mistakes on a novel and ill-prepared (complex) task.

Incentive Theory

The difference between incentive theories of motivation and the preceding theories lies in the locus of motivation. Specifically, whereas the other theories assume some sort of internal process that motivates behavior, incentive theories suppose that environmental factors play a role in establishing goals and stimulating behavior. Behavior is seen as a response to the pleasurable consequences of some environmental stimuli, and the negative consequences of others. In other words, one is motivated in an attempt to approach desirable stimuli and to avoid unwanted or repulsive stimuli. Recent research within this framework has made further distinctions between "wanting" and "liking" a stimulus. This approach allows for more cognitive factors, such as the evaluation of expected pleasure or disgust, as compared to the biological slant of other theories.

Opponent-Process Theory

Most modern researchers believe that motivation is too complex to be explained by a single theory. Therefore, much motivation research focuses on individual motives, such as those discussed in the following section. Opponent-process theory is one modern theory of motivation that embraces a broad view of motivation but is more modest than traditional single-concept theories. Theorist Richard Solomon argues that many acquired motives (learned motives) arise from the interplay of two opposing processes in the brain. Opponent-process is a theory that promises to explain a variety of behavior patterns, and awaits further research to confirm its value to a general understanding of motivation.

According to opponent-process theory, one might fall in love because one experiences pleasure with the beloved. Later, however, one stays with that person despite boredom or conflict primarily in order to avoid the pain of breakup and loneliness. One's behavior in the love-hate relationship is motivated by a process of balancing and progressing between the opponent forces of pleasure and pain. Often, the

arousal of the first process weakens, and that of the opponent process increases. For example, thrill-seekers are motivated by the increased relief they feel after successfully facing extreme dangers, as the initial apprehension about engaging in the activity subsides over time.

Specific Common Motives

The discussion of theories of motivation has been purposely non-specific about which motivated behaviors may be involved. These theories could be applied, in principle, to explain a number of different behaviors. Earlier in this chapter, we identified general classes, sources, or types of motivation; here, we discuss some specific motivated behaviors, or motives, that have received considerable attention. We begin with hunger and sexual drive, the two most intensively studied motives. We also include some discussion of other motives, such as social motives and curiosity.

Hunger and Thirst

Hunger and thirst are almost certainly the most basic and important motives of human behavior. Due to survival necessity, these physical motives tend to outweigh other motives, in the sense that they need to be satisfied first and foremost.

Physiology of Hunger

Early research on hunger focused on localizing (identifying physical origins for) the sensations and energy that drive eating behavior. Classic research by Walter B. Cannon (1871–1945) initially concluded, erroneously, that the stomach contractions that accompany hunger pangs are themselves the physical stimulus for eating behavior. Later research rejected this simplistic localization in favor of a more physiological explanation. Hunger is generally cyclical, corresponding to the rhythms of homeostasis, the bodily balance essential to healthy function. When nutrients are needed to fuel the body, the individual feels hungry; when one is well nourished, one feels sated and disinclined to eat further.

Brain research has identified the location of the body's hunger signals as cells within the hypothalamus, a part of the limbic system that is integrally involved in motivation and emotion. Cells in the lateral hypothalamus (LH; the sides of the structure) appear to function as a "start" center, sending signals to eat when the concentration of glucose, a simple sugar, in the bloodstream is low. Conversely, cells in the ventromedial hypothalamus (VMH; a front, central region of the structure) function as a "stop" center, indicating satiety, a level of adequate glucose concentration. Together, the LH and VMH comprise a lipostat, a brain center that measures the nutrient level of the bloodstream and regulates eating behavior to maintain that ideal balance, or **set point**.

Psychology of Eating

For humans, eating is a complex behavior, strongly but not exclusively influenced by internal signals of hunger. Research suggests that eating behavior is influenced by external factors as well as by hunger (an internal state). These influences include perceptual factors such as the smell, taste, and texture of food. Eating behavior is also strongly influenced by time (for example, whether it appears to be mealtime) and sensory access to food (for example, seeing a bag of snack food close at hand). Furthermore, people's eating behavior is strongly influenced by social factors, including cultural preferences and aversions to certain foods, norms for which foods are served for specific mealtimes, and the role of food in accompanying social activities.

Eating Disorders

Unfortunately, eating disorders are quite prevalent in our society, with women and youths the two groups who are generally most afflicted. **Obesity**, a condition where one is severely overweight, is perhaps the most common, especially in the United States. By standards developed by the World Health Organization using body mass index (BMI), thirty-six percent of U.S. adults are overweight, and an additional twenty-seven percent are obese (a BMI greater than 30). Other eating disorders result in individuals whose weights fall below the normal range of BMI for their gender, age, and body type. Perhaps the most common of these, affecting approximately one to three percent of young women in the U.S., is **bulimia nervosa**, which is characterized by patterns of binge eating (overeating) followed by purging (induced vomiting), so as not to gain weight. Another disease driven by the attempt to remain thin is **anorexia nervosa**, which involves self-starvation, excessive use of laxatives, and other means that result in severe weight loss. Again, the disease affects predominantly women, who account for an estimated ninety-five percent of total cases in the United States.

Some research suggests that individuals with eating disorders may be suffering the effects of an altered set point, feeling hungry when they are physically sated (obesity), or feeling sated when they are physically starving (anorexia). However, it is probable that the major factors that lead to eating disorders are social and psychological. Larger portions and the increased availability of quick meals high in fat content and calories are often cited for the growing epidemic of obesity in the United States. The social emphasis on the desired ideal of thinness, portrayed in advertisements and the popular media, contributes greatly to the perceived need for thinness that can contribute to bulimia nervosa and anorexia nervosa. Other psychological factors include low self-esteem, stress, depression, and perfectionism. Treatment for eating disorders typically involves closely-monitored therapy, sometimes even hospitalization.

Thirst

Like eating, drinking is a behavior strongly but not exclusively influenced by a physiological drive, in this case the thirst drive. Early attempts to localize thirst as triggered by dryness in the mouth and throat were abandoned in favor of a physiological explanation. Thirst is regulated by two bodily fluid balances: the fluid within the body's cells, and the fluid between the body's cells. In the first case, high intracellular (within-cell) sodium levels dehydrate cells, causing stimulation of receptor cells in the hypothalamus. This "drink" center activates the thirst drive, and we engage in drinking behavior. A second thirst regulator, sensitive to the functioning of the kidneys, appears to monitor extracellular (between-cell) fluid levels. This regulator interacts with the first one to produce the internal signal of thirst.

Social factors—including peer pressure and advertising—can also affect drinking behavior, especially for fluids other than water. Environmental cues also affect what we drink and when, as iced tea may sound refreshing in the summer, while hot chocolate is the beverage of choice for winter weather. Learned behaviors, such as that of drinking that accompanies eating, can also influence thirst (that is, by increasing perceived thirst around mealtimes, or while eating).

Sex and Physical Contact

According to some evolutionary researchers, survival of one's lineage is an important motive second only to one's own survival. Modern research studies the physiological function and interpersonal psychology of sexual behavior and physical contact.

Physiology of Sex

In animals, sexual behavior is demonstrably influenced by physiological factors like hormones and bodily rhythms (for example, the estrous cycle of females preparatory to mating). For nonhumans, sex could be considered a physiological drive. For humans, however, sex does not function as a clearly physiological drive. Although there is evidence of distinct sex hormones in both males (primarily androgens, such as testosterone) and females (primarily estrogens and progestins) that are correlated with sexual behavior, they do not appear to drive it. These hormones are responsible for cyclic behavior and sexual development, such as women's menstrual cycles and puberty in adolescence, as well as sexual desire (but not necessarily physical ability). Many animals have been found to secrete pheromones, scented glandular substances that may externally influence sexual response in the opposite sex. Although some research supports similar effects among humans, the role of such substances is yet unclear.

Sexual activity in humans is often characterized physiologically by the **sexual response cycle**, involving four stages.

- The first stage, or excitement phase, involves increased blood flow to the genitals, producing swelling (penile erection) and vaginal secretion in females.
- In the second stage (the plateau phase), blood flow, respiratory rate, and pulse continue to increase, and secretions may occur (in males) or increase (in females).
- During orgasm, the third stage, muscle contractions occur in the genitals and other areas of the body, which serve in part to increase the reception of sperm in the female and foster conception.
- Finally, during the resolution phase, the body relaxes and genital swelling dissipates. At this point, males experience a refractory period during which they cannot be physically sexually aroused; women, however, are capable of repeating the sexual response cycle immediately.

Psychology of Sex

Human sexual behavior is motivated by learned and individual factors, in addition to physiological mechanisms outlined in the preceding section. The development of scientific research on sexual behavior is often credited to Alfred Kinsey (1894–1956). Although he employed mainly survey methods, his work opened the door for his followers who performed physical measurement of sexual arousal and conducted experiments. Today, the Kinsey Institute at Indiana University is world-renowned for its research on the psychology of human sexuality.

The number and nature of stimuli that can activate human sexual behavior is almost infinite. Although cultural norms exist for sensory impressions that are considered erotic (sexually arousing), no specific criteria have been identified for stimuli to have aphrodisiac effects. Although there seem to be some general gender differences—for example, men respond more than women to visual stimuli, whereas women are influenced more by the mood and setting of material—these differences may be fewer than similarities. Sexual arousal is also affected by social factors, such as propriety, religion, and the perception of one's peers, as well as psychological factors such as stress. Furthermore, society and culture may imply **sexual scripts**, or guidelines for appropriate sexual behavior and conduct in sexual encounters. Thus, human sexual behavior is better explained by a combination of biology and cultural influences than by either set of factors alone.

Sexual Dysfunction

The very same factors that contribute to sexual function in humans can also result in **sexual dysfunction**, or abnormalities in sexual desire, arousal, and response. In men, common sexual disorders include erectile dysfunction (formerly known as impotence), and premature ejaculation. These disorders involve the inability to become erect in preparation for sex, and the recurrent tendency to orgasm during sex sooner than desired, respectively. For women, the most common sexual disorder is arousal disorder (frigidity), the inability to become physically aroused during sexual activity. Each of these disorders can result from a combination of biological (for example, diabetes, age-related changes, inadequate blood flow, drug use) and psychological factors (for example, stress, anxiety, feelings of inadequacy).

Sexual Orientation

Human sexual orientation is classified by whether individuals are sexually motivated by members of the same sex (homosexual), members of the opposite sex (heterosexual), or both (bisexual). In fact, sexual orientation is usually conceptualized along a graded continuum, rather than as a set of discrete categories, with relatively few people at the extremes. The causes of sexual orientation are not clear and are hotly debated. Some equivocal evidence supports biological factors, including genetic links, prenatal hormonal levels (but not adult levels), and the lack of environmental influences (for example, the lack of relation between one's orientation and that of one's caregiver). Social convention may also play a role in shaping sexual orientation, or at the very least, one's expression of it. Homosexuality has been subject to a stigma that has only recently—and partially—begun to relax. Not until 1973 did the American Psychological Association remove homosexuality from its official classification of mental disorders; the World Health Organization did not follow suit until twenty years later.

Physical Contact

Simple physical contact is also a motive, especially as established in the bond between infant and caregiver. Classic research with infant monkeys has indicated the need for physical contact in healthy development. Given the choice between a wire-mesh milk dispenser and a soft, cuddly (inanimate) "mother" who did not dispense milk, baby monkeys chose to spend all their non-nursing time clinging to the comfortable surface. Being deprived of physical contact has been associated in both humans and primates with illness, poor development, and failure to attach. Contact and physical access appear to be important in attachment to significant others in infancy, and perhaps throughout life.

Social Motives

Many behaviors can be explained in terms of social motives, concerning relationships with others. These social motives include aggression, affiliation, and motives for achievement and power.

Aggression

Aggression is any behavior intended to harm another. Instrumental aggression uses harm to achieve another goal (for example, attacking another to obtain food), while hostile aggression intends harm as its sole purpose.

Freud argued that aggressive behavior is the motive expressed by the unconscious death instinct. According to psychoanalytic theory, human nature is inherently aggressive, but aggressive impulses can

be relieved through catharsis, a vicarious release of emotion, such as watching a violent film or fantasizing about harming an enemy. Research, however, has failed to support the contention that watching aggressive stimuli reduces rather than enhances aggressive behaviors. Another instinct theory of aggression has been proposed by ethologists, who argue that aggression in nonhuman species is usually tied to territorial protection and survival.

A more recent theory of aggression posits its cause as frustration, failure of one's efforts to reach a goal (see the "Frustration" section later in this chapter). According to frustration-aggression theory, frustration always results in the impulse to aggress, and aggression can always be traced to the experience of frustration. If the target of intended aggression is unavailable or retaliatory, one may displace aggression by harming an object or person other than the original target. In a revision of the original theory, frustration is theorized to lead not directly to aggression but to anger, a readiness to behave aggressively. Anger, in turn, may give way to aggressive behavior if triggered by such social and environmental influences as attack, pain, and extreme heat.

Undoubtedly, much aggressive behavior is learned through reinforcement (operant conditioning) when the aggressive behavior leads to getting what one wants or removal of a negative stimulus. Aggressive behavior may also be learned through lessons of modeling (observational learning), such as when a child who has wrongly hit another child (an aggressive behavior) is in turn spanked by an adult (another aggressive behavior).

Affiliation

Both humans and nonhumans often exhibit a preference to **affiliate**, or be physically close to others of their own species. Classic research by Stanley Schachter in 1959 studied whether affiliation is a response to fear. Schachter led some young women to believe that, as part of a psychology experiment, they would experience intense pain, while others were told the experience would involve no pain. When asked where they would prefer to wait while the experiment was set up, those who expected pain expressed a strong preference to wait with other women. Those who expected no pain expressed no such affiliative preference.

One explanation for this misery-loves-company effect is that affiliation gives us the opportunity for social comparison, an evaluation of how our own beliefs and behaviors compare to those of others. The less sure we are of the validity of our own thoughts and actions, the more we rely on and are reassured by our similarity to others.

Achievement

One factor in an individual's success is that person's need to achieve—a need to excel and overcome obstacles. Such achievement motivation is theorized to function independently of any desire for reward or response to incentives. Some individuals interpreting ambiguous stimuli tell stories that are significantly higher in success and achievement imagery than those of others. These individuals have been found to behave in achievement-oriented ways when presented with tasks and problems. Achievement-motivated behavior is characterized by ambitious but realistic goal-setting. It has been linked to child-rearing practices that emphasize encouragement and independence.

Another factor in success may be an individual's need for power—the need for recognition by or influence over others. Measurements of the need for power have been related to a variety of behaviors, from American presidents' effectiveness to patterns of control and abuse in personal relationships.

Effectance Motives

Many behaviors appear early enough in human development to seem inborn, and yet they seem more varied in expression and direction than physiological motives. Among these are behaviors motivated by activity, exploration, and curiosity. Some researchers have termed these **effectance motives** because they comprise an individual's abilities to function within and have an effect on his or her environment.

Activity

Contrary to the predictions of drive-reduction theories of motivation, both humans and animals appear more likely to seek and display activity than an inert, nonstimulated, or satisfied state. Research indicates that general activity levels may be higher when specific drives increase. For example, a hungry caged rat runs more and faster on a treadmill as a regularly scheduled mealtime approaches. This suggests that general activity may be energized by the arousal of specific drives.

Exploratory Behavior

Exploration and curiosity also serve as motives for behavior, even in the absence of biological, learned, or other identifiable motives. There may be a motivational "need to know," stimulated especially by uncertainty and mystery. Animals will learn when reinforced only by opportunities to explore the environment. Humans rate scenic views as more aesthetically pleasing when they include mystery, whether a partially obscured view or a disappearing pathway. Gestalt principles of perception (see Chapter 6) also suggest that humans value meaning, closure, and understanding, and that we may undertake behaviors in search of these qualities.

■ EMOTION

Emotion is, like motivation, a construct, a process that is hypothesized to explain unseen connections between observable stimuli and responses. Emotions are states of feeling that are not under conscious control and influence thoughts, perceptions, and behavior. Emotions accompany motivational states and also produce physiological changes. They can be classified according to their characteristics, corresponding physiological response, and level of arousal. Several theories have sought to explain emotional processes, development, and expression.

Defining Emotions

It may seem a difficult task to identify and distinguish between specific emotions. However, there is, in fact, a great deal of uniformity in the conveyance of distinct emotions, even across cultures. Some general properties characterize any given emotion.

- They are transient, or temporary, in that a relatively clear beginning and end are identifiable.
- They are either positive or negative, and usually quite strong and passionate, rather than lukewarm or indifferent.
- They are determined in part by cognitive appraisal of a situation—such as whether ending a romantic relationship is for better or for worse—and, in turn, alter thought processes to some degree.
- They often lead to a tendency toward directed action or response (they are motivating), although they themselves are not under conscious control.

The Eight Basic Emotions

According to Robert Plutchik, humans and animals experience eight basic categories of emotions that motivate adaptive behavior: fear, surprise, sadness, disgust, anger, anticipation, joy, and acceptance. These are often arranged in order in a circle, with adjacent emotions (for example, fear and surprise) being functionally alike and opposing emotions (for example, fear and anger) being functionally opposite. In addition, these basic emotions can serve as "ingredients" that combine to produce new hybrid emotions (for example, joy + acceptance = love; surprise + sadness = disappointment). In Plutchik's model, emotions can vary in intensity as well. For example, the most intense form of anger is rage, and the least intense form of anger is annoyance. This model has been applied to observations of emotional development in young children in determining the functions and effectiveness of different types of emotions.

Physiology of Emotions

Both the central nervous system (in particular, the brain) and the autonomic nervous system play a role in the regulation of emotions. The limbic system, and in particular the amygdala, are most often associated with the expression of emotion. Emotions have cognitive components that are served by the brain. This implicates the role of cortical regions, and even some tentative hemispheric differences, supported by neuroscience research. Finally, the physical expression of emotions, such as smiles accompanying joy, or furrowing of the brow in concern or worry, are controlled by the brain as well. In fact, there appears to be a distinct motor system for the involuntary production of these physical expressions when they accompany emotions (as opposed to their voluntary expression otherwise).

Emotions often produce a preparatory response in the body, which is the work of the autonomic nervous system. For example, fear may produce the fight-or-flight response through changes in heart rate, blood flow, respiration, and adrenaline release. Perhaps you sweat profusely when you are nervous, for which the autonomic nervous system is also responsible. Emotion is closely related to, although not synonymous with, the concept of arousal. That is, these physiological changes, which are characteristic of particular emotions, result in an overall level of activity or arousal.

An Application: Lie Detection

The relationship of physical arousal to emotion is central to assumptions about the usefulness of polygraphy, the general term for measurements such as so-called "lie detection." Individuals subjected to polygraphy examinations respond to verbal questions while ongoing measurements are made of various physiological arousal effects, such as heart rate, blood pressure, and sweat gland activity (hence the term polygraph from *poly*, "many," and *graph*, "written record"). The assumption of polygraphy is that lying requires effort, produces anxiety, and causes measurable arousal. Polygraphy is more a business than a science, and although many employers rely on lie detectors for tests of workers' honesty, there is no consistent scientific evidence to support its use for such purposes. For this reason, its acceptance in judicial applications is the subject of ongoing debate and repeated revision of federal and state law.

Theories of Emotion

There are several specific and well-formulated theories of emotion that have been offered by psychologists. Here, we focus on three of these theories that have been arguably the most popular and influential.

James-Lange Theory

In the late 19th century, William James formulated a theory of emotion similar to that proposed about the same time by Danish psychologist Carl Lange. The so-called **James-Lange theory** of emotion proposes that emotions are experienced in the following sequence: (1) an emotional stimulus is presented, causing one to experience (2) physiological reactions, which are (3) consciously experienced as an emotion. For example, when one encounters a growling wild animal (emotional stimulus), one feels a faster heartbeat, widening eyes, and a physical urge to flee (physiological reactions). As one becomes aware of these changes, one experiences the feeling of fear (emotion). In other words, one experiences a particular emotion because of one's physiological response, rather than vice versa.

Cannon-Bard Theory

Walter Cannon and Philip Bard disputed the James-Lange theory, arguing that the brain plays a more important role in producing em_____ simply experiencing it. The **Cannon-Bard** theory of emotion asserted that an emotional s_____ __ly triggered both the bodily changes and the conscious awareness of the emotio_____ the example in the preceding section, according to the Cannon-Bard th_____ animal (emotional stimulus) would simultaneously lead one t_____ odily changes) and to realize that one was experienci_____

Schachter-Singer Theory

In 1962, Stanley Scha_____rch identifying a cognitive process in emotional res_____ctions of either an arousing drug or an inert saline _____re a confederate acted either extremely angry or eu_____ describe their emotional state. Results indicated that_____re of its effects were most likely to adopt the emotio_____to behave likewise. Schachter and Singer concluded ___

- A state of p_____
- A cognitiv_____on.

According t_____abel is not an emotion; a label without arousal ____

Express_____

Becaus_____ble. In conducting research on emotion, psychologists usually ob_____ssions of emotion. Although the study of verbal expression of emotion—s_____is most direct, it is also subject to the bias and distortion of self-report. For this reas_____e more likely to study nonverbal expressions of emotion.

Facial Expressions

Probably the most common expressions of emotions are the facial expressions that accompany them. Evolutionary theorist Charles Darwin originally proposed that facial expressions of emotion have specific

survival value and are part of our biological heritage. This would explain such phenomena as the universality of a smile as a facial sign of happiness. Cross-cultural research has indicated that, while cultures vary in many norms for facial expressions of emotion, six emotions are universally recognizable in this manner: happiness, sadness, fear, anger, disgust, and surprise.

There is, however, considerable individual variation in facial affect or the facial expression of emotion. In one study, people who acted as senders of emotional signals examined emotionally arousing visual stimuli, pictures of scenes and events that aroused various emotions. While they viewed these stimuli, a video camera transmitted the sender's face alone (without the stimuli) to another room where a subject acting as a receiver watched. Results indicated gender differences in both sending and receiving, as well as senders who were harder to read (that is, whose faces showed little emotional expression) than others. Interestingly, these people were found to experience higher measurable levels of physiological arousal than senders whose faces were expressive and easy to read. In other words, poker-faced people seemed to be internalizing their emotional experiences, while expressive-faced individuals showed less internal arousal. This finding has led to speculation that facial expressions are causally related to physiological arousal.

Nonverbal Communication

Psychologists in recent years have also studied various forms of nonverbal communication. In addition to facial affect, research has focused on patterns in tone of voice, eye contact, gesture, body position, and posture. These channels of nonverbal communication indicate such factors as immediacy (the tendency or wish to be physically close to others) and status (social rank). For example, open body positions—with arms uncrossed and upper body relaxed—are associated with positive affect and acceptance; while **closed body positions**—crossed arms and legs, upright posture—are associated with negative affect and rejection.

■ STRESS

A concept closely related to those of motivation and emotion is stress. **Stress** refers to the process of adjusting to a demand or set of demands, thereby producing negative emotional and physiological effects. The word "stress" derives from the Latin *stringere*, "to stretch." The term implies a stretching of physical and psychological resources to meet demands placed on an organism. Oftentimes, the word "stress" is used to refer to the demands that require adaptation, rather than the process itself. Here, we prefer to make the distinction between **stressors**, the events or situations that disrupt (or threaten to disrupt) and require adjustment, and the reaction to them (stress).

Sources of Stress

Stressors can range from dramatic catastrophic events to life changes and problems to chronic ever-present stressors to the minor hassles that arise in our daily lives. Primitive humans faced challenges such as starvation, exposure to the elements, and attack from enemies or predators—the physiological stress response (see the "Physiological Response" section later in this chapter) has developed largely as a result of these stressors. However, the majority of individuals in most modern societies are relatively free from the pressures and worries of our ancestors. These days, stress can result from sources such as frustration, conflict, and trauma.

Frustration

Frustration is the experience of having one's path or access to a goal blocked. A goal may be blocked because an obstacle has been introduced to prevent access, as when a roadblock stops a vehicle from continuing to its destination. Alternatively, a goal may be inaccessible because one lacks the resources to approach it, as when the vehicle is out of gas. Psychologists have identified three general reactions to frustration: aggression, regression, and nonaction. The classic reaction to frustration is aggression, either toward the stressor or **displacement** of aggression toward a safer, less retaliatory target. Regressive behavior reflects the immature tactics of an early age: a frustrated friend may whine childishly to get his way or win attention; a frustrated manager may bully her coworkers, arousing their fear but not winning their respect. Finally, repeated frustration may result in nonaction, which may appear to be apathy, or a lack of concern. A more common explanation is that the frustrated individual suffers from learned helplessness (see Chapter 7).

Conflict

Conflict is probably the most common stressor. **Internal conflict** is the experience of incompatible goals or demands, such as the lure of two incompatible motives toward action. Two people are in **interpersonal conflict** when one opposes what the other desires. Gestalt psychologist Kurt Lewin (1890–1947) described conflict as involving two kinds of forces between persons and goal-objects: approach and avoidance. **Approach** is the attraction toward a desired goal, while **avoidance** is the aversion felt toward an undesirable state or event. Given that conflict involves two or more incompatible goals, approach and avoidance combine to form various forms of conflict. In approach-approach conflict, one must choose between two mutually exclusive attractive goals. For example, a college applicant may have to choose between attending a large university in an exciting urban setting or a small high-quality school in a beautiful scenic region. An unpleasant experience is avoidance-avoidance conflict, where one must choose which of two threatening or unpleasant possibilities can be escaped. Dealing with such conflict usually involves choosing the lesser of two evils, as in facing brief dental treatment to prevent a worsening tooth disease.

The most difficult conflicts to resolve are approach-avoidance conflicts, where one is both attracted and repelled by the same goal. For example, a college student may want to marry rather than delay being with a partner, but fear the loss of freedom and the burden of responsibility involved in young marriage. Approach-avoidance conflicts are complex and difficult to resolve, because both the attraction and the repulsion create tension, especially as the goal comes closer (for example, a deadline for making a decision approaches). Avoidance generally becomes stronger than approach, however, with the result that one often panics, pulls back, becomes attracted again, and continues in a cycle of vacillation until matters are otherwise resolved.

Extreme Stressors

Laboratory research on stress necessarily involves only mild and short-term stressors; real-life stressors are unconstrained by such ethical considerations. Naturalistic observation has identified stress response patterns in the wake of extreme stressors like natural and technological disasters, personal losses, and societal changes. We can identify five major categories of such extreme (traumatic) stressors: unemployment; relationship termination; bereavement; combat; and environmental disasters.

Evidence indicates that the effects of unemployment are, like other life changes, to exacerbate existing problems rather than create new ones. Similar effects are ironically observable after economic upturns, another form of life change. Divorce and separation are major sources of stress, whether one seeks to end a relationship or is the victim of rejection or abandonment. It is not surprising that death of one's spouse tops the list of stressful life changes. Reactions to loss through death involve disruption in activity and change in identity. Bereavement, like responses to separation and divorce, is often characterized by the use of defense mechanisms such as denial and displacement. Common symptoms subsequently observed among veterans of wars include low threshold for frustration, spontaneous crying or rage, sleeplessness, fear of sudden noises, and confusion. Effects are sometimes long-term, and such symptoms collectively have been labeled posttraumatic stress disorder (PTSD; see Chapter 14). Finally, reactions to experienced catastrophes like earthquakes, floods, hurricanes, fires, and plane crashes produce a variety of complex and stressful emotions ranging from shock to even sometimes guilt (for having survived), as well as PTSD symptoms.

Stress Responses

We have described some typical reactions to the various sources of stress identified above. There are also more general descriptions about the way we deal with stress. For example, there is a characteristic physiological response to stressors of various types, called the **general adaptation syndrome.**

Physiological Response

In his research with animals, the Canadian physiologist Hans Selye (1907–1982) discovered a pattern of physical symptoms emerging among animals subjected to a variety of stressors. As a result, he identified three stages of a **general adaptation syndrome**, a physiological and psychological pattern of symptoms in the wake of a stressor event. These three stages are termed alarm, resistance, and exhaustion.

The Alarm Stage

In the alarm stage, an event is interpreted as a stressor and bodily reactions are triggered. During the first phase of alarm, the shock phase, signals from the brain (the cortex and hypothalamus) initiate the activity of the adrenal glands. The adrenal medulla secretes adrenaline directly into the bloodstream. The effect of adrenaline is heightened heart rate and respiration, as well as other consequences of sympathetic nervous activity. A backup response is initiated by hypothalamic stimulation of the pituitary gland, which begins a sequence of hormonal messages to the adrenal cortex. The adrenal cortex produces corticosteroids, hormones which energize striated muscle strength and endurance. Steroid effects are visible in one's ability to continue running from danger even after the initial adrenaline rush, as well as in the shakiness and weak-kneed sensation that can follow a stressful or frightening experience.

The second phase of the alarm stage, countershock, restores and conserves physical energy through rapid response of the parasympathetic branch of the autonomic nervous system. For example, on first seeing a threatening situation, a person in shock will gasp, experience a rapid heart rate, and react reflexively (shock). Soon thereafter, she may feel faint as her body reacts to the sudden expenditure of energy (countershock).

Resistance

During the second stage, resistance, physical defenses are employed in response to the threat identified in the alarm stage, via the fight-or-flight activity of the sympathetic branch of the autonomic nervous system. If the threat can be attacked (fight), resources will be directed to the upper body, and the individual will strike and dodge. If the threat can be escaped (flight), energy and strength (in the form of increased blood supply and muscle tension) will be channeled to the lower-body muscles, and the threatened individual will run. Resistance then can take the forms of both physical reflexes and behavioral reactions.

Exhaustion

In most experiences of stress, resistance strategies will succeed in solving the problem. The cold person will stay alive and awake long enough to find shelter. The person who is attacked will escape or defend himself. However, if resistance fails to reduce the stressor (if one continues to interpret events as requiring adaptation), one enters the third stage, exhaustion. In exhaustion, the physical activity begun in the alarm stage begins again. The danger in exhaustion is that the body has fewer resources to expend in its weakened state. Continued, unrelieved sympathetic arousal results in the breakdown of the body's stress response systems. Consequences will take the form of endocrine, vascular, muscular, and gastric illness and symptoms.

Psychological Response

Psychological responses to stress generally take one of two forms: defending or coping. Defending behaviors reduce the stress or anxiety without eliminating the source. Coping responses restore balance and remove the threat. Because coping requires resources like strength and time, most early responses to stress are defensive rather than effective in coping.

Defending

Defensive reactions to stress, conflict, and anxiety can involve either palliative treatments or defense mechanisms. Palliative measures are treatments that alleviate the pain or distress without effecting a cure. Some palliatives are medicinal, such as taking a pain-relieving drug for a tension headache (instead of identifying and removing the source of tension). Others are distracting or numbing, such as drinking alcohol or taking psychoactive drugs to forget about problems or reduce anxiety.

According to psychoanalytic theories of personality, because conflicts (and stress) are unconscious, they cannot be recognized or addressed in a directly conscious behavioral strategy. As a result, behavior is likely to become defensive rather than to effectively cope. The behavioral strategies or responses made to alleviate or reduce anxiety are termed **defense mechanisms**. Freud and other psychoanalytic theories identified a number of patterns in defense mechanisms, such as displacement, repression (suppressing stressful thoughts), denial, rationalization, and others.

Coping

Coping requires dealing with the source of stress or anxiety, not merely alleviating the symptoms. Coping involves three choices for action: confrontation, compromise, and withdrawal. In confrontation, one faces a stressful situation honestly and forthrightly. This may involve intensifying effort, learning

new skills, or enlisting others' aid. For example, a woman who is worried about paying the bills may confront her situation by selling her car and using public transportation instead, or moving to a smaller apartment, and packing lunches instead of eating out. Compromise is one of the most effective and common ways of coping with conflict. In compromise, each party in the conflict gains something and sacrifices something.

Sometimes the best response to stress is to remove oneself or withdraw from the situation. A victim of abuse may be better off escaping the abusive household than either staying and trying vainly to change the abuser or calling on police to "teach him a lesson." Withdrawal as a coping response should not be confused with avoidance learning or learned helplessness. Withdrawing from a severe conflict will not necessarily teach one to avoid or give up in all future conflict experiences. When faced realistically, withdrawal from hopeless conflict may be the only effective response an individual can choose.

Adjustment

The goal of any program for dealing with stress is adaptation or adjustment, a criterion for mental health. The alternative is a maladjusted pattern of behavior, a characteristic of behavioral disorders (see Chapter 14). Research on adjustment frequently begins as stress research that discovers effective coping strategies. Some important characteristics of adjustment are control and a sense of self-efficacy.

An important common factor in stressful situations is loss of control. For example, sounds are not necessarily stressful but unwanted noises usually are annoying and stressful if persistent. Research on learned helplessness has shown that subjects were more likely to keep trying to solve new problems when they had some control over their experiences. Adjustment involves identifying ways one can establish control over stressful experiences or factors. In many cases, the control may not be real, but the perception of control is sufficient to help one cope and adjust.

Research has also shown that apathy and helplessness in institutionalized individuals can be overcome by giving them manageable responsibilities, like caring for plants or pets. The experience of success in being effective with such care can generalize to greater responsibilities and an overall sense of self-efficacy. This, in turn, can help people adjust to situations that may otherwise be quite stressful.

Motivation is the process that initiates and guides goal-directed behavior. Because it is a construct, we must determine ways to classify and measure what we mean by motivation. Often, motives are said to be either primary (natural, innate, or biological motives) or secondary (cognitive, social, and emotional motives). Motives can also come from within (intrinsic motivation) or from the environment (extrinisic). Maslow's hierearchy is another popular method of classifying motives and suggests progression from satisfaction of basic needs to self-actualization. Two of the most commonly studied specific motives are hunger and sexual drive. Others include learned motives such as achievement motivation and effectance motives.

Several theories of motivation have been proposed to explain why we do what we do. These include early theories that humans, like other animals, relied on instincts. Some theorists, including Clark Hull, suggest that departures from homeostasis create a need in an individual, which then produces a drive; the motivation is thus to achieve balance by eliminating the need. Some theories suggest that motivation is determined by an optimal level of arousal—too much or too little arousal can be detrimental to performance. Still others place the focus of motivation on environmental incentives that motivate one to perform. A more contemporary approach suggests an opponent-process theory, whereby complementary motives coincide to motivate and regulate behavior.

Emotions can serve as a type of motivation and, like motivation, are constructs that resist simple and precise definitions. However, there are general characteristics that define emotions, such as their relatively transient nature and their strong (positive or negative) valence. Furthermore, some research suggests basic emotions that can be thought of as ingredients for more complex emotions. Emotions are expressed through many (mostly nonverbal) means, of which a prime example is facial expression.

There are also several theories about the manifestation of emotions. The James-Lange (peripheral) theory supposes that physiological responses occur, and witnessing these leads one to conclude that one is experiencing a particular emotion. In contrast, the Cannon-Bard (central) view implies that one identifies an occasion for experiencing a particular emotion, which in turn causes the physiological response. A more cognitive view is posited by Schachter and Singer, whereby emotions are a combination of physiological arousal and a cognitive appraisal thereof.

Finally, stress is related to emotion in terms of arousal, and can be linked to motivation especially when conflicting motives occur. Other sources of stress (stressors) include frustration and a variety of traumatic events. The physiology of stress is rooted in our species' characteristic response, termed the general adaptation syndrome. This involves an alarm stage, resistance, and exhaustion. One can deal with stress either by defending or coping. Defending against stress can provide short-term relief, but only by coping with the stress can one eventually adapt and become well-adjusted.

Key Concepts

affiliate
aggression
anorexia nervosa
approach
arousal
avoidance
bulimia nervosa
Cannon-Bard theory
coping
defense mechanisms
displacement
drive
effectance motives

emotions
extrinsic motivation
frustration
general adaptation
 syndrome
homeostasis
instincts
internal conflict
interpersonal conflict
intrinsic motivation
James-Lange theory
motivation
need

obesity
primary motives
Schachter-Singer theory
secondary motives
set point
sexual dysfunction
sexual response cycle
sexual scripts
stress
stressors
Yerkes-Dodson law

Key People

Walter B. Cannon
Clark Hull
Alfred Kinsey
Kurt Lewin
Abraham Maslow
Hans Selye

SELECTED READINGS

Alder, B. (Ed.). (2000). *Motivation, emotion and stress.* Blackwell Publishers.

Cooper, C. L., & Dewe, P. (2004). *Stress: A brief history.* Blackwell Publishers.

Dalgleish, T., & Power, M. J. (1999) *The Handbook of Cognition and Emotion.* John Wiley & Sons, Ltd.

Evans, D. (2001). *Emotion: The science of sentiment.* Oxford University Press.

Reeve, J. (2004). *Understanding motivation and emotion, 4th Ed.* Wiley, John & Sons, Inc.

Test Yourself

1) Biological motives are _____ motives, whereas cognitive and social motives are _____ types of motivation.
 a) primary; secondary
 b) secondary; primary
 c) intrinsic; extrinsic
 d) common; psychological

2) Stating that motivation is little more than the expression of innate impulses is in line with which theory of motivation?
 a) arousal theory
 b) incentive theory
 c) instinct theory
 d) drive-reduction theory

3) Conceptualizing motivation as an attempt to lessen one's need is in line with which theory of motivation?
 a) arousal theory
 b) incentive theory
 c) instinct theory
 d) drive-reduction theory

4) Which of the following motives can have biological, psychological, and social components?
 a) hunger
 b) thirst
 c) sex
 d) all of the above

5) Which of the following was not introduced in the chapter as a social motive?
 a) aggression
 b) activity
 c) achievement
 d) affiliation

6) Which of the following properties was listed as a characteristic of emotions?
 a) They have an unclear onset and ending.
 b) They are more often lukewarm than strong or passionate.
 c) They are determined in part by cognitive appraisal of a situation.
 d) They rarely lead to an overt response of any sort.

7) Which theory of emotion assumes simultaneous activation of a physiological response to an emotional stimulus and a realization of the experienced emotion?
 a) James-Lange theory
 b) Cannon-Bard theory
 c) Schachter-Singer theory
 d) opponent-process theory

8) Which of the following was *not* listed in the chapter as a psychological response to stress?
 a) adjustment
 b) coping
 c) defending
 d) resistance

9) Briefly describe or illustrate Maslow's hierarchy of motives and explain why these are considered a hierarchy (rather than just a collection of motives).

10) Briefly describe Selye's general adaptation syndrome as a response to stress.

of the nervous system. If resistance fails to reduce the stressor (if one continues to interpret events as requiring adaptation), one enters the third stage, exhaustion. In exhaustion, the physical activity begun in the alarm stage begins again.

Human Development

Developmental psychologists explore the changes that occur over time in a variety of human processes, including physical, motor, language, cognitive, social, emotional, and personality processes. Thus, developmental psychology is not simply a topical area in psychology; it is a unique approach to the study of all psychological processes. The province of developmental psychology is the life cycle, the period of constant change between conception and death. The modern discipline of developmental psychology evolved from child psychology, which studies changes in physical, cognitive, social, and personality functions from birth through adolescence. There has been, however, increasing interest in development before birth, the prenatal period, and development after adolescence, the adult years.

■ STUDYING HUMAN DEVELOPMENT

Developmental psychology seeks to describe the typical patterns of change—physical, emotional, social, moral, and intellectual—that occur over a life span. After patterns have been identified, developmental psychologists attempt to explain these changes through psychological theory. An important element of developmental psychology is the study of how factors other than age affect development, because age alone cannot capture the extent of differences among people. Developmental psychologists make use of a variety of experimental and nonexperimental techniques, including both longitudinal and cross-sectional designs (Chapter 2), as well as twin studies (Chapter 3), to answer various questions about human development. There are specific theoretical approaches and pervasive themes in developmental research as well, including the question of continuity versus stages and the relative influence of heredity and the environment.

Research Paradigms in Human Development

Many developmental psychologists approach the study of psychological change from a particular perspective or paradigm. Because each paradigm is characterized by its own themes and assumptions about the nature of development, different psychologists focus on different aspects of developmental

change. Focusing on certain aspects implies lack of attention to others, so no single theory or line of research can by itself capture the complexity of human development. Those who are most successful at explaining developmental changes adopt an eclectic or multidimensional perspective.

Early Approaches

In the early twentieth century, two perspectives dominated American psychology and thus the study of developmental processes. The psychoanalysts, led by Sigmund Freud, focused on factors in early childhood that presumably affected the structure and functioning of adult personality. Physical maturation was seen as precipitating a series of psychosexual crises or conflicts between the expression of instinctual drives and the pressures of socialization.

The learning theorists, following the lead of behaviorist John B. Watson, rejected the notion that development was determined by maturational crises. Proponents of learning theory stressed the role of environment in shaping responses to objects and events. Development was viewed as the accumulation of sets of behaviors through specific experiences.

Cognitive Perspective

Although the perspectives of both the psychoanalysts and learning theorists currently exist in somewhat modified form, a third perspective has assumed a major role in developmental psychology. This cognitive view, alternately referred to as the genetic-structural perspective, reflects the influence of the late Swiss psychologist Jean Piaget (1896–1980). Cognitive developmental psychologists focus on the way thoughts and behaviors are organized. These psychologists view development as the emergence of a series of structures and rules, or operations, which are used to organize thought and behavior. As the word "genetic" implies in its alternative label, the cognitive perspective assumes that maturation plays a major role in developmental change.

Continuous versus Discrete Development

Many developmental researchers now prefer to be called lifespan psychologists, a term that underscores the life long capacity of humans to grow and change. These psychologists make certain (implicit or explicit) assumptions about how this life-long change takes place. Learning theorists see development as the product of experience, whereas psychoanalytic and cognitive theorists emphasize the role of maturation. Furthermore, learning theorists view developmental change as gradual and continuous, referred to as quantitative change. That is, children acquire more and more complex responses over time. In contrast, proponents of psychoanalytic and cognitive stage theories see developmental change as discontinuous or occurring in a series of discrete stages that produce qualitative change. In this view, children literally acquire different types of responses over time. Increasing research suggests that development may be broadly guided by critical periods and discrete stages, but that this process is subject to much more variability and individual differences than previously believed.

Heredity and the Environment (Revisited)

We introduce the question of nature and nurture and a brief introduction to behavioral genetics in Chapter 3. Nowhere is this topic of more central importance than in the study of human development. G. Stanley Hall (1844–1924), one of the first developmental psychologists, represented a rather extreme

position on the side of genetics. Strongly influenced by Darwin's evolutionary theory, Hall professed that development of the individual reflected the evolutionary development of the species. Hall saw development as influenced not only by the genes of one's family but by the broader genetic inheritance we possess as members of the human race. This view was challenged in the early twentieth century by the environmentalists, led by the behaviorist John B. Watson. Watson and other behavioral psychologists believed that development was the cumulative result of our experiences, and that genetics did not predispose individuals to particular developmental outcomes. The environmentalists' rejection of genetic predispositions had great appeal in a democratic society, and this environmentalist view dominated American psychology for several decades.

Today, there is less emphasis on the question of which factor, heredity or environment, determines human development. Most psychologists view development as the result of an interaction of hereditary and environmental factors. Behaviors and characteristics are seen as resulting from the combined effect of genetic inheritance and experience. Although some psychologists attempt to determine the relative amount of each influence, usually as a percentage (the heritability ratio), many believe that each factor affects the other to produce a result not equal to the sum of the two influences.

■ PHYSICAL DEVELOPMENT

An understanding of psychological development cannot be removed from an understanding of physical development. Indeed, many mental milestones are only reached when one is equipped with the physical capacity necessary to perform certain behaviors. We therefore begin with a brief introduction to physical development.

The Prenatal Period

The prenatal period lasts roughly 280 days and is divided into three stages:

- The germinal stage
- The embryonic stage
- The fetal stage

These stages also define labels for the growing prenatal human, such as the embryo and the fetus.

The Germinal Stage

Conception marks the beginning of the first prenatal stage, the germinal stage. Conception involves fertilization of an ovum (egg) by a sperm and usually occurs in a Fallopian tube. During the next ten to fourteen days, the **zygote** (fertilized egg) repeatedly divides as it travels to the uterus. The divisions are mitotic, meaning that the cell merely replicates itself. The cells that implant in the lining of the uterus is therefore a mass of undifferentiated cells, each one exactly like the others.

The Embryonic Stage

When the cell mass implants, the **embryonic stage** begins. For the next six weeks, the cells differentiate in both structure and function. This stage is known as a **critical period**, because it marks a time when specific changes and growth must occur if development is to continue normally. Some cells develop

into protective structures, including the placenta, the umbilical cord, and the amniotic sac. The **placenta** is the protective organ that surrounds the embryo and facilitates nourishment and waste elimination. The umbilical cord carries blood containing nutrients from the mother to the embryo via the placenta. It discharges wastes from the embryo to the mother by the same route. The amniotic sac surrounds the embryo in a suspension of fluid called amnion. Other differentiating cells develop into the actual body structures. By eight weeks past conception, a rudimentary form of each body structure is present, although many of them are nonfunctional.

The Fetal Stage

The fetal stage begins when a basic form of each structure is present. For the remaining thirty-two weeks, cells continue to divide and differentiate to produce functional body structures and to increase the size and weight of the fetus. Development proceeds in a proximodistal (literally "near to far" or trunk-to-limb) and cephalocaudal ("head to tail" or head-to-toe) fashion. This is why the newborn's head is so large relative to the rest of the body at birth. The fetus is still totally dependent on the mother for nutrients and discharge of wastes.

Potential Problems

Although the course of prenatal development is genetically determined, the developing child is susceptible to problems resulting from the uterine environment. Because the blood supplies of mother and child interact, substances in the mother's blood can be passed into the child's body. The placenta functions as a primitive filtration system, but many substances, including drugs and viruses, can enter the child's bloodstream and affect the course of prenatal development. These harmful substances, known as **teratogens**, can be responsible for a variety of birth defects, especially when they are present during the critical period (embryonic stage). For example, smoking during pregnancy is associated with low birth weight and premature birth; the viral infection rubella (German measles) is associated with blindness and deafness. Alcohol is an especially dangerous teratogen, often leading to **fetal alcohol syndrome**. Sadly, nearly half the children born to mothers who abuse alcohol show the associated pattern of defects, including mental retardation and physical deformation.

Infancy

Infancy spans the first two years after birth, beginning with the newborn (neonatal) period (first month). The newborn infant is amazingly competent. Although the cerebral cortex is not yet mature, newborns exhibit a variety of inborn, coordinated motor behaviors called **reflexes**. For example, the rooting reflex permits the infant to locate a nipple in spite of poor vision: If an object touches a newborn's cheek, the head automatically roots, turning in the direction of that object. Newborns also have well-developed senses of hearing and smell that can be used to identify people. Their visual pathways and eyes are not yet fully developed, but they can see blurry images (some research estimates around 20/300 vision). Around three to four months after birth, reflexes give way to voluntary movements, and limitations on the sensory systems disappear.

The first two years of life continue the rapid course of growth begun prenatally. Body proportions change as the legs and arms grow to "catch up" with the head and trunk. Development of muscles and the motor centers of the cortex enable the infant to reach, grasp, sit, crawl, walk, and vocalize. The order of

these physical and motor changes is surprisingly regular throughout the world, and they are viewed as evidence of the role of **maturation**, growth due to aging rather than learning that is relatively independent of the environment.

Childhood

Childhood is the period from about two to twelve years. Although physical growth slows markedly, changes in behavior emerge almost daily. Improvements are seen in gross and fine motor coordination and in eye-hand coordination. By age five, children can catch a ball, cut with scissors, and write letters and numbers. Individual differences in skills and abilities emerge, providing a dramatic illustration of the effects of varying genetic endowment and experiences. Depending on their experiences, children can become proficient at tasks such as playing the piano, playing soccer, or playing video games.

Adolescence

Adolescence is the stage between childhood and adulthood, roughly from twelve to eighteen. As a stage of development, adolescence is greatly influenced by one's culture. In more primitive societies, for example, the transition from childhood to adulthood is rapid and marked by traditionally prescribed rites of passage (puberty rites). In American and European societies, the transition period has been steadily increasing over the past 100 years, giving rise to a specific adolescent subculture. In addition, the conflicting signals regarding when one truly becomes an adult contribute to a variety of stress-related problems. Adolescence is associated with both sexual maturation (**puberty**) and an overall growth spurt. Both of these result from a sequence of hormonal changes initiated by the hypothalamus and orchestrated by the pituitary gland (see Chapter 3).

Adulthood

The adult years have only recently become a popular research area for developmental psychologists. In part, this interest reflects changing demographic trends. A significant increase in population occurred in the United States during the Baby Boom, a period of highly increased birthrate between 1946 and 1964. The social and economic consequences of the aging of the Baby Boomers born during this span has underscored the importance of understanding development during adulthood. Psychologists and sociologists who specialize in the study of older adults (those sixty years of age and older) are called **gerontologists**.

Adults reach their physical peak between eighteen and twenty-five years of age. For most adults, physical decline is slow and gradual. By middle age there are noticeable changes in reaction time and sensory functions (for example, vision and hearing). Advanced age generally leads to further deterioration in the senses (again, vision and hearing are good examples), motor control, and cognitive phenomena such as memory. Internal systems, such as digestion and circulation, also become less efficient, and any remaining reflexes weaken or disappear.

■ COGNITIVE DEVELOPMENT

The most comprehensive account of general cognitive development is the work of Jean Piaget, on which we focus here. Piaget proposed that cognitive development was the result of an adaptation process.

Just as animals adapt their appearance or behavior to a changing environment, Piaget saw the child as adapting cognitively as his or her world expands. This adaptation requires formulating new rules and structures to organize knowledge, to reason, and to solve problems. Along with our biological propensity to adapt comes a propensity to organize information. Adaptation and organization are called Piaget's functional invariants, processes characteristic of and operating similarly in all humans.

Piaget saw adaptation as involving two complementary processes: assimilation and accommodation. **Assimilation** occurs when new information is incorporated into existing knowledge and is dealt with through existing behaviors. A breast-fed infant can assimilate a bottle nipple, identify it as a nipple, and operate it through the existing sucking routine. **Accommodation** occurs when new information produces a reorganization of existing knowledge and the acquisition of new responses. A ten-month-old infant given a cup of milk learns that milk also comes in a container without a nipple, and to drink, the infant must use a behavior other than sucking. Both processes are necessary for cognitive or intellectual growth. It was in this context that Piaget introduced the term "schema" that we define in Chapter 8. Essentially, he believed that children must integrate new information into existing schemas (assimilation) and expand existing schemas to encompass new and different elements (accommodation).

Piaget's Stages of Cognitive Development

Piaget was a stage theorist, proposing that intelligence develops through a sequence of four cognitive stages maturationally related to age. Children progress through the stages as they experience uncertainty and attempt to adapt their understanding of the world to reduce uncertainty. Progress through the four stages is reflected not only in intellectual growth but also in language, social, emotional, and moral development. (See Table 11-1 for a summary of Piaget's stages). Although contemporary research has deemphasized the discrete nature of Piaget's stages, they still serve as a good approximation through which to study cognitive development.

Sensorimotor Stage

For Piaget, the **sensorimotor stage** lasted from birth until around two years of age, and is composed of six substages. During the sensorimotor stage, children's understanding of the world is based totally on their sensory and motor interactions with it. Schemas at this stage are all organized systems of overt behavior. The earliest schemas are composed of basic reflexes, such as sucking, through which children explore the world around them. As the body and brain mature, children become better able to control and direct their movements and to coordinate sensory and motor information. Schemas expand to include coordinated voluntary actions.

Sensorimotor development is characterized by a series of behaviors called **circular reactions**, seemingly meaningless repetitions of chance events that catch an infant's eye. For example, an infant may by chance brush her face, and then repeat the action. Circular reactions eventually apply to external objects, such as accidentally kicking a toy that produces an amusing sound, and then kicking to try to reproduce the sound. To Piaget, circular reactions represent the emergence of intelligent action. Through these interactions with objects, children learn how to learn by combining different actions, such as "grasp" and "look," and varying the actions used with an object, such as "suck" or "shake." Children learn to discriminate between and classify objects based on their perceptual properties, such as "feels smooth," and the ways they respond to motor actions, such as "it rolls." Linking actions with objects to

Piaget's Stages of Cognitive Development

Stage	Ages	Tasks and Characteristics
Sensorimotor	0-2 years	Overt behavioral schemas; circular reactions; egocentrism; development of *object permanence*; emergence of symbolic function.
Preoperational	2-5 years	*Preconceptual phase:* Symbolic schemata; language; still egocentric. *Intuitive phase:* More logical thinking, decline in egocentrism; still no operational ability.
Concrete Operations	6-12 years	Mastery of *conservation*, hierarchical classification; concrete, present-oriented thinking; trial-and-error problem-solving. Operational ability limited to concrete concepts.
Formal Operations	12+ years	Abstract thinking, hypothesis testing; logical reasoning. Formal operational ability develops.

Fig. 11-1: Piaget's Stages of Cognitive Development

produce reactions—for example, kicking a mobile to make it spin—leads to a basic understanding of cause-and-effect relationships.

A child at this age is **egocentric**, unable to conceptualize a world existing outside him- or herself that is affected by the actions of others. Sensorimotor children also lack an appreciation of the permanence of objects. To the young infant, out of sight is out of mind. The disappearance of an object is not troublesome; attention moves rapidly elsewhere. However, after a child's first birthday, the protests often made when mother leaves the room or a toy is taken away demonstrate the emergence of the concept of **object permanence**. The child knows these things or people continue to exist somewhere, and expresses this in demanding to have them back. This is a major achievement of the sensorimotor stage.

The other major achievement of the sensorimotor stage is the emergence of the symbolic function, the ability to represent objects and events mentally (such as with words or pictures). This representational skill is important for observational learning and language acquisition, as well as the ability to think and solve problems. Through the development of the symbolic function, a child has the capacity to progress to the next stage.

Preoperational Stage

The **preoperational stage** is divided into two substages: the preconceptual phase (two to three years of age) and the intuitive phase (four to five years).

Preconceptual children are capable of symbolic schemas, rather than being limited to the behavioral schemas of infancy. They can organize information mentally by thinking about the properties of objects

and events or about the relationships between them. Language appears, and children begin to draw pictures that represent things. However, they tend to be egocentric in that they use their own experiences and ideas as the basis for this organization. Thus a drawing of three trees of different sizes is said to depict the "daddy," "mommy," and "baby" tree. Although they understand the concepts of classification and causality, their egocentrism interferes with appreciation of more objective systems for organizing information. To a three-year-old, a bird cannot be a bird if it cannot fly. The sun goes down to make it dark so we can sleep. These interpretations seem perfectly logical to the preconceptual child.

In the intuitive phase, thinking begins to become more logical and objective. Classification and problem solving skills improve, and egocentrism begins to decline. However, intuitive phase children still cannot represent a series of actions mentally and thus cannot solve problems requiring attention to sequences. This development comes at the next stage.

Concrete Operational Stage

It is during the stage of **concrete operations** (six to twelve years) that the ability to use logic matures. Concrete operational children are much less egocentric and are more objective about the world around them. Their representational skills have improved to the point that they can follow a sequence of actions and coordinate information about more than one dimension of an object or event. During this stage, children master the idea of **conservation**, understanding that changes in the appearance of objects do not necessarily imply changes in properties. For example, one cup of fruit juice is the same amount (the amount is conserved) whether it is poured into a tall thin glass or a short squat cup.

Concrete operational children have also mastered hierarchical classification, as in understanding that the class of "birds" may have two subgroups, "flying birds" and "nonflying birds." They are able to use logical rules or operations, such as addition and subtraction, and to see relationships between rules, such as subtraction being the opposite of addition. Thinking at this stage is present-oriented and tied to concrete, physical evidence. Although much of their problem solving is often trial-and-error, their performance improves greatly.

Formal Operational Stage

In **formal operations**, thinking becomes more abstract, systematic, and probabilistic. Adolescents are able to think hypothetically (making guesses about explanations for events), to consider possibilities, and to imagine future outcomes of present actions. They also learn to solve problems by systematically generating and testing hypotheses, a far cry from the more random trial-and-error approach of childhood. They can use past experiences and present events to assign probabilities to possible outcomes, and they can reason deductively. This sometimes contributes to the self-absorption shown by many adolescents. Being able to think in such abstract, hypothetical ways is a double-edged sword that can lead to various preoccupations: "Should I abstain from sex?", "Are drugs really bad?", and "Is there a God?"

Updating Piaget's Theory

Piaget proposed his four stages as representing an invariant sequence of changes maturationally tied to age. Recent research indicates that although the sequence of changes is reliable, the changes do not necessarily represent separate, distinct stages of development. Children may show features of several stages at a given point in development. Children also can be taught certain concepts, such as

conservation, at ages when Piaget assumed their conceptual skills were too immature. In addition, Piaget appears to have underestimated the abilities of infants and young children and overestimated the abilities of adolescents and adults. Using different types of tests, other researchers have demonstrated object permanence almost six months before Piaget's proposed age and conservation in four- to five-year-old children. Testing of adolescents and adults indicates that formal operations is not a universal outcome of development. The ability to reason in formally operational ways is highly dependent on environmental factors such as culture and education. Some contemporary researchers believe that cognitive development is a matter of advances in information processing, allowing for successful completion of increasingly complex tasks and problems.

Adulthood

Cognitive ability does not necessarily decrease substantially in older adults, contrary to popular belief. Older people can react just as quickly, can be just as "sharp," as their younger counterparts. Older adults can also take advantage of the wisdom and experience they have gained over the years. Research suggests that at least through age sixty, cognitive abilities continue to increase, and adult thinking is in some ways qualitatively different than that of adolescents or young adults. In adulthood, thinking becomes dialectical, meaning that adults understand that knowledge and intelligence are relative rather than absolute.

It is not until later in adulthood that cognitive abilities may decline—and even then not in a systematic way or for all individuals. Older adults perform as well as their younger counterparts on familiar tasks, but often not on those requiring divergent thinking or flexibility. It may be that many apparent cognitive deficits stem from limitations on attention, the inability to divide attention, or slower information processing (fluid abilities). Given sufficient time and opportunity, older adults often do just as well as younger adults. Furthermore, crystallized abilities including specific skills, comprehension, reading, and writing do not seem to suffer much even in late adulthood. Although memory problems increase in late adulthood, these are largely in terms of episodic memory, rather than semantic knowledge. By far the largest threat to cognitive ability in adulthood is the onset of Alzheimer's disease, which deteriorates cognitive functions and other aspects of life, resulting ultimately in premature death.

■ DEVELOPMENT OF LANGUAGE

A specific cognitive task, the development of which deserves specific attention, is communication through language. (See Chapter 9 for a general discussion of language.) When children first begin to speak, they utter only short sentences of two to three words. Later, sentences become longer and their structure becomes more complex. Psychologists who believe that development is continuous suggest that these changes reflect gradual increases in the child's ability to remember words and to use them grammatically in sentences. No special predisposition for learning language nor fundamental change in the child's knowledge of language is assumed. Other psychologists maintain that these changes reflect fundamental changes in the child's organization of language information. They see language acquisition as a movement through a series of qualitatively different stages. Although the sequence of these stages is maturationally determined, the environment may influence the rate at which a child progresses through them.

Theories of Language Acquisition

There are many different theories of language acquisition that vary in their level of detail and coherence. These theories also vary in their emphasis on the relative role of biological capacity and environmental influences, as with many other psychological theories.

Learning Theory

B. F. Skinner offered a learning theory explanation for language changes using the principles of operant conditioning (see Chapter 7). In this view, children are reinforced first for making sounds, then for combining sounds, and later for using these sound combinations as words in appropriate contexts (that is, shaping). Parents and others continue conditioning language behavior by later reinforcing children's combinations of words in grammatical sentences.

Social Learning

Many psychologists see operant conditioning as an unlikely explanation of language change. Children learn language so quickly that it is difficult to imagine enough conditioning experiences occurring in such a short time. Social or observational learning theorists have expanded the traditional learning account by including the process of imitation. In addition to being reinforced for appropriate language behavior, children imitate the language of the models around them. Although the inclusion of imitation reduces the hypothetical amount of time needed for learning language, research indicates that children are limited in ability to imitate language that is more sophisticated than their usual speech. In addition, children in different cultures appear to show similar patterns of change in language behavior, even though the extent of their contact with adult speakers varies. These cross-cultural regularities have led other psychologists to look to biology and maturation to explain language development.

Innate Linguistic Ability

Noam Chomsky claims that humans have an innate (inborn) ability for language acquisition. This human predisposition for learning language, like the human predisposition to walk upright on two legs, results from our species' genetic heritage. It is independent of our level of intelligence or our frequency of contacts with adult speakers. This genetic language acquisition device, or **universal grammar**, enables us to learn any human language once we have contact with its sounds and can control our vocal apparatus, regardless of model observation or reinforcement.

Although psychologists have not yet discovered any language genes, biological factors clearly influence language behavior. Specific areas of the cerebral cortex (see Chapter 3) control language production and comprehension, as is obvious from the changes in language behavior following damage to these areas (for example, as a result of stroke or head injury). Infants do not begin to develop language until the brain has reached a certain level of maturity, and language learning is generally easiest during the critical period of rapid brain growth.

Maturational Sequences and Stages

Psychologists also see maturation reflected in studies of children's language behavior. Infants from a variety of environments, although they ultimately learn different languages, all begin by babbling the same sound combinations (for example, "bababa" or "deedee"). The sequence of language changes, from

babbling to words to sentences, is remarkably similar cross-culturally. And milestones in language development are correlated with milestones in motor development, a finding interpreted as a sign of the importance of neurological maturation.

The maturational quality of language, and the appearance of a predictable sequence of changes, is the focus of the cognitive-developmental view of language. Roger Brown and his colleagues have proposed that language acquisition involves progression through a series of stages. Each stage is characterized by a new set of rules and skills that organize the child's language knowledge and permit production of utterances exhibiting new forms and levels of complexity.

Key Stages in Language Development

Although psychologists still debate the precise roles of conditioning, imitation, and maturation in language acquisition, much is currently known about the characteristics of children's language behavior. By studying the development of language in children, we can come to learn much about language acquisition, production, and comprehension in general.

Most developmental psychologists see language development as reflecting an interaction of maturation and experience, with maturation playing a central role in infancy and experience becoming increasingly influential over time. There are a variety of systems for categorizing the course of language development. The following sections describe what cognitive-developmental psychologists see as qualitatively different types of language behavior. In each stage description, note instances where children's language fits better with a maturational development perspective.

Prebabbling Phase (Birth to Six Months)

During the first three months of life, infants communicate primarily by crying. They lack sufficient neuromuscular development to control their vocal apparatus and produce individual speech sounds. Nevertheless, crying is an effective means of communication. Experienced parents and observers can discriminate between cries associated with such states as hunger, pain, or fear. Toward the end of this phase, infants begin making speech-like sounds including the vowels *a* and *e*. The sounds are often referred to as cooing. Language behavior at this age does not vary across cultures.

Babbling Phase (Six to Twelve Months)

By six months of age, infants expand their speech sounds to include the consonants *m*, *b*, *d*, and *p*. The order of emergence of speech sounds, or phonemes, is determined to a great extent by the infant's motor abilities. The vowels *a* and *e* are produced in the back of the mouth and require little motor control. The consonant *m,* for example, simply requires closing the lips and allowing air to vibrate in the nasal cavity. Compared to later phonemes, such as *r* or *t*, early phonemes require minimal control of the lips, tongue, and air passages. These developments are cross-culturally regular.

By eight months, most infants begin to combine sounds and repeat combinations over and over, producing such common babbles as "mama" and "dada." Although initially all infants produce the same babbles, beginning at eight months the variety of sounds produced changes to better match the sounds commonly occurring in the language the infant hears. The period from eight to twelve months is characterized by continuing changes in phoneme production and increasingly word-like babbles.

Children as young as eight or nine months are able to effectively use nonvocal language, or sign language, before they are able to articulate words vocally. Although deaf children and those with hearing difficulties have always relied on nonvocal communication, there is a growing trend for parents of children with normal hearing to use sign language with their children. Children will even babble in sign language before using any correct signs, and research suggests that the use of sign language in children with normal hearing does not impede vocal language development.

First Words (Twelve to Eighteen Months)

The first words children use are idiosyncratic and typically are not the words they have heard other people use. These invented words or semi-words, approximations of adult words, demonstrate the creative quality of language production and underscore the belief that child language is not simply an imitation of the language of adults. Children learn words at an intermediate level of specificity first, such as "dog" rather than "animal" (more general) or "Fido" (more specific). Children twelve to eighteen months often overgeneralize words, as in calling a cow a "dog." Such behavior implies that early words are defined in terms of perceptual features, such as "four legs," "brown and white," and "has a tail." First words are often used as **holophrases** at this age, single words used to convey whole thoughts (or words meant to be whole phrases). The word, combined with intonation, gestures, and context, functions as a sentence would for an adult. Context is, therefore, important. For example, a child who says "sock" in a whiny voice, while waving arms and indicating bare feet, means something quite different from a child who says the same word, with the same intonation and gestures, but is wearing socks.

Early Sentences (Eighteen to Twenty-Four Months)

Children typically begin producing two- to three-word sentences at eighteen to twenty-four months. These sentences are **telegraphic** in that they contain only the minimum number of words important to expressing the underlying idea, similar to the spare style of a telegram whose cost is calculated by the word. Function words (for example, articles and prepositions) and grammatical suffixes are eliminated even in speakers of languages that require suffixes to identify parts of speech (for example, German or Russian). The universality of telegraphic speech clearly implies maturational constraints on children's language behavior.

Intonation, gestures, and context are still important to interpreting children's speech at this age. Adults often engage in expansion, repeating a child's telegraphic sentence in its complete grammatical form. When asked to imitate a complete sentence, children usually continue to produce a telegraphic version of the modeled sentence. Although expansion does not explain how children move from telegraphic speech to grammatical speech, exposure to grammatical speech at this age is important for later language development. Children exposed primarily to baby talk do not advance to the next stage as quickly as children exposed to more adult grammar.

Emergence of Grammar (Ages Two to Five)

By the age of two, children may have a vocabulary of 250 to 300 words. Between the ages of two and five, children acquire the function words (for example, prepositions and modifiers) and suffixes necessary for grammatical speech. An important distinction in grammar is the difference between regular and irregular words. Some words are regular in that they are changed according to standard rules that apply to many other words (for example, adding -*s* to pluralize many words, or -*ed* to form the past tense). In contrast,

other words are irregular, and are changed in unique ways rather than according to the rules. The distinction between regular and irregular words is difficult to grasp, and children often **over-regularize** irregular words (apply common rules to words that are exceptions to those rules). For example, a child might form the past tense of "go" by adding the regular ending, producing "goed."

Cognitive-developmental psychologists see over-regularization as a reflection of the child's active attempt to organize language information, and to formulate and test language hypotheses. Children also are learning more about the **pragmatics** of language, the social rules of communication. Listening skills, topic focus, taking turns in conversations, and politeness all improve during this period.

Refinement of Language (Beyond Age Five)

Children at age five are amazingly competent speakers of language. Beyond age five, most language changes involve increasing vocabulary and mastering the fine points of grammar and syntax, the rules for combining words into meaningful sentences. Children become able to produce longer sentences with more complex grammatical structures and to understand passive and embedded sentences. The child's environment, including the family, mass media, involvement in reading, and school, greatly influence rate of progress and level of sophistication attained. At this age, experience clearly surpasses maturation as a determinant of language behavior.

■ SOCIAL DEVELOPMENT

Theories of cognitive development and language acquisition consider children as thinking beings. Children are also social creatures from the moment of birth. An understanding of development is incomplete without a consideration of how interaction with others is developed. Beginning in infancy, children are interested in contact with other people. In fact, the psychiatric disorder known as early infantile autism is diagnosable in infancy because children with autism do not shift to being more interested in people than in objects. Perhaps the most influential work—although not the most widely supported today—is that of a neo-Freudian named Erik Erikson (1902–1994).

Erikson's Stages of Psychosocial Development

Erikson, like Piaget, proposed a series of stages through which individuals progress during their development. Erikson's stages concerned psychosocial development, or the shaping of personalities and social relationships. Erikson believed that life presented a series of crises or challenges that needed to be overcome at certain points in life. If one was successful in resolving each issue, this would allow one to competently face the next crisis. Alternatively, one could be troubled psychologically and be unable to cope effectively with subsequent crises. This sets up a pair of potential outcomes for each psychosocial crisis, as shown in Table 11-2.

Erikson proposes that each stage is indicative of the need to make a choice or decision about one's relationship with the social world. The child acquires either a positive social attitude or a negative one, depending on experiences. For example, Erikson claimed that the first crisis that children must face, in their first year, is the ability to develop trust that their needs would be met, or else they would be forever mistrustful in future relationships. Resolving this crisis corresponds to whether or not an individual feels secure with one's caretaker. Or, two- to four-year-olds (in the crisis of autonomy versus shame and doubt)

Erikson's Psychosocial Crises

Crisis	Ages	Choice or Decision Involved
Trust vs. Mistrust	0-1 years	Can my parents and environment be trusted, or is my future insecure?
Autonomy vs. Shame and Doubt	2-3 years	Can I control myself and be physically competent, or must I doubt my abilities?
Initiative vs. Guilt	3-5 years	Am I encouraged to meet new challenges, or am I unworthy and incompetent?
Industry vs. Inferiority	6-12 years	Am I productive and useful to myself and others, or am I powerless and inadequate?
Identity vs. Role Confusion/Diffusion	12-19 years	Can I identify and develop my unique but meaningful roles, or is my distinction and social role unclear?
Intimacy vs. Isolation	20s and 30s	Can I form an intimate, loving relationship with another, or must I remain lonely and incomplete?
Generativity vs. Stagnation	30s to 50s	Can I be productive and creative in my work and relationships, or is my life stagnated, routine, and unpromising?
Integrity vs. Despair	60s+	Can I come to terms with the approach of my own death, or do I feel despair over the disappointments in my life?

* The abbreviation "vs." = versus, indicating the choice Erikson sees as implicit in each psychosocial crisis.

Table 11-2: Erikson's Psychosocial Crises

who are encouraged by parents to become independent develop a sense of autonomy. Conversely, those who are reprimanded for asserting their independence are likely to doubt their competence. This may also correspond to requisite accomplishments at this stage, such as toilet training. Each successive stage presents its own challenges, and its own risks if the crisis is not successfully resolved.

Parenting and Attachment in Infancy

The most important social development during infancy is the strengthening bond between infant and caregiver(s). **Attachment** refers to this close, affectionate, and enduring relationship between an infant and those who provide for him or her. Most infants have a permanent and primary caregiver (usually the mother) to whom they can form an attachment. Otherwise, there may be negative impacts on the child's

development, such as becoming depressed, withdrawn, and temperamental. Even the type of attachment can influence later social tendencies and personality. **Secure attachment** describes a pattern where infants feel comfortable leaving their caregiver to explore, and are happy and receptive when the caregiver returns after a brief absence. **Insecure attachment** is not lack of attachment, but rather an avoidant (tends to avoid or ignore) or ambivalent (becomes distressed upon separation but rejects the caregiver upon return) relationship. Securely attached infants are more likely to develop other positive social relationships, such as romantic interpersonal relationships.

The method by which parents interact with and discipline children can also impact the child's social and emotional development. **Authoritarian parents** are strict and firm, relying on punishment to establish obedience in their children and authority in themselves. In contrast, **permissive parents** are more concerned with appearing congenial, giving their children greater freedom and little real discipline. Between these two extremes, **authoritative parents** are firm, yet understanding; they reason with their child and promote compromise. Although there is no globally correct way to rear children—indeed, many cultural differences exist as well on this subject—some evidence has shown more positive social and emotional outcomes (for example, more cooperative, independent, trustful, and so on) in children with authoritative parents.

Peer Interaction in Childhood

In childhood, the nature of social interaction shifts from the parent-child relationship to that among children and their peers. Children learn to adjust to the realities of the social world through play experiences, particularly through social play with peers. Play provides children with opportunities to learn about and test different roles, to confront the expectations of others, and to adapt to group norms.

In addition to theorizing about the functions of play, psychologists have researched the structure of play. At two to three years, most children enjoy playing in the company of other children. On close examination, however, it appears that these children often play alongside one another but engage in different activities, referred to as parallel play. By three to four years of age, children often play in groups of several people. While they appear to be playing together, they are more likely to be playing with the same materials as the others but using them in different ways. While such associative play is a shared experience, it does not necessarily involve the theme and cooperative effort characteristic of social play, which develops next. It is not uncommon to see one four-year-old pushing another on a swing, or children on a see-saw together, or role playing. These activities, requiring coordinated actions on the part of two or more children, exemplify the principle of cooperative play. Board games and team sports, favorites of the over-six age group, require a basic facility with cooperative play.

An important step in social development is the departure from the egocentric thinking that characterizes early thinking in Piaget's framework. Specifically, recent work on social (and cognitive) development has emphasized the role of a **theory of mind**, the realization that others are their own beings, with their own interests, thoughts, likes, dislikes, desires, intentions, and so on. Even if this type of understanding is present innately, only through social experience and interaction can it be developed. A more sophisticated theory of mind will also include the ability to reason about the actions of others, such as predicting what others will do, and why.

Adolescence and Adulthood

Some psychologists conceptualize the tasks of adolescence as a process of separation-individuation, a process of distancing oneself from parents and establishing a sense of individuality. Much has been written over the years about the generation gap (the perceived divergence between adolescents' values and those of their parents) and the tendency of adolescents to be over-influenced by their peers. Research indicates that, in fact, parents and peers influence different spheres of adolescent life. Adolescents do experience and give in to peer pressure to conform, especially around puberty, but peers tend to influence adolescent decisions only about superficial matters like dress, language, and recreation. Parents usually continue to influence adolescent values and long-term goals. In fact, the basic values of most adolescents' friends are quite similar to those of their parents, possibly because adolescents' friendship choices are influenced by values learned at home.

The adult years in most cases are characterized by stability in social behavior. Complex social relationships, such as interpersonal love, characterize social development for many during adulthood. Adults who are socially and sexually active in their twenties tend to maintain those patterns into their sixties. Social isolation becomes a more serious problem with advancing years. It is associated with both poor health and decline in cognitive functions.

■ DEVELOPMENT OF IDENTITY, PERSONALITY, AND MORALS

Beyond development of the cognitive mind and interactions with others, it is important that individuals develop a stable sense of who they are and what they stand for. The development of identity, personality, and moral reasoning are important steps toward healthy psychological growth.

Developing Self-Identity

A sense of identity also evolves rather early in life. As early as two months of age, infants demonstrate stable patterns of reaction to objects and events, referred to as infant **temperaments**. Children form a self-concept and basic gender identity between two and five years of age. At age five, most children's self-descriptions are categorical (for example, in terms of age, gender, behavioral patterns) and greatly influenced by the messages they receive from other people. Between five and twelve years, children's self-concepts begin to broaden. They are more likely to describe themselves in terms of psychological attributes (for example, nice or smart) and to evaluate themselves relative to their peers. This social comparison process is influential in the establishment of a sense of self-esteem.

Adolescence brings dramatic physical and cognitive changes that can disrupt childhood self-image. Erikson saw adolescence as precipitating an **identity crisis**, a period when one reevaluates oneself with an eye toward entering the adult world. Adolescents must come to terms with their adult-like bodies and with the impending tasks of adulthood. Cognitive changes enable the adolescent to consider relationships between "who I am" and "who I want to be." Typically, establishing an identity involves adopting a sense of personal values and making an initial vocational decision. Adolescents who are unable to resolve these issues are viewed as experiencing diffusion, an incomplete sense of identity.

Gender and Ethnic Identity

Much to the dismay of many parents, **gender roles**—the behavior patterns considered appropriate for one gender or the other—are typically stereotyped. This means children have inflexible, narrow definitions of what is considered feminine and masculine. For two- to five-year-olds, both patterns of self-concept and of gender role are likely to reflect the categorical thinking characteristic at these ages. While there is indeed a biological predisposition that may contribute to gender roles, there is a large social factor as well. Social convention and expectations dictate acceptable behavior for each gender. Similarly, through observation (for example, advertising) and interaction (for example, play) children also learn **gender schemas**, or generalizations about gender-appropriate toys, activities, likes, dislikes, occupations, and so on. The direct efforts of many modern parents to deemphasize gender roles and discourage stereotypes and gender schemas may help to eliminate artificial gender differences in some skills, but other more deeply rooted (in our evolutionary history) traits may be resistant to elimination.

Researchers also believe it is important for children to develop a sense of ethnic identity. Especially in "melting-pot" nations such as the United States, it is increasingly common for individuals to use aspects of their race, religion, or culture in developing an ethnic identity that contributes to their personal identity. Children at a young age become aware of their ethnic identity, through obvious cues such as skin color. This often leads to identification and affiliation with similar individuals, for better (increased self-esteem) or for worse (prejudicial thought).

Personality Development

Many psychologists see personality development as progressing through a series of stages. As with the theories of Piaget and Erikson, these stages are perhaps more theoretical than empirical. Perhaps one of the earliest coherent theories of personality development was that of the psychoanalysts, led by Freud. They point to the importance of a series of psychosexual stages where children must learn to control their instinctual biological impulses and act in appropriate ways (see Table 11-3). At each psychosexual stage—named for the body's erogenous zones or regions associated with physical pleasure—the resolution of this conflict between instinct and social mores shapes later personality. For example, children subjected to stress during toilet training (the anal period) may develop into compulsively neat adults. Many modern theorists put little stock in the progression offered by Freud. Instead, the development of one's personality is seen as being the result of a number of factors based more on experience and environment than unconscious desires.

Although psychologists once assumed that personality was stable from adolescence on, current researchers and theorists see adulthood as a time of continuing personality development. Erikson, one of the first lifespan theorists, sees adults as confronting the tasks of establishing intimacy with others, a sense of generativity or lasting accomplishment, and a sense of personal integrity. Other theorists, such as Daniel J. Levinson and Gail Sheehy, see adults as alternating between periods of stability and periods of transition. These transitions are passages during which adults must adapt to changing abilities and expectations. Many must cope with the potentially stressful events of children leaving home (the empty nest), retirement, and caring for aged parents. Overall, however, most people successfully adapt to the changes of the adult years.

Freud's Psychosexual Stages of Development

Stage	Ages	Characteristics
Oral	0-1 year	Focus on mouth as region of pleasurable stimulation, nourishment, contact with mother. *Adult fixation:* oral gratification sought when stressed; excessive eating, drinking, or smoking.
Anal	2-3 years	Focus on elimination functions as sources of personal physical control, in conflict with limits of toilet training. *Adult fixation:* excessive efforts to be neat, clean, tidy in stress, or "explosive" rejection in the form of sloppiness, overspending.
Phallic	3-6 years	Focus on genitals and self-stimulation as pleasurable activity. Curiosity about sex differences. Attachment to opposite sex parent and rejection of same sex parent, resolved by identifying through gender role with same sex parent. *Adult fixation:* selfish behavior, especially in relationships and sexual intimacy.
Latency	6-12 years	Hiatus in psychosexual associations with erogenous zones while child is preoccupied with school and peer relations. (No zone of focus, no fixation).
Genital	12+ years	Focus on genitals and other features as aspect of relationship with appropriate intimate partner. Necessary for mature experience of love. (No associated fixation).

Table 11-3: Freud's Psychosexual Stages of Development

Moral Development

Moral development is the process by which children acquire knowledge of right and wrong. Developmental psychologists have studied this process as well as how this knowledge affects children's behavior. Some of the approaches we have already considered above have made statements about moral development as well.

Psychoanalytic theory proposed that morality resided in the superego, a part of the psyche formed through identification with the same-sex parent during preschool. (Chapter 12 discusses in detail the psychoanalytic approach toward personality.) Learning theory proposed that morality or a set of values was a meaningless concept. Instead, children acquire patterns of responses to specific situations based on their experiences with reinforcement, punishment, and models. This doctrine of specificity predicts that children will not necessarily act in morally consistent ways in different situations. There appears to be some validity to this proposal. Although current research indicates that children can evaluate situations and explain why a course of action is "right" or "wrong," there is little relationship between a child's stated values and his or her behavior.

Kohlberg's Theory of Moral Development

Cognitive theories focus on the emergence of moral judgment or reasoning, the child's ability to understand and apply concepts of "right" and "wrong" to specific situations. For example, Piaget proposed two stages of moral development maturationally tied to concrete operational and formal operational thinking. As research progressed, however, it became clear that the two-stage model was unable to capture the variety of judgments seen in childhood, adolescence, and adulthood. Lawrence Kohlberg (1927–1987) noted that there was not the age-related consistency in moral judgments predicted by Piaget's theory. In fact, when confronted with moral dilemmas, word problems posing two possible courses of action, some subjects in each age group could reason in ways to support either choice (see also Test Yourself, #10). There were, however, definite patterns in the types of reasons generated. Kohlberg subsequently developed a model of moral reasoning containing three levels of moral development, each containing two stages (see Table 11-4).

Kohlberg's Stages of Moral Development

Ages	Level, Stage and Orientation
4-10	Level 1: **Preconventional** Stage 1: Obedience and punishment orientation Stage 2: Naive hedonistic and instrumental orientation
10+	Level 2: **Conventional** Stage 3: Good boy/good girl orientation Stage 4: Law and authority orientation
13+	Level 3: **Postconventional** Stage 5: Social contract orientation Stage 6: Universal ethical principle orientation

Table 11-4: Kohlberg's Stages of Moral Development

Kohlberg's stages were viewed as sequential and universal across cultures, tied both to cognitive and social experiences. Although Kohlberg's theory has not been supported on such a broad, sweeping scale, it remains the dominant model of moral development today.

Preconventional Moral Reasoning

In the **preconventional level** (age four to ten years), children's reasoning does not reflect an awareness of rules as a system with inherent benefits to those who use it. Thinking reflects an emphasis on the physical consequences of actions and the power of authority figures. At Stage 1, the obedience and punishment orientation, children make choices based on the principles of avoiding punishment and obeying authority figures. In Stage 2, naive hedonistic and instrumental orientation, choices are governed by the principle of self-satisfaction (that is, hedonism, or seeking pleasure and avoiding pain), and satisfying the needs of others who are important in the life of the child.

Conventional Moral Reasoning

At the **conventional level** (beyond ten years of age), reasoning reflects not only the pressure to conform for personal gain but also a loyalty to codes of behavior based on a sense of belonging to a family or society. Doing "the right thing" becomes an end in itself. In Stage 3, the good boy/good girl orientation, children make choices reflecting a desire for the approval of others. At Stage 4, the law and authority orientation, the decisions reflect a sense of duty to obey recognized authority and the avoidance of actions that might undermine the social order. According to Kohlberg's research, most adolescents and adults demonstrate some form of conventional thinking.

Postconventional Moral Reasoining

The **postconventional level** probably can be attained only by adults who are formal operational and have had experience both with freedom of choice and the effects of the lack of such freedom. Individuals at this level are guided by concern for the rights of the individual rather than loyalty to the group. In Stage 5, social contract orientation, concern is focused on balancing the value of social stability with the rights of the individual. Morality is viewed as a social contract in which individuals derive benefits from compliance with rules. Rules can and should be adjusted when adherence to those rules fails to protect the rights of individuals. At Stage 6, universal ethical principle orientation, decisions are based on conscience and principles such as justice, reciprocity, human rights, and personal dignity. Violation of principles, rather than laws, is condemned.

Updating Kohlberg's Theory

As with any stage theory, it is quite a stretch to assume that such a rigid progression always applies across individuals, groups, and cultures. For example, Kohlberg's first four stages have been supported in cross-cultural research, but postconventional moral reasoning has not. Psychologist Carol Gilligan, in particular, has criticized Kohlberg's research and theory on the grounds that his assumptions—and thus his conclusions—are sexist. Specifically, in explaining girls' and women's judgments that certain moral dilemmas were decided rightly or wrongly, Kolhberg suggested that they reasoned at a lower level of moral development than boys and men. For example, should a man steal an expensive drug to save the life of his sick wife if he cannot afford to pay the pharmacist's price? Kohlberg found that boys and men

tended to say yes, because human life is more important than money or property. But Kohlberg found that girls and women gave less absolute answers, and did not cite the "principle" that life is more valuable than property.

Gilligan's criticism of Kohlberg suggests that males and females are taught different values as they develop, not different levels—higher versus lower—of the same values or principles. Specifically, Gilligan argues that boys and men are taught to value independence, autonomy in identifying the important principles of moral decision making. Girls and women, however, are taught to value relationships and connections with others as being of lasting importance. Thus, many girls and women responded to the drug-theft dilemma by suggesting that the thief and the druggist cooperate to find a solution to their problem, rather than forcing the thief to take drastic action alone.

Gilligan's research serves as a reminder that developmental theories, like all theories, may be subject to the biases and expectations of the theorist. An important function of psychological research is to examine and question the value of past theories in applying them to present observations and experience.

Developmental psychology is much more than a topical area in psychology; it is a unique approach to the study of all psychological processes. Much initial work on human development focused on children, but modern developmental psychologists take a lifespan perspective. Different approaches contribute to developmental research, including psychoanalysis, learning theory, and cognitive viewpoints. Research also involves physiology and genetics as much as it does psychology, to enlighten nature-nurture questions.

Physical development begins at the moment of conception, and proceeds prenatally through germinal, embryonic, and fetal stages marked by extensive growth. Rapid growth continues in the neonatal infant and throughout infancy, as the developing child fully develops his or her faculties. Skills continue to develop through childhood, and adolescence marks a time of dramatic physical changes—puberty and a growth spurt. After reaching a peak in early adulthood, little physical change occurs through much of adulthood, until slow and gradual deterioration of senses and other changes become noticeable.

Discussion of cognitive development is almost always framed in the context of the stages theorized by Jean Piaget. He suggested a developmental cycle fueled by adaptation and organization, as one attempts to make sense of an ever-expanding world, through accommodation and assimilation. He envisioned cognitive development as a progression through a series of four stages, culminating in the ability for abstract, systematic thought. The development of one particular cognitive task, language, has been intensely studied. Different theories exist for linguistic development, ranging from learning theories to those suggesting an innate biological ability. By studying the development of language abilities in children, we can begin to understand how biology and the environment play a role.

Social and emotional development begins at birth—if not before—through the attachment bond between child and caregiver. Through attentive and involved parenting, children learn to trust and develop a sense of security that allows them to explore further social interactions. These lead to a variety of peer relationships in childhood, and social interactions such as play. Erikson's theory of psychosocial development suggests that one progresses through a series of challenges or crises. Successful resolution of each prepares one for life's next challenge.

Development of self-identity, personality, and morals may seem more complicated to study objectively. However, much work has been done in these areas. Research has examined the type of identity

characteristic of children of different ages, as well as how they develop gender and ethnic identity. Piaget developed a theory of moral development in conjunction with his cognitive theory. Kohlberg expanded upon this by presenting a series of levels of moral reasoning.

Recent empirical evidence suggests that some of the details of these theories are incorrect. For example, there seems to be much more variability and individual differences than previously assumed. Development seems to be, generally, more of a continuous process than one that leaps in discrete stages. The environment plays a large role in development, interacting with biological tendencies. Despite their shortcomings, the work of these pioneering psychologists has contributed a great deal to the understanding of human development across the life span.

Key Concepts

accommodation	fetal stage	pragmatics
adolescence	formal operational stage	preconventional level
assimilation	gender roles	preoperational stage
attachment	gender schemas	puberty
authoritarian parents	germinal stage	reflexes
authoritative parents	gerontologists	secure attachment
circular reactions	holophrases	sensorimotor stage
concrete operational	identity crisis	telegraphic
conservation	insecure attachment	temperaments
conventional level	maturation	teratogens
critical period	menopause	theory of mind
developmental psychology	object permanence	universal grammar
egocentric	permissive parents	zygote
embryonic stage	placenta	
fetal alcohol syndrome	postconventional level	

Key People

Erik Erikson

G. Stanley Hall

Lawrence Kohlberg

Jean Piaget

SELECTED READINGS

Adams, G. R., & Berzonsky, M. D. (2003). *Blackwell handbook of adolescence.* Blackwell Publishers.

Damon, W., & Lerner, R. (Eds.). (2006). *Handbook of child psychology: Theoretical models of human development, Vol. 1.* Wiley, John & Sons, Inc.

Harris, M., & Butterworth, G. (2003). *Developmental psychology: A student handbook.* Psychology Press (UK).

Lust, B. C., & Foley (Eds.). (2004). *First language acquisition: The essential readings.* Blackwell Publishers.

Sigelman, C. K., & Rider, E. A. (2005). *Life-span human development, 5th Ed.* Wadsworth.

Test Yourself

1) Which of the following statements best describes current views of developmental research, as put forth in the chapter?
 a) Human development proceeds in a specific manner through discrete stages.
 b) Human development warrants a lifespan perspective.
 c) We have discovered that development is a matter of nurture, not nature.
 d) Human development exhibits very little individual differences and variability.

2) Which of the following is the best order for terms describing physical development, in order of increasing age?
 a) fetus, embryo, infancy, adolescence, childhood, adulthood
 b) embryo, fetus, infancy, adolescence, childhood, adulthood
 c) fetus, embryo, infancy, childhood, adolescence, adulthood
 d) embryo, fetus, infancy, childhood, adolescence, adulthood

3) According to Jean Piaget, children acquire an understanding of object permanence in the _____ stage, and conservatism in the _____ stage.
 a) sensorimotor; preoperational
 b) preoperational; concrete operational
 c) sensorimotor; concrete operational
 d) preoperational; sensorimotor

4) Culture and/or the environment play a key role in which of the following?
 a) physical development
 b) cognitive development
 c) social development
 d) all of the above

5) Which of the following terms is mentioned as being most important for the social development of infants?
 a) attachment
 b) play
 c) intimacy
 d) all of the above

6) Which of the following was mentioned as a method of peer interaction that affects social development?
 a) aggression
 b) play
 c) both of the above
 d) neither of the above

7) The crisis of identity-versus-role-confusion occurs during _____, and the crisis of integrity-versus-despair occurs during _____, according to Erik Erikson.
 a) adolescence; old age
 b) adolescence; middle age
 c) childhood; adolescence
 d) adolescence; early adulthood

8) Which of the following suggested stages of moral development?
 a) Kohlberg
 b) Freud
 c) Piaget
 d) all of the above

9) Describe and contrast the processes of assimilation and accommodation in Piaget's theory. Include the notion of schemas in your answer.

10) Briefly state how an individual at each of Kohlberg's stages of moral development would supposedly reason about the morality of a man who stole a drug for his sick wife, from a pharmacist who is charging an exorbitant fee for the drug.

Test Yourself Answers

1) **b.** Most developmental psychologists would agree that human development warrants a lifespan perspective. Current theory has shifted away from discrete stages and has recognized variability as well as the role of both nature and nurture.

2) **d.** The correct order is embryo, fetus, infancy, childhood, adolescence, adulthood.

3) **c.** According to Jean Piaget, children acquire an understanding of object permanence in the sensorimotor stage and conservatism in the concrete operational stage.

4) **d.** All of the types of development are affected by culture and/or the environment (teratogens, education, and parenting, respectively).

5) **a.** Attachment is mentioned as being most important for the social development of infants. The other concepts are important later in life (childhood and early adulthood, respectively).

6) **c.** Both of the first two answers, aggression and play, were mentioned as methods of peer interaction that affect social development.

7) **a.** The crisis of identity-versus-role-confusion occurs during adolescence, and the crisis of integrity-versus-despair occurs during old age, according to Erik Erikson.

8) **d.** All of the researchers suggested stages of moral development. Piaget's were in line with his cognitive theory, Freud's were psychosexual, and Kohlberg's involved stages of moral reasoning.

9) Piaget saw cognitive development as a child's attempt to come to terms with an ever-expanding world. He suggested that when encountering something new, such as a new phenomena that needed explanation, one had to figure out a way to reconcile this new information with existing schemas. Assimilation and accommodation are both mechanisms for doing so. Assimilation involves integrating the new information into existing schemas, whereas accommodation involves changing existing schemas, or creating new ones, to make sense of the new information.

10) This example is one of the classic examples, used by Kohlberg in his own research. In Stage 1, most children would say stealing the drug was bad because the man will be punished for doing so. In Stage 2, they would understand that the man has a different point of view than the pharmacist, and stealing may be okay to the man. In Stage 3, one might say that the man was okay to steal because he had good intentions—saving a life. Stage 4 participants oppose the man's theft, because it is breaking the law, against social order. In Stage 5, participants make clear that although generally breaking a law is wrong, the man's wife has a moral right to live that should be upheld. People reasoning at Stage 6 would attempt to look at the dilemma from all sides, and determine that stealing the drug is the "just" outcome in this case.

Personality, Intelligence, and Individual Differences

In the long history of psychology as a human interest, personality has been one of the most enduring subjects. **Personality** is defined as an individual's characteristic pattern of behavior, thought, and emotion. The word "personality" derives from the Latin *persona*, or "mask." Many theories of personality suggest that an individual adopts a strategy for behaving from one situation to the next, similar to putting on a mask, although it represents one's real self rather than a false face.

■ IDENTIFYING AND CLASSIFYING INDIVIDUAL DIFFERENCES

Sir Francis Galton (1822–1911) maintained a lifelong interest in individual differences in abilities. His convictions about the origins of individual differences were apparently influenced by ideas about physiognomy (see Chapter 1). Galton sought to identify key physical differences between "eminent" British citizens and their undistinguished, anonymous countrymen. He believed that the eminence of successful statesmen and scholars could be traced to such physical distinctions as head size, distance between the eyes, length of nose, and hand-grip strength. Galton failed to take into account important differences in education and environment (nurture) as well as inherited physical traits (nature), and he failed to confirm his hypothesis. Nonetheless, his early efforts mark the beginning of psychology's continued interest in assessing individual differences.

These days, psychological research has focused on more specific individual differences as well as the environmental and biological influences upon them. For example, some psychologists research gender differences in skills, abilities, tendencies, and behaviors. Two of the most common individual differences in psychological research are personality and intelligence. After centuries of research, there is still no definitive answer to how individuals differ on these concepts. This chapter reviews some of the dominant theories that have emerged across this time span. We begin by comparing key assumptions about the structure of personality and intelligence. Specifically, we explore the distinction between notions of personality as involving traits or types, and the distinction between a general versus specific view of intelligence.

Structure of Personality

There are two basic ways that researchers have characterized personality. Some see one's personality as belonging to one of (perhaps many) specific types, while others view it as a collection of individual traits.

Personality Types

The **type approach** is popular among laypersons because it simplifies understanding of commonalities and individual differences. The type approach is a qualitative approach toward personality. That is, it categorizes people into specific classes. A modern example of the type approach is the profile of the Type A personality, a behavior pattern characterized by impatience, concern with time and punctuality, anger, and perfectionism. First described in the 1970s, the Type A profile is interesting because it has been linked to a higher risk of cardiovascular disease like heart attacks.

Based loosely on psychoanalytic theorist Carl Jung's theories of personality (see the "Jung's Contribution" section later in this chapter), the Myers-Briggs Type Indicator is a paper-and-pencil personality inventory that categorizes respondents along four dimensions: introverted-extroverted; sensing-intuiting; thinking-feeling; and perceiving-judging. A respondent's pattern of answers is categorized along these four choices based on its resemblance to others' answers. This technique is more popular as an informal self-assessment experience than a formal diagnostic tool. For example, management trainees may complete the Myers-Briggs to discover their individual management styles and identify better strategies for working with others.

Personality As Traits

Whereas the type approach to personality is qualitative, the **trait approach** is quantitative. That is, the trait approach describes specific features or characteristics that individual's may exhibit to differing degrees. Thus, in contrast to the type approach, the trait approach does not intend to label or categorize individuals but to measure and identify the relative strength of characteristics they believe are global or present in everyone. These characteristics, or traits, are relatively stable personality tendencies such as generous, ambitious, aggressive, and shy. This approach is more influential in modern personality theories; several trait approaches are discussed in detail later in this chapter.

Structure of Intelligence

No single agreed-upon definition exists for intelligence, although most accept that it is a quality of the ability to acquire and use knowledge. The meaning of intelligence is understood differently by psychologists and laypersons. Research suggests that most laypersons think of intelligence as composed of verbal ability, practical problem-solving ability, and social competence (for example, being fair with others and/or having a social conscience). In contrast, many experts follow the lead of Yale psychologist Robert Sternberg (b. 1945), who characterizes intelligence by the possession of knowledge, the efficient use of such knowledge to reason about the world, and functioning adaptively in the world by applying this reasoning. Intelligence should not be considered as synonymous with cognitive abilities discussed in Chapter 9.

A major distinction of theories of intelligence that have developed over time in psychological research is that between general and specific notions of intelligence. Charles Spearman (1863–1945)

began a heated debate that has spanned decades by positing a general intelligence measure, which he called simply g (for general intelligence), based on the positive correlation among scores on various mental aptitude tests. Although he also acknowledged specialized intelligence, which he referred to collectively as s, he assumed that g was a good estimate of one's global intelligence.

Psychologist Raymond B. Cattell (1905–1998) applied a mathematical procedure called factor analysis to support his notion that there at least two kinds of g, which he called fluid intelligence (basic reasoning) and crystallized intelligence (specific knowledge gained through experience). L. L. Thurstone (1887–1955) suggested multiple intelligences, which he referred to as primary mental abilities. He found evidence for seven different (relatively independent) abilities, such as numerical ability, verbal fluency and comprehension, spatial visualization, and reasoning.

Although there is no answer to the debate over how many basic intelligences there are, most psychologists agree that intelligence is multifaceted. Yet, most would also agree that there seems to be some general notion of intelligence that applies across domains.

■THEORIES OF PERSONALITY

Most theories of personality attempt to describe personality differences, or account for the development of personality, or both. Whether it is descriptive, developmental, or both, a theory of personality must account for two paradoxical ideas:

- The commonality or similarity of experiences and behaviors that is observed across individuals, despite their uniqueness
- The individual differences among people despite this commonality.

Different theories can also be classified according to whether they support the trait or type distinction of personality.

Early Theories

The earliest recorded personality theory was a type theory, a model of the categories of personality descriptions. This was the **four humors theory** adapted by the early Roman physician Galen, based on the ideas of the ancient Greek physician Hippocrates (see Chapter 1). According to this theory, the human body produced and required four humors or bodily fluids to function: blood, yellow bile, black bile, and phlegm. An imbalance among these humors would cause physical or psychological illness, where excessive levels of any one humor could be diagnosed by specific moods or personality tendencies. For example, a predominance of phlegm would make one phlegmatic, a term still used today to mean lethargic and apathetic. Such excesses could be corrected by the process of bloodletting, a practice popular through the Middle Ages of opening a vein to release the excess humors. Bloodletting was usually done by barber-surgeons, using scissors and scalpels; their nonverbal sign of trade, a white arm trailing a spiral of blood, can be recognized in the modern barber shop pole.

Psychodynamic Approach

Most psychoanalytic theories begin with the work and ideas of Sigmund Freud (1856–1939), the Viennese physician who originated psychoanalysis. Psychoanalysis has been applied to therapy, human

nature, and personality theory, emphasizing the role of unconscious motivation in conscious behavior. The best-known concepts in psychoanalytic personality theory were developed by Freud himself. In addition, important contributions were made by Freud's followers and students, who went on to develop important variations. These include the theories of Carl Jung, Alfred Adler, Erik Erikson, and Karen Horney.

Freud's Original Theories

Sigmund Freud was trained in medicine and specialized in the treatment of nervous disorders such as hysteria (conversion disorder), a pattern of physical symptoms with psychogenic (psychologically originating) rather than physiological causes. In the course of his practice, Freud built upon mechanistic ideas of the physical bases of behavior, as well as early ideas of levels of consciousness.

According to Freud, all human behavior is driven by two basic, antagonistic, biological instincts: the life instinct (*Eros*) and the death instinct (*Thanatos*), which respectively emerge in the motives of sex and aggression. These instincts are not part of conscious deliberation but reside in the larger region of the mind that is unconscious, unavailable to conscious reflection and memory. Between the conscious and the unconscious minds is a preconscious level where ideas and images remain accessible to consciousness before they are retrieved (for example, memories). The relationship among these Freudian concepts of levels of consciousness is often depicted as a largely submerged iceberg, emphasizing that the visible personality (above the surface) is but a small part of one's total personality and motivation.

Freud proposed that much of one's unconscious motivation is antisocial and selfish and violates the laws of civilized society. When such ideas are consciously considered, one experiences anxiety, an overwhelming feeling of dread similar to fear. To avoid anxiety, one represses unwanted thoughts, feelings, or memories, pushing them beyond conscious access into the unconscious. When life experiences are threatening or frustrating, an individual is strongly motivated to defend against possible anxiety by employing defense mechanisms, behavior patterns that reduce the symptoms of anxiety but do not necessarily eliminate the sources of the conflict (see also Chapter 10).

Id, Ego, and Superego

One of Freud's most enduring contributions to a popular understanding of personality is his theory of the structure of personality. According to Freud, the individual at birth has no personality or public persona yet. The infant is completely selfish and motivated by the **pleasure principle**, the drive to seek physical pleasure and satisfaction. This is embodied in a part of the personality known as the **id** (Latin for "it").

In the first few years of childhood, one develops an **ego**, a self that is largely visible (in contrast with the completely unconscious id). The ego abides by the reality principle, effecting compromise that will satisfy some of the id's demands while not violating too many of society's constraints. Unlike the id, the ego recognizes the needs and desires of others. In the course of early childhood discipline, the child develops ideas of right and wrong, of permitted and forbidden behavior. The understanding that some acts are wrong comprises one's conscience, while the gradual understanding of what is good and socially rewarded becomes one's idealized self. Together these constitute the third aspect of personality, the **superego**.

For example, when one meets an attractive new person, one's id might commence sexual fantasies and urge aggression, while one's superego pretends disinterest and advises escape. One's ego might effect a compromise by remaining in the situation but acting with restraint, perhaps starting a conversation or

asking the other person for a date, without making any aggressive advances. It is important for these different personality components to develop in balance. A powerful id or weak superego may result in unchecked antisocial behavior, such as criminal activity. A weak id or powerful superego may result in personally ineffective behavior, self-denial, and unrealistic standards of behavior. Freud asserted that in healthy individuals the ego was the strongest component, which could reconcile the desires of the selfish id with the moral superego while appreciating the realities of a situation.

Psychosexual Personality Development

Freud's psychoanalytic theory is one that makes specific claims about the development of personality. For Freud, the psychic energy of unconscious motivation, called **libido**, originated in biological growth. In the course of early life, as our bodies change, we associate pleasure with the stimulation of different parts of the body. From infancy to adolescence our development is guided by experiences associated with these erogenous zones. Freud referred to this development, through changing associations of physical pleasure, as psychosexual development (see also Chapter 11).

Jung's Contribution

Carl G. Jung (1885–1961) was once thought of as Freud's "crown prince of psychoanalysis" before he broke with his mentor over differences in their theories. Jung's interests in symbolism and mysticism have made his ideas enduring and popular today. Jung differentiated within the unconscious mind between a personal unconscious and a collective unconscious. One's personal unconscious contains one's own repressed thoughts, forgotten experiences, and undeveloped ideas—any of which can be triggered into recall by new sensations. The collective unconscious consists of memories and behavior patterns inherited from one's ancestors. Among the thought forms stored in the collective unconscious are archetypes, ideas and memories that people have had in common from primitive human origins. Archetypes form the basis for many universally recognizable symbols. Jung claimed that they explain why myths and fairy tales are so similar across vastly different times and cultures worldwide. Two other archetypes, the anima and animus, represent an unconscious level of gender. Jung believed that every woman's personality includes an animus, her male traits, and every man's personality includes an anima, his female traits. These are important in successful interaction with members of the opposite sex, because they provide a degree of recognition and empathy.

Jung is credited with categorizing personalities into two types based on attitudes toward others. **Introverts** are unsociable, withdrawn, and concerned with their private worlds, whereas **extraverts** are outgoing, interested in participation in external events and involvement with others. This distinction is still employed by other approaches to personality, discussed in the following sections. Jung also categorized people according to their use of reason in guiding their actions. Rational people think and feel, making decisions on the basis of ideas, emotions, and value judgments. Irrational people base their perceptions on sensations and intuitions, relying on surface impressions or unconscious insights.

Adler's Theory of Power

While Jung's theories resemble Freud's in many ways, those of another Freudian disciple, Alfred Adler (1870–1937), differed obviously. Freud's model of personality emphasized the value of physical pleasure and biological satisfaction, while Adler argued that a more important goal in human behavior is

the achievement of competence or power. One implication of this is the use of the defense mechanism of **compensation**, efforts to overcome real or imagined personal deficiencies. A popular Adlerian image is that of the French dictator Napoleon, compensating for shortness in physical stature by becoming politically "tall" as emperor. In cases where compensation fails and one becomes defeated as well as disillusioned with oneself, Adler blames an inferiority complex, a paralyzing fixation on one's inadequacies.

Beyond childhood concerns with power and domination, Adler argued, adult life is characterized by striving for perfection, efforts to become personally superior as well as make one's society better. Early in life, one develops guidelines and personal meanings that influence one's style of life. Specifically, an individual composes a set of goals that make up his or her fictional finalism, the values he or she believes in and pursues, whether they are attainable or not.

Other Neo-Freudian Ideas

Many researchers are referred to as neo-Freudian theorists because although their work may have a Freudian flavor, their own theories build or differ in innovative ways upon those of Freud. One such theorist is Erik Erikson, whose elaboration on Freudian theory is his sequences of psychosocial development (discussed in Chapter 11). Another neo-Freudian, Karen Horney (1885–1952), argued that sex and physical pleasure had been overemphasized as motivating forces in personality. Instead, Horney posited that the noxiousness of anxiety was a more basic motivator of behavior. In contrast with Freud's characterization of anxiety as based in sexual conflict, Horney pointed out that anxiety has many other sources. For example, young children are dependent for survival on their parents, a relationship that must prepare one for both satisfaction and disappointment. In response to the anxiety of this dependency, children build up defensive ways of reacting, first to their families and ultimately to the world.

For Horney, the defensive behaviors people develop can become neurotic trends, patterns that work as defenses only at the cost of independence. Neurotic trends were characterized by three types of personality, revealed in people's personal relationships. The compliant type of individual approaches and submits to others in an effort to gain their approval; the aggressive type attacks and moves against others rather than approaching them; and the detached type withdraws and moves away from others. These trends are neurotic because they become inflexible traps from which individuals cannot escape or develop freely and independently.

Horney may be best known for her decidedly feminist approach to psychodynamic theorizing. Whereas Freud posited such concepts as penis envy in women, Horney suggested that the source of women's frustrations was not psychosexual but the result of restrictions and oppression from men in society and domestic life. Thus, like many neo-Freudians, in contrast to Freud, she emphasized the role that culture plays.

Humanistic Approach

Psychoanalytic theories of personality development generally portray human motivation as self-interested and uncivilized unless socially acceptable roles and outlets are provided. In contrast, humanistic theories of personality assume that human nature is essentially positive, productive, and growth-oriented, and that people would develop in healthy ways if they knew how. This approach sees personality as developing through an ongoing process of self-actualization in accord with each person's unique view of the world. The most prominent theories in the humanistic framework are those of Abraham Maslow and Carl Rogers.

Abraham Maslow

The work of Abraham Maslow (1908–1970) has powerfully shaped humanistic theories of personality. His hierarchy of motives proposes that human motivation is founded in needs, but that these needs range from basic physiological survival to social needs like belonging and esteem, and ultimately to a distinctly human need for self-actualization (see Chapter 10). Maslow focused his research on the phenomenon of **self-actualization** by studying friends, acquaintances, and historical figures whose lives seemed to embody the principles of productiveness, self-acceptance, dignity, and appreciation of the world. He observed that the achievement of self-actualization is often marked by peak experiences, feelings of ineffable happiness and peace in the course of one's life activities. Generally, he saw personality and personal growth as determined by the extent to which one is focused, or oriented, toward things one has versus does not have.

Carl Rogers

Carl Rogers (1902–1987) is known for his humanistic approach to therapy (see Chapter 15) as well as his contributions to humanistic personality theory. Rogers has argued that each individual possesses a genetic blueprint for his or her life's potential, and a biological urge propels him or her forward to realize it, a drive he calls the **self-actualizing tendency**. Thus, self-actualization is not only possible for every human, it is natural and would be universal if all people were encouraged and assisted in this process. Rogers proposes that the difficulty in actualizing oneself originates in an unrealistic or unhealthy self-concept or self-image. One's **self-concept**—the way one thinks of oneself—develops from childhood as a result of positive regard, the favorable treatment and evaluation others provide. Rogers argues that an individual must feel unconditional positive self-regard, a positive estimation of self-concept that is not conditional on any specific behaviors or bargains with others. That is, positive self-evaluations lead to a positive self-concept. When one accepts oneself positively and unconditionally, one closes the gap between one's present self-concept and one's ideal self (similar to Freud's assumption), and becomes a fully functioning person, self-directed, independent but respectful of others, and open to experience.

Trait Theories

We saw in the section "Structure of Personality" that one of the common ways to conceptualize personality is consisting of various specific traits. Trait theories attempt to specify exactly how many traits are important, and what they are.

Allport's Trait Theory

American psychologist Gordon W. Allport (1897–1967) believed that the trait was the best unit of analysis for the study of personality. For Allport, an individual's traits were part of his or her nervous system, and thus basic to his or her behavior. In research spanning thirty years, Allport identified almost 18,000 trait words (although many were redundant) in the English language, testifying to their importance in behavior and society. Allport distinguished among cardinal traits, central traits, and secondary traits. Cardinal traits are rare but are so central to one's personality that they influence virtually all behavior. For example, an extremely selfish person may convey this characteristic in all he or she does. **Central traits** are usually, but not always, detectable in overt behavior, such as a general shyness which is not evident when one is with friends or family members. **Secondary traits** come into use in particular situations but

not general behavior. For example, one may behave aggressively when absolutely necessary but avoid doing so under normal circumstances.

The Big Five Model

Raymond B. Cattell, mentioned previously in this chapter's discussion of the structure of intelligence, also applied factor analysis to a narrowed-down list of 200 personality traits. Results of this analysis showed that the many different trait terms sorted into sixteen basic personality factors. For example, the different terms "persevering," "determined," "responsible," "ordered," "attentive," and "stable" are all slight variations of the same basic personality factor. Still other efforts to reduce the load of terms that encumber trait theories have suggested that there are even fewer then sixteen basic personality factors. A great deal of research has utilized and supported the **five-factor model**, or big five model. This model suggests five primary dimensions of personality (see Table 12-1): extraversion; agreeableness; conscientiousness; emotional stability (conversely, neuroticism); and openness to experience.

The "Big Five" Personality Dimensions

Trait	Characteristics and qualities
Openness to experience	Curious, creative, imaginative, diverse interests
Conscientiousness	Dependable, organized, reliable, punctual, thorough
Extraversion	Outgoing, assertive, talkative, ambitious, energetic
Agreeableness	Kind, generous, forgiving, considerate, pleasant, amenable
Neuroticism	Anxious, impulsive, tense, worrisome, volatile

Table 12-1: The "Big Five" Personality Dimensions

Biological Trait Theories

So-called biological trait theories attempt to understand not just what the descriptive dimensions are that define personality, but also what the underlying causal mechanisms are for different traits. Perhaps the most popular of these theories is that proposed by British psychologist Hans Eysenck (1916–1997), and modified by Jeffrey Gray. Eysenck produced a two-dimensional model that can be used to derive and place many different traits (see Fig. 12-1). He proposed a continuum of introversion-extraversion and a continuum of emotionality-stability, and argued that people fall at different points along these dimensions based on inherited predispositions. These predispositions, in turn, influence arousal and sensitivity to various stimuli, which in turn guide personality and behavior. For example, someone born with an overactive or responsive nervous system would be more sensitive to stress and more easily aroused, and would thus seek to minimize encountering stressful situations and exciting stimuli—this person would be considered introverted.

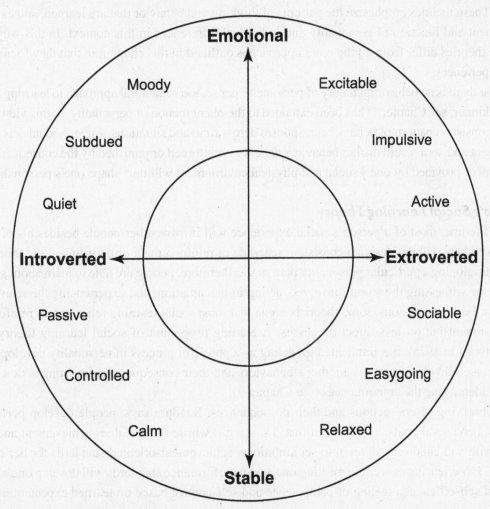

Fig. 12-1: Eysenck's two-dimensional model of personality. Placement on each of the two continua determine the individual personality trait.

Gray, another British psychologist, concurs with the two dimensions proposed by Eysenck. However, he disagrees with the underlying causal mechanisms of personality. He describes the biological substrates of personality in terms of approach and inhibition. He suggests that the brain possesses two distinct systems: an approach system that determines an individual's sensitivity to rewards, and an inhibition system that affects the influence of potential punishments. An individual's location on Eysenck's continua is interpreted as a result of the relative sensitivity or activity of each system. Those with an active reward system and inactive inhibition system will be extraverted, whereas the converse will be true for introverts. Increased sensitivity to both rewards and punishments leads to emotionality, whereas the opposite leads to emotional stability. Gray's theory has quickly usurped Eysenck's as the leading biological trait theory, thanks to converging evidence from neuroscience.

Social-Cognitive Theories

Both psychoanalytic and humanistic theories portray human personality as naturally driven, whether by biological impulses or a self-actualizing tendency. Unlike these are the social-cognitive theories of per-

sonality. These theories emphasize the patterns of thinking and behavior that are learned, and explain the development and function of personality and individual differences in this context. In this way, social-cognitive theories differ from all the other approaches outlined in this chapter, in that they focus on conscious experiences.

While there is no behavioral theory of personality per se, the behavioral approach to learning (like that of B. F. Skinner; see Chapter 7) has been extended to the phenomenon of personality. In this view, personality is a consistent pattern of behavioral responses across time and situations. An individual acts upon the environment and, as a result, his/her behaviors are either reinforced or punished by the consequences. The consequences provided by one's social and physical environment will thus shape one's personality.

Bandura's Social Learning Theory

In a lifetime, most of a person's social experience will involve other people besides his or her parents. Most others will not design a consistent schedule of reinforcement or punishment to "train" someone into developing a particular personality pattern. Furthermore, people are able to learn about situations without ever witnessing the stimuli involved, acting in the situation, and experiencing the relevant consequences. For these reasons, some theorists argue that most social learning relies not on reinforcement and punishment but on less direct processes. A leading proponent of social learning theory, Albert Bandura (born in 1925), has implicated modeling as a powerful process in personality development. In modeling, an individual observes another's behaviors and their consequences, imitating actions and vicariously identifying the consequences (see Chapter 7).

By observing others' actions and their consequences, Bandura says, people develop performance standards, behavioral goals, and expectations. Thus, a girl whose father values achievement and praises it in his wife and children will learn to set ambitious, achievement-oriented standards for her own performance. Experiencing success in meeting one's own performance standards will develop one's sense of **perceived self-efficacy**, a feeling of competence and self-control based on learned expectations of success in given situations.

Social learning theory has gained popularity because of its simplicity and applicability. However, it has also been criticized for being a "personality theory without the person." One response to that criticism is that personality depends not on the consistency of behavior across experiences and situations but on its flexibility. Bandura suggests that persons and situations interact in a mutually influential process called **reciprocal determinism**. Situations shape persons' behaviors and thought processes in ways that may endure. Then these behavior patterns, thoughts, and feelings influence both the selection and impact of future situations.

Mischel's Cognitive/Affective Theory

Psychologist Walter Mischel has argued that people's behavior across situations fails to show the consistency and reliability to be expected of personality. In essence, he claimed that personality traits are poor predictors of behavior. Whereas this conclusion led him to be a vocal critic of trait approaches, he admits that his theory is generally consistent with the trait approach. Like Bandura, Mischel argues that people's behaviors are shaped by the rewards and punishments provided by their social situations. These lead to learned beliefs and feelings that define an individual, as well as expectancies about the world

around them. These cognitive person variables, as Mischel calls them, interact with the particular situation to determine how personality is manifest in a particular situation. His theory incorporates personal predispositions, but those that are learned in a social-cognitive sense rather than those that are biologically programmed.

■ THEORIES OF INTELLIGENCE

The psychometric approach to intelligence emphasizes the product or application of intelligence. This approach depends largely on the measurement of intelligence, such as through the use of intelligence tests (see Chapter 13). The information-processing approach toward intelligence focuses on the mental processes that underlie intelligent behavior. That is, in contrast to the psychometric approach, this paradigm focuses on the means, rather than the ends. Research in this tradition relates concepts such as attention, learning, memory, and other topics from Chapters 6–9 to intelligent behavior. Intelligence may be linked not just to efficient or productive processes, but processing speed as well. Three distinct theories of intelligence have been offered by Sternberg, Howard Gardner, and J. P. Guilford. Note that these popular contemporary theories all advocate the view of multiple intelligences.

Guilford's Three-Dimensional Model

In 1967, J. P. Guilford presented a three-dimensional model of intellect. Guilford depicted his system as a cube-shaped structure, divisible into many smaller cubes. The three dimensions of this cube-shaped model represented three categories of intelligence test items: the content of an item (for example, figures and semantic meaning); the kind of operation the item required performing (for example, evaluating and remembering); and the product resulting from applying a particular operation to that content (for example, systems and transformations). According to Guilford, there were four kinds of content, five possible operations, and six categories of products, yielding 120 identifiable intellectual abilities.

Sternberg's Triarchic Theory

In contrast with the early models of Thurstone and Guilford, recent work by Robert Sternberg concludes that intelligence tests are not an appropriate source of information about the nature of intelligence. Sternberg's work has emphasized the importance of real-world problem solving and reasoning, and it encompasses a broader variety of skills than these earlier theories. Sternberg's **triarchic theory of intelligence** describes three kinds of intelligence: componential, experiential, and contextual.

- Componential intelligence involves the ability to learn, acquire new knowledge, and use it effectively.
- Experiential intelligence is illustrated by adjusting well to new tasks, using new information, and responding effectively in new situations.
- Contextual intelligence involves wise selection of environments for one's efforts, adapting oneself or changing the scene as necessary. Contextually intelligent people enhance their strengths and overcome their weaknesses, and they work to achieve a good match between their skills and their settings.

Gardner's Theory of Multiple Intelligences

Howard Gardner takes a diverse approach to the study and definition of intelligence. He believes that all people have some set of their own idiosyncratic intelligence, the result of eight intelligences present to differing degrees: linguistic, logical, spatial, musical, intrapersonal, naturalistic, and kinesthetic (sense of one's body). Each type of intelligence requires, and draws upon, different skills that are developed through the fostering of innate capabilities. That is, biological dispositions afford the capacity for several types of intelligence, and sociocultural influences (for example, language) provide the means for developing these intelligences. Gardner has utilized biological, developmental, cognitive, psychometric, and cross-cultural research to support his framework.

◼ INFLUENCES ON PERSONALITY AND INTELLIGENCE

The theories of personality and intelligence reviewed in this chapter recognize to different degrees the influence of biological, environmental, and sociocultural factors that contribute to individual differences.

Biological Influences

Biological influences are those that can be attributed undeniably to physiological factors. While it is difficult to classify any effect in this manner, genetics and gender can safely be seen in this way.

Genetics and Heredity

The genetic map for the nervous system is, of course, inherited. Insofar as nervous system operation is a function of its anatomy, consequent behavior may show inherited influences. (See also the discussion of behavioral genetics in Chapter 2.) One example of a genetic influence on personality is the function of a biochemical, monoamine oxidase (MAO), which regulates certain neurotransmitters' concentration in the brain. Low levels of MAO have been associated with a high degree of sensation-seeking, a readiness to take risks and try new behavior. Other examples of genetic influences on individual differences are supported by twin studies in which identical twins, separated at birth and raised in separate households, have been found to resemble each other in significant ways as adults.

Gender

One's biological gender—whether one is anatomically male or female—will have consequences for the physical changes and hormonal influences that every individual experiences. However, the effects of gender are usually confounded (blended or confused) with those of gender role, the set of behavioral norms a culture considers standard for individuals of a given gender (Chapter 11). Thus, it is difficult to discern whether men are more aggressive than women because of being male (gender) or acting masculine (a learned gender role). Similarly, it is not clear that women are more sensitive than men because they are born female (gender) or have learned to act feminine (gender role). The same confound exists when trying to determine the influence of gender on various intelligences and other individual differences.

Environmental Influences

Experience plays an undeniable role in the development and structure of personality and intelligence. Experiential factors can be found in family influences, cultural norms, and the physical and social environment.

Family

The structure and nature of one's family environment plays a crucial role in an individual's personality and intelligence development, especially during childhood. Direct family influences include parents' attitudes and practices concerning childrearing, such as support, affect, and discipline. Another family-related factor thought to influence personality development is birth order, one's place in the sequence of children. For example, oldest children have been found to outnumber other birth-order categories in some indices of success and achievement. The family environment can also influence intelligence, through factors such as the value placed on intelligence and scholastic performance. Creating an atmosphere that encourages intellectual growth—whether mathematical, musical, or otherwise—can only help to foster development.

Culture

One's culture or society develops norms, prescriptive patterns of behavior, that are communicated to every individual. Rewards are given for conforming to the norms and penalties for violating or deviating from them. An example is the relative value of a trait like "independence" in American society. While independence is considered an important value—for example, the American celebration of the Fourth of July as Independence Day—children may not learn many acceptable ways of behaving independently without violating other cultural norms like "respecting one's elders" and "obedience to authority." Cultural differences in the value placed on intelligence and academic achievement also undoubtedly influence intellectual development, as evidenced by large cultural differences in the performance of children in school (for example, the excellence of Asian schoolchildren in comparative studies). Classic social psychological research (see Chapter 16) suggests that cultures do differ with respect to values and norms, and that these differences can be measured in individuals' behavior.

Environment

An important environmental influence on personality development is stress, the demands to which an individual must adapt (see Chapter 10). A child raised in an isolated rural farm family must deal with the stresses of family responsibility, chores, loneliness, and boredom; whereas one raised in a small apartment in a big city will have to face crowding, anonymity, and crime. Furthermore, the children may develop vastly different problem-solving abilities related to their personal experience (for example, repair and survivalism versus street smarts). Even individuals raised in the same families and environments bring different genetic and temperament factors to bear on their situations. This helps to explain why siblings can be so different, despite similarities in their experiences. A recurring theme throughout this book is underscored here—individual differences, such as in personality and intelligence, are the product of an interaction between genetic and biological influences (nature) and experiential influences (nurture).

There exist many individual differences that characterize what makes people unique. The most commonly studied of these are personality and intelligence. Both of these concepts are hard to define, but many researchers have tried to understand what underlies these qualities of an individual. Personality is either viewed qualitatively, as being one of several distinct types, or quantitatively, as being composed of a collection of traits. Intelligence is either viewed as a single, general faculty, or a collection of multiple domain-specific intelligences.

Modern theories of personality can be characterized according to the psychological approach they adopt. Perhaps in personality research more than anywhere else in psychology, the name identifies the theory more than some other label. Psychoanalytic theories are mostly derivative from the ideas of Sigmund Freud. He believed that personality was the result of hidden desires, and an unconscious conflict between the pleasure-seeking id, the disciplined superego, and the manifest ego. Freud also suggested development of personality across five psychosexual stages. Neo-Freudian theories have been proposed by Alfred Adler, Carl Jung, Erik Erikson, and Karen Horney. Humanistic theories, including those of Abraham Maslow and Carl Rogers, view personality in terms of the development of the self, including self-actualization or the realization of one's potential. Trait theories of personality, such as the work of Gordon Allport and Raymond B. Cattell, assume that personality is a collection of distinct traits. Many current versions of trait theories, including that of Hans Eysenck, offer biological underpinnings for the manifestation of different trait dimensions. Finally, social-cognitive theories, such as Albert Bandura's social learning theory, interpret personality in the context of the social environment and the learning of behavior.

Intelligence can also be studied using different frameworks. The psychometric approach to intelligence focuses on the product of intelligence, or how it is displayed or measured (for example, scores on tests). In contrast, the information-processing approach describes intelligence in terms of the processes that are used, such as attentional focus and strategy use. Specific theories of intelligence include those of Charles Spearman, who suggested a general intelligence factor, and Sternberg's triarchic theory, hypothesizing three distinct types of intelligence. J. P. Guilford also suggested a three-dimensional view, and Howard Gardner proposed a large number of distinct intelligences.

It is important for one to appreciate the influence of various factors on individual differences and abilities. Although they may be termed "individual," they are actually very much dependent on environmental and sociocultural factors. These factors influence predispositions that are indeed individual, such as inherited biological characteristics. Only by considering a broad range of influences working in conjunction can we hope to understand what differences—and similarities—exist among individuals.

Key Concepts

central traits	introverts	self-actualizing tendency
compensation	libido	self-concept
ego	perceived self-efficacy	superego
extraverts	personality	trait approach
five-factor model	pleasure principle	traits
four humors theory	reciprocal determinism	triarchic theory of
g	s	intelligence
id	secondary traits	type approach

Key People

Alfred Adler	Sigmund Freud	Carl Rogers
Gordon W. Allport	Sir Francis Galton	Charles Spearman
Albert Bandura	Karen Horney	Robert Sternberg
Raymond B. Cattell	Carl G. Jung	L. L. Thurstone
Hans Eysenck	Abraham Maslow	

SELECTED READINGS

Hergenhahn, B. R., & Olson, M. H. (2002). *An Introduction to Theories of Personality, 6th Ed.* Prentice Hall.

McAdams, D. P. (2005). *Person: An integrated introduction to personality psychology, 4th Ed.* Wiley, John & Sons, Inc.

Mischel, W., Smith, R. E., & Shoda, Y. (2003). *Introduction to personality: Toward an integration, 7th Ed.* Wiley, John & Sons, Inc.

Pervin, L. A., & John, O. P. (2001). *Handbook of personality: Theory and research.* Guilford Publications, Inc.

Sternberg, R. J. (2000). *Handbook of intelligence.* Cambridge University Press.

Test Yourself

1) The _____ approach to personality is qualitative, grouping into categories and applying labels, whereas the _____ approach is quantitative, identifying collections of characteristics.
 a) type; trait
 b) trait; type
 c) general; specific
 d) specific; general

2) A historical debate in intelligence research is whether there exists a single notion of intelligence, as advocated by _____, or multiple intelligences, as advocated by _____.

 a) Allport; Gardner
 b) Allport; Spearman
 c) Spearman; Gardner
 d) Spearman; Allport

3) Psychoanalytic theories of personality, such as those of Freud and Jung, place the focus of personality on what concept?
 a) lack of control over sexually deviant behavior
 b) unconscious desires and the conflicts they create
 c) self-actualization and the realization of one's potential
 d) the biological mechanisms that give rise to specific characteristics

4) Humanistic theories of personality, such as those of Maslow and Rogers, place the focus of personality on what concept?
 a) reciprocal determinism and the role of the environment
 b) unconscious desires and the conflicts they create

 c) self-actualization and the realization of one's potential
 d) the biological mechanisms that give rise to specific characteristics

5) Which of the following did *not* propose a model of multiple intelligences?
 a) Bandura
 b) Thurstone
 c) Sternberg
 d) all of the above proposed a model of multiple intelligences

6) Which of the following did *not* advocate a trait theory of personality?
 a) Allport
 b) Cattell
 c) Eysenck
 d) all of the above proposed trait theories

7) The _____ approach studies intelligence by measuring the product, whereas the _____ approach examines the process.
 a) psychodynamic; cognitive
 b) type; trait
 c) general; specific
 d) psychometric; information-processing

8) Which of the following was *not* mentioned in the chapter as a key influence on individual differences such as personality and intelligence?
 a) history
 b) heredity
 c) society
 d) family

9) Briefly outline Sternberg's triarchic theory of intelligence. Mention at least one way in which his theory is similar to Gardner's theory, and one way they differ.

10) Briefly describe the premise behind Bandura's theory of personality development, including the notions of reciprocal determinism and perceived self-efficacy.

Test Yourself Answers

1) **a.** The type approach to personality is qualitative, grouping into categories and applying labels, whereas the trait approach is quantitative, identifying collections of characteristics.

2) **c.** A historical debate in intelligence research is whether there exists a single notion of intelligence, as advocated by Spearman, or multiple intelligences, as advocated Gardner. Allport was a personality theorist, not an intelligence researcher.

3) **b.** Psychoanalytic theories of personality, such as those of Freud and Jung, place the focus of personality on unconscious desires and the conflicts they create. Although these theories have psychosexual components, they do not focus on sexual deviance. The last two options describe humanistic and biological trait approaches, respectively.

4) **c.** Humanistic theories of personality, such as those of Maslow and Rogers, place the focus of personality on self-actualization and the realization of one's potential. Reciprocal determinism and the role of the environment are included in Bandura's social learning theory.

5) **a.** Bandura did not propose a model of multiple intelligences, but uses social learning theory as a framework for understanding personality.

6) **d.** All of those listed advocated trait theories of personality.

7) **d.** The psychometric approach studies intelligence by measuring the product, whereas the information-processing approach examines the process. The first two options refer to personality theory, not intelligence, and the general-versus-specific distinction does not relate to the product-versus-process distinction.

8) **a.** History was not mentioned in the chapter as a key influence on individual differences such as personality and intelligence. Although history, if interpreted as meaning "experience," may be a broad influence on individual differences, various biological, sociocultural, and environmental factors were explicitly mentioned.

9) Sternberg emphasizes the importance of real-world problem solving and reasoning. His theory of intelligence describes three kinds of intelligence: componential, experiential, and contextual. Componential intelligence involves the ability to learn, acquire new knowledge, and use it effectively. Experiential intelligence is illustrated by adjusting well to new tasks, using new information, and responding effectively in new situations. Contextual intelligence involves wise selection of environments for one's efforts, adapting oneself or changing the scene as necessary. His theory is similar to Gardner's work in that they both adopt a view of multiple intelligences (as opposed to a general view). However, whereas Gardner suggests several particular domains (for example, musical, logical, linguistic, and so on), Sternberg's three dimensions are more comprehensive and denote skills.

10) Bandura assumes that modeling, or observing others' actions and their consequences, plays a key role in personality development. This leads to the development of behavioral goals and expectations. When these goals are met, it supports one's perceived self-efficacy, a feeling of competence and self-control. With the phrase "reciprocal determinism," Bandura was referring to the interaction between the individual and the environment. Situations shape behaviors, which, in turn, influence both the selection and impact of future situations.

Psychological Assessment and Testing

Psychological assessment is a process designed to measure characteristics of individuals or groups. Assessment procedures involve gathering samples of responses or behaviors for description of present characteristics and/or prediction of future ones. The most common type of assessment is psychological testing; other techniques include observation, interview, and rating. These methods are most commonly used to assess individual differences such as intelligence and personality. To varying degrees of success, the procedures used in this chapter can help to evaluate the different theories and approaches introduced in Chapter 12.

■ EVALUATING TEST QUALITY AND USEFULNESS

To be useful, it is important not just to have a test or measure of some characteristic—one should have a good test or measure. So, what does it mean for a psychological assessment to be a good one? A psychological assessment should have the same properties as a physical measurement—reliability, validity, and objectivity. Tests provide a good illustration of these principles.

- A reliable test produces a similar value or score each time a person takes it (unless the person has changed in some way between testings).
- A valid test measures what it is designed to measure.
- An objective test is unaffected by the attitudes or biases of the person giving the test.

Psychological tests also should be standardized by administering them to large, representative samples of people. The scores generated by the standardization group can be used to determine norms, or patterns of responses characteristic of different types of people.

Reliability

A synonym for **reliability** is consistency. A reliable test gives consistent results each time a person takes it, unless the person has changed in some way between administrations. In other words, the scores for a given pattern, or a given individual, do not fluctuate without good reason. Such consistency in the absence of change is necessary for the test to detect real change when it occurs. For example, if your bathroom scale gave wildly different weights when you stepped on it twice only five minutes apart, it would not be a very reliable scale, and thus not very useful. Three forms of reliability are test-retest reliability, alternate form reliability, and internal consistency.

Test-Retest Reliability

After a test is developed, it is given to the same group of people repeatedly over a period of months. Results are used to identify parts of the test needing revision. The process is repeated until the test produces a reasonable level of consistency across testing occasions. This consistency across testing sessions constitutes **test-retest reliability**. A similar process is used with other types of assessments, such as observations, interviews, and projective measures. Assessments made by several "raters" are compared to identify parts of the assessment associated with inconsistent results.

Alternate-Form Reliability

Whenever more than one form of a test is developed, data must be collected to ensure that test takers would earn relatively similar scores on either form. **Alternate-form reliability**, then, is a measure of the equivalency between forms. If your instructor gives an exam that has two different versions, perhaps with questions in different orders, your score on the exam should not depend on which form you took.

Internal Consistency

Internal consistency is a measure of reliability within a test. Internal consistency analyses determine whether test takers receive similar scores on different items designed to tap the same knowledge, ability, or skill. In other words, do all the items on an algebra exam really test the knowledge (algebra) they are supposed to? If all the items are supposed to determine proficiency in algebra, but everyone in the class misses some subset of items, perhaps the exam has questionable internal consistency.

Validity

It is not enough to ensure that a measure gives reliable readings. Even if your bathroom scale reported the same weight every time, you might suspect something was wrong if this weight was twenty pounds. You would realize your scale may be reliable, but is not very accurate. A synonym for **validity** is accuracy—a valid test measures what it was intended to measure.

Construct Validity

Some tests are designed to measure constructs, characteristics such as intelligence that cannot be defined objectively. **Construct validity** is determined by comparing scores on the test with performance on other well-researched measures of the same construct. For example, if you develop a new method of measuring intelligence, you would compare it to existing intelligence tests to see if they corresponded.

Content Validity

Content validity refers to the accuracy of the content; in other words, whether the content is related to what it is supposed to measure. Perhaps everyone missed the subset of items on the algebra exam because they were questions about trigonometry. If this were the case, the test suffers from low content validity—the questions do not correspond to what the test is supposed to measure.

Criterion Validity

Tests also can be designed to predict performance on another measure called a criterion. College entrance exams provide an example of this **criterion validity** procedure. To determine whether SATs are a valid predictor of success in college, SAT scores from a group of entering students would be compared to their later college GPAs.

Test Objectivity

A more difficult measure to quantify is the **objectivity** of a test or procedure. This refers to the fairness of a test, whether it is free from biases in its measurement. A test may be reliable and valid in general, but at the same time unfair to certain individuals or groups. Consider an intelligence test that seeks to assess reasoning skills about cause and effect. If one of the test items asked about a particular chemical reaction, only those with specialized knowledge of chemistry would get the correct answer. Although the item may indeed represent cause and effect (that is, it is valid) and produce the same score across administrations (that is, it is reliable), it is biased toward those familiar with chemistry. We discuss specific concerns about objectivity of intelligence tests in the "Objectivity of Intelligence Tests" section later in the chapter.

Even if a test is fairly designed and free of bias, if a test administrator gives an advantage to any particular individual or group—either purposefully or otherwise—this introduces a problem in interpreting test results, regardless of reliability or validity. For example, if an exam proctor provides one group of students with additional information in instructions, or allows more time for test-taking compared to another group of students, it is unfair to compare results across groups. Thus, standardization of test administration procedures is also important.

■ ASSESSING INTELLIGENCE

Intelligence tests measure verbal and/or performance (nonverbal) skills. These tests are designed to measure a person's potential or aptitude for intellectual performance. A long-term goal of intelligence testing is the development of an objective, culture-free test that is valid regardless of cultural background. Two examples of popular intelligence tests are the Stanford-Binet Test for children and the Wechsler Adult Intelligence Scale (WAIS).

Stanford-Binet Test

In 1905, the French educator Alfred Binet (1857–1911) was asked by the French government to devise a means of classifying students for entry into a new nationwide public education system. Binet and his colleague Theophile Simon (1873–1961) developed a test of questions to answer and problems to solve, which they attempted to match to various age levels. This was the forerunner of what we now call

the intelligence test. In 1916, Lewis Terman (1877–1956), on the faculty of Stanford University, revised the original Binet-Simon test, dubbing the new version the Stanford-Binet test.

The Stanford-Binet test score was originally expressed as an **Intelligence Quotient** (IQ). Traditionally, the Stanford-Binet contained age-graded items in a variety of skill areas. Items were coded according to the average age at which children succeed on those items. A child taking the Stanford-Binet would be classified according to age level achieved (mental age, or MA). That is, one's score was compared to average scores of children from varying age levels to determine where one stands. The child's mental age was then compared to the child's chronological age (CA) to produce an intelligence quotient, or IQ, using the formula: $IQ = MA/CA \times 100$. This procedure set the IQ score of the average child at 100.

Recent revisions of the Stanford-Binet have abandoned this ratio scoring procedure in favor of a point scale similar to that used in Wechsler tests (see "The WAIS" section that follows). The average IQ, however, remains at 100.

Both the Binet-Simon and the Stanford-Binet tests were designed to be administered to one respondent at a time. After the outbreak of World War I, however, there emerged a need for a system for testing large numbers of military inductees to make appropriate leadership and task assignments. One psychologist, James McKeen Cattell (1860–1944), involved himself in this effort despite his personal opposition to America's entry into the war. Cattell had been Wilhelm Wundt's first laboratory assistant at Leipzig. In his career, he pursued psychometric studies and also founded and edited several influential journals, including *Psychological Review*. The standardized tests so familiar to American college students are a modern legacy of the work of Cattell and other early assessment developers.

The WAIS

The current (third) edition of the **Wechsler Adult Intelligence Scale** (WAIS-III) uses fourteen subtests—seven verbal and seven performance (nonverbal)—to generate three IQ scores: a verbal IQ (VIQ), a performance IQ (PIQ), and a full-scale IQ (FSIQ) representing overall level of performance. This test also produces scores for factors such as cognitive processing speed, working memory, and verbal comprehension. The WAIS, and Wechsler tests developed for other age groups, uses a point scale where points are earned for each correct answer. Standardization of Wechsler tests determines the scale for converting raw score (points earned) to an IQ score. The average IQ arbitrarily is set at 100, where the test taker is compared to others of the same age using standardization samples of adults over the age of sixteen.

The Reliability and Validity of Intelligence Tests

Years of study indicate that IQ is not necessarily constant over the life span. Although infant intelligence tests are available, IQ scores do not begin to distinguish between those likely to be high or low ability until about age five. From this age until around age twelve, scores obtained do not correlate well with scores later in life. Finally, even though intelligence test scores are reasonably stable from age twelve to adulthood, wide fluctuations in test scores are still possible. Despite these concerns, IQ tests generally have good reliability once these age differences are taken into consideration.

Concerning validity, although IQ tests were designed to predict success in school, academic achievement is greatly influenced by other factors such as interest, motivation, stress or anxiety, family support, and the quality of instruction. Even greater care must be exercised when using IQ score to predict other outcomes, such as occupational success. Occupational success reflects the additional influences of personality

and specialized talents. Nevertheless, people in professional or managerial careers traditionally have a higher average IQ than people in unskilled jobs.

Objectivity of Intelligence Tests

Intelligence tests were conceptualized as a pure measure of intellectual potential, free from the influence of wealth or privilege. Some critics argue that test performance in fact is greatly influenced by type of upbringing, social background, culture, and education. There is continuing debate over whether these tests measure inherited ability, which is genetically determined, or learning, which incorporates the effects of experience. Although there is research to support both points of view, critics contend that intelligence tests have become instruments for discriminating against lower social class or minority group children. For example, it has been shown that African American children generally score lower on the Stanford-Binet test; but this is almost certainly due to bias inherent in the test items, rather than naturally lower intelligence in African-Americans.

Abnormal Levels of Intelligence

Regardless of how intelligence is measured, it is evident that not all individuals have equal cognitive abilities. Psychological research has examined those individuals with lower intelligence or higher intelligence than is considered "normal." Granted, these extremes are usually identified by intelligence tests and IQ scores; but by any reasonable standards it is apparent that some groups of individuals do not represent the average in intelligence.

Giftedness refers to those individuals who have unusually high IQ scores. Although there is no "official" criterion, those with scores higher than 130 or so have been involved in studies following gifted children as they become adults. These individuals are not necessarily characterized by accomplishments indicating genius, but many do earn advanced degrees, or attain high-paying or selective jobs. On the other end of the spectrum are those who possess mental retardation, also known as **mentally challenged** individuals. These individuals are classified in varying degrees by IQ scores lower than 70, if such scores are accompanied by behavioral deficits (for example, inability for autonomous living). Research has implicated both genetic origins (for example, Down syndrome, resulting from an extra chromosome) and environmental causes (for example, prenatal teratogens, see Chapter 11, or head trauma).

Learning disabilities refer not to cases of impoverished intelligence, but a lack of ability to apply or display one's intelligence. That is, those with learning disabilities show a discrepancy between measured intelligence (IQ scores) and academic performance. These disabilities occur in many different forms and with variable severity. For example, some people may have trouble interpreting semantics in written text (dyslexia), difficulty in speech production or comprehension (dysphasia), or problems in writing (dysgraphia). Many learning disabilities are difficult to diagnose because of other potential causes for apparently poor performance, such as attention disorders (see Chapter 14) or poor instruction. Learning disabilities also seem to have a largely biological basis, although precise origins are still unclear.

■ ASSESSING PERSONALITY AND ABILITY

A number of different testing instruments have been developed with the purpose of accurately identifying—to the extent this is inherently possible—an individual's personality and potential. Although

there is no standard for defining the quality of these instruments, the prolific use of those reviewed here is one indication of how well they have been accepted.

Personality Tests

Personality tests measure personal qualities, sometimes referred to as traits (see Chapter 12). Personality assessment techniques are usually classified as either projective or objective. **Projective tests** are so labeled because the respondent is assumed to project his or her own needs and character onto an ambiguous test stimulus—one that can be interpreted in different ways—in developing a story or description. **Objective tests** do not guarantee test objectivity (as defined in the "Test Objectivity" section earlier in this chapter), even though they are more objective than projective tests and, hence, derived their name. They present specific questions or statements that are answered by selecting one of a set of alternatives (for example, true or false).

Projective Tests

Projective personality tests use ambiguous stimuli into which the test taker presumably projects meaning. This indirect type of assessment is believed by some to more effectively identify a person's real or underlying personality. Because the participant is free to respond in any way, rather than being required to select an answer from a set of alternatives, projective tests can be difficult to score. To ensure reliability, projective tests must be accompanied by a specific set of scoring criteria. Projective tests are more reliable and valid when scoring focuses on the way the questions are answered (structure of responses) rather than the content of the answers.

One of the most well-known psychological assessment techniques is the inkblot test. Swiss psychiatrist Hermann Rorschach (1884–1922) first employed respondents' interpretations of inkblot shapes as keys to dimensions of personality. That is, individuals are asked to describe in detail their impressions of a series of inkblots. Scoring involves analysis of both the structure and content of responses. In 1935, American psychologist Henry A. Murray (1893–1988) and his colleagues developed the **Thematic Apperception Test** (TAT), a technique in which a respondent examines and tells stories about each of a series of pictures. TAT analysis traditionally focuses on the role played by the main character in each story.

Objective Tests

The best known objective technique for assessing personality is the **Minnesota Multiphasic Personality Inventory (MMPI)**, developed by two University of Minnesota faculty members in 1943. The MMPI consists of 550 true-false items, and a participant's response pattern reveals his or her scores on various personality traits. The construct validity of the test is evaluated among a large clinical population (a group of patients in a setting like a clinic or psychiatric hospital). The Sixteen Personality Factor Inventory (16PF), a personality inventory standardized on a normal population, was developed in 1950 by Raymond B. Cattell (see Chapter 12) and his colleagues, who conducted a sophisticated mathematical analysis of many personality traits into a profile of sixteen basic personality "factors."

Aptitude and Achievement Tests

Aptitude tests are designed to measure a specific capability, usually one's capacity for learning a particular skill or performing certain tasks. The key difference between aptitude tests and intelligence is

that although aptitude tests may measure existing knowledge, as intelligence tests do, they are more concerned with assessing one's potential. For example, colleges and universities use the Scholastic Aptitude Test (SAT) in an attempt to gauge one's potential for success in college. Some employers also use specific aptitude tests to determine the potential success of applicants. **Achievement tests** measure knowledge that has been gained in a particular area. For example, the Graduate Record Examination (GRE) subject tests are used for graduate schools to assess students' achievement in a particular area, whereas the GRE general test is used as an indication of potential success in graduate school (an aptitude test).

Psychological assessment refers to the measurement of characteristics of individuals or groups. The most common assessment techniques are tests designed to measure constructs of intelligence and personality. It is important for tests to exhibit qualities that make them useful for measuring these concepts. Tests should be reliable, or consistent, giving the same measurements when applied to the same individuals under the same circumstances. They should also be valid, or measure what they are supposed to measure. Many tests are also standardized, allowing for comparison within a specific cohort such as an age group. A key debate involves whether psychological tests are fair and objective, rather than being biased against certain cultures, socioeconomic groups, or ethnicities.

Intelligence tests are designed to measure aspects of intelligent thinking such as verbal ability and nonverbal performance. The most popular intelligence tests are the Stanford-Binet test that results in an IQ score, and the Wechsler Adult Intelligence Scale (WAIS). Personality tests can be classified as projective and objective. Projective tests are thought to provide insight into one's personality by offering a chance for individuals to project their personalities onto ambiguous stimuli. Objective tests use specific scoring trends to determine personality traits in individuals.

Key Concepts

achievement tests	internal consistency	test-retest reliability
alternate-form reliability	learning disabilities	Thematic Apperception Test
aptitude tests	mentally challenged	(TAT)
construct validity	MMPI	validity
content validity	objectivity	Wechsler Adult Intelligence
criterion validity	objective tests	Scale (WAIS-III)
giftedness	projective tests	
Intelligence Quotient (IQ)	reliability	

Key People

Alfred Binet

Henry A. Murray

Hermann Rorschach

Theophile Simon

Lewis Terman

Introduction to Psychology

SELECTED READINGS

Hergenhahn, B. R., & Olson, M. H. (2002). *An introduction to theories of personality, 6th Ed.* Prentice Hall.

Cohen, R. J., & Swerdik, M. (2001). *Psychological testing and assessment: An introduction to tests and measurement.* McGraw-Hill.

Hogan, T. P. (2003). *Psychological testing: A practical introduction.* John Wiley & Sons, Inc.

Kaplan, R. M., & Saccuzzo, D. P. (2004). *Psychological Testing: Principles, applications, and issues.* Wadsworth.

Pervin, L. A., Cervone, D., & John, O. P. (2004). *Personality: Theory and Research, 9th Ed.* Wiley, John & Sons, Inc.

Test Yourself

1) Which of the following terms is a synonym for the consistency of a test?
 a) objectivity
 b) reliability
 c) standardization
 d) validity

2) Which of the following terms is a synonym for the accuracy of a test?
 a) objectivity
 b) reliability
 c) standardization
 d) validity

3) If a test measures what it is supposed to measure, it is said to have _____ validity, and if it gives results in line with other measures of the same concept, it is said to possess _____ validity.
 a) construct; content
 b) construct; criterion
 c) content; construct
 d) content; criterion

4) The intelligence test most commonly administered to adults is which of the following?
 a) WAIS
 b) Stanford-Binet IQ test
 c) SAT
 d) GRE

5) How are the most popular intelligence tests currently scored?
 a) MA/CA x 100
 b) standardizing to a mean of 100
 c) computing subset scores and composite scores
 d) none of the above

6) _____ personality tests involve interpreting ambiguous stimuli; a popular example is the "inkblot test" developed by _____.
 a) Objective; Terman
 b) Projective; Cattell
 c) Objective; Rorschach
 d) Projective; Rorschach

7) _____ personality tests involve analyzing response patterns and comparing them to (clinical) reference samples; a popular example is _____.
 a) Objective; the TAT
 b) Projective; the TAT
 c) Objective; the MMPI
 d) Projective; the MMPI

8) What type of test discussed in the chapter is used primarily to assess potential, rather than current knowledge?
 a) aptitude tests
 b) achievement tests
 c) objective tests
 d) ability tests

9) Briefly describe the controversy involved with the current state of intelligence testing. In particular, what objections do critics of intelligence testing raise?

10) Describe how one would know if a newly developed intelligence test exhibits internal consistency, content validity, and construct validity.

Test Yourself Answers

1) **b.** Reliability is a synonym for the consistency of a test. Although the other properties are desirable in a test, they refer to other characteristics.

2) **d.** Validity is a synonym for the accuracy of a test.

3) **c.** If a test measures what it is supposed to measure, it is said to have content validity, and if it gives results in line with other measures of the same concept, it is said to possess construct validity. Criterion validity refers to a test's predictive power on a specific criterion.

4) **a.** The WAIS is the intelligence test most commonly administered to adults. The Stanford-Binet IQ test is more often administered to children, and the SAT and GRE are aptitude tests, not intelligence tests.

5) **b.** The most popular intelligence tests, the Stanford-Binet test and WAIS, are currently scored by standardizing to a mean of 100. The Stanford-Binet was formerly scored using the formula MA/CA x 100, but is no longer; it does not use subset scores.

6) **d.** Projective personality tests involve interpreting ambiguous stimuli; a popular example is the inkblot test developed by Rorschach.

7) **c.** Objective personality tests involve analyzing response patterns and comparing them to (clinical) reference samples; a popular example is the MMPI. The TAT is a projective test.

8) **a.** Aptitude tests are used primarily to assess potential, rather than current knowledge. Achievement tests measure specialized knowledge, objectivity is a test property, and ability tests are not a test type (mentioned in this chapter).

9) The most prominent controversy in intelligence testing is the objectivity of the tests. Critics argue that intelligence tests are unfair to certain minorities and specialized groups. The tests have not been developed to be objective, or unbiased, which results in lower scores for particular ethnicities, socioeconomic groups, cultures, genders, and so on. Some argue that intelligence testing in general measures only performance related to the specific knowledge domain(s) incorporated into the test.

10) One could determine the internal consistency of a new intelligence test by checking to ensure that all of the items on the test were useful in measuring intelligence. That is, making sure that all items were measuring the same thing. Content validity could be measured by making sure that the test was indeed a measure of intelligence (as opposed to measuring some other concept). If the test developers compare scores on the new test to other measure of intelligence, such as the WAIS or Stanford-Binet test, they are attempting to establish construct validity.

Psychological Disorders

Any layperson's first associations with psychology are usually ideas about abnormal behavior and its treatment. Ideas of abnormality have varied over time and have affected attitudes toward disordered behavior and its treatment. In this chapter, we explore the definition of abnormality and the criteria for determining whether a pattern of behavior represents a psychological disorder. We also review theoretical models of psychological disorder and summarize identifiable behavioral patterns of many recognizable psychological disorders.

■ DEFINING AND DIAGNOSING DISORDERS

Abnormality is a derivative concept, because it depends on an understanding of normality. Moreover, it does not prescribe what is necessarily healthy or adaptive. Recently, psychologists have turned to a term with fewer connotations, and refer to an abnormality as a psychological disorder, mental disorder, or **psychopathology**. These refer to a general pattern of disruptive thinking, feeling, and behaving that disturbs the person affected and/or those around him or her. The idea of abnormal behavior still guides thinking about these disorders, even if they go by a different name. It is helpful, therefore, to begin with an understanding of abnormality.

Defining Abnormality

Abnormal literally means "away from the norm." The norm is the average or typical behavior or characteristic of the population. Thus, abnormality technically describes departures from norms of behavior relative only to a particular group (society or culture). Norms are different for different populations and can change with time and conditions. Abnormal behavior has been defined in different ways by psychologists and social scientists: statistically, culturally, and in terms of functioning.

Statistical Abnormality

Statistically abnormal behavior includes any behavior that is significantly different from the norm. In a normal distribution of characteristics or qualities, both very high scores and very low scores are considered statistically abnormal. For example, in terms of intelligence, only average intelligence is considered statistically normal—significant departures (above or below) from average intelligence are considered abnormal. In the statistical sense, unusually well-adjusted behavior might be considered abnormal, just as disordered behavior would be. Another way to think of abnormality in a statistical sense is as a rarity; that is, extremely rare or infrequent behavior—which is statistically unlikely—is abnormal.

Cultural Abnormality

In cultural terms, it is normal to abide by cultural norms, or standards and expectations of behavior. Cultures have norms for every social behavior, from personal practices in sexual behavior and child-rearing, to public actions like driving a car or choosing what to wear. The cultural definition of abnormality includes any behavior that deviates from cultural norms. If an individual does not know how to dress in public, he or she will be considered abnormal. If an individual deliberately chooses to be a nonconformist in some way, he or she will be considered abnormal.

A problem with this definition is its dynamics across time and cultures. It was normal in the twelfth century for American men to wear powdered wigs and pigtails, but not so these days! Judging nonconformists to be abnormal because they do not abide by a dress code will lead to erroneous identifications of abnormality.

Psychological Inadequacy

Closer to the modern psychological understanding of abnormal behavior is a definition in terms of adequacy or functioning. This has taken two forms, a value-based interpretation and a practical interpretation. In one sense, an individual is abnormal if his or her behavior is not healthy. This view assumes common understanding about what healthy behavior is. Common criteria include such basic tenets as that one is not a physical threat to oneself or others and is free from personal distress. Insofar as these values might vary across individuals, even across professionals, this view of abnormality has the same liabilities as the cultural definition. Most people will not achieve ideal mental health but will still function adequately and should not be considered abnormal.

Psychological inadequacy can also be defined practically. That is, does one set and achieve goals? Is one capable of independent living? Does one form and sustain close relationships with others? In this view, abnormal behavior is that which is maladaptive, self-defeating, socially unskilled, personally distressed, or out of touch with reality. This approach to abnormality is more practical than some others and invokes more common sense as well.

Classifying Psychological Disorders

In recent years, psychologists have been less concerned with agreeing on a definition for abnormality than with identifying its common patterns. This is done by keeping records of symptoms, how often they are observed, and in what combinations they appear. Different disorders are then identified as patterns or categories of such symptom combinations. The classification approach to abnormality can assist

in treatment because once a pattern of symptoms is recognized and the category diagnosed, recommendations for successful treatments can be identified.

The primary system of classification for abnormal behavior in use today is the *Diagnostic and Statistical Manual of the American Psychiatric Association*, Fourth Edition, abbreviated **DSM-IV** (or simply DSM). Because psychiatrists are medical doctors, it is not surprising that the DSM accepts the medical model of abnormality (see the "Early Models of Abnormality" section later in this chapter). The DSM system lists commonly observed patterns of symptoms and assigns each a label. The practice of labeling provides convenience and prescriptive action, but it has been criticized for its judgmental assumptions. Research suggests that once a diagnostic label has been applied, professionals may look for confirmation of the label rather than signs of improvement or change.

Updating the DSM

The original DSM was published in 1952, containing around sixty disorders. The DSM continues to be revised in light of both the actual occurrences of disordered behaviors and prevailing psychological and medical theories of behavior. Each revision, or edition, of the DSM incorporates important changes in assumptions and terminology about abnormality. Each revision is preceded by a literature review that attempts to determine whether a different classification scheme should be used, whether criteria should be added or deleted, or whether terminology and coding should be revised. The DSM-IV now contains over 300 distinct disorders.

The revision in 1968 (DSM-II) was strongly influenced by the psychodynamic approach, whereas the medical model still evident in the DSM-IV was implemented during the third revision in 1980. This version, the DSM-III, also abandoned a clear etiology, or causal theory for disorders. As an example of specific changes, the use of terms such as "neurosis" and "psychosis" that were common thirty years ago no longer applies. Another important change is the removal of "homosexuality" from the list of disorders, as mentioned in Chapter 10. Once considered a disorder in itself, homosexuality is no longer viewed as pathological (that is, a form of illness). The DSM-IV underwent a text revision in 2000, although this did not alter diagnostic criteria but only clarified existing text (and added some new research information). The literature review for the DSM-V is slated to begin in 2007, and it is expected to be implemented around 2011.

■ UNDERSTANDING AND EXPLAINING PSYCHOPATHOLOGY

The DSM-IV serves as a way to classify psychopathology, without providing any etiology or understanding of why many disorders occur. Theorists have, for centuries, attempted to explain the causal mechanisms of abnormal behavior. Models of psychopathology have changed over time, from ascribing spiritual causes to disorders, to viewing abnormality as erroneous behavior, to finally understanding abnormality as involving disorders.

Early Models of Abnormality

Archaeological and archival evidence indicates that abnormal behavior has been identified throughout human history. Originally, abnormal behavior was ascribed to spiritual sources, and its treatment was

related to religious practices and concepts. Thus, disorders might be labeled as demonic possession, whereby the victims were beaten, ostracized, exorcized, or executed. For example, it is believed that many of the men and women charged with and executed for witchcraft during the Middle Ages were suffering from various psychological disorders. This spiritual model of abnormal behavior provided social and legal rules but no understanding of its causes or treatments.

A moral model of abnormal behavior emerged gradually from the 16th century onward in Western Europe. Physical treatments were attempted (for example, bloodletting to release bad humors), but those with psychological disorders were segregated from those with physical disorders. A difference between the two was perceived, although no therapeutic models had yet been developed. Beginning with the work of French physician Philippe Pinel in the late 18th century and continued by American teacher and social activist Dorothea Dix in the 19th century, the moral model of abnormal behavior advocated the view that the mentally ill needed compassion, kindness, and pleasant surroundings.

The medical model of abnormality was developed in the late nineteenth century with the growth of the medical specialty of psychiatry. In the medical model, disordered behavior and thought are the symptoms or observable signs of diseases that affect the function of the nervous system. Cures and treatments are applied to the patients to alleviate their symptoms and eliminate the illness. Although alternative therapies constitute an ever-increasing component of therapy for disorders (see Chapter 15), the medical model remains popular and influential today. A reference to the medical model can be observed when social problems like drug addiction and crime are simplistically labeled as "diseases."

Psychological Models

Psychological theories have led to different models of abnormal behavior, each with its own assumptions about the causes and forms of abnormality. The psychoanalytic model explains disordered behavior in terms of unconscious conflicts. According to the behavioral model, abnormal behavior is learned, just as normal behavior is, through experiences of associations, reinforcements, and punishments. The humanistic model explains psychopathology in terms of failure to realize or express one's feelings, which leads to failure in actualizing one's potential and distortions of perception, emotion, and behavior as a result. More recently, the cognitive model has argued that internal processes like expectations, biases, errors, and illusions in conscious thought result in maladjusted and disordered behavior. Each of these models makes therapeutic recommendations on the basis of its own terms and assumptions (see Chapter 15). An increasingly popular approach is a hybrid viewpoint known as the biopsychosocial model.

The Biopsychosocial Model

The **biopsychosocial model** is essentially a combination of the three component approaches in its name: the biological or medical approach, psychological models, and a sociocultural consideration. The biological component is most specifically a neurobiological one, which distinguishes it from earlier medical models such as those implicating imbalances among "humors." Instead, the focus is on how chemical and anatomical disturbances in the brain and other bodily processes are manifest in psychological disorder. For example, perhaps the over- or underproduction of specific neurotransmitters, or the decay of a particular brain region, is largely responsible for abnormal behavior. The psychological component can include any single model, or any combination, from the various approaches outlined above.

The biopsychosocial model also recognizes the influence of society and culture on the causes, definition, and interpretation of psychopathology. This sociocultural aspect suggests that the key to understanding psychopathology is to look at more than just the individual's biological and psychological processes. Rather, it is important to consider issues such as gender, age, marital status, and ethnicity; environmental factors such as living and working space; and the social structure in which one functions, including economic and cultural aspects. Recent research suggests that some disorders may be rather general or similar across societies and cultures, whereas others are quite specific to certain cultures, or take on specific forms within a particular culture.

The biopsychosocial model is powerful and flexible, because it considers many facets of an individual's life and being as contributing to psychopathology. This framework advocates what is referred to as a **diathesis-stress** approach in determining the etiology of psychological disorders. This approach supposes that an individual may have a biological disposition, or diathesis, toward a particular psychological disorder. However, this does not necessarily predetermine that an individual will exhibit abnormal behavior. Rather, only if the individual also encounters sufficient stress will he or she develop a psychological disorder. Note how this approach to psychopathology mirrors the stance of including both "nature" and "nurture" in studying other topics such as personality and development.

■ REVIEW OF PSYCHOLOGICAL DISORDERS

In this section, we review some of the most prominent psychological disorders as classified by the DSM-IV. The DSM provides a method for annotating any disorders that may be diagnosed on any or all of five distinct axes:

- Axis I: Clinical syndromes (major mental disorders)
- Axis II: Personality disorders or mental retardation
- Axis III: General medical conditions
- Axis IV: Psychosocial and environmental problems
- Axis V: Global assessment of functioning

The diagnostician notes any symptoms or disorders across the first four axes that characterize an individual, and assigns a numeric value between 1 and 100 for Axis V. Here, we focus on disorders that fall under Axis I, as well as some personality disorders (Axis II).

Anxiety Disorders

An **anxiety disorder** is a condition in which severe anxiety interferes with normal adjustment and functioning; these are the most common psychological disorders in North America. **Generalized anxiety disorder** is characterized by persistent anxiety that is not focused on any particular object or situation. For this reason, it is also commonly called free-floating anxiety. A **panic attack** is a sudden, unpredictable experience of intense fear. It may be accompanied by chest pains, difficulty breathing, dizziness, and a feeling that one is about to die. A panic attack typically lasts only a few minutes, but the threat of recurrence is constant.

Other common types of anxiety disorders are more specific, and/or the source of the anxiety can be better localized. For example, research among veterans of war and victims of terrorism and natural disasters has

identified a pattern of panic attacks traceable to the original traumatic experience; this pattern comprises the **posttraumatic stress disorder** (PTSD; see also Chapter 10).

Phobias

Phobias, or phobic disorders, are characterized by experiencing intense, irrational fear associated with a particular condition or target. Phobias are different from fears in that they usually focus on normally nonthreatening stimuli. For example, aversion to being bitten by a poisonous snake is a fear, but intense aversion to any snake, poisonous or not, or anything that resembles or depicts a snake is evidence of a phobia. The DSM-IV classifies phobias as social phobias, specific phobias (such as toward heights, animals, and so on), and agoraphobia (a strong fear of being away from a secure or familiar place or person).

Obsessive-Compulsive Disorder

Obsessions are recurring, uncontrollable, unwanted thoughts. Compulsions are repetitive, ritualistic, urgent behaviors. Obsessions and compulsions are usually linked in a pattern known as **obsessive-compulsive disorder** (OCD), a condition involving recurring thoughts and urges to perform certain rituals. For example, a man who is obsessively worried about cleanliness and keeping free of germs and bacteria may feel compelled to wash and rewash his hands dozens of times every time he touches something.

Cognitive Disorders

Cognitive disorders refer to problems in cognitive functioning such as certain thinking abilities or memory processes. Many of these are also referred to as organic disorders, because they usually involve physical problems with the brain (the "organ" of the mind). Cognitive disorders stem largely from deterioration of specific brain regions as a result of disease, aging, or drug/alcohol abuse. Two of the most common cognitive disorders are dementia and delirium.

Dementia involves the loss of specific cognitive functions or intellectual capacities. This may involve language, attention, memory, or problem-solving skills. Dementia is thus actually a nonspecific term that refers to any loss of cognitive functioning—many different types of dementia have been documented, of which Alzheimer's disease is one. **Delirium** is, put quite simply, an inability to think straight. It includes "cloudy" consciousness, confusion, and disorientation, as well as problems in perception and/or cognitive functions.

Dissociative Disorders

Dissociative disorders are rare conditions in which part of an individual's personality becomes dissociated from the rest, and he or she cannot reestablish the associations. Rare as these disorders are, they are a source of great popular fascination. Amnesia is clinically considered a dissociative disorder (discussed in Chapter 8). Similar to a dissociative amnesia is a **dissociative fugue**, which involves a sudden loss of personal memories and identity, and the assumption of a new identity in a new locale.

The most popularized dissociative disorder is **dissociative identity disorder** (DID), the clinical label for what is formerly known as (and still commonly called) multiple personality disorder. This involves the appearance of more than one distinct identity within the same person. Each identity has a unique way of thinking, feeling, and behaving. In true cases, the names, mannerisms, histories, memories, voices, and even intelligence levels are quite different across the personalities. Sometimes the separate personalities do

not know about each other or that the individual body is so disordered. This disorder is the subject of a great deal of study and debate, including those who claim that such multiple personalities do not exist, but are a convenient and socially recognized method of expressing distress.

Mood (Affective) Disorders

Many disorders involve disruptions in experiencing and controlling mood or affect (emotion). These **affective disorders** usually involve a restricted range of emotional behavior and inflexible change within this range. The most common affective disorders involve the extremes of depression and mania, or the erratic cycling between these two (bipolar disorder).

The term depression commonly refers to a period of sadness and inactivity in the wake of disappointment or loss; such a reaction is normal and not considered disordered. However, when one is overwhelmed with grief or guilt, unable to resume or enjoy normal living and activities, and immobilized by lethargy or apathy, the diagnosis of a **major depressive disorder** is likely. Depression may not be traceable to a triggering event, or it may extend dangerously beyond normal periods of grief. Less common than depression is a state termed **mania**, characterized by hyperactivity, euphoria, talkativeness, and impulsive behaviors. Manic episodes can involve aggression and hostility, and often end in self-exhaustion.

Mania rarely appears by itself in its pure form. It is more usually coupled with periods of depression. When an individual's behavior alternates between cycles of manic and depressive behavior, he or she may be diagnosed as suffering from **bipolar disorder** (alternating between those two "poles" or extremes of emotion), also sometimes referred to as manic depression.

Schizophrenia and Other Psychotic Disorders

Generally considered the most serious of psychological disorders, **schizophrenia** is a pattern of behavior characterized by disordered thought, perception, emotion, judgment, and behavior. Schizophrenia is a type of **psychotic disorder**, or condition involving delusions or hallucinations—both of which are symptoms of a seemingly disconnected and malfunctioning mind. Other psychotic disorders may involve a combination of schizophrenia and other psychopathology, or involve one or more specific delusions.

Hallucinations and delusions are referred to as **positive symptoms**, because they appear in addition to normal mental activity. Hallucinations are false sensory perceptions, causing one to see or hear stimuli that are not, in fact, present. While common impressions about hallucinations deal with "seeing things," in fact, schizophrenics are more likely to experience auditory than visual hallucinations. For example, a schizophrenic may attribute her unusual ideas to the "voices" of important people who whisper advice to her. Delusions are false beliefs about reality with no basis in fact, such as the schizophrenic's delusion that he is a king or God (this is, he has delusions of grandeur), or being followed or victimized (this is, delusion of persecution). In contrast, **negative symptoms** refer to characteristics that are noticeably absent from the schizophrenic's mental activity, such as lack of motivation or social isolation.

Different types of schizophrenic disorders have been identified, with distinct patterns of symptoms and themes. These are labeled disorganized, catatonic, paranoid, undifferentiated, and residual types.

- Disorganized schizophrenia is characterized by such childish behavior as giggling, making faces, wild gestures, abandonment of toilet training skills, and lack of personal hygiene.

- Catatonic schizophrenia involves a distinctive pattern of motor disturbance. A common form is extreme immobility and rigidity, in which the individual seems to freeze in midposture. Alternatively, catatonia may involve frenzied movement, talking and shouting, or robotlike movement. Many catatonics oscillate between these two extremes.
- Paranoid schizophrenia is characterized by the delusions of grandeur and persecution. Paranoid schizophrenics can be hostile if their delusions are questioned or challenged.
- Undifferentiated schizophrenia has a mixture of symptoms from the various other types without clearly resembling any one of them.
- Residual schizophrenics have had previous schizophrenia but are not currently symptomatic.

Somatoform Disorders

An individual suffering from a **somatoform disorder** experiences vague, recurring, sometimes unrelated physical pains and dysfunctions for which medical examinations can find no physiological cause. Common complaints involve back pain, dizziness, partial paralysis, and abdominal pains. Less common somatoform complaints involve loss of sensory function (for example, blindness or deafness), extensive paralysis, seizures, and false pregnancy. In these **conversion disorders**, a psychological conflict is apparently converted into a distinct, debilitating physical symptom or handicap. Conversion disorders have been recorded for many centuries and were once thought to affect only women, hence the archaic term hysteria (from the Greek *hysteros* for "uterus," once thought to be the origin of the symptoms). The real physical symptoms of conversion disorders are painful or debilitating, but are frequently accepted by sufferers with good humor and apparent indifference. Such acceptance is a diagnostic clue to a somatization disorder.

A hypochondriac, or one who suffers from **hypochondriasis**, experiences a pronounced, unjustified fear that he or she suffers from severe physical problems such as cancer or AIDS. This is in a sense almost the reverse of a conversion disorder—a hypochondriac has few or no symptoms of physical illness but complains of pain and other difficulties, perhaps shopping from one physician to the next for treatments like drugs and even unnecessary surgery. A related condition, of which some hypochondriacs are previously or concurrently diagnosed, is **somatization disorder**, or numerous (often vague) complaints of physical illness. A pain disorder involves complaints of severe pain, often in the back, neck, or chest, without an underlying physiological cause.

Personality Disorders

The most complex and hard-to-describe disorders are the personality disorders. These are not all characterized by the same pattern of symptoms. Rather, **personality disorders** reflect a failure of the personality itself to develop, adjust, and learn. If the function of personality is to help the individual adjust and adapt across situations, the disordered personality is not doing its job. Many patterns of personality disorders have been identified and described. In the DSM-IV, these are classified on Axis II and also according to three clusters. The odd-eccentric cluster includes paranoid, schizoid, and schizotypal disorders; the anxious-fearful cluster includes avoidant, dependent, and obsessive compulsive disorders; and the dramatic-erratic cluster includes narcissistic, histrionic, borderline, and antisocial disorders.

Odd-Eccentric Cluster

There are three odd-eccentric personality disorders. Just as paranoid schizophrenia is characterized by delusions of grandeur and persecution, similarly the paranoid personality disorder involves suspicion, mistrust, and hypersensitivity to any criticism or threat. Although such disordered individuals see their behavior as rational and fair, they are secretive, self-aggrandizing, and argumentative. An individual with schizoid personality disorder lacks the skills to form or maintain relationships with others, as well as warm or tender feelings for others. Such a person may be viewed as cold and distant, and may act distracted and withdrawn. Schizotypal personality disorder results in similar detachment from (and perhaps fear of) social relations, in addition to the experience of odd thoughts, perceptions, and behaviors.

Anxious-Fearful Cluster

Avoidant personality disorder characterizes those who suffer from a constant sense of inadequacy and low self-esteem, and are thus inhibited in social situations and hypersensitive to criticism. People with dependent personality disorder act as if they are helpless, with difficulty in making decisions for, or taking care of, themselves. They are clingy and submissive. Those with obsessive-compulsive personality disorder exhibit a preoccupation with orderliness, cleanliness, and control (but without the anxiety or persistent rituals associated with OCD, as detailed in the "Obsessive-Compulsive Disorder" section earlier in this chapter).

Dramatic-Erratic Cluster

People with narcissistic personality disorder are totally self-absorbed, self-important, obsessed with fantasies of success, and demanding of others' attention and love. They are, however, incapable of loving or caring for others and may be afraid of commitment. For example, such an individual might continually establish brief, superficial relationships with others, driven by the need for reassurance. Those with histrionic personality disorder have a flair for dramatic and theatrical behavior. They are extremely emotional overtly, yet shallow, and are preoccupied with being the center of attention.

The pattern signaling borderline personality disorder varies widely, but most cases share the general tendencies of unstable self-images, uncertainty about their relationships and work, impulsiveness and angry outbursts, and self-destructiveness (for example, promiscuity, drug/alcohol abuse, suicide threats/attempts).

Antisocial Personality Disorder

The **antisocial personality disorder**, which has also been known as psychopathic or sociopathic behavior, has been widely studied and afflicts an estimated three percent of U.S. men and one percent of U.S. women. People with this disorder consistently violate the rights of others—they lie, cheat, steal, manipulate, and harm others—with no evidence of guilt or remorse. They often blame others for forcing them to behave as they do. This blame may be focused on individuals (parents, teasing peers) or larger entities such as a school system or society as a whole. At best, they are annoying or bothersome—manipulative, unreliable, con men, and so forth. At worst, they can be extremely dangerous.

Other Psychological Disorders

There are a great many psychological disorders that were not mentioned in this chapter. Some psychopathologies were mentioned in the context of other chapters, including eating disorders and sexual dysfunction discussed in Chapter 10, and sleep disorders and substance abuse disorders included in Chapter 4. Other assorted disorders range from paraphilias (sexual arousal through strange objects or situations) to childhood disorders such as attention deficit hyperactivity disorder (ADHD). Another class of disorders are impulse control disorders, where one is incapable of refraining from behaviors that are harmful to oneself or others, such as gambling or stealing.

There are many ways to define abnormality, including statistical, sociocultural, and maladaptive criteria. Psychologists often use terms other than abnormality, such as psychopathology or psychological disorder, to refer to a general pattern of disruptive thinking, feeling, and behaving. These disorders are classified according to a system referred to as the DSM, which is updated every several years to take new research into account.

Psychopathology is understood and explained from many different perspectives. Early theories included spiritual, moral, and naïve medical theories. With increased sophistication in the fields of medicine and physiology, these medical theories were refined. Today, most psychologists follow some sort of biopsychosocial model, acknowledging the influence of neurobiological, sociocultural, and psychological factors on the development and expression of personality.

The current DSM-IV uses five axes or dimensions in evaluating psychopathology. As a result of a diagnosticians assessment on these axes, an individual may be diagnosed with one of hundreds of specific disorders, which can largely be grouped into seven major types. Anxiety disorders are the most common in North America, describing individuals for whom severe anxiety interferes with normal adjustment and functioning. These include phobias, obsessive-compulsive disorder, and PTSD. Those with somatoform disorders suffer from physical ailments that have no identifiable physiological basis. Mood or affective disorders, such as depression and mania, affect emotional feelings and expression. Cognitive disorders impair mental functioning, usually as a result of brain deterioration. Personality disorders are hard to summarize, reflecting any one of many failures of the personality itself to develop, adjust, and learn. Dissociative disorders, such as DID (formerly known as multiple personality disorder), are characterized by a split or dissociation of a part of one's personality. Schizophrenia is characterized by disordered thought, perception, emotion, judgment, and behavior, often involving paranoia and hallucinations. Other more specific disorders fall outside these general classes, such as sexual deviance and impulse control disorders.

Key Concepts

affective disorders	cognitive disorders	dissociative fugue
antisocial personality disorder	conversion disorders	dissociative identity disorder (DID)
anxiety disorder	delirium	DSM-IV
biopsychosocial model	dementia	generalized anxiety disorder
bipolar disorder	diathesis-stress	hypochondriasis
	dissociative disorders	

major depressive disorder

mania

narcissistic personality disorder

negative symptoms

obsessive-compulsive disorder (OCD)

panic attack

personality disorders

phobias

positive symptoms

posttraumatic stress disorder (PTSD)

psychopathology

psychotic disorder

schizophrenia

somatization disorder

somatoform disorder

SELECTED READINGS

Callahan, M. D. (1997). *Introduction to psychopathology: The student guide to the study of abnormal psychology.* Counselsource Publications.

Durand, M. V., & Barlow, D. H. (2000). *Abnormal psychology: An introduction.* Wadsworth.

Halgin, R. P., & Whitbourne, S. K. (2005). *Abnormal psychology: Clinical perspectives on psychological disorders. Updated 4th Ed.* McGraw-Hill.

Meyer, R. G. (1990). *Clinician's Handbook: The psychopathology of adulthood and adolescence, 2nd Ed.* Allyn & Bacon, Inc.

Weckowicz, T. E. (1984). *Models of mental illness: Systems and theories of abnormal psychology.* Charles C. Thomas Publisher, Limited.

Test Yourself

1) Which of the following approaches defines abnormality in terms of its practical, functional, or maladaptive nature?
 a) statistical abnormality
 b) sociocultural abnormality
 c) psychological inadequacy
 d) none of the above

2) What is the most popular system for classifying psychopathology in the United States?
 a) MMPI
 b) DSM
 c) PTSD
 d) medical dictionaries

3) The _____ model is currently the most popular theoretical framework for understanding psychopathology. Within this approach, an explanatory mechanism mentioned in the chapter is that of _____.
 a) medical; humors
 b) moral; desires
 c) behavioral; learning
 d) biopsychosocial; diathesis-stress

4) Which of the following is *not* an anxiety disorder mentioned in the chapter?
 a) phobia
 b) obsessive-compulsive disorder
 c) post-traumatic stress disorder
 d) all of the above are anxiety disorders

5) Which of the following is not a personality disorder mentioned in the chapter?
 a) multiple personality disorder
 b) narcissistic personality disorder
 c) antisocial personality disorder
 d) all of the above are personality disorders

6) A conversion disorder is a type of somatoform disorder, where an individual suffers from _____ without _____.
 a) a nervous breakdown; an identifiable cause
 b) a physical ailment; physical causes
 c) a transformation; a cure
 d) hallucinations; knowing it

7) When an individual cycles through alternating periods of mania and depression, he or she suffers from which mood disorder?
 a) bipolar disorder
 b) double dissociation disorder
 c) dramatic-erratic disorder
 d) none of the above

8) What is the most prominent cause of cognitive disorders?
 a) lack of attention
 b) lack of education
 c) brain damage
 d) mental block

9) Briefly describe the major types of schizophrenia discussed in the chapter.

10) Give an example of *specific* factors that might be considered using the biopsychosocial model in explaining a psychopathology.

Test Yourself Answers

1) **c.** Assessment of psychological inadequacy defines abnormality in terms of its functional or maladaptive nature. The other approaches define abnormality in terms of rarity and social expectations.

2) **b.** The DSM is the most popular system for classifying psychopathology in the United States.

3) **d.** The biopsychosocial model is currently the most popular theoretical framework for understanding psychopathology. Within this approach, an explanatory mechanism mentioned in the chapter is that of diathesis-stress. The other pairs of terms are valid, but are not currently the most popular approach.

4) **d.** All of the above disorders are anxiety disorders mentioned in the chapter.

5) **a.** Multiple personality disorder is not a personality disorder mentioned in the chapter; it is another name for a dissociative disorder (DID).

6) **b.** A conversion disorder is a type of somatoform disorder, where an individual suffers from a physical ailment without physical causes.

7) **a.** When an individual cycles through alternating periods of mania and depression, he or she suffers from bipolar disorder, a mood disorder.

8) **c.** Brain damage is the most prominent cause of cognitive disorders.

9) Disorganized schizophrenia is characterized by childish behavior (for example, giggling, making faces, wild gestures, relieving oneself, and lack of personal hygiene). Catatonic schizophrenia involves a distinctive pattern of motor disturbance, such as immobility and rigidity, frenzied movement, or oscillation between these two extremes. The paranoid pattern of schizophrenia is characterized by the delusions of grandeur and persecution. Undifferentiated schizophrenia has a mixture of symptoms from the various other types without clearly resembling any one of them. Residual schizophrenics have had previous schizophrenia but are not currently symptomatic.

10) A neurobiological factor that might be considered is the abundance or underproduction of specific neurotransmitters that may contribute to a psychological disorder. Relevant sociocultural factors may include gender, age, marital status, and ethnicity; environmental factors such as living and working space; and the social structure in which one functions, including economic and cultural aspects. Psychological factors can include a number of concepts, depending especially on which psychological approach one adopts. For example, a behaviorist may consider how one learns certain associations, a psychoanalyst may consider unconscious desires, or a humanistic psychologist might implicate one's opportunity for self-actualization (or lack thereof).

Treatment of Psychological Disorders

I n Chapter 14, we introduce a survey of psychological disorders. These disorders vary in form, symptoms, etiology, and severity. Most disordered behavior is not severe and does not require formal therapeutic treatment. However, therapy for psychological disorders is a major application of professional psychology. This chapter reviews the history of treatment, the diverse structures of treatment available, the different kinds of medical therapies and psychotherapies practiced today, and some evaluation of these different approaches.

■ HISTORY OF THE TREATMENT OF PSYCHOLOGICAL DISORDERS

There has been a substantial progression in the treatment of psychological disorders over time. Importantly, this has included a growing appreciation of the afflicted individual and attention to individual well-being, rather than simply treating people with mental disorders as cursed, or deserving of punishment, casting out, or seclusion.

Early Approaches to Therapy

Whatever the form or theoretical perspective, all forms of therapy for disordered behavior share the common goal of changing behavior. The history of treatment closely parallels the history of approaches to understanding abnormal behavior discussed in Chapter 14. Although abnormal behavior has been documented throughout recorded human history, it has not always been understood. Whether individuals with behavior disorders were treated—and how they were treated—has depended on the model by which societies understood such behavior. Four broad approaches to therapy can be identified in human history: punitive approaches; moral therapy; medical therapy; and psychotherapy.

Punitive Approach

Evidence suggests that ancient societies believed in spiritual causes for abnormal behavior. Through the late Middle Ages in the Western world, individuals whose behavior we might recognize today as disordered were assumed to be possessed or influenced by evil spirits or demons. Disordered individuals were likely to be imprisoned, tortured, or executed. The assumption often made in such treatment was that behavior was not so much disordered as evil. It required discipline or destruction in order to protect the rest of the community. These punitive approaches caused abnormal behavior to be viewed with suspicion and fear, and prompted the families of such individuals to react with shame and guilt. The influences of this view are persistent today in similar concerns for how disordered behavior will reflect on one's family and community.

Moral Therapy

In the late sixteenth century, Henry VIII of England declared that Bethlehem Hospital in London (a name corrupted to "Bedlam") should house the mentally ill exclusively. Punitive attitudes gave way to social segregation. Disordered individuals were housed not in prisons but asylums, where conditions were hardly different. Crude medicinal treatments such as blood-letting and confinement in cages were practiced with predictably poor results. In the late eighteenth century, the French physician Philippe Pinel (1745–1826) argued for the treatment of mental patients with dignity and compassion. In the nineteenth century, the American social activist Dorothea Dix (1802–1877) campaigned for humane treatment of the mentally ill. Though not at that time supported by medical or psychological theory, the essence of this moral therapy movement was that disordered behavior could benefit from treatment with kindness, compassion, and pleasant surroundings.

The increasing public concern generated by the moral therapy movement led to legislation for the care of the mentally ill. As a consequence, more people demanded treatment than facilities were available for the provision of individual care. Private asylums became state institutions, and their function again emphasized warehousing the mentally ill and separating them from their communities. The book *A Mind That Found Itself*, by former mental patient Clifford Beers (1876–1943), exposed the deterioration and inhumanity of state institutions around the beginning of the twentieth century.

Modern Approaches to Therapy

Modern treatments for mental disorders can be classified as medical and psychotherapeutic. Often, a single individual benefits from treatments using both methods.

Medical Therapy

With the development of psychoanalytic theory and the medical specialty of psychiatry in the late nineteenth century, the medical model of abnormal behavior gained prominence (see Chapter 14). Psychological disorders came to be viewed as illnesses, with identifiable symptoms, causes, and courses of treatment. Those suffering from them were patients who needed the services of professional physicians. Psychiatrists moved into clinical settings like hospitals and institutions to treat their charges. Individuals who were not severely disordered could seek treatment as they might consult physicians about any physical malady. Because psychological disorders were viewed as diseases, medical treatments were favored. These included surgical procedures, electroconvulsive therapy, and drug treat-

ments, discussed in more detail in the "BIOLOGICAL (MEDICAL) APPROACHES" section later in the chapter.

Psychotherapy

The development of psychoanalysis also contributed to other methods of treatment besides medical approaches. Psychotherapeutic techniques emphasize psychological approaches, such as dialogue and behavior change, rather than medical. Psychotherapies today include insight therapies like psychoanalysis and humanistic therapy, behavior therapies like applied operant conditioning and modeling, and cognitive therapies such as rational-emotive behavior therapy. These techniques are also described in detail in the "PSYCHOTHERAPEUTIC APPROACHES" section later in the chapter.

■ DESCRIBING THERAPISTS AND THERAPY

Any therapeutic treatment involves the **client** (the affected individual), the therapist, and the formation of a special relationship between the two. Although it is common to think of psychologists and psychiatrists as the sole providers of treatment for disordered behavior, a wide variety of helping professions exist for such conditions. Clinical settings also vary, from institutions to public clinics to private practices. Therapies have been designed to address clients individually or in groups.

Professions Associated with Therapy

Within the broad profession of psychology, counseling psychologists and clinical psychologists can work as therapeutic practitioners. **Counseling psychologists** work with the problems of normal adjustment rather than abnormal function, including stress management, relationship conflict, and behavior modification. **Clinical psychologists** work with so-called clinical populations, individuals treated on an inpatient or outpatient basis for more severe disorders, including affective, addictive, and schizophrenic disorders. Whereas both of these professionals are trained in psychology, some practitioners are trained in the medical field. Within the medical profession, physicians who have trained in the specialty of psychiatry work as practicing therapists. **Psychiatrists** are medical doctors who have completed specialized training in psychological disorders. They may utilize many of the psychotherapeutic methods that psychologists use, as well as medical therapies like drugs. Other practitioners in the helping professions may be trained as counselors (degrees in education) or psychiatric social workers (degrees in social work). Chapter 1 also reviews the broad spectrum of helping professionals, including school and community psychologists.

Treatment Settings

Hospitalization has been the treatment of choice in the United States for the last 150 years. Mental hospitals admit almost two million people annually, yet there is more demand for hospital treatment of disordered behavior than there is room in such facilities. Nonetheless, the majority of mental illness admissions are made to general hospitals without psychiatric units. There are also alternatives to these institutional settings, such as community centers and private practices. In most situations, insurance carriers play a pivotal role not only in determining feasible outlets for therapy but also in maintaining a degree of quality control in both inpatient and outpatient situations.

Community Psychology

The 1963 Community Mental Health Act legislated deinstitutionalization, or the release of mental patients back to their communities. As a result, community mental health centers were established nationwide to provide treatment on an outpatient basis or through residential centers like halfway houses. Many neighborhoods are still ambivalent over housing such patients and former patients. The private and public high cost of insurance and treatment is also controversial. Consequently, the quality and effectiveness of such treatment varies widely.

Key missions of community health centers are public education and prevention. The aim of investment in prevention is based on the expectation that it will result ultimately in reduced need for radical treatments and institutionalization. The focus of community psychology on prevention also extends to the use of intervention techniques. This involves professional counselors who help families and/or friends to approach troubled individuals before their behavior deteriorates or their psychopathology fully develops. Many such intervention programs are aimed toward disorders such as substance abuse and impulse control disorders (such as gambling).

Private Practice

For disorders that are not severe and families that can afford it, private practice—privately chosen arrangements for therapy—is the preferred approach to treatment. Such arrangements have the advantage of allowing clients to make their own choices among practitioners. Because no institution or agency governs the arrangement, however, they have the disadvantage of some risk. Not all therapists have comparable training and credentials, and clients must become critical consumers of therapeutic information and services. Many private practices focus on specialized subsets of psychopathology, such as centers for children with behavioral or emotional problems, or those for individuals with substance abuse disorders.

Individual versus Group Therapies

In both private practice and institutional settings, many problems can be addressed in group contexts rather than individually. The cost of group therapies may be comparably lower. A therapy group may consist entirely of clients meeting with a facilitator, or may include other helping professionals like hospital staff members. Group therapies can be particularly useful in family therapy, where the problems themselves have social implications. They can also employ techniques like role playing and psychodrama (see the "Gestalt Therapy" section later in this chapter), which often rely on dialogues and group settings. In some types of therapy, such as marital and relationship therapy (couples therapy), the "group" consists of only two people.

A nonprofessional extension of group therapies has been the development of support and self-help groups. Organizations such as Alcoholics Anonymous, Weight Watchers, and support groups for veterans, the families of crime victims or cancer patients, and others have all been found to provide important benefits like sympathy, understanding, and practical advice.

Evaluating Therapies

There is no guaranteed "cure" for psychopathology, and no method that can be labeled the "best" in absolute terms. Just as psychological disorders are complex phenomena that have biological, psychological, and environmental components, therapies are likewise multifaceted and often incorporate multiple

treatment procedures (for example, psychotherapy and psychoactive drugs). Hans Eysenck (see Chapter 14) reported in 1952 that those receiving psychotherapy actually had a lower rate of improvement compared to those who received no treatment. However, this claim has been widely criticized on grounds of poor methodology and biased data interpretation, and subsequent studies have reported contradictory results.

There are several issues that make evaluating the utility of treatment methods difficult. First, there are no clear criteria for defining "success" or "improvement." How much improvement must be shown, and when is a person "cured"? Second, the data to be used are not always clear (for example, psychometric tests versus interviews versus observations of behavior). Furthermore, there is great variability across specific administrations of treatments, such as between different therapists even if they use the same technique. Individual differences among those being treated must also be considered in assessing treatments. Perhaps most critical is realizing that different treatment approaches are likely to be differentially effective for different psychopathologies.

In short, there is no clear way to assess treatment methods, whether they be used in isolation or in combination. Nevertheless, the American Psychological Association has endorsed a partial list of empirically supported therapies of varying effectiveness for many specific disorders. To this day, however, there is controversy over the use of both psychotherapeutic approaches as a whole and specific psychotherapies, as well as debate about the use of psychoactive drugs in general and specific drugs.

■ PSYCHOTHERAPEUTIC APPROACHES

Psychotherapy involves the treatment of psychological disorders through talking and other methods as a means to modify thinking, feeling, and behavior. Such treatment is not performed haphazardly, but rather it is guided by the therapist's preferred theoretical approach toward the nature of psychopathology and evidence for effectiveness of treatments for particular disorders. This, in turn, determines the procedure that is used to help change the undesired behavior. In this section, we describe psychodynamic, humanistic, behavioral, and cognitive approaches. Psychotherapies vary and overlap considerably. Most practicing therapists are eclectic, meaning they employ a variety of techniques from different therapeutic models.

Psychodynamic Psychotherapy (Psychoanalysis)

Originally developed by Sigmund Freud in his work with individuals suffering from hysteria (the former term for conversion disorder), psychoanalysis is a therapeutic system that emphasizes identifying an individual's unconscious conflicts. **Psychoanalysis** follows the medical model and employs medical terminology: the client is called a patient; the complaints are his or her symptoms. Originally, Freud employed hypnosis as a means of relaxing patients and inviting them to reveal the origins of their conflicts. He abandoned this procedure and came instead to rely on free association, a process in which the patient talks openly and without censoring, while the analyst listens for clues to unconscious motives and themes.

The key to psychoanalysis is to make the patient aware of the unconscious thoughts, emotions, and motives that influence his or her life. Freud believed that there was important hidden meaning (latent

content) that underlies what is revealed in free association or dreams (manifest content). This notion gave rise to the term Freudian slip, whereby an individual unconsciously substitutes a word that reveals some unconscious desire or motive (for example, saying "sex" instead of "six"). It was such seemingly insignificant—but potentially meaningful—behavior and action on which Freud focused.

The relationship between analyst and patient is essential to the work of therapy. During psychoanalysis, which may take years, the patient may project feelings about personal or past relationships onto the analyst, a process called **transference**. The patient may also try to protect defenses from being analyzed by engaging in **resistance**, by refusing to talk, forgetting to keep appointments, or not paying the analyst's bill. Psychoanalysis is considered effective when the patient has achieved insight into the unconscious motivations and conflicts that the disordered behavior has been defending against.

Updating the Classical Approach

As Freud's theories of personality came under criticism, his treatment methods became less popular. Today, there are a wide variety of psychotherapies that retain the basic flavor of traditional psychoanalysis, such as the role of analyzing transference. However, revised neo-Freudian psychotherapies focus on different elements and often require less time and intensity of the patient-therapist relationship. One example is object relations therapy, which focuses on an especially meaningful object (person or event) and fulfills the patient's need for attention and support.

Humanistic Psychotherapy

Just as humanistic personality theory disagrees with psychoanalytic theory about the nature of personality and conflict, so does its therapeutic approach differ from that of psychoanalysis. Humanistic psychotherapy focuses on subjective perception of events and actions, and seeks to help people realize goals, promote the self, and achieve. There are key characteristics of humanistic psychotherapy that distinguish it from psychodynamic techniques. First, the relationship between client and therapist is one of two equals, not of an expert and a patient. Second, although it focuses on achieving insight, this is the result of perceptual awareness and acceptance of oneself, not revelations about unconscious desires. Humanistic approaches stress the worth of the individual, regardless of how dysfunctional the expressed behaviors are. Finally, therapy is tailored around the assumption that individuals will improve if given the right conditions, and they are responsible for deciding how and when this occurs.

Client-Centered Therapy

The humanistic system developed by Carl Rogers (see Chapter 12) is termed **client-centered therapy**. In client-centered therapy, the therapist's goal is to help the client become a fully functioning human. Client-centered therapists provide unconditional positive regard to their clients, accepting them no matter what they say or do. They also emphasize the importance of being nondirective, refusing to tell the client what to do or direct his or her actions. Instead, using techniques like active listening, client-centered therapists reflect back to the client what he or she seems to want and believe, offering this as the basis for genuine behavior change. This offers the client the benefit of empathy, or the feeling that another genuinely understands the way he or she is feeling. Another component is congruence between the therapist's feelings and actions toward the client.

Gestalt Therapy

The German word "Gestalt" means "whole pattern" (see Chapter 1), and **Gestalt therapy** emphasizes the importance of helping an individual to contact and understand his or her whole self. According to its developer, Fritz Perls (1894–1970), Gestalt therapy seeks to make the individual aware of who he or she is and what he or she is doing. The emphasis is not on the "why" insights of psychoanalysis, but rather on "how" to live and go on with life. It also emphasizes present experience instead of one's past actions or feelings. Gestalt therapy also promotes an individual's independence and sense of responsibility. One Gestalt technique is psychodrama, acting out scenes (for example, parent-child conversations) in order to bring out their emotional significance.

Behavioral Psychotherapy

Behavior therapists argue that, for some disorders at least, insight is unnecessary to alleviate symptoms and change behavior. For example, if dealing with a woman who has a phobia of elevators, a behavior therapist might consider how to train the phobic woman to feel relaxed on elevators, so that her incompatible anxiety can no longer prevent her from living and traveling as she wishes. Many behavior therapies are used in combination with each other and with other psychotherapeutic techniques. Here we consider four techniques and approaches to behavior therapy: operant conditioning, aversive conditioning, desensitization, and modeling.

Operant Conditioning

The application of operant conditioning principles (Chapter 7) in behavior therapy involves providing changes in reinforcement to bring about changes in behavior. First, positive reinforcement may be used to promote behavior. For example, a client who wants to eat less will identify nonfood rewards to be earned by sticking to a behavior-change contract. He may permit himself to buy a book or make a long-distance phone call only if he eats 1,000 fewer calories on a given day. Second, the removal of reinforcement may remove the associated (undesirable) behaviors, known as extinction. If acting out gives a child the attention he or she desires, refraining from giving this attention may extinguish the behavior. Other operant conditioning principles may be incorporated as well, such as punishment to prevent unwanted behaviors.

A common operant conditioning strategy is the token economy, whereby token rewards are provided for performing desired behaviors. These tokens can then be exchanged for valued items or services. For example, a retarded child will be paid in tokens for brushing her teeth. When she earns enough tokens, she may exchange them for toys or treats. A newer development, especially in school contexts, is functional assessment and behavioral intervention. In short, this technique seeks to determine the functional basis for problem behaviors, and then implements an intervention plan that provides motivation for alternative methods (more appropriate behaviors) for achieving the same functional results.

Aversive Conditioning

Aversive conditioning applies the principles of classical conditioning by pairing an aversive stimulus (for example, a painful electric shock or drug-induced nausea) with a behavior one wishes to eliminate. For example, an alcoholic who takes the drug Antabuse will become nauseated and vomit if he drinks any alcohol. While on the drug, he will become conditioned to associate alcohol with nausea, and will eventually generalize this association to drinking when not taking the drug.

Desensitization

Desensitization, also discussed in Chapter 7, is a behavior therapy commonly employed in the treatment of phobias (see Chapter 14). Desensitization involves developing a hierarchy of anxiety, a rank-ordered listing of phobic situations the client imagines. The therapist then teaches the client how to relax, through breathing exercises, guided imagery, muscle control, and biofeedback (information about physiological arousal). Finally, the client imagines each item on the anxiety list, beginning with the least frightening, while maintaining effective relaxation. Gradually, the client is able to imagine and then behave in the most phobic situation while retaining controlled relaxation. In this way, the phobic's anxious behavior is replaced with nonanxious behavior. In the course of the process, each anxious image has become less and less sensitive, or desensitized.

Modeling

Desensitization is sometimes augmented by modeling, a technique discussed by Albert Bandura as a key to social learning (See Chapter 7). In therapeutic application, this involves teaching new behaviors by having the client observe others doing them. For example, a man with a phobia of snakes might practice desensitization and learn to imagine snakes without anxiety. By watching a model touch and handle a snake, he benefits both from clearer imagery and the behavioral model he himself may learn to copy.

Cognitive Psychotherapy

Cognitive psychotherapy focuses on changing the way people think about their behaviors. Rather than trying to discover unconscious motives through insight, or need reassurance that one is a worthy individual, cognitive therapies focus on a rational assessment of behavior.

Beck's Cognitive Approach

Psychologist Aaron Beck has proposed that depression results from a negative style of thinking. For instance, a young woman who has been stood up for a date may tell herself that this would not have happened if she were attractive and worthy of love. As a result, she concludes she must be unattractive and unworthy of love. In cognitive therapy, the therapist focuses on the client's unrealistic expectations and distorted assumptions. The therapist may point out that relationships are not controlled by only one person, and that it is unrealistic to think that all disappointments are deserved. The client will also be encouraged to keep a mood diary to discover patterns of depressive thoughts and the events that seem to have triggered them.

Attribution Therapy and Stress-Inoculation

A more specific rationale for cognitive therapy involves understanding attributions, which are our explanations for our own and others' behaviors (see Chapter 16). Research has found that some kinds of depression can be traced to erroneous patterns of attribution, or to a negative attributional style. The negative attributional style is characterized by three dimensions of explanation: internal versus external; global versus specific; and stable versus unstable. Internal attributions blame one's personality or skills, while external attributions blame circumstances. Global attributions generalize effects across one's experience, while specific attributions focus narrowly on individual incidents, and stable attributions expect no change while unstable attributions anticipate that change is possible.

Attribution therapy questions these negative attributions and suggests replacing them with more realistic explanations. For example, if a student has received a poor grade on a paper, an internal, global, stable attribution might be, "I did poorly because I am a poor student, I get poor grades on everything, and I'll never do any better." Not surprisingly, this negative style can lead to depression. Attribution therapy might suggest showing the student that he or she could just as easily make the following external, specific, unstable attribution: "I got a poor grade because it was a hard paper to do, but it's only one paper, and I'm sure I can do better next time."

A similar form of therapy involves helping a client reduce the stress he or she feels in certain situations, called **stress inoculation therapy**. This may be done in three stages: first by analyzing self-statements ("I hate being stuck in traffic"); second by practicing new self-statements ("When I'm stuck in traffic, I can listen to the radio and enjoy the music"); and third by rehearsing such new strategies in behavioral situations.

Rational-Emotive Behavior Therapy

Psychologist Albert Ellis has developed **rational-emotive behavior therapy** (REBT) to question and correct the irrational beliefs that underlie disordered feelings and behaviors. In REBT, every disordered behavior is the last event in a three-stage sequence: (1) an activating event triggers (2) a belief, either rational or irrational, that leads to (3) a behavioral consequence. For example, a young man receives a call from his girlfriend canceling their date for the next evening. This activating event could prompt him to consider either a rational belief ("This is disappointing; now I will have to change my plans for tomorrow evening"), or an irrational belief ("This is terrible! She never wants to see me again, and I will never find true love"). As a result, the emotional and behavioral consequences will be either rational ("Even though it won't be as special, I'll call a friend and go to a movie"), or irrational ("I may as well sit at home and get used to living the rest of my life alone"). In REBT, the beliefs underlying one's behaviors and feelings are analyzed, and irrational ones are questioned and discarded in favor of more rational ones. REBT is considered quite effective for normal individuals who are behaving in self-defeating ways and wish to change.

Thought Stopping

One cognitive method that seems effective in many situations is thought stopping. Most generally, this technique involves realizing when bothersome or distressing thoughts threaten one's well-being, and then responding by eliminating them. This may entail a number of methods, ranging from simply yelling "Stop!" to oneself, to substituting other thoughts such as those that are more pleasant, intentionally distracting, or intentionally discouraging. For example, if an addict begins to have thoughts about engaging in the addictive behavior, he or she may try to instead think about more positive alternate behaviors, or think of something negative or aversive about the addictive behavior.

■ BIOLOGICAL (MEDICAL) APPROACHES

As a result of the medical model popularized in the early twentieth century, many therapies were developed which emphasize medical techniques. Early biological treatments included psychosurgery and electroconvulsive therapy (ECT). A revolution in medical therapies occurred in the first half of the twentieth

century, when psychoactive drugs were identified and developed to alleviate the symptoms of many severe psychological disorders. These drugs made restraints and confinement unnecessary in many cases and changed the operation of psychiatric hospitals and asylums.

Early Biological Treatments

A dramatic and controversial treatment that has proven effective in treating many cases of severe depression is so-called shock therapy, more accurately termed **electroconvulsive therapy** (ECT). In ECT, a sedated, relaxed (via muscle relaxants) patient experiences a mild convulsion induced with electrical current. On awakening a few minutes later, the patient may have some memory loss and confusion, but over time (several sessions), the depressive symptoms are alleviated. Critics have argued that no one knows why or how ECT works, and that it entails unwarranted risk to cognitive function. Supporters contend that, as a last resort treatment, it has proven highly effective where other methods have failed.

Another early form of biological treatment, **psychosurgery** or neurosurgery, involves surgical procedures to remove or destroy focused regions of brain tissue in an effort to effect behavior change. For example, in a prefrontal lobotomy, the brain's frontal lobes are severed from deeper brain connections. This was sometimes employed to reduce a patient's violence to self and others. Psychosurgical techniques were widespread in the 1940s and 1950s, and are still used to some degree today—although quite sparingly and with greater apprehension. Effects of such surgery vary widely among individuals, they pose great and permanent risks (including death), and therefore are also used primarily as a last resort.

Psychoactive Drugs

By far, the most common biological treatment is the use of psychoactive drugs. The decline in ECT and psychosurgery was not only because of the dangers involved but also largely because of the development of increasingly effective psychoactive drugs. This development of drugs to alleviate the symptoms of severe psychological disorders has been revolutionary in therapeutic practice. The use of drugs to achieve psychological change is termed **psychopharmacology**. Drugs produce only temporary changes in affect, cognitive processes, and/or behavior, and their side effects are easier to predict than surgical techniques. Psychoactive drugs are usually classified according to the disorders for which they are targeted, which also describes their effects. Although our discussion here is general, it should be noted that psychoactive drugs, due to their operation on a biological level, may have differential effects on different ethnicities or genders.

Antidepressants

Antidepressants are psychoactive drugs used in the treatment of depression. Antidepressants work to increase the levels of certain neurotransmitters in the brain, such as serotonin and norepinephrine. They can have dramatic effects alleviating the symptoms of depression, although these behavioral effects may take a week or more to develop. However, they are not equally effective in all cases, and full recovery from affective disorders may require a combination of drug therapy with psychotherapy. There are different classes of antidepressants, such as monoamine oxidase inhibitors (MAOIs), and tricyclic antidepressants (TCAs). The most popular is probably fluoxetine (Prozac), which increases serotonin in the brain but has fewer and milder side effects than MAOIs and TCAs.

Sedatives and Anxiolytics

Sedatives include substances as varied as alcohol, barbiturates (Seconal), methaqualone (Quaalude), and tranquilizers like diazepam (Valium) and chlordiazepoxide (Librium). Sedatives depress central nervous system activity. In large doses they induce sleep, and in smaller doses they can relieve anxiety and reduce inhibitions. Valium is an example of an **anxiolytic drug**, one that reduces feelings of anxiety; another popular anxiolytic drug is alprazolam (Xanax). Although these drugs are popular treatments for anxiety, they relieve anxious symptoms without "curing" their sources. They are sometimes abused by those to whom they are prescribed as well as by recreational users. A number of antidepressant drugs have also been effective in treating anxiety, such as fluoxetine and sertraline (Zoloft).

Neuroleptics (Antipsychotics)

In the early twentieth century, sedatives were used to calm mental patients but were not useful as therapeutic agents because they induced sleep. In the mid-twentieth century, however, the major tranquilizers were found to reduce psychotic (for example, schizophrenic) symptoms as well as alleviate anxiety and aggressiveness. Drugs that alleviate these symptoms of severe disorders are now called **neuroleptics** or antipsychotics. Chlorpromazine (Thorazine) and haloperidol (Haldol) are commonly the treatments of choice for schizophrenic symptoms such as hallucinations and delusional thought. Antipsychotic drugs do not cure schizophrenia, however, and can involve numerous undesirable side effects like blurred vision and motor disturbance.

Lithium

In the 1970s, researchers discovered that **lithium** could minimize and prevent the mood disorders of depression and mania associated with bipolar disorder. This treatment has been found to be quite effective, although the dosage must be carefully controlled to prevent harmful side effects from overdose. Although it cannot control manic episodes in progress due to the time lag involved (much like antidepressants), it has considerably eased life for those diagnosed with bipolar disorder.

Approaches to treatment of disordered behavior closely parallel the models of its causes. Historically, disordered behavior was punished or segregated. The development of moral therapy advocated humane treatment of the mentally ill. In the twentieth century, the rise of the medical and psychological therapies have broadened the possibilities of treatment. Many professionals are trained to provide treatment of disordered behavior. These professionals include psychologists, psychiatrists, and counselors. Treatment may be provided in various clinical settings, such as hospitals and institutions, community mental health centers and residential centers, and private practice settings. Most therapies involve individual treatment, but many group, family, and couples therapies are also available and appropriate for certain applications.

Psychotherapies can be categorized as emphasizing the importance of either insight therapy or behavior change. The insight therapies include psychoanalysis (both Freud's and modern approaches), and the client-centered and Gestalt approaches to humanistic therapy. Behavioral therapies apply the principles of learning theory to change behavior. Representative therapies of this type are operant conditioning, aversive conditioning, desensitization, and modeling. Related to these behavioral therapies are

cognitive therapies, including Beck's cognitive approach, attribution and stress-inoculation therapy, and rational-emotive behavior therapy.

Biological or medical therapies employ biological techniques to effect behavior change. These include psychopharmacology, electroconvulsive therapy, and psychosurgery. Psychoactive drugs are by far the most widely employed of these techniques in modern times. Those that are useful in medical treatment of disordered behavior include antidepressants, sedatives, anxiolytics, neuroleptics, and lithium.

Key Concepts

antidepressants

anxiolytic drug

attribution therapy

aversive conditioning

client-centered therapy

clinical psychologists

counseling psychologists

desensitization

electroconvulsive therapy (ECT)

Gestalt therapy

lithium

neuroleptics

psychiatrists

psychoanalysis

psychopharmacology

psychosurgery

psychotherapy

rational-emotive behavior therapy (REBT)

resistance

sedatives

stress inoculation therapy

transference

Key People

Aaron Beck

Clifford Beers

Dorothea Dix

Frits Perls

Albert Ellis

Philippe Pinel

SELECTED READINGS

Beck, J. S. (1995). *Cognitive therapy: Basics and beyond.* Guilford Publications, Inc.

Cheshire, K., & Pilgrim, D. (2004). *A short introduction to clinical psychology.* SAGE Publications.

Bedell, J. R. (Ed.). (1994). *Psychological assessment and treatment of persons with severe mental disorders.* Taylor & Francis, Inc.

Durand, M. V., & Barlow, D. H. (2000). *Abnormal psychology: An introduction.* Wadsworth.

Halgin, R. P., & Whitbourne, S. K. (2004). *Abnormal psychology: Clinical perspectives on psychological disorders.* McGraw-Hill.

Test Yourself

1) Which of the following professionals is necessarily a medical doctor?
 a) counseling psychologist
 b) clinical psychologist
 c) psychiatrist
 d) counselor

2) Which of the following treatment facilities is most focused on prevention of psychological disorders, in addition to treatment?
 a) hospitals
 b) asylums
 c) private practices
 d) community centers

3) Which of the following is *not* a common occurrence during a session of a patient and a psychoanalyst?
 a) analysis of latent content
 b) clients treated as equals
 c) transference
 d) resistance

4) Humanistic therapy focuses on the realization of self-potential and the acknowledgment of individual worth; this approach includes _____therapy focusing on the whole self and Rogers's _____ therapy.
 a) client-centered; Gestalt
 b) client-centered; REBT
 c) Gestalt; client-centered
 d) Gestalt; REBT

5) Which of the following is *not* introduced as a behavioral approach to psychotherapy?
 a) operant conditioning
 b) aversive conditioning
 c) desensitization
 d) all of the above were introduced as behavioral psychotherapies

6) Which of the following is *not* introduced as a cognitive approach to psychotherapy?
 a) modeling
 b) attribution theory
 c) Beck's approach
 d) all of the above were introduced as cognitive psychotherapies

7) Which of the following statements best describes psychoactive drugs, based on the material in the chapter?
 a) Psychoactive drugs are currently the second leading biological treatment.
 b) Most psychoactive drugs are used to control neurotransmitter levels.
 c) Psychoactive drugs are popular because they produce permanent biological changes with few side effects.
 d) Psychoactive drugs should not be used in conjunction with psychotherapy.

8) Psychoactive drugs include _____, used to treat anxiety, and those that are used to treat severe disorders such as schizophrenia, called _____.
 a) Prozac; axiolytics
 b) axiolytics; Prozac
 c) Xanax; neuroleptics
 d) lithium; Thorazine

9) Besides on a one-to-one basis, list two other ways therapy can be administered. Give an example of each of these types.

10) Provide brief support for, or opposition to, the following statement: "We should know which single treatment works best for a certain disorder so we can apply it to anyone afflicted."

Test Yourself Answers

1) **c.** Psychiatrists are the only professionals listed who are required to have medical degrees.

2) **d.** Community centers are most focused on prevention of psychological disorders, in addition to treatment.

3) **b.** Clients treated as equals is not a common occurrence during psychoanalysis, but rather this is true of humanistic psychotherapy. In psychoanalysis, clients are patients who need to be treated.

4) **c.** Humanistic therapy focuses on the realization of self-potential and the acknowledgment of individual worth; this approach includes Gestalt therapy focusing on the whole self and Rogers's client-centered therapy.

5) **d.** All of the answers were introduced as behavioral psychotherapies.

6) **a.** Modeling was not introduced as a cognitive approach to psychotherapy. Although there is likely a cognitive component, this technique was introduced as a behavioral psychotherapy that relies on social learning.

7) **b.** According to the chapter, most psychoactive drugs are used to control neurotransmitter levels. They are currently the leading biological treatment, produce relatively short-term treatment with risk of side effects, and are often used in conjunction with psychotherapy.

8) **c.** Pscyhoactive drugs include Xanax used to treat anxiety, and those that are used to treat severe disorders such as schizophrenia, called neuroleptics. Xanax is a type of axiolytic, and Thorazine is indeed a type of neuroleptic, but these responses were not matched with each other (Prozac is an antidepressant and lithium is used to treat bipolar disorder).

9) Therapy can involve more than one person. In couples therapy, a pair of people in a relationship or marriage receive therapy together. In group therapy, many individuals are treated simultaneously. This can involve a group of people with a similar disorder (such as the same phobia), or a family unit that wishes to have therapy together.

10) There is really no such thing as "the best single treatment" that would work for everyone who is afflicted with a psychological disorder. What works for one person may not work for others, because the causes of psychological disorders are not well understood. Although some treatments seem to be generally effective for certain disorders, there is no guaranteed biological or psychotherapeutic treatment based on given symptoms. Furthermore, ethnic and gender differences in response to biological treatments, and individual variation in response to certain psychotherapies cannot be ignored.

Social Psychology

Social psychology is the field of psychology that studies the social influences on the individual. It has common interests with both sociology, which studies groups, and personality psychology, which studies individual differences. In this chapter, we first examine the effects of social settings on the individual. Then, we survey the major topical areas comprising social psychology: social cognition, involving cognitive processes like perception and thought that concern social experiences; attitudes, a major area of research within social psychology; and social influences and interactions, including interpersonal relationships and group processes.

■ SOCIAL EFFECTS ON THE INDIVIDUAL

Like other fields of psychology, social psychology studies individual thought and behavior. However, other fields study these phenomena by examining internal structures or processes (for example, the nervous system, learning, perception) or individual characteristics and developmental experiences (for example, personality theory or developmental processes). In contrast with these internal or personal perspectives on behavior, social psychology adopts a situational perspective on behavior and thought. In other words, whereas other fields are more likely to ask what is going on inside the person, social psychologists ask what is going on around the person.

Self-Perception

According to social psychologist Daryl Bem, people come to understand themselves by making inferences based on observations of their own behavior. This is the reverse of the common-sense notion that we know ourselves, and then act in such a way as to be true to ourselves. An example of the self-perception process would be figuring out how to answer a question about your own political values. If you have not already formulated an answer to the question, you will have to consider what your position is on several issues, and then draw a conclusion about what your basic position—for example, political liberal or conservative—must be. In a sense, you observe your own behavior by reviewing your positions

and remembering how you have voted. Then you make an inference about the connective causes of your behaviors. You thereby arrive at a perception of yourself.

Even if we do not know ourselves very well, we are apparently predisposed to like ourselves and give ourselves the benefit of the doubt. One demonstration of this tendency is the application of **self-serving biases**, tendencies to perceive and judge our own actions in ways that preserve our self-esteem. For example, numerous studies indicate that we explain and judge the causes of our behaviors in positive ways while making negative attributions about others' actions (see the "Attribution" section later in this chapter).

An ironic extension of self-serving tendencies is our search for self-serving attributions about expected failures or losses. For example, a student who worries that she will do poorly on an upcoming examination must decide whether to spend the previous evening studying or partying. If she studies and then fails, she will be forced to conclude that her best efforts were still incompetent—an unacceptable self-attribution. Alternatively, if she parties and then fails, she may conclude that her failure was due to negligence rather than incompetence—a more acceptable self-attribution. Such self-disparagement in quest of more acceptable reasons for failure is known as **self-handicapping**. Self-handicapping can involve engaging in somewhat self-defeating or self-destructive behavior, in the cause of establishing relatively acceptable reasons for failure. Furthermore, if one succeeds in spite of these behaviors, then one can arguably claim exceptional abilities or talents. The danger of self-handicapping obviously is that in manufacturing a "more acceptable" excuse for failure, we may guarantee a failure that may otherwise have been unlikely.

Social Identity Theory

When asked to describe oneself, some characteristics that people mention are qualities such as "honest," "hard-working," or "sensitive." Other responses may reflect an influence of the social environment. That is, whereas the characteristics just listed reflect a focus on one's personal identity, other descriptions such as "American," "student," or "Catholic" reflect one's **social identity**. Although recognizing a group or social identity can be beneficial in instilling a sense of pride or belongingness, it can also lead to distinct biases or prejudices (discussed in the "Prejudice and Stereotyping" section later in this chapter).

Social Comparison Theory

According to social psychologist Leon Festinger (1919–1989), an important influence of the social environment is how we use others to gauge ourselves. According to Festinger's **social comparison** theory, we compare ourselves with others socially, using others' opinions and actions as a standard for judging our own. In brief, people seek information and compare their judgments with those of other people in an effort to verify that information. Especially powerful are comparisons to those within our **reference groups**, or categories of people to which we feel like we belong. These may include ethnic, religious, occupational, recreational, or other groups. This may lead to a sense of **relative deprivation**, where one believes that one is achieving, attaining, or receiving less than is expected by membership in the reference group. In other words, a professional athlete may feel slighted if she or he is making "only" $7 million a year, compared to other athletes in the same sport.

A combination of self-serving bias and social comparison can lead to some additional interesting phenomena. For example, we may have a self-serving bias by which we believe ourselves to be more moral than average, better than average, safer than average, and so on. As a result, we may wrongly judge how our actions compare with those of others. One example of this is the **false uniqueness effect**. We see our positive actions, skills, and abilities to be relatively unusual, misjudging the likelihood that others are also good or talented. Alternatively, when we acknowledge the selfishness or failures we have experienced, we may suffer from the **false consensus effect**. We overestimate how common our negative behaviors and prejudices are, justifying cheating on our taxes by arguing that "everyone does it," and excusing an angry outburst by claiming "it's normal for people to lose their temper once in a while."

Deindividuation

When we are immersed in group or crowd situations, we may lose some self-awareness and become less inhibited. This is more pronounced when we feel anonymous, either because the crowd is so large or some other reason (for example, the room is very dark). The combined effects of social immersion and anonymity result in **deindividuation**, a state of reduced self-awareness that results in uninhibited, irresponsible behavior. An example of deindividuation is what happens when a group of people panics and becomes a violent mob. Research indicates that each member of such a mob feels less like an individual self, and so less accountable for his or her actions. The effect can be reduced by increasing self-awareness and reinforcing individual identity. For example, calling people by name, turning up the lights, or watching people individually can all work as reminders to group members that they are individually accountable for their actions.

Social Motivation

Research has shown that the "mere presence" of others can have a motivating effect on individuals (see also Chapter 10 for social motives). Early research found that when people perform simple tasks like riding bicycles, they work better and faster in the presence of others than when alone; this phenomenon is called **social facilitation**. An example of this is the tendency of athletes to work out harder or play better when their teammates are around or when an audience is watching. In other circumstances, it seems that the presence of others is distracting, called **social impairment**. For example, if someone is watching you work or solve a difficult problem, you may complain that your performance is worse when you are being watched. Why does others' presence sometimes enhance, but sometimes hinder, human action? The explanation for social facilitation and impairment is that the presence of others is arousing. As reviewed in Chapter 10, arousal will enhance performance of simple tasks but hinder performance of complex tasks. The interesting discovery of social facilitation research is that the presence of others indeed has an arousing effect.

Another source of social motivation involves not just the presence of others, but working with others. Specifically, research has shown that when working in a group setting or among many others, individuals are more likely to reduce their effort compared to when working on the same task alone, an effect known as **social loafing**. This occurs because it is usually harder to identify the contributions (or lack thereof) of an individual in a group, and rewards for performance are typically distributed evenly among group members based on group performance, rather than the sum of individuals' performance.

Interestingly, whereas social loafing is predominant in Western cultures, the opposite effect (called social striving) is prevalent in collectivist Eastern cultures.

■ SOCIAL PERCEPTION AND COGNITION

Social cognition involves the way that people interpret information about, draw inferences about, and categorize others, as well as how this determines their own actions. It is difficult to draw a distinction between social perception and social cognition, so we will simply use the latter term to refer to both the perception of others and subsequent use of this information. Social cognition applies much of what has already been reviewed in other areas of psychology to the unique concerns of social psychology. Consider the bases of a great deal of research on social perception and cognition: impression formation, attribution, attitudes, and stereotypes. As we discovered in chapters on perception, memory, and cognition, schemas are important for determining how we perceive and process information (including information about ourselves). Similarly, schemas are also important for how we perceive and categorize others.

In self-perception, we have the luxury of time with ourselves and a broad perspective on our actions over many situations. In perceiving others, however, we are usually granted only limited time and circumstances. Nonetheless, we may have to make important decisions about others with lasting consequences. Faced with important decisions and insufficient opportunity to collect information, we resort to various strategies and heuristics (informal guidelines) to draw conclusions about others. These patterns of social cognition influence our experiences and actions in four broad areas: impression formation, attribution, attitudes, and stereotypes.

Impression Formation

We look for reasonable explanations of others' behavior rather than assuming that people are inscrutable and impossible to understand. Other researchers have pointed out that, in everyday life, we often behave like "naive scientists" in forming impressions of others. Specifically, when we meet someone, we collect information by various means (for example, asking others about him or her, making observations of his or her likes and dislikes, and so on). After collecting the information (data), we speculate about the connections among the person's characteristics (form hypotheses) and test these in real life. We rely on numerous strategies for combining and interpreting information about others, such as the use of central traits, primacy effects, and recency effects.

Central Traits

In classic research, social psychologist Solomon Asch (1907–1996) asked students to form an impression of individuals whose traits had been listed for them. Half of the students read a list including the trait "warm," while the other half read an otherwise identical list which included the trait "cold." The trait dimension "warm-cold" was found to be central to impressions formed of the other traits. For example, someone who is "warm and intelligent" seems to be a different kind of intelligent than someone who is "cold and intelligent." **Central traits** are traits influential in modifying the total impression formed as well as the way each trait in the impression is interpreted. Central traits may vary among people. If kindness is important in someone's life, the impression he forms of others may be centrally influenced by whether those others appear to be kind or not.

Primacy and Recency Effects

In further work, Asch gave participants lists of traits to form impressions about. Half received a list of several positive traits followed by several negative traits. The other half received the same list in reverse order. The impressions participants formed were influenced more by the first traits on each list—an effect influencing memory, more generally (Chapter 8). This influence can be seen in the power of first impressions. In some cases, it has been found that the last information available has swayed the impression being formed (recency effects). However, the recency effect seems to occur only under special circumstances, as when we are caused to doubt the truth of first impressions or warned against the dangers of hasty social judgments. In those conditions, when the latest information contradicts the first, last impressions are stronger.

Attribution

One of the most basic questions people (including psychologists) ask about behavior is, "Why?" Research on motivation essentially endeavors to answer that question about human behavior. Social psychologists refer to this explanation process as **causal attribution**, attributing behavior and events to appropriate causes. People ask attributional questions about others' behavior all the time. Often the reasons for others' behaviors are obvious. Why did she stop at the red light? She stopped because she knew the law required her to do so. Why did he eat all the cake? He ate it all because he wanted to and no one objected. At other times the reasons for others' behavior are not so obvious: Why did my supervisor give me such a low rating? Why was that student so late for class? Why is my spouse so distant lately? When the behaviors in question are important to us, surprising, or have negative consequences, we are especially likely to ask attributional questions. Social psychologists have identified patterns in the ways people make attributions about their own and others' behavior.

Internal versus External Attributions

In trying to explain someone's (the "actor's") behavior, we generally consider two categories of reasons: internal factors such as the actor's disposition or personality, and external factors, such as the immediate demands of the actor's situation. Although behavior is usually a product of both sets of influences, people tend to make either **internal attributions** or **external attributions** about a given actions. For example, why did the car in front of you veer into your lane of traffic, forcing you to brake suddenly and almost causing a collision? An internal attribution about the driver's action might be, "That driver is unskilled and not paying attention, and began to change lanes without noticing my presence." Such an attribution would be grounds for anger and blame toward the "bad driver." Alternatively, an external attribution might be, "Traffic up ahead is very congested, and the weather is bad. The driver is having difficulty being careful because conditions are poor." This kind of attribution would provide grounds for caution but probably not anger at the driver ahead.

Correspondent Inferences

Another theory about how people assign attributions suggests that we are simplistic in understanding causality. We assume that the outcomes of people's behaviors are intended, and that their motives must be deliberate. In this view, called the theory of correspondent inferences, we first observe others' behavior and its effects; we then infer corresponding motives. For example, if you see a couple you know talking quietly at a party and notice that the man is speaking in a sharp tone while the woman is crying,

you may infer that he is "angry" and is deliberately "making her cry" by frightening or threatening her. This pattern of making correspondent inferences is simplistic because it ignores alternative explanations, such as the influence of external factors. It unfairly conceptualizes all behavior as intentional and planned.

Attribution Sources

Social psychologist Harold Kelley has proposed that, in making careful attributions about others' behavior, we analyze that behavior, separately considering its possible causes and forms. According to Kelley, we should specifically consider three qualities in analyzing behavior that serve as sources for internal versus external attributions: its consistency across situations, the distinctiveness of its occurrence, and the consensus of others about its conditions. For example, consider an attributional analysis about why your professor has criticized you for arriving five minutes late to class. Is the professor's behavior consistent: Does she usually criticize you for arriving late? Is the professor's criticism distinctive: Does she criticize other latecomers, or only you? Finally, what is the consensus about the professor's criticisms: Do other professors criticize you for being late? Depending on the answers to these questions, we make common-sense attributions about the specific reasons for another's actions.

Fundamental Attribution Error

Researchers have found that, especially when explaining negative or unpleasant behaviors, we reveal a bias in our causal attributions. Specifically, when we have done something with unpleasant consequences, we make an external or situational attribution about our own behavior. But when another person has done the unfortunate thing, we more readily make internal or dispositional attributions about his or her behavior. This tendency to underestimate situational influences and overestimate dispositional influences in explaining behavior is termed the **fundamental attribution error**. In other words, we are more likely to make an internal attribution when explaining others' behavior than our own. We seem to give ourselves the benefit of the doubt and blame uncontrollable circumstances when our own actions have been wrong or unsuccessful. In contrast, we are quicker to blame others for intending the harm or deserving the failure that results from similar actions.

The fundamental attribution error has been itself attributed to several factors that influence causal analysis. For example, the actor's perspective on his or her own behavior is different from the observer's view of the action, that is, the two have divergent perspectives). The actor is likely to be focusing on the surrounding situation and its demands and details. In contrast, the observer is focusing primarily on the actor him- or herself. Not surprisingly, the actor's explanation for his or her own behavior tends to blame "the situation," while the observer's explanation blames "the actor." Their different explanations are due to their divergent perspectives, a result of focusing their attention in different directions.

There also seems to be cross-cultural differences in the fundamental attribution error. So-called Western societies (like Europe, the United States, and Canada) traditionally favor seeing people rather than circumstances as the cause of events. Rationalist and religious values have emphasized the idea of people as doers who freely choose their actions and deserve the consequences. Thus, in Western cultures, we would expect more internal attributions and trait-ascriptions in explaining behavior, such as blaming minorities for being discriminated against or looking for someone to blame or sue when a disaster occurs.

Non-Western cultures, on the other hand, may be less individualistic (or "collective") and more accepting of ideas like fate or uncontrollable circumstances. This leads to lower prevalence of the fundamental attribution error.

Attitudes

An **attitude** is an evaluative reaction to a person, object, or event. A dislike of broccoli is an attitude, as is a preference for liberal Democratic candidates. A "neutral attitude" is a contradiction in terms: to be "neutral" about something—neither positive nor negative—is equivalent to having no attitude about it.

It is often difficult to distinguish attitudes from related concepts, such as values and opinions. An attitude is more specific than a value: one might value freedom in general but have a positive attitude about the Bill of Rights. Values are more general and abstract than attitudes, which tend to be more focused and concrete. Many researchers use the term "attitude" interchangeably with "opinion." Social psychologists use the more precise term attitude to connote the several components attitudes involve.

Attitudinal Components

Attitudes consist of three basic components: cognitive factors (beliefs), affective components (feelings), and behavioral components (actions). Beliefs make up the cognitive component of an attitude. For example, an unfavorable attitude about eating meat might include beliefs that eating meat causes health problems and that most meat is processed and packaged in unhygienic ways. Furthermore, related emotions might include feeling nauseated by the sight of raw meat and reacting with anger to meat-industry advertising campaigns. This is the affective component of the attitude. Finally, behaviors comprise the responsive or active component of an attitude. If one has an unfavorable attitude about eating meat, one will probably refuse meat at meals, and this attitude may generalize to other forms of behavior, such as criticizing others for eating meat or boycotting stores and restaurants that sell meat.

Forming Attitudes

Attitudes are formed, or acquired, rather than inborn. Specifically, attitudes are thought to be acquired through the three major forms of learning (see Chapter 7). Some attitudes may be developed from emotional or sensory associations (classical conditioning). An individual may associate a particular sensory experience with an emotional reaction: the UCS-UCR connection. Later, the UCS may be associated with a new association, the attitude object (CS). After repeated pairings of the UCS with this new CS, the attitude object alone will elicit the emotional reaction: the CS-CR connection.

Although classical conditioning may explain quick, gut-level responses like emotions, it cannot explain more complex attitude formation. More complex attitudes are probably formed through operant conditioning, as an individual is reinforced for holding and voicing certain attitudes. Perhaps we form certain attitudes due to the observation of others holding those same attitudes. The attitudinal influence of observational learning is the basis for an important factor in the process of persuasion (see the "Persuasion" section later in this chapter). For this reason, opinion leaders like celebrities, athletes, and entertainers are often requested to endorse products being advertised or candidates running for office.

Attitude Change

In an effort to simplify our social thinking, we resist changing our attitudes unless it is necessary to do so. Thus there are patterns in the ways attitudes are changed. One important theory of attitude change is social judgment theory. **Social judgment theory** argues that attitude change is affected by factors like the original attitude—the attitude being changed or replaced—and the difference between it and the new or replacement attitude. According to social judgment theory, a current attitude will be more easily changed to a similar attitude than to a different attitude. Attitudes about related issues are judged along a continuum, rather than as completely separate categories. Thus there is no sharp line between liberal and conservative, but many varying degrees of liberal, moderate, and conservative attitudes.

Another theory of attitude change was proposed by Leon Festinger, who suggests we sometimes form attitudes to justify our own recent behavior. Festinger's **cognitive dissonance theory** asserts that self-justification is necessary because a mismatch between attitudes and behavior creates disharmony (dissonance), which produces psychological tension. This tension works like a drive that we are motivated to reduce. Tension reduction is achieved when we change our attitudes so they are harmonious with our recent behavior.

In Festinger's classic experiment, participants completed a tedious and boring task, and then were paid for efforts to persuade other participants to perform the task by claiming it was enjoyable or exciting. Festinger found that participants who were paid less for these (persuasion) efforts were more convincing and exaggerated the task's entertainment much more than those who were paid more. Festinger argued that those who were paid very little did not have sufficient external justification to lie to others about the task. Thus, in order to eliminate the dissonance associated with lying, they convinced themselves that the task really was enjoyable, and thus were more exuberant when persuading others. In other words, unless you have a good reason to lie (for example, you are paid well to do so), you may convince yourself that you actually believe the lie so you don't feel uncomfortable telling it.

Prejudice and Stereotyping

Negative manifestations of impression formation, attribution, and attitudes include stereotypes and prejudice. A **stereotype** is a generalization about a group of people that distinguishes them from others. Thinking of the British as conservative, the French as romantic, blacks as more athletic than whites, and men as more politically sophisticated than women are all forms of stereotypes. A stereotype is not necessarily inaccurate, but by generalizing about all members within a group and ignoring their individual differences, it is more likely to be inaccurate than otherwise.

Stereotypes can be triggered by any clue to an individual's group membership: physical appearance, accent, language, or context. Stereotypes are a common factor in **prejudice**, an unjustifiable negative attitude toward all members of a group. Because we frequently must make decisions about future interactions based on inadequate information, we often make hasty and automatic judgments about others. Unfortunately, this often includes prejudice. Prejudice may involve stereotyping, but the terms are not synonymous. For example, if we meet someone who has a Southern accent, we may invoke a stereotype, thinking "a typical Southerner." However, we may or may not resort to a prejudice such as, "a typical stupid Southerner that I don't want to get to know." Prejudice involves more than stereotyping; it involves an unfair and negative prejudgment.

There has been a great deal of research on prejudice and **discrimination**—the behavioral component of prejudice, treating people in unfairly different ways because of their perceived group membership. This

research has identified three major sources of social prejudice: social influences, emotional factors, and cognitive factors.

Social Influences

One social influence stems from attempts to rationalize inequalities in groups' rights and status. Arguing that women cannot be effective in combat roles serves to justify denying women in the military the same combat-related advancement opportunities as men. Organized religions have often produced other rationalizations for prejudice, as when fundamentalist Christians cite Biblical justifications for denying the civil rights of homosexuals, or when Muslim leaders in Saudi Arabia forbid women to drive cars. Merely separating people into social groups appears to facilitate prejudice. When schoolchildren are assigned to play games on different teams, they quickly agree that their own teams are "better" in various ways and that the other teams are "worse." This is an example of **ingroup bias**, the belief that the members of one's own social group (the ingroup) are superior to nonmembers (the outgroup).

Motivational-Emotional Influences

Perhaps prejudice and discrimination make some people feel more secure about themselves. This pattern, called the **authoritarian personality**, was found to include such tendencies as superstition, anti-intellectualism, a tendency to stereotype, exaggerated respect for conventional authority, and ethnocentrism, a bias in favor of one's own and against others' ethnic groups. Research on the authoritarian personality provids some intriguing clues to the emotional origins of prejudice. Many authoritarians in an early sample were found to have been raised in harshly disciplinarian homes by punitive fathers and weak, submissive mothers. Self-esteem among such individuals may have depended on displacing such harsh judgment onto others.

Cognitive Influences

Human information processing has a limited capacity that results in simplifying information. When forming impressions of others, we may simplify our cognitive chores by categorizing people in various ways. Once having categorized people, we tend to see those within categories as more like each other and as more different from people outside those categories. This strategy for simplifying thought is a powerful factor in prejudice. Other cognitive factors include heuristics for processing information, including social information. For example, we remember things better that are salient or vivid; over time, the availability of salient or vivid cases leads to confusion about whether these cases are typical or not. For example, if newspaper headlines repeatedly describe an offender as a "homosexual child molester," the vividness of the information may create the erroneous impression that most "child molesters" are also "homosexual" (although heterosexuals make up the significant majority of convicted child molesters). This **illusory correlation**—false impression of a connection—caused by salience or vividness can be another source of prejudice.

■ SOCIAL INFLUENCE

We opened this chapter by describing effects of the social environment on the individual. These included thoughts, perceptions, and feelings. Here, we discuss four ways in which the social environment influences people's actions.

Conformity

One of the most interesting forms of social influence is conformity. **Conformity** occurs when an individual changes his or her behavior as a result of real or imagined group pressure. It is interesting because the pressure to conform can be imaginary or unspoken. An example would be arriving at a party to find people lined up at the door, and joining the waiting line instead of going past them through the door.

The most famous experiment on conformity was a study of group pressure originally conducted by Solomon Asch in the late 1940s. Asch was interested in whether judgments of fact would be less susceptible to conformity pressures than judgments of opinion. In Asch's experimental situation, a participant was grouped with several others for many trials of a line-length judgment task. Each person called out his judgment of the length of a vertical line presented to the group. Unbeknownst to the participant, on predetermined trials, the rest of the group unanimously called out obviously false judgments. Results indicated that, although these judgments were obviously false, participants conformed and called out the same wrong answers on around one-third of the trials on average. Although some people never conformed, a large majority (about three-fourths) conformed at least once, about one-fourth conformed half of the time, and some always conformed.

Compliance

Whereas conformity is generally the result of unspoken group pressure, **compliance** refers to the voluntary change of behavior because of a (usually explicit) request. Compliance can be as simple as doing something when someone asks for it, but social psychologists have studied other ways that people foster compliance—all by asking for something else. For example, if you ask someone for a small favor to which they agree, you are more likely to be successful in obtaining from them subsequently larger favors. This is called, descriptively enough, the **foot-in-the-door phenomenon**. Alternatively, the **door-in-the-face procedure** involves asking for a larger favor than desired (which is likely to be denied), in hopes that by subsequently asking for a smaller favor—the one actually desired—one appears willing to compromise. Finally, an all too common technique in sales is the **lowball approach**. This involves increasing the cost (monetary or otherwise) of the compliant action after a commitment is obtained. Because one has already committed to the action, one is more likely to comply even after the stakes have been raised—such as through a "clerical error."

Obedience

Critics might argue that the price of conformity is small, and that group pressure easily outweighs any personal preference for accuracy. What if the behavior being encouraged seems morally wrong or distasteful? This was the question asked by Stanley Milgram (1933–1984) in a classic series of studies he commenced in the early 1960s. After World War II, much propaganda and public opinion maintained that the horrors of Nazi Germany were impossible in the United States, because Americans value independence and would never accept orders to harm others. Milgram wondered if such tendencies to obey authority would indeed vary across cultures, so he designed an experiment to test this comparison.

In Milgram's famous experiment, participants were asked to act as "teachers" reciting word-pairs for a "learner" to memorize. With each mistake from the learner, the participant was instructed to administer an electric shock of increasing voltage. Actually, unbeknownst to the participant, an actor played the part of the learner and received no electric shock. As the "shock level" increased, the actor would plead,

scream, and otherwise indicate the pain being caused. An experimenter would urge the teacher to obey the rules of the experiment (administer the shock) but would not threaten or harm him. How far would the teacher go before refusing to obey the experimenter's orders?

Social experts that Milgram consulted insisted that only a small percentage of participants would obey such orders, especially if the learner protested. Much to everyone's surprise, although the learner moaned and shouted throughout the "painful" experience, sixty-three percent of the participants in Milgram's first experiment went all the way to the upper limit of voltage ("450 volts," which was even labeled to imply death) without disobeying. In a second series, Milgram had the learner complain of a heart condition and refuse to answer after 300 volts. In this series, sixty-five percent of the participants nonetheless obeyed all the way to the upper limit of voltage, at which point the learner feigned unconsciousness.

Milgram concluded that the situational factors in his experiment were too powerful for most individuals to overcome. In subsequent experiments, he varied several factors in the situation to learn their importance in obedience to authority. For example, participants were more likely to obey if their victims were physically distant or if the authority figure (the experimenter) was physically near. Also, participants were obedient only when they considered the authority figure respectable and legitimate. When the experiment was conducted in a non-university location, the obedience level was lower. When intruders "illegitimately" took over the experiment and gave orders, people refused to obey them. For orders to be obeyed, one's authority must be perceived to be legitimate and credible.

Persuasion

Persuasion is a form of social influence that involves application of the principles of attitude change. **Persuasion** occurs when individuals change others' attitudes. A popular approach to understanding persuasion involves studying the components of the persuasion process. A group of social psychologists at Yale University have developed a communication model of persuasion that implicates the source, the message itself, the context of the message, and the audience.

The source of a persuasive message is the communicator who is presenting it. A source is more persuasive if he or she is seen as credible (believable) and attractive. Persuasive messages can involve emotional appeals or rational arguments. When time is limited, short emotional appeals may be more effective than rational arguments. Research shows that sometimes a one-sided message is more persuasive, and in other circumstances two-sided message seems more fair and persuasive. Many context factors may affect susceptibility to persuasion, such as whether one is distracted or the situation in which the message is embedded. Finally, numerous research efforts have focused on the recipients of persuasive messages, the audience, to discover when some people are more persuadable than others. Many audience characteristics, such as intelligence, interact with message variables. Intelligent recipients are more persuaded by complex or two-sided messages, while unintelligent recipients are more persuaded by simple emotional messages.

The elaboration-likelihood model describes a way in which the source, message, and audience interact to determine whether persuasion will be successful. This model suggests two main routes that can be used in persuasion. The central route involves careful processing of the information of the message, where one may be persuaded by high-quality arguments. In the peripheral route, one attends less to the actual message but may be persuaded by persuasion cues, such as the characteristics of the source. Generally, although the peripheral route may be more immediately persuasive, the central route has more

enduring effects. Factors that involve which route will be followed in a given situation include some of those just identified, the audience's (or individual's) involvement with the topic or content, and the amount of mental effort involved.

■ GROUP PROCESSES

Interests in group problem solving and management have stimulated the study of group dynamics, the ways in which group members work together. Findings have yielded new insights into such processes as group polarization, groupthink, minority influence, and group leadership.

Group Polarization

When group members talk together, their opinions provide a sense of the group norm. Research has shown that such discussion enhances a group's preexisting opinions, an effect known as **group polarization**. For example, if most people on a jury are already leaning somewhat toward conviction before they begin deliberations, their discussion will probably polarize their opinions more extremely in favor of conviction. Knowing this tendency, it is sometimes useful to have group members consider their opinions more carefully before group discussion, to avoid becoming caught up in group momentum.

Groupthink

Groupthink is the term given to the tendency of group members to give higher priority to a sense of cohesiveness than to the quality of their work. If a group is assembled to work on a task or solve a problem, group members will first develop a sense of group membership and purpose. If they become very cohesive, they may fear the disruption that would be caused by disagreeing about how to solve the problem. As a result, they may distort their true opinions, pressure each other to conform, and nurture illusions about their abilities in an effort to stay friendly. When this effort becomes more important than the task at hand, a group is capable of making extremely confident but very bad decisions. Prescriptions for avoiding groupthink include alternating leadership roles among members; appointing some members to officially question every group recommendation (for example, a devil's advocate), breaking the group into smaller subgroups that work in parallel; and encouraging members to make their opinions known anonymously so that no one feels put on the spot about saying something unpopular.

Minority Influence

Given the pressures of conformity, authority, norms, and groupthink, can a majority ever be persuaded by a minority? Democratic systems are based on the assumption that minorities will at least influence the rest of the group, even though they may not win a debate. Research on the role of minorities in group discussions (that is, individuals who disagree with majority opinion) suggests that three characteristics can make a minority both effective and influential. First, a minority must be confident. This demonstrates to the majority that other points of view deserve respect. Second, a minority must be consistent. By not wavering, a minority will not invite inroads or persuasive criticism. Finally, a minority should try to win defections from the majority. Because a defector cannot gain popularity by joining the minority, the implication is that he or she is motivated by the truth and rightness of the minority position.

Group Leadership

Another characteristic to consider in groups is how they are led. In particular, groups are more successful at accomplishing tasks when they are effectively led. While there is some correlation between certain personality traits (such as agreeableness and extraversion) and leadership ability, this does not guarantee that an individual is a good leader in all circumstances. Depending on the task at hand, different leadership styles may produce different results. Research on groups and leadership have identified two general leadership styles. **Task-oriented leaders** provide close supervision and direct the group through giving orders, discouraging group input and discussion. **Person-oriented leaders** provide less strict supervision, and are concerned with group members' input as well as their feelings.

■ SOCIAL RELATIONS

The social nature of life does more than affect how we view ourselves, how we view others, and how others affect our behaviors—the topics discussed in previous sections. We are also social creatures, not living daily life in isolation. We interact and form various relationships with those around us. This section briefly introduces such social relations as attraction, love, aggression, altruism, cooperation, competition, and conflict.

Attraction

An important focus of social perception research is interpersonal attraction, or the processes involved in forming preferences for specific others. Although most people like being with their own kind (affiliation; see Chapter 10), attraction involves moving beyond mere affiliation to being with specific others. What is the first determinant of whether or not we like someone else? Classic research by Festinger and his colleagues examined the best friend selections among older college students and their spouses, and only one factor emerged as a common denominator: proximity. Students who came to like each other lived closer to each other than those who did not. The **proximity effect**—the influence of physical nearness in increasing interpersonal attraction—has since been extended to many environments and situations. Research by social psychologist Robert Zajonc has identified the key variable in the proximity effect as the power of "mere exposure" or familiarity.

Research on interpersonal attraction has consistently concluded that we are also attracted to good-looking, or physically attractive, people. One reason for the physical attractiveness effect is the role of stereotyping. Physically attractive people as a cognitive "group" are considered to be attractive in other ways, such as in talent, friendliness, intelligence, and conversational skills. However, research suggests that beautiful people do not appear more likely to be successful in other ways than the rest of us.

By far, the most consistent finding in analyzing interpersonal attraction is that we like others who are similar to ourselves. This similarity can be a quality of our intelligence levels, physical appearances (a trend known as matching), or especially our attitudes. Research on long-term relationships indicates that, the more alike two people are at the beginning of their relationship, the more likely their relationship will last.

Interpersonal Relationships

A major division of social psychology is concerned with interpersonal relationships. This involves how people interact with one another and how they come to form associations of various types and strengths.

Friendship

Work on friendship has involved research on the factors in interpersonal attraction as well as the study of how relationships are maintained over time. Like attraction in general, friendship is initially affected by such variables as proximity, familiarity, physical attractiveness, and attitude similarity. Further work on relationship maintenance suggests that friendship involves different interpersonal processes than mere social contact. In casual interactions and in the early stages of friendship, relations are conducted on principles of social exchange. According to the rules of social exchange, relationships are maintained as long as they are mutually rewarding. For example, if an acquaintance does you a favor, you are obligated to return the favor or pay her back. As relationships progress, however, returns become long-term rather than short-term. The basis of the relationship is no longer exchange but communality. A shift from an exchange basis to a communal basis can be a signal that a relationship has deepened. Likewise, a shift from communal to exchange interactions can signal a deterioration in relations.

Intimate Relationships

Hard as it is to study intimate relationships objectively, social psychologists have been able to learn much about these social relations. Research repeatedly points to the critical role of communication in establishing and maintaining intimate relationships. Inadequate communication may leave individuals feeling unknown and lonely, whereas distorted or one-sided communication can lead to serious relationship conflict. One of the most important findings in relationships research has been the value of equity or fairness. When partners are both contributing to a relationship (for example, money, sex, housekeeping), they should both reap the benefits (for example, security, comfort, pleasure). If one partner is contributing more than his or her share, but gets the same benefits, this person may see the relationship as inequitable. Some theorists have argued that all relationship breakups can ultimately be traced to inequity.

Love

An early theory of love sought to distinguish it from "mere" liking, suggesting that these are both attitudes that involve different dimensions. Liking consists of feelings of affection and respect, and perceptions that the other person is trustworthy and similar to oneself. Loving consists of attachment, intimacy, and caring. An important finding was that the future of a relationship depends more on liking than loving. People who love each other but do not like each other are not likely to stay together. This suggests that friendship is the most solid foundation for more intimate relationships. Similarly, some theories distinguish between companionate love and passionate love. Companionate love is the love of deep friendship, while passionate love is the intense, emotional, labile experience we associate with falling in love. An interesting theory of love is Robert Sternberg's triangular theory of love. In Sternberg's theory, the three dimensions of love are passion, intimacy, and commitment. Different combinations of these three dimensions make up different kinds of love, like empty love, infatuation, and consummate love.

Aggression and Interpersonal Conflict

Chapter 10 discussed aggression and conflict as they relate to motivation and stress. Here, we briefly reiterate some of the central themes from that discussion. We defined aggression as an act that is intended to harm another person—a truly social behavior. But why are people aggressive? An increasing amount

of recent research has implicated a complex interplay between biological and environmental influences. It seems likely that genetic influences may provide a disposition or impulse to act aggressively, whereas environmental factors are what lead to aggressive behavior itself. This is in line with theories of aggressive behavior, such as frustration-aggression theory (Chapter 10). Social learning may also influence people's tendency to act aggressively, by observing others use aggression to solve problems or get what they want.

Interpersonal conflict, resulting from the belief that one is opposed from reaching a goal by another individual or group, differs from the discussion of internal conflict that was the focus in Chapter 10. There are four primary causes for interpersonal conflict. One cause, which has an evolutionary basis, is the competition for scarce resources. In modern times, resources may involve something like a competitive pay increase that leads two coworkers to engage in conflict. A second, simple cause of conflict is revenge for previous wrongdoing. Third, conflict can arise through attributions, if one attributes selfish or hostile motives to others (especially if these are incorrect). Finally, conflict can arise through communication errors, such as if comments intended as constructive criticism are perceived as derogatory or taken personally.

Altruism

Altruism is an unselfish concern for the welfare of others; this often leads to giving assistance when not required, sometimes even in the face of danger to oneself. People usually do not help others in hopes of obtaining some tangible or specific reward. Although some abstract reward may lie behind religious or moral motives that may come into play, other theories have been offered that do not implicate rewards. Of course, some people may be more inclined to help based on their personality; others may help because they feel empathy toward those in distress. One leading theory of helping behaviors suggest the role of arousal. Specifically, the distress of another individual produces a negative affect or unpleasant arousal, which one is motivated to reduce (by helping). If the costs of helping (for example, the risk of harm to oneself) do not outweigh the benefits of helping (for example, the reduced distress of the other person), one will be willing to help.

This theory suggests that circumstances that reduce the level of arousal, decrease the benefits, or increase the costs of helping will therefore reduce an individual's tendency to help. A striking example is the diffusion of responsibility that takes place when many people are around. This leads to the **bystander effect**, where the likelihood that any single individual will offer assistance decreases as the number of individuals present increases. According to the theory of arousal as a basis for altruism, when many people are around, it is easy to convince oneself that someone else will help, which lowers the costs of not helping. Research supports many other factors that can be accommodated by this framework as well, such as the clarity of the need for help.

Cooperation and Competition

Some social phenomena result from situations where multiple individuals are striving for the same goals. One potential result is interpersonal conflict. A related but distinct concept is that of **competition**, where an individual attempts to attain a goal while denying it to others. Competition does not necessarily have the negative connotation that conflict does. In fact, some research suggests that friendly competition can be motivating and beneficial. If two individuals are not in competition, they may **cooperate**, or

work together to achieve goals. This often involves two individuals who share resources, especially if they each possess unique resources, to attain a common goal. It can also involve individuals who are simultaneously pursuing separate goals, but help each other to achieve them. Just as with many other social phenomena, good communication is essential in fostering cooperative behavior.

Social psychology studies the effects that our social surroundings have on the individual. This includes ways that individuals think about themselves, such as by using reference groups and norms to draw social comparisons, or by forming a social identity. It also includes impact on individual behavior, including the perils of deindividuation and the motivating influence (for better or for worse) of the presence of others or working in groups. It also includes such direct social influences on our behavior as conformity, compliance, obedience, and persuasion. These concepts involve the way we align our behaviors with others through indirect pressure, direct request, instruction from an authority figure, or through convincing messages.

A key area for research in social psychology is that of social perception and cognition. This includes various research topics devoted to understanding the way we think, feel, and reason about ourselves and others. This research studies the way we form impressions about others, and how we attribute causes to our own behavior and the behavior of others. It also studies how we form attitudes, and how those attitudes are changed—often attitudes change to be consistent with our behavior, or vice versa. The way we perceive others may also be susceptible to stereotypes and prejudices, which can lead to discriminatory behavior.

Finally, social psychologists research the interactions that exist among individuals in a social atmosphere. Individuals can form many types of relationships, such as friendships and intimate relationships, based on interpersonal attraction. Individuals can also help each other through cooperative efforts or altruistic behavior. However, individuals can also oppose one another through competition and conflict, or act aggressively toward one another. When individuals are formed into groups, other interesting dynamics can be observed. Groupthink and group polarization are tendencies that may appear in group settings, and different leadership styles and minority influence are examined as well.

Key Concepts

altruism	door-in-the-face procedure	interpersonal conflict
attitude	external attributions	lowball approach
authoritarian personality	false consensus effect	person-oriented leaders
bystander effect	false uniqueness effect	persuasion
causal attribution	foot-in-the-door	prejudice
central traits	phenomenon	proximity effect
cognitive dissonance theory	fundamental attribution	reference groups
competition	error	relative deprivation
compliance	group polarization	self-handicapping
conformity	groupthink	self-serving biases
cooperate	illusory correlation	social cognition
deindividuation	ingroup bias	social comparison
discrimination	internal attributions	social facilitation

social identity

social impairment

social judgment theory

social loafing

stereotype

task-oriented leaders

Key People

Solomon Asch

Leon Festinger

Stanley Milgram

SELECTED READINGS

Aronson, E., Wilson, T. D., & Akert, R. M. (2004). *Social psychology, 5th Ed.* Prentice Hall.

Brown, R., & Gaertner, S. (Eds.). (2001). *Blackwell handbook of social psychology: Intergroup processes.* Blackwell Publishers.

Burn, S. M. (2003). *Groups: Theory and practice.* Wadsworth.

Myers, D. (2005). *Social psychology, 8th Ed.* The McGraw-Hill Companies.

Tesser, A., & Schwarz, N. (Eds.). (2001). *Blackwell handbook of social psychology: Intraindividual processes.* Blackwell Publishers.

Test Yourself

1) Which of the following describes how reference groups most commonly affect an individual's self-perception?
 a) social comparison
 b) social impairment
 c) social facilitation
 d) causal attribution

2) _____ attribution presumes the cause for behavior lies within an individual's motives or personality, and _____ attributions place the cause on environmental sources. The fundamental attribution error involves placing more emphasis on _____ attributions when judging others' behavior.
 a) Internal; external; external
 b) Internal; external; internal
 c) External; internal; external
 d) External; internal; internal

3) Which of the following is not a component of attitudes mentioned in the chapter?
 a) cognitive belief
 b) affective feeling
 c) behavior
 d) self-serving bias

4) _____ refers to changing one's behavior as a result of (often implicit) group pressure; _____ involves adjusting behavior because of a request; and _____ involves behaving as a result of a command.
 a) Compliance; obedience; acquiescence
 b) Compliance; conformity; obedience
 c) Conformity; compliance; obedience
 d) Conformity; obedience; compliance

5) Which of the following is *least* likely to affect group performance?
 a) group polarization
 b) social facilitation
 c) social loafing
 d) groupthink

6) Which of the following is the *most consistent* determinant of interpersonal attraction?
 a) proximity
 b) physical attractiveness
 c) similarity
 d) wealth

7) _____ may occur when individuals pursue the same goals; this is listed in the chapter as one of the sources of _____.
 a) Cooperation; success
 b) Cooperation; attribution
 c) Competition; conflict
 d) Conflict; attitude change

8) For which of the following phenomena has learning *not* been proposed in the chapter as an explanation or contributing factor?
 a) cooperation
 b) aggression
 c) attitude formation
 d) learning has been mentioned in the context of all of the above

9) Advertisers are keenly aware of the research in social psychology, especially as it relates to their livelihood. Describe three examples of methods discussed in this chapter that could be used to increase the sales of a commercial product.

10) Briefly describe Asch's study involving line lengths and report what that has taught us about a social phenomenon.

Test Yourself Answers

1) **a.** Social comparison involves comparing oneself to a reference group.

2) **b.** Internal attribution presumes the cause for behavior lies within an individual's motives or personality, and external attributions place the cause on environmental sources. The fundamental attribution error involves placing more emphasis on internal attributions when judging others' behavior.

3) **d.** Self-serving biases affect self-perception. They are not a component of attitudes, whereas the other three terms are specifically mentioned.

4) **c.** Conformity refers to changing one's behavior as a result of (often implicit) group pressure; compliance involves adjusting behavior because of a request; and obedience involves behaving as a result of a command.

5) **b.** Social facilitation is least likely to affect group performance. It usually refers to an individual's performance in the presence of others. The other terms were specifically mentioned as occurring in groups.

6) **c.** Similarity was mentioned as the most consistent determinant of interpersonal attraction, although physical attractiveness and proximity were mentioned as well (wealth was not).

7) **c.** Competition may occur when individuals pursue the same goals; this is listed in the chapter as one of the sources of conflict. Cooperation may also occur when individuals pursue similar goals, but it is not paired with a viable answer option.

8) **a.** Cooperation was not related to learning concepts, although attitude formation was discussed in terms of conditioning, and observational learning was implicated in aggressive behavior.

9) Many principles of social psychology can be applied in marketing. For example, establishing product use in consumers' likely reference groups could increase sales through social comparison and perception of relative deprivation. Also, research on effective persuasion could be applied, such as ensuring credible spokepersons. Associating products with favorable images and/or desirable people's modeling of products can create favorable attitudes towards products.

10) In Asch's experiment on judging line lengths, a participant was grouped with several other people. Each person called out his judgment of the length of a vertical line presented to the group as whole. All other members of the group were instructed, on some trials, to unanimously call out obviously false judgments. Results indicated that although these judgments were obviously false, participants called out the same wrong answers on over a third of the trials. This experiment shows the enormous social pressure to conform, even to behaviors that may be obviously wrong—or opinions that may be obviously false—to a neutral, objective individual.

GLOSSARY

■ CHAPTER ONE: PSYCHOLOGY: HISTORY AND APPROACHES

applied research: Applied research is conducted with the purpose of solving a particular immediate practical problem in mind, such as how to select applicants for a certain job. In this sense, applied research is often defined in contrast to basic research.

basic research: Basic research is conducted with the intent of addressing fundamental questions about the nature of things, such as the characteristics of learning and memory, and employs a broader focus than does applied research. Thus, basic research is often the theoretical basis upon which applied research builds.

behavioral approach: The behavioral approach refers to a particular theoretical framework or method of psychological science that emphasizes the importance of studying observable behaviors in terms of stimulus-response patterns (learning history), and that derives its name from its primary advocates, behaviorists and neo-behaviorists.

behaviorism: Behaviorism, attributed to J. B. Watson and B. F. Skinner, is a perspective in psychology that lies in contrast with mentalism, due to emphasis on the need to study only what is observable: overt (non-cognitive) behavior.

biological approach: The biological approach refers to a particular theoretical framework or method of psychological science that assumes behaviors are the end result of distinct biological processes and, therefore, emphasizes the importance of studying the biological and biochemical foundations of behavior.

clinical psychology/psychologists: Clinical psychologists are medical practitioners who specialize in the diagnosis and treatment of the more severe adjustment problems of "clinical" populations, such as those typically addressed in hospitals or mental health clinics.

cognitive approach: The cognitive approach in many ways lies in contrast with the behaviorist approach and refers to a particular theoretical framework or method of psychological science which emphasizes the importance of considering how behavior arises as the result of mental processes like information processing, attention, and memory.

community psychology/psychologists: Community psychologists advocate the prevention (rather than treatment) of psychological disorders through the use of community-based programs and institutions of social change, which may minimize the development of psychological disorders before they become pronounced enough to require treatment.

comparative psychology/psychologists: Comparative psychologists derive their name from their efforts to make meaningful, domain-specific (e.g., cognitive, social, developmental) comparisons between human and nonhuman organisms by studying the biological bases of behavior across species.

counseling psychology/psychologists: Counseling psychologists, though not medical practitioners, provide guidance and therapy to individuals experiencing "normal," everyday adjustment problems.

determinism: Determinism refers to the key theoretical assumption, crucial as a basis of any science, that present conditions (effect) can be understood if one examines past influences (cause).

developmental psychology/psychologists: Developmental psychologists adopt a life-span perspective to psychological science, studying the changes in psychological function of an organism as the organism grows and ages (develops) over time.

dualism: Dualism, often called "mind-body dualism," refers to the notion that the mind and body are two fundamentally distinct entities, each possessing different functional and compositional characteristics.

educational psychology/psychologists: Educational psychologists specialize in applied (practical) research intended to address issues concerning the underlying psychological processes of teaching and learning.

empiricism: Empiricism refers to the crucial tenet that scientific evidence be based upon observations made in the real world, rather than purely upon logic or reason.

environmental psychology/psychologists: Environmental psychologists study how the physical environment, broadly defined, shapes mental processes and behavior.

ergonomics: Ergonomics is derived from the Greek *ergo*, meaning "work." See **human factors psychology.**

evolutionary psychology: Evolutionary psychology, also called the "sociobiological approach," is a relatively new branch of psychology that applies evolutionary concepts like natural selection and adaptation to human behavior, especially human social interaction.

forensic psychology/psychologists: Forensic psychology may be thought of as "psychology of law," because forensic psychologists work at the intersection of psychology and the law, addressing such issues as involved in evaluating the mental competence of defendants in trial settings.

functionalism: Functionalism is attributed to W. James and is a perspective in psychology that lies in contrast to structuralism due to its emphasis on examining psychological processes in terms of their function/purpose for the organism, rather than in terms of those psychological processes' underlying (structural) component parts.

Gestalt psychology: *Gestalt* roughly translates as "form," "shape," or "pattern" (German). Hence, Gestalt psychology is recognized for its emphasis on the importance of the meaningful "whole" in, for example, perception, and may be contrasted with structuralism, due to its focus on the "parts."

health psychology: Health psychology refers to a relatively new branch of psychology that specializes in examining the physical and mental processes that may contribute to human wellness and illness, and vice-versa.

human factors psychology: Human factors psychology, also called "ergonomics," focuses on the human factor in the person-machine relationship, attempting to optimize people's usage of, and interaction with, machines, computers, signs, and other types of technology.

humanistic approach: The humanistic approach, attributed to A. Maslow and C. Rogers, refers to a particular theoretical framework or method of psychological science that assumes humans are unique, autonomous, and essentially motivated to be productive and healthy and that, therefore, emphasizes the importance of taking a person-centered approach (i.e., a psychology oriented around individuals) to the psychological study of human behavior.

industrial psychology/psychologists: Industrial psychologists work within industrial or employment settings to study and improve the relationship between workers and their jobs and workplace.

introspection: Introspection ("looking within") is a psychological research technique employed by, for example, W. Wundt and E. B. Titchener, and refers to the practice of considering one's own actions and reactions, and self-consciously trying to analyze their sequence and components.

mentalism: Mentalism is a perspective in psychology that lies in contrast with the behaviorist approach (behaviorism) due to its emphasis on studying mental events and processes.

monism: Monism refers to the philosophical perspective that all of reality has but a single nature, being composed of either mental objects and events (idealism) or physical objects and events (materialism).

neobehaviorist: Neobehaviorists ("new behaviorists") introduced the concept of intervening variables—changes in processes within the organism that cannot be observed but can be used to explain stimulus-response patterns—into the traditional behaviorist approach.

neuroscience: Neuroscience refers broadly to the scientific study of the nervous system and encompasses such scientific fields as biological psychology, neuroanatomy, and neurobiology.

organizational psychology/psychologists: Organizational psychologists may be regarded as more specific instantiations of industrial psychologists, studying the relationship between the employee and his or her employing organization, focusing on group dynamics, leadership, management, and communication.

personality psychology/psychologists: Personality psychologists specialize in the study of individual differences—how and why individuals differ from one another—otherwise known as "personality characteristics."

phrenology: Phrenology, popularized by F. J. Gall, literally means "study of the personality" (Greek) and is a technique for inferring personality characteristics from the shape and form of an individual's skull.

physiognomy: Physiognomy refers to the belief that it is possible to infer an individual's personality characteristics, and thereby explain human behavior, based on his or her physical features.

psychoanalysis: Psychoanalysis, attributed to S. Freud, refers to a therapeutic approach that emphasizes the importance of treating psychological disorders by analyzing the individual's "psyche" in order to gain insight into, and ultimately to resolve, his or her underlying (unconscious) psychological conflicts. Psychoanalysis has also come to be known as a "theory" (psychoanalytic theory) of personality and a perspective on human nature based on unconscious drives and internal conflicts.

psychodynamic approach: The psychodynamic approach is based on Freud's psychoanalytic approach and focuses on the innate, pervasive, and mostly unconscious desires and conflicts of the individual.

psychology: Psychology is defined as the science of behavior and mental processes, with the goal of understanding, predicting, and controlling behavior and mental processes.

psychophysics: Psychophysics is a discipline that focuses on the relationship between physical and environmental changes (stimuli) and the sensory processes that they trigger.

psychophysiology: Psychophysiology is the study of the relationship between physiological processes and psychological experience and how physical events are psychologically experienced.

school psychology/psychologists: School psychologists provide advice and guidance within schools and school systems, concentrating on the needs of the student within the educational environment.

sociobiological approach: See **evolutionary psychology.**

sociocultural approach: The sociocultural approach to psychology studies how thinking and behavior vary across cultures, emphasizing the role of situational influences on individuals in certain places, conditions, and times.

sports psychology/psychologists: Sports psychologists study various aspects of sports-related behavior, such as competition and the psychological benefits of sports and exercise.

structuralism: Structuralism, attributed to W. Wundt and E. B. Titchener, is a perspective of psychological science that emphasizes the study of individual sensations as the building blocks, or structure, of consciousness.

■ CHAPTER TWO: RESEARCH METHODS IN PSYCHOLOGY

between-subjects design: In a between-subjects design, each participant receives only one experimental condition, so that each different level of the independent variable is experienced only between different individual participants.

blind: For reasons of control, reducing unexpected placebo effects, and reducing experimenter bias, it is desirable to keep participants and investigators unaware (blind) of the exact conditions and assignments of an experiment. For example, subjects who do not know which conditions they are in—the control group or the experimental group—are said to be blind to their assignments.

case study: Case studies are intensive investigations of single situations, incidents, or people.

control: Control, or holding constant factors that are not under investigation, is essential to guarantee that any results in one's experiment are due to the hypothesized factor(s), and not merely due to chance differences between groups or their situations.

control group: The control group is the group of participants in an experiment who undergo the same experiences as all the other groups in the experiment,

except that they do not experience the experimental manipulation (independent variable) of interest.

correlation: Correlation refers to a particular statistic, representing the degree to which two variables change together, and is measured by the correlation coefficient.

cross-sectional study: A cross-sectional study is a research method that examines the behavior of many differently aged individuals of a single group (e.g., school children) at one period in time, as a means of estimating the change in a factor of interest (e.g., risk-taking behavior) across the lifespan.

debriefing: Debriefing is the ethical procedure of revealing all relevant information after a research study.

dependent variable: The dependent variable is the measurement of interest, usually a measure of behavior, mood, or cognitive function, and derives its name from the fact that it is dependent upon the independent variable.

descriptive statistics: Descriptive statistics (e.g., measures of central tendency, variability, and covariance) serve the important function of characterizing, or summarizing, large amounts of data so that they can be readily comprehended.

double-blind procedure: A double-blind procedure refers to the technique of reducing the influences of researcher and participant biases by designing a study so that neither the participants nor the observers know the group experimental assignments.

experiment: An experiment is a carefully controlled research method in which one manipulates some factor(s) or variable(s) within some system of interest and observes the results on some other factor(s) in order to draw conclusions about causal relationships among variables of interest.

experimental group: The experimental group is the group of participants in an experiment who undergo the same experiences as all the other groups in the experiment, except that they experience the experimental manipulation (independent variable) of interest.

experimenter bias: Experimenter bias occurs when an experimenter's expectations about the progression

or outcome of an experiment influence (bias) the experiment's results or the experimenter's interpretation of those results.

fabrication: Fabrication refers to the unethical act of making up research results, or saying that results were obtained that actually were not.

factor: The term "factor" is more formally known as an independent variable. See **independent variable**.

false negative: In terms of hypothesis testing, a false negative claim, or Type II error, occurs when one rejects a hypothesis that is, in fact, true.

false positive: In terms of hypothesis testing, a false positive claim, or Type I error, occurs when one concludes that a relationship exists between two (or more) variables, when it, in fact, does not.

frequency: The count or number of occurrences of an event.

frequency distribution: A list of the frequencies for each of many events, such as the number of scores in a sample that are of a particular value.

hypothesis: A hypothesis is a testable prediction about behavior, mental events, or other phenomena that is stated before research is conducted, in order to formalize what one may expect based on the theoretical principles under examination.

independent variable: In an experiment, the independent variable is the manipulation or treatment itself that an experimenter intends to observe the impact of on some other variable.

inferential statistics: Inferential statistics provide formal measures of the comparison between groups so that researchers may interpret datasets and draw conclusions.

informed consent: Informed consent is a fundamental ethical requirement for research involving human subjects and refers to a subject's agreement to participate based on sufficient information about the study.

level (of the independent variable): In terms of conducting research in the psychological sciences, a "level" may refer to different types, values, or amounts of an experimental factor or manipulation (independent variable). For example, the independent

variable "intelligence-enhancing pill" may have two levels, "pill given" and "placebo given."

longitudinal study: Longitudinal studies follow individuals and observe their behavior for significant periods of time (e.g., months or years) as a means of estimating the change in a factor of interest (e.g., risk-taking behavior) across the lifespan.

mean: The mean, or "average," is the most commonly used statistical measure of central tendency, and is formally defined as the sum of all the scores in a dataset divided by the total number of scores in the dataset.

median: The median is a statistical measure of central tendency that appears exactly in the middle of a rank-ordered distribution of scores, meaning half the scores in a dataset are greater than the median and half the scores are less than the median.

mode: The mode is a statistical measure of central tendency and is defined as the most frequently occurring score in a dataset.

naturalistic observation: Naturalistic observation is a research method in which the researcher observes the interesting behavior(s) of participants in their natural setting or environment, without actually interacting with the participant(s) of investigation.

operational definition: An operational definition takes an abstract, conceptual variable (dependent or independent variable) and restates it in terms of a formal definition of which concrete aspects of behavior one will observe or measure (in the case of the dependent variable) and which concrete elements of the factor or treatment one will manipulate (in the case of the independent variable).

placebo effect: The placebo effect refers to the phenomenon in which a participant receiving only an inert, inactive, or neutral treatment or condition assignment may still exhibit some apparent change in subjective experience or behavior due to his or her expectations about the possible or "likely" effect of that treatment or condition (in this case, a placebo).

placebo group: In an experiment, the placebo group consists of individuals receiving a placebo (e.g., sugarless candy), and is used in order to make pertinent comparisons about placebo treatment effects between the control (receiving no candy) and experimental (receiving sugared candy) groups.

plagiarism: Plagiarism is the unethical act of presenting the work of others, whether ideas or words, as one's own.

population: A population is the entire collection of objects (e.g., people or animals), events (e.g., rolls of a die), scores (e.g., participants' scores on a test or questionnaire), or observations that a researcher is interested in investigating.

random assignment: Random assignment refers to the procedure of selecting participants for each condition in an experiment in such a way as to assure that each participant has an equal chance of being assigned to a particular condition.

random sampling: Random sampling is a procedure for generating a nonbiased, representative sample. Simple random sampling is accomplished by selecting members for the sample in such a way that each element of the population has an equal likelihood of being selected from that population for inclusion in the resulting sample.

replication: Replication refers to the fact that research findings will not be considered established until they are shown to be repeatable (replicable) on multiple occasions and perhaps by multiple different researchers.

sample: A sample refers to a particular subset or subgroup of a population.

scientific method: The scientific method refers to a particular protocol of investigation that is intended to reduce investigative error and bias, and is distinguished from other methods of inquiry by its adherence to a formalized system of inquiry in which the requisite components are standard ways of posing research questions, stating hypotheses, testing those hypotheses against empirical observations, and ultimately drawing conclusions.

significance level: In formal statistics, the significance level (symbolized a, alpha) refers to the probability value that will be considered the standard boundary at which one's obtained result(s) may be interpreted as evidence either in favor or against rejecting or failing to reject the null hypothesis.

standard deviation: Standard deviation, conceptually the average standard distance of each single value in a dataset from the mean score, refers to a particular statistic that is used as a measure of the dispersion (variability of scores) in a data set.

statistics: Statistics, like sums or ratios, represent information about samples of events or individuals in a quantitative/numerical form.

stratified sampling: Stratified sampling is a procedure for generating an unbiased, representative sample and is defined by the requirement that a predetermined number of people be drawn from various sectors, or strata (meaning "layers"), of the population.

survey: A survey refers to a self-report method of data collection in which participants respond to questions asked of them either by an interviewer or contained within a questionnaire.

theory: A theory is a set of integrated principles and assumptions that organizes data, explains behaviors, and makes testable predictions.

variance: Variance, conceptually the standard deviation squared, refers to a particular statistic that is used as a measure of the dispersion (variability of scores) in a data set.

within-subjects design: In a within-subjects, or "repeated measures" design, the independent variable is manipulated within each participant, and measurement of the dependent variable is repeated for each participant.

■ CHAPTER THREE: BIOLOGY, BRAIN, AND BEHAVIOR

action potential: The action potential, often referred to as the "firing" of a neuron, serves as the basis of information transfer across and between neurons and is defined as a sudden, positive electrical charge that travels down the axon of a neuron to the terminal buttons, where it causes neurotransmitter release.

adoption study: An adoption study is a research study that investigates the role of heredity on some behavior(s) of interest by taking advantage of opportunities to study adopted children, who can be compared to both their biological parents and their adoptive parents.

adrenal glands: Members of the endocrine system, the adrenal glands, or "caps," lie atop the two kidneys and are responsible for the production and release of adrenaline (e.g., epinephrine and norepinephrine), which play a role in sleep and arousal.

associative neurons: Associative neurons are specialized cells that provide linkages among other neurons in the brain.

autonomic nervous system: The autonomic (meaning "autonomous" or "self-governing") nervous system is the part of the peripheral nervous system that controls the homeostatic (life-maintaining) functions essential to any organism's sustained survival and is divided into two major "branches," which are the sympathetic and the parasympathetic nervous systems, respectively.

axon: The axon of a neuron is the elongated, often myelinated, fiber that extends from the soma and that is responsible for the propagation of information signals (action potentials) from the body of the cell to the terminal buttons.

basal ganglia: The basal ganglia (or basal nuclei) are the major components of a system of structures near the thalamus that is important in motor control of the body, especially the regulation of slow movements.

behavioral genetics: The field of behavioral genetics is concerned with the study of how genes and heredity affect behavior.

brain: The brain is the highest, most complex of the hierarchical components of the nervous system and is responsible for the centralized integration and processing of the many functions of the nervous system.

cell body: The cell body, or "soma," is the part of the cell that contains the cell nucleus.

cell membrane: The cell membrane, or cell wall, is the outer, lipid- and protein-formed barrier of the cell that helps control the entrance and exit of entities into the cell and that also contains the cell's cytoplasm, organelles, and other key components.

central nervous system: The central nervous system is one of two primary divisions of the nervous system and is composed of the brain and spinal cord.

cerebellum: The cerebellum (or "little brain") is part of the hindbrain and plays a vital role in the production of coordinated, fine motor control.

cerebral cortex: The cerebral cortex refers to the wrinkled outer surface of the brain that is only a few millimeters thick (approximately 3 mm) but large in total area (approximately 2.5 square feet) and is thought to be intimately involved in higher intelligence, conscious experience, and the analysis of sensory information.

computerized axial tomography (CAT): The computerized axial tomography (CAT) scan is essentially an X-ray photograph of the brain detailing the anatomical structure of the imaged region.

corpus callosum: The corpus callosum is a collection of neuronal fibers lying between, and functionally connecting, the left and right hemispheres of the brain.

dendrite: Dendrites are the many small, branchlike structures of a neuron that are specialized to receive signals from other neurons.

electroencephalogram (EEG): An electroencephalogram is a macro level (multiregion) measure of brain activity (electrical fields, or "brain waves"), acquired by distributing multiple electrodes across the person's scalp.

endocrine system: The endocrine system is a collection of glandular bodies, including the pituitary, thyroid, and adrenal glands and the pancreas and gonads, that regulate global body function through the secretion of various hormones.

event-related potentials (ERPs): Event-related potentials refer to the changes in electrical activity across regions of the brain that accompany the presentation of corresponding manipulations or stimuli and are often recorded using the EEG.

excitatory postsynaptic potential (EPSP): An increase in the electrical charge of a neuron, caused by the neurotransmitter-mediated opening of ion channels at a synapse.

family study: A family study is a research study that investigates the role of heredity on some behavior(s) of interest by seeing if a behavior or trait "runs in the family," or if closely related family members are more similar than distantly related or unrelated individuals.

forebrain: The forebrain, consisting of the cerebral cortex and other structures that are responsible for higher order behaviors and mental processes, is the largest of the three superficial divisions of the brain.

frontal lobes: The frontal lobes constitute the largest of the four major divisions of the cerebral cortex and are involved in planning future behavior, initiating and regulating behavior, short-term memory, emotion, motor function and many other higher-order functions.

functional MRI (fMRI): The functional MRI neuroimaging technique involves performing multiple MRI scans in quick succession, thereby permitting observation of not only anatomical structure, but also of changes in blood oxygenation levels (BOLD) that indicate neuronal, functional activity.

gene: A gene is single segment of a chromosome (strand of DNA) that guides the development of an individual through the production of proteins.

genotype: An organism's genotype is its unique collection of genes.

glands: Glands (e.g., the pituitary, thyroid, and adrenal glands) control many internal biological functions of the body by releasing small quantities of chemicals (hormones) directly into the bloodstream, where they influence target organs.

glial cells: Glial cells (glia) are a specialized class of supportive cells in the central nervous system that provide nutrition, structural support, and insulation to neurons. Some glial cells are responsible for the cleanup, or removal, of dead neurons.

gonads: The gonads (ovaries for women, testes for men) are members of the endocrine system and are responsible for the secretion of sex cells (eggs or sperm) and hormones that regulate the reproductive system and the onset and expression of secondary sex characteristics.

gray matter: The gray matter area of the brain corresponds to the exposed surface of the cerebral cortex and derives its apparent gray pigmentation from the many cell bodies and synaptic connections of which it is composed.

hierarchical processing: The notion of hierarchical processing entails that much of the brain's processing can be characterized as being structured in levels of increasing detail or complexity.

hindbrain: The hindbrain, consisting of the cerebellum, medulla, and pons, is one of three superficial divisions of the brain and is associated with many basic and vital life-maintenance functions.

hippocampus: The hippocampus is a member of the limbic system and is associated with memory.

hormone: A hormone is a chemical substance that is released from an endocrine gland and that influences the arousal level and activity of organs and other regions/systems of tissue.

hypothalamus: The hypothalamus is a member of the limbic system and is associated with the basic homeostatic (life-maintenance) functions (e.g., basic biological needs and drives) of the organism.

inhibitory postsynaptic potential (IPSP): A decrease in the electrical charge of a neuron, caused by the neurotransmitter-mediated opening of ion channels at a synapse.

lesion: A lesion, or destroyed part of the brain, provides some insight into the normal (and abnormal) function of various parts of the brain, and may be due to natural causes (e.g., through disease or injury) or experimental causes (e.g., deliberate lesioning of an animal's brain).

limbic system: The limbic system consists of such forebrain structures as the thalamus, hypothalamus, hippocampus, amygdala, and septum, and is collectively associated with emotion, memory, and motivation.

magnetic resonance imaging (MRI): Magnetic resonance imaging is a neuroimaging technique that uses a strong magnetic field to produce static, 2- or 3-D images detailing the structure of a person's brain.

magnetoencephalogram (MEG): A magnetoencephalogram is a macro level (multi-region) measure of brain activity that is obtained by measuring magnetic fields associated with the electrical activity of various regions of the brain.

medulla: The medulla structure constitutes the lower portion of the hindbrain and is associated with the control of a number of vital functions (e.g., blood pressure, heart rate, and respiration) and other such involuntary functions as the coordination of the two eyes.

midbrain: The midbrain is one of three superficial divisions of the brain and corresponds to the small region under the forebrain and above the hindbrain.

mitochondria: Mitochondria are specialized organelles that are essential for the production of energy within a cell.

motor neurons: Motor neurons (or "efferent" neurons, for the Latin "carrying outward") are specialized cells that send information outward from the central nervous system to control the muscles.

multiple cell recording: Multiple cell recording refers to the procedure of recording the electrical activity of a cluster, or group, of individual cells.

myelin sheath: The myelin sheath is generated by specialized glial cells and essentially is a blanket of fat that wraps around certain areas of an axon, thereby permitting faster, more finely regulated conductance of signals across the cell.

neurons: The neuron, one of two specialized basic cells of the nervous system, is distinguished by its key role in the reception, storage, and transmittal of information.

neurotransmitter: Neurotransmitters (e.g., norepinephrine, serotonin, and acetylcholine) are a class of organic chemical substances, native to the organism, that are released by the terminal buttons of a neuron as a means of sending messages to other neurons.

nucleus: The nucleus of a neuron serves as the functional center of the cell and is where the genetic material for the cell is found.

occipital lobe: The occipital lobes, located at the back of the forebrain, constitute one of four major divisions of the cerebral cortex and are involved almost entirely in vision.

pancreas: The pancreas is one of the major endocrine glands of the body, playing a central role in the production of glucose-metabolizing insulin and other digestion-related processes and functions.

parasympathetic nervous system: The parasympathetic nervous system is the part of the autonomic nervous system that is associated with relaxed-state arousal levels and activities (e.g., energy storage, digestion, and sleep).

parietal lobe: The parietal lobes, located above the temporal lobes and to the front of the occipital lobes, constitute one of four major divisions of the cerebral neocortex and are important for body sense (somatosensory, or "touch") and object recognition.

peripheral nervous system: The peripheral nervous system is one of two primary divisions of the nervous system and is composed of all of the nervous system that lies outside the brain and spinal cord (i.e., the central nervous system).

phenotype: A person's phenotype is his or her unique expression of his/her underlying genotype, meaning that one's phenotype is one's outward, visible expression of one's inward genetic makeup.

pituitary gland: The pituitary gland lies in the core of the brain near the midbrain division, and is sometimes called the "master gland" due to its supervisory regulation of the many other components of the endocrine system.

polygenic: Polygenic characteristics, physical and psychological, are influenced by more than one gene.

pons: The pons structure of the hindbrain is associated with sleep and arousal and also serves as a functional "bridge" between the brainstem, the cerebellum, and other areas of the brain.

positron emission tomography (PET): A positron emission tomography scan is a neuroimaging technique capable of providing both a structural and a functional image of the brain through the use of radioactive tagging substances (e.g., glucose, neurotransmitters, and drugs) that highlight cellular activity in regions of the brain.

receptor: The numerous different types of receptors of any given neuron essentially are binding sites/areas of a cell that absorb only specific neurotransmitters and thereby permit only certain channels, or gates in the cell membrane, to open and allow particular ions to enter the cell.

reticular formation: Being part of the brainstem, the reticular formation forms a cylindrical core through the mid- and hindbrain and is fundamentally important in the regulation of arousal and attention.

sensory neurons: Sensory neurons (or "afferent" neurons, for the Latin "carrying toward") are specialized cells that transmit signals from the sensory organs to the central nervous system.

single cell recording: Single cell recording refers to the procedure of recording the electrical activity of a single cell through the usage of a microelectrode.

somatic nervous system: The somatic nervous system is one of the two divisions of the peripheral nervous system and consists of the motor (efferent) nerves that supply the muscles of the body, and the sensory (afferent) nerves that carry signals to the central nervous system from such sensory structures as the eyes, ears, tongue, and skin.

staining: Staining is a basic technique of dying particular areas, or portions, of cellular tissue to aid in the observation of various cellular structures.

substantia nigra: The substantia nigra, meaning "black substance," is a darkly pigmented region of nuclei in the midbrain that serves an important role in the motor system and is functionally connected to the basal ganglia.

sympathetic nervous system: The sympathetic nervous system, also known as the fight-or-flight system, is the part of the autonomic nervous system that is responsible for elevating the organism's activity level to a high state of arousal, thereby preparing the organism for heightened, often emergency, levels of activity and energy usage.

synapse: The term "synapse" may be used as both a noun, to describe the microscopic gap between the axon of one neuron and the dendrites of another neuron that separates the two cells, and a verb, to describe the general notion of one neuron functionally connecting to another.

temporal lobe: The temporal lobes, roughly located beneath the temples, constitute one of four major divisions of the cerebral cortex and are associated with hearing (audition), speech and language, and memory.

terminal button: The terminal buttons of a neuron lie at the neuron's end and perform the specialized function of releasing chemical messengers across the synapses to neighboring neurons.

thalamus: The thalamus is located in the forebrain and is often thought of as the "hub" of sensory processing since all incoming sensory information, except that associated with the sense of smell, is processed by the thalamus before being sent to other structures/regions of the brain.

thyroid gland: The thyroid gland, located in the neck in front of the windpipe and below the vocal cords, regulates the metabolic rate of the body.

twin study: A twin study is a research study that investigates the role of heredity on some behavior(s) of interest by comparing both identical and fraternal (nonidentical) twins, with the assumption that greater similarities among identical twins suggest a genetic influence, whereas greater differences between identical twins implicate environmental factors.

white matter: The white matter area of the brain is located beneath the gray matter of the cortex and derives its name from its being mostly composed of the "white," myelinated axons of cortical cells.

■ CHAPTER FOUR: CONSCIOUSNESS

activation-synthesis theory: The activation-synthesis theory suggests that dreams have no inherent meaning and are merely our cognitive system's attempt at making sense out of "random" neural activity.

agonists: Agonists are drugs, or other chemical substances, that bind to a neuron's receptor sites for specific neurotransmitters and mimic the effect(s) of that neurotransmitter.

alpha rhythm: The term "alpha rhythm" refers to the pattern of EEG activity occurring between the range of 8–12 Hz that characterizes the first stage of sleep (Stage One) and is observed when a person is in a passive, restful state of mind.

antagonists: Antagonists are drugs or other chemical substances that bind to receptor sites for specific neurotransmitters and rather than mimicking the neurotransmitter's effect, prevent the natural neurotransmitter from binding at that receptor site, thereby preventing it from producing its natural effect.

beta rhythm: The term "beta rhythm" refers to the desynchronized pattern of EEG activity obtained between the range of 13–30 Hz that characterizes the state of wakefulness and general arousal (e.g., being attentive or actively engaged in thought).

circadian rhythm: A circadian rhythm is a behavioral or physiological change occurring within the organism on a regular, approximately twenty-four-hour schedule.

conscious level (processes): The term "conscious level" refers to a degree, or state, of consciousness, in which one is (perhaps momentarily) aware of one's own mental activity, or elements (e.g., ideas, experiences, cognitive states) thereof.

consciousness: Consciousness is typically defined as awareness of one's own mental activity as well as of the external environment.

delta rhythm: The term "delta rhythm" refers to the synchronized pattern of EEG activity obtained between the ranges of 1–3 and, more typically, 2–3 Hz that characterizes the intermediate stage of sleep, Stage Three sleep.

depressants: Depressants (e.g., alcohol and barbiturates) are controlled substances that reduce or inhibit the activity of the nervous system.

hallucinogens: Hallucinogens, or "psychedelics" (e.g., LSD and THC), are controlled substances that produce hallucinations in the drug user, including distortions of reality and identity, as well as dramatic changes in mood, emotion, perception, and thought.

hypnosis: Hypnosis is an altered state of consciousness characterized by a state of deep relaxation and increased suggestibility.

insomnia: Insomnia is the pervasive inability to fall asleep or remain asleep during the night.

meditation: Meditation is defined as the self-induced process of relaxation providing heightened awareness, tranquility, and opportunities for internal reflection.

narcolepsy: Narcolepsy is a rare sleep disorder in which a person will suddenly transition from a conscious, waking state into REM sleep.

narcotics: Narcotics, or "opiates" (e.g., heroin, morphine, and codeine), are a class of controlled substances that are derived from opium and are known for their sleep-inducing and pain-relieving properties.

nonconscious level (processes): The term "nonconscious level" refers to a mode, or condition, of cognitive function, of which one cannot become aware, such as activity of the autonomic nervous system.

NREM sleep: NREM (non-rapid eye movement) sleep refers to the group of four, slow-wave stages of sleep, occurring in the absence of REM activity and initially taking place during the first thirty to forty-five minutes of sleep.

physiological dependence: Physiological dependence is the tendency to acquire a physical need for a controlled substance (e.g., morphine, nicotine, or alcohol) so that withdrawal from it is uncomfortable, painful, or even dangerous.

psychoactive drugs: Psychoactive drugs are controlled substances that affect the nervous system, producing psychological changes in the person taking them.

psychological dependence: Psychological dependence is defined as the tendency to become psychologically dependent on a drug, even in the absence of physiological dependence.

REM sleep: REM (rapid eye movement) sleep, occurring in about ninety-minute intervals during

sleep, is associated with dream sleep and is characterized by both the rapid movement of the eyes under the closed eyelids and an EEG pattern that resembles that of Stage One or Two sleep (i.e., theta rhythm activity).

sleep apnea: Sleep apnea is a sleeping disorder that is characterized by brief, but persistent, periods where the inflicted individual stops breathing during sleep.

sleep paralysis: Sleep paralysis involves paralysis of the body at sleep onset or upon awakening. It is often accompanied by hallucinations, and is more frequent in those who suffer from narcolepsy or some personality disorders.

sleep spindles: Sleep spindles, brief bursts of high amplitude activity (12–14 Hz) in an EEG reading, indicate that a person is drifting into the deeper stages of sleep.

state of consciousness: A state of consciousness is a stable configuration or pattern of psychological processes such as mood, memory, ability to reason, body sense, sense of self, and so on.

stimulants: Stimulants are psychoactive drugs (e.g., nicotine, caffeine, cocaine, amphetamines, and MDMA) that have an excitatory effect within the central nervous system, as well as upon behavioral activity.

subconscious level: The subconscious, or unconscious, level of consciousness refers to a mode, or condition, of mental activity that is not conscious, but nevertheless influences conscious thought or activity.

theta rhythm: The term "theta rhythm" refers to the relatively slower, larger, and intermittently occurring pattern of EEG activity obtained between the range of 4–7 that characterizes the early stages (Stages One and Two) of sleep.

tolerance: Tolerance (of a controlled substance) is the tendency to require, with prolonged drug usage, increasingly large dosages of the drug in order to produce the same level of effect within the person.

■ CHAPTER FIVE: SENSATION

absolute threshold: The absolute threshold of a particular sensory modality (e.g., visual, auditory, gustatory, and so on) refers to the minimal amount of physical intensity a given stimulus must produce to allow its detection by the sensory system.

accommodation: Accommodation refers to the process of lens adjustment, in visual perception, to focus on nearby objects.

amplitude: In visual or auditory perception, "amplitude" refers to the height of a light or sound wave, respectively, and is associated with experiential/perceptual intensity (e.g., brightness intensity in the case of vision).

analgesic: An analgesic substance, whether native to the person (e.g., neurotransmitters and endorphins) or not (e.g., morphine and codeine), exerts a pain-relieving effect within the body, inhibiting the activation of neural systems associated with pain.

anvil: The anvil, or *incus* (Latin), is the second of three small bones (hammer, anvil, and stirrup) that are located in the middle ear and collectively contribute to the amplification of incoming sound waves, or the "air pressure" thereof.

auditory nerve: The auditory nerve comprises of a bundle of bipolar, interneuron axons, and carries information from the inner ear (the cochlea) on to the brain (thalamus) for higher-order auditory perceptual processing.

basilar membrane: The basilar membrane is the thin, tapered membrane that resides in the cochlea and houses the auditory receptor cells (cilia).

blind spot: The blind spot of the eye corresponds to the area of the eye that lacks visual receptors (i.e., is "blind") due to the optic nerve exiting there.

cilia: Cilia, or "hair cells," are auditory receptor cells.

conduction deafness: Conduction deafness refers to deafness that occurs when some mechanical element(s) of the ear fail to operate properly, such as if the bones of the middle ear do not vibrate, or the eardrum is punctured.

cochlea: The cochlea is a fluid-filled cartilage spiral in the inner ear, containing two membranes (the tectorial membrane and basilar membrane) that transform vibrations into neural signals.

cones: Cones are the "cone-shaped" photoreceptor cells that predominantly reside in the foveal region of the retina and are sensitive to wavelengths of light, approximating the subjective experience of red, green, and blue colors, respectively.

cornea: The cornea is the transparent outer layer of the eye that allows light to enter one's eye.

difference threshold: The difference threshold of a particular sensory modality (e.g., visual, auditory, gustatory, and so on) refers to the minimal amount of change in physical intensity a given stimulus must produce to allow that change to be detected by the sensory system.

eardrum: The eardrum, or "timpanic membrane," is the thin membrane that overstretches, and lies at the end of, the ear canal, and that vibrates in response to auditory stimuli (sound waves, or air pressure).

feature detectors: Feature detectors are specialized cells in the visual cortex that respond only to a specific feature (e.g., a line, spot, or curvature) of an object.

fovea: The fovea corresponds to the center of the visual field and retina and provides not only high acuity vision, but also color vision due to the high concentration of cones there.

frequency-matching theory: The frequency-matching theory of audition explains the audition of very low frequency sounds through the proposition that the firing rate of neurons in the auditory nerve match the frequency of incoming sound waves, such that if a sound has a frequency of 50 Hz, for example, the neurons fire fifty times per second.

ganglion cells: Ganglion cells are specialized retinal cells that synapse with bipolar cells in the retina, conveying visual information to the brain via their axons (which collectively form the optic nerve).

gate-control theory: The class of pain-control theories known as "gate-control theories" propose that the spinal cord can block pain signals being sent to the brain, thereby diminishing one's feeling of pain.

gustation: Gustation is the sensory modality most commonly referred to as "taste."

hammer: The hammer, or *malleus* (Latin), is the first of three small bones (hammer, anvil, and stirrup) that are located in the middle ear and collectively contribute to the amplification of incoming sound waves, or the "air pressure" thereof.

hue: The term "hue" refers to the particular color perception (e.g., "green") that we experience in the presence of a certain wavelength of light (e.g., 500–530 nanometers).

hyperopia: Hyperopia, or "farsightedness," is the condition of seeing distant objects with more acuity than those that are nearby.

intensity: Intensity (e.g., visual, auditory, or somatosensory intensity), as the term is used in this chapter, refers to the magnitude, strength, or degree of extremity of some aspect (e.g., brightness, loudness, or weight) of a particular stimulus.

iris: The iris is the "colored" (e.g., green, brown, or blue) muscular structure of the eye that forms and adjusts the shape of the pupils, thereby regulating the amount of light entering the eye.

just noticeable difference (jnd): See **difference threshold.**

kinesthesia: Kinesthesia is one's sense of the position of the parts of one's body, and those body parts' relation to one another during movement.

lateral geniculate nucleus (LGN): In reference to the primary visual pathway, the lateral geniculate nucleus is the thalamic relay nucleus for vision that is enervated by the optic nerve and sends information to the primary visual cortex ("area V1").

lens: The (crystalline) lens is one of the optic mechanisms of the eye, and it focuses light received through the pupil onto the retina during the process of visual accommodation.

loudness: Loudness, or intensity, of the auditory stimulus is a function of the amplitude (height) of sound waves, and is measured in decibels (dB).

myopia: Myopia, or "nearsightedness," is the condition of seeing nearby objects with more acuity than those that are distant.

nerve deafness: Nerve deafness is a type of hearing loss that is caused by damage to the cochlear hair cells and results in the inability to hear higher frequencies (e.g., violins or birds chirping) rather than lower frequencies (e.g., drumbeats or bass).

olfaction: Olfaction is one's sense of smell.

olfactory area: The olfactory area corresponds to the uppermost part of the nasal cavity and is the location where olfaction occurs, thanks to the numerous odor-receptor cells located there.

olfactory bulb: The olfactory bulb is a brain structure that is enervated by the olfactory area and sends information to the olfactory cortex, where odor sensations undergo higher-order perceptual processing.

opponent-process theory: The opponent-process theory of color perception proposes that color vision is the result of the excitatory and inhibitory interplay among specialized neurons (e.g., ganglion and thalamic cells) that are arranged into pairs of "opponent" colors (i.e., red-green, blue-yellow, and black-white) and are particularly sensitive to certain wavelengths of light (color) while being insensitive to others.

optic chiasm: The optic chiasm, or "optic X," derives is name from its X-shaped appearance, and is the anatomical point at which information coming from the eyes via the optic nerve is divided and projected to each hemisphere of the brain.

optic nerve: The optic nerve comprises the axons of the ganglion cells of the eye and carries visual information from the eye to the brain.

pheromones: Pheromones are special chemicals transmitted among animals, and possibly humans, that impact the recipient's physiology and/or behavior (e.g., sexual drive and menstrual cycle).

pinna: The pinna is the "funnel"-shaped, outer portion of the ear that initially collects sounds and directs them down into the auditory canal.

pitch: In auditory perception, pitch corresponds to the frequency (in Hz), or rapidity of oscillation, of sound waves, and is subjectively experienced as the scaling, "low" or "high," of the sound.

place theory: The place, or "traveling wave," theory of auditory perception explains well the perception of

relatively high frequencies in terms of vibratory patterns of certain areas (places) of the basilar membrane, but poorly accounts for low-frequency perception.

primary auditory cortex: The primary auditory cortex refers to a portion of the cortical region of the temporal lobes that is responsible for higher-order, perceptual processing of auditory information.

primary visual cortex: The primary visual cortex (area V1) is responsible for higher-order perceptual processing of visual information and corresponds to the cortical region of the occipital lobes.

proprioception: Proprioception is one's sense of body position.

psychophysics: Psychophysics is the study of the computational/quantitative relationship of stimuli to the perceptual system.

pupil: The pupils of the eyes are "black" openings/holes in the center of each of the eyes that are formed by the opening and closing of the irises.

receptive fields: Receptive fields are regions of the physical or chemical spectrum that cause a particular receptor cell, or group of receptors, to be optimally active (i.e., to which a class of receptors is optimally sensitive).

receptors: Receptors, or "receptor cells," are specialized neurons (sensory neurons) that detect a particular form of energy (e.g., light versus temperature) or chemical in the environment and thereby constitute the first link in the chain of sensory-information processing.

retina: The retina is a specialized light-sensitive extension of the central nervous system that is responsible for image processing in the eye and resides at the inner back of the eye, where the photoreceptors (cones and rods) are housed.

rods: Rods are the rod-shaped photoreceptor cells that predominantly reside in the periphery of the eye (i.e., exterior to the fovea) and are very sensitive to even low levels of light (hence, night vision) but insensitive to the wavelength (color) of light.

semicircular canals: The semicircular canals are half-circle-shaped structures of the inner ear that play a key role in one's sense of balance, acceleration, and head orientation (vestibular sense).

sensory adaptation: Sensory adaptation refers to the tendency to decrease in sensitivity, or responsiveness, to a constant sensory stimulus with increased exposure and, therefore, provides the ability to focus on novel stimuli in one's environment.

somatosensory cortex: The somatosensory cortex processes sensory information associated with skin (e.g., pressure, warmth, cold, and pain) and the internal body and is located in the forward portion of the parietal lobes.

stirrup: The stirrup, or *stapes* (Latin), is the third of three small bones (hammer, anvil, and stirrup) that are located in the middle ear and collectively contribute to the amplification of incoming sound waves, or the "air pressure" thereof.

taste buds: Taste buds are the sensory receptor cells of the mouth that support gustation.

tectorial membrane: The tectorial membrane is a thin, yet rigid membrane that lies above the basilar membrane of the inner ear and is instrumental to audition due to the role it plays in the flexing of the hair cells that contact it.

topographic organization: Topographic organization refers to the regular organization of the cortices (e.g., the visual cortex) according to the structural organization of their corresponding receptor field(s) (e.g., visual receptor fields).

transduction: Transduction is the process of converting external physical energy into neural information.

trichromatic theory: The trichromatic theory of color perception, attributed to T. Young and H. V. Helmholtz, proposes that one's perception of the many colors in the color spectrum are the product of the three primary colors of light—red, green, and blue—and their corresponding photoreceptors—red-, green-, and blue-sensitive photoreceptors.

vestibular sense: The vestibular sense is the sense of position and movement of one's head.

visual acuity: Visual acuity is largely a function of the lens of the eye, and refers to accuracy/clarity of visual focus.

wavelength: The term "wavelength" refers to the distance between the peaks (or troughs) of individual waves of energy (e.g., light and sound waves).

■ CHAPTER SIX: PERCEPTION

apparent motion: Apparent motion is the misperception of motion when there is, in fact, none (e.g., the phi phenomenon).

area MT: Area MT, or "V4," of the visual cortex (occipital lobes) contains cells that are specialized to such fundamental features of the visual field as motion, orientation, speed, and direction.

attention: Attention is the process of controlling and allocating mental resources to enhance perception and behavior.

binocular cues: Binocular cues (e.g., convergence and binocular disparity) are those depth perception cues that involve information acquired by both eyes.

binocular disparity: Binocular disparity is a binocular cue that informs one's perception of depth through the comparison of the unique images/views provided by the two eyes' different vantage points.

bottom-up processing: Bottom-up processing, in sensory perception, refers to the process of information traveling "up" from the hierarchically more rudimentary sensory receptors to the more sophisticated brain, where it is passively interpreted.

brightness constancy: Brightness (or lightness) constancy refers to one's subjective perceptual experience of an object's brightness remaining stable despite changes in lighting conditions.

closure: Closure is the Gestalt principle of visual perception that we tend to perceive complete figures, although, in fact, part of the figure may be hidden from view or actually incomplete (as when one perceives a line composed of "dotted," or broken, lines).

color constancy: Color constancy refers to one's subjective perceptual experience of an object's color remaining stable despite changes in lighting conditions.

common fate: The phrase "common fate" is a Gestalt principle of visual perception that objects existing under a common state, or condition (e.g., in motion: moving the same direction and speed), will be perceived as a single entity.

connectedness: Connectedness, a Gestalt principle of visual perception, refers to the tendency to perceive elements, or objects, that are connected by other elements as belonging to a group.

connectionist models: Connectionist models, or "neural network" models, are models of cognitive processes that are often also called "parallel distributed processing models," because they attempt to explicitly model the architecture of various cognitive systems by specifying the distinct neural units involved in those processes in a way that suggests processing occurs simultaneously across a network of widely distributed units.

continuity: Continuity is a Gestalt principle of visual perception that suggests that figures that appear to create a continuous form actually belong together.

convergence: Convergence is a binocular depth cue that informs one's depth perception based on the information that is gleaned from our eyes being in different places on the face and, therefore, having to turn inward (toward each other) in order to focus on a common object.

depth perception: Depth perception is our ability to judge distance.

divided attention: Divided attention is the capacity, or process, of simultaneously focusing on two or more entities or events (e.g., objects, stimuli, or mental phenomena).

figure-ground relationship: The figure-ground relationship of a visual array refers to the Gestalt-theory notion that in visual perception, a form always appears as a vital figure against a background.

illusions: Illusions are erroneous perceptions.

inferotemporal cortex (area IT): The inferotemporal cortex, or "area IT," is found at the bottom of the temporal lobes and is thought to be involved in object recognition.

interposition: Interposition, or "occlusion," is a monocular cue of depth that informs depth perception on the basis of one object in the visual field blocking, or being blocked by, another object—the blocked object being farther away than the occluding object.

linear perspective: Linear perspective is a monocular cue of depth that informs one's perception of depth based on the principle that straight, parallel lines appear to converge as they become more distant, such as when looking down railroad tracks.

monocular cues: Monocular cues (e.g., relative brightness, clarity, and height) are those depth perception cues that involve information acquired only by a single eye.

noise: In reference to detection of target stimuli, "noise" means any nonsignal/nontarget event, whether internal (e.g., preoccupation, fatigue) or external (e.g., cloud formations, a flock of birds).

optical flow: Optical flow is the change in the retinal image across the entire visual field.

perception: Perception (Latin, *per* or "thorough" and *capio* or "grasp") involves recognizing the meaning of what has been sensed and is usually taken to mean the final, organized, and meaningful experience of sensory information.

perceptual set: Perceptual set refers to a frame of mind, explicit or implicit, in which one's preconceived notions about what one is going to experience influence one's perceptions.

proximity: The Gestalt grouping principle of proximity suggests that objects or events occurring close to each other will be perceived as belonging together as a single entity.

relative brightness: Relative brightness is a monocular cue of depth that informs one's perception of depth based on the principle that more distant objects will appear dimmer than the same objects up close.

relative clarity: Relative clarity is a monocular cue of depth that informs one's perception of depth based on the principle that more distant objects will appear hazier than the same objects up close.

relative height: Relative height is a monocular cue of depth that informs one's perception of depth based on

the principle that more distant objects will occur higher in one's visual field than the same object up close.

relative motion: Relative motion, or "motion parallax," is a monocular cue of depth that informs one's perception of depth based on the principle that the speed of objects in the visual field (optic flow) correspond to certain distances, with more distant objects appearing to move slower than nearby objects.

relative size: Relative size is a monocular cue of depth that informs one's perception of depth based on the principle that when two or more objects in the visual field are the same size, images that are smaller on the retina correspond to objects that are actually farther away.

selective attention: The term "selective attention" refers to the fact that, because one's attentional resources are limited, one focuses only on a particular subset of all available information at any given moment.

sensitivity: In signal detection theory, sensitivity (symbolized d', "d-prime") is one's ability to detect a signal, or target stimulus.

shape constancy: Shape constancy refers to the perceptual phenomenon that the apparent shape of an object does not change as it rotates or moves in space, although, in fact, it produces altered retinal images.

signal: In signal detection theory, the signal is the stimulus of interest, as well as any changes that may occur in that stimulus over time.

signal detection theory: Signal detection theory is a formal theory of perception that characterizes the perception of a given stimulus (e.g., a sound or visual image) as a decision-making process about whether one has really experienced a target stimulus (signal) or not (noise).

similarity: The Gestalt grouping principle of similarity refers to the tendency for similar elements to be perceived as forming a group, or single entity.

size constancy: Size constancy refers to the perceptual phenomenon that objects do not appear to change in size when they come nearer to, or farther from, the eye, despite the fact that in either case,

either a larger or smaller retinal image, respectively, is being produced.

stroboscopic motion: Stroboscopic motion refers to the perceptual phenomenon of perceiving motion in a series of still photograph frames projected in rapid succession (as in a movie), when, in fact, there is no motion.

texture gradient: The texture gradient cue is a monocular depth cue that informs one's perception of depth based on the principle that more distant objects will appear finer or "grainier" in texture, compared to closer objects, which appear coarser and more distinct.

top-down processing: Top-down processing refers to recognition, or cognitive processing, that is guided by "higher-order" cognitive processes and existing knowledge.

Weber's Law: Weber's Law, attributed to E. H. von Weber, is the earliest formalization of a psychophysical relationship, stating that the noticeability of a change in stimulus strength (e.g., a bright object becoming brighter or dimmer) depends on the magnitude of the stimulus before the change (e.g., the initial brightness of the object).

■ CHAPTER SEVEN: LEARNING

acquisition: Acquisition is the attainment of a conditioned response (CR) to a conditioned stimulus (CS). The acquisition phase of classical conditioning consists of the development of the CR as trials proceed.

adaptation: In a learning context, or in biology and physiology, "adaptation" refers to beneficial changes in an organism's behavior in response to changes in the environment—i.e., the ability to change to fit with one's surroundings. This may include the decrease in responsiveness to repeatedly experienced stimuli (sensory adaptation). In an evolutionary context, "adaptation" refers to advantageous changes in the genetic characteristics of a species that increases the species' odds of survival, or better addresses some obstacle of survival.

associative learning: Associative learning (e.g., classical conditioning) involves not just learning about a single stimulus, but learning associations or connections between multiple stimuli and/or behaviors.

avoidance conditioning: Avoidance conditioning involves training an organism to perform so as to prevent, or avoid, an aversive stimulus (e.g., learning to evacuate a building when a fire alarm sounds).

biofeedback: Biofeedback refers to the use of information about the states of one's own body (i.e., body/physiological cues) to guide and control one's behavior.

classical conditioning: Classical conditioning, or "Pavlovian conditioning," is attributed to I. Pavlov and is a fundamental type of associative learning involving the acquisition of a learned response to a previously neutral stimulus after repeated pairings of the neutral stimulus and the response outcome.

cognitive map: A cognitive map is a mental representation of the spatial layout and characteristics of some physical space (e.g., a room, a maze, or an entire landscape).

conditioned response (CR): In classical conditioning, the conditioned response is the acquired, or learned, response that is elicited by the learned stimulus (conditioned stimulus).

conditioned stimulus (CS): In classical conditioning, the conditioned stimulus is the previously neutral, nonresponse-eliciting stimulus that has, with repeated presentation with some outcome, acquired the capacity to elicit a learned response (conditioned response).

continuous reinforcement: One of the schedules of reinforcement in associative learning, continuous reinforcement entails giving an organism reinforcement every time the organism performs the desired, or target, behavior.

discrimination: In associative learning, discrimination lies in contrast to generalization and is the ability to distinguish between similar stimuli and thus refrain from responding.

discriminative stimulus: A stimulus that an organism identifies as a signal that reinforcement will occur if a particular response is given.

escape conditioning: In operant conditioning, escape conditioning involves training an organism to respond in a way that stops, or reduces the duration of, an aversive stimulus (e.g., an electric shock or alarm clock).

extinction: In associative learning, extinction is the process, or phenomenon, of the gradual disappearance of the learned response (CR) (e.g., escape behavior) in the presence of the learned stimulus (CS), with repeated presentations of the CS (e.g., a sound) in the absence of the associated outcome (e.g., an electrical shock).

fixed-interval schedule: One of the schedules of reinforcement in associative learning, the fixed-interval schedule involves giving an organism reinforcement after a certain, constant/fixed, period of time has passed (e.g., receiving a food pellet every ten minutes).

fixed-ratio schedules: One of the schedules of reinforcement in associative learning, the fixed-ratio schedule entails giving the organism a reinforcement only after a certain number (i.e., ratio) of desired/targeted responses have been performed (e.g., receiving a food pellet after pressing a button ten times).

generalization: In associative learning, generalization lies in contrast with discrimination as the tendency for the learned response (CR; e.g., crying) to be evoked by stimuli that are similar (e.g., stimuli that are furry and have four legs) to the learned stimulus (CS; e.g., a dog), but have themselves never been paired with the unconditioned stimulus (UCS; e.g., a cat).

habituation: Habituation, one of the two most common forms of nonassociative learning, lies in contrast with sensitization and refers to the process of adapting to a stimulus by becoming less responsive in its presence with increased exposure.

higher-order conditioning: In associative learning, higher-order conditioning refers to the phenomenon of a previously established conditioned stimulus (CS) coming to serve as an unconditioned stimulus (UCS) in yet another chain of learned responses.

instrumental conditioning: The term "instrumental conditioning" is attributed to E. L. Thorndike and refers to Thorndike's emphasis on an organism's responses as being important, or "instrumental," to the attainment of reinforcements.

intermittent (or partial) reinforcement: In terms of schedules of reinforcement, intermittent reinforcement schedules (including fixed- and variable-ratio and fixed- and variable-interval ratio) dictate rules of reinforcement that provide reinforcement for only a defined proportion of either responses (ratio) or time (interval).

inter-stimulus interval: In terms of the timing, or sequencing, of events in an associative-learning paradigm, the inter-stimulus interval (ISI) refers to the amount of time, or waiting period, between the presentation of stimuli. For example, an ISI of two seconds would entail the presentation of the first stimulus, a two-second time period, and then the presentation of the second stimulus.

latent learning: Latent learning is learning that occurs (usually in the absence of an incentive, or reinforcement) but is not exhibited until there is an incentive involved (i.e., a reason to demonstrate the learned ability or capacity).

law of effect: The law of effect, or "Thorndike's Law," states that responses followed by a satisfying state of affairs (e.g., receiving a reward after pressing the correct button) will be more likely to occur under similar circumstances in the future, while responses followed by an aversive state of affairs (e.g., being punished for pressing the incorrect button) will be less likely to occur and, therefore, will be gradually eliminated from the organism's behavior

learned helplessness: Learned helplessness, attributed to M. Seligman, is the psychological state of apathy, or unresponsiveness to try (i.e., helplessness), that is thought to develop from an acquired expectation that one's attempts to influence the environment and, therefore, achieve certain goals, will be ineffective or useless.

learning: Learning is defined as a relatively permanent change in behavior and understanding due to experience that cannot be explained by instinct, maturation, or temporary states of the organism.

modeling: In terms of observational learning, "modeling," refers to the process of acquiring vicarious conditioning.

negative reinforcers: In reference to operant conditioning, a negative reinforcer is an aversive stimulus (e.g., an annoying alarm clock) whose removal (e.g., turning the alarm off) strengthens a behavioral response (e.g., waking up on time in the morning).

neutral stimulus: In classical conditioning, a neutral stimulus is one that does not naturally produce the relevant response.

nonassociative learning: Nonassociative learning (e.g., habituation and sensitization) involves learning about one particular stimulus and the direct relationships that stimulus possesses.

observational learning: Observational learning is a highly cognitive form of learning that essentially entails learning how to do something by watching others do it.

operant conditioning: Operant conditioning is a learning paradigm in which the organism, acting under conditions of voluntary control of its own response behavior, learns to respond to the environment in a way that produces desirable consequences.

overjustification effect: The overjustification effect refers to the phenomenon of motivation, in which giving rewards for doing an activity for which one is already intrinsically motivated to perform actually decrease one's desire to perform the activity.

positive reinforcers: In operant conditioning, a positive reinforcer (e.g., awarding points for answering a psychology question correctly) is a desirable event or outcome whose presentation, or receipt, strengthens a behavioral response.

primary reinforcers: Primary reinforcers are those that are naturally reinforcing to an organism because of their property to satisfy basic needs, such as how food and water satiate hunger and thirst.

punishment: In terms of operant conditioning, punishment refers to either the removal of desirable stimuli (e.g., taking away a child's allowance) or the provision/applying of aversive ones (e.g., spanking a child), in order to decrease the likelihood of a behavior occurring in the future.

reconditioning: The reconditioning effect refers to the relatively rapid relearning of a conditioned relationship after extinction has occurred.

reinforcer: In reference to operant conditioning, a reinforcer is an event whose occurrence increases the likelihood that the immediately preceding response (operant behavior) will occur again in the future.

secondary reinforcers: Secondary reinforcers (e.g., money) are those that an organism must learn the significance of through experience and that derive their reinforcing property from their instrumental value as a means of acquiring primary reinforcers.

sensitization: Sensitization, one of the two most common forms of nonassociative learning, lies in contrast with habituation and refers to the process of adapting to a stimulus by becoming more responsive in to its presence with increased exposure.

shaping: In operant conditioning, "shaping" refers to the process of training an organism to perform some complex, multipart behavior by reinforcing the organism for increasingly specific steps that ultimately lead toward the attainment of the desired behavior.

spontaneous recovery: In classical conditioning, the phenomenon of spontaneous recovery refers to the apparently spontaneous reacquisition of a conditioned response (CR) in the presence of a presumably extinct conditioned stimulus (CS), following a period of nonexposure to the conditioning situation.

systematic desensitization: Systematic desensitization is the process of using principles of classical conditioning to condition against, or counter (i.e., countercondition), a previously acquired aversive response to some stimulus (e.g., a phobia).

unconditioned response (UCR): In classical conditioning, the unconditioned response is the naturally occurring, or innate, response that is elicited by a stimulus (in particular the unconditioned stimulus, UCS).

unconditioned stimulus (UCS): In classical conditioning, the unconditioned stimulus is the stimulus that naturally elicits a particular response (in particular, the unconditioned response, UCR).

variable-interval schedule: A variable-interval schedule of reinforcement dictates that a reinforcer will be administered after a varying period of time has passed (e.g., a reinforcer may be given after one, five, and thirteen minutes have transpired, respectively).

variable-ratio schedules: A variable-ratio schedule of reinforcement dictates that a reinforcer will be delivered after a varying number of target responses have been performed (e.g., a reinforcer may be given after ten, eleven, or eighteen performances of the desired behavior).

vicarious conditioning: Vicarious conditioning is the learning of a conditioned response by witnessing (or hearing about) others being conditioned.

■ CHAPTER EIGHT: COGNITION I: MEMORY AND KNOWLEDGE

acoustic encoding: Acoustic encoding describes encoding of how a stimulus sounds, or for what sounds it might be responsible.

anterograde amnesia: Anterograde amnesia is the type of memory loss in which newly acquired knowledge fades rapidly and is often lost within half an hour, if not sooner, although those memories formed prior to the damage remain unaffected.

automatic processing: Automatic processing occurs without our awareness, thus allowing one to focus attention and mental effort elsewhere.

chunking: Chunking is the grouping of information into meaningful units for storage rather than storing each bit of information separately.

cues: Cues are stimuli that promote more effective retrieval of information.

declarative knowledge: Declarative knowledge is information that is a part of explicit memory because the information can be directly stated or declared.

echoic memory store: The echoic memory store stores memory for several seconds or longer, and is the auditory register of the sensory store.

effortful processing: Effortful processing requires attention in a concentrated attempt to encode information.

elaborative rehearsal: Elaborative rehearsal involves deeply examining information, turning it over in one's mind and giving it special attention.

encoding: Transformation of incoming information for memory storage, such as the way a computer encodes all its information using 1s and 0s.

encoding specificity principle: The encoding specificity principle states that the effectiveness of a cue depends on the degree to which it provides a signal to the information.

episodic memory: Episodic memory is a record of specific events experienced and remembered.

explicit memory: Explicit memory refers to the direct or conscious access of information.

formal concepts: Formal concepts are concepts that are defined by specific rules or properties.

iconic memory store: The iconic memory store stores memory for only about half a second, and is the visual register of the sensory store.

implicit memory: Implicit memory processes are applied to information or events that are somehow stored or influential, but without direct or conscious access.

long-term potentiation (LTP): Long-term potentiation (LTP) describes an enduring increase in the neural firing potential of a neuron or group of neurons resulting from repeated activation.

long-term store (LTS): The long-term store (LTS), or long-term memory, is generally considered to be practically unlimited and relatively permanent.

maintenance rehearsal: In maintenance rehearsal, information is merely repeated so that it is maintained in short-term memory until it is needed.

method of loci: The method of loci is a mnemonic device in which an imaginary walk through familiar places is taken in order to remember items associated with those places.

mnemonics: Mnemonics are memory strategies that create powerful cues for specific items of information that one desires to memorize.

mood-congruence: Mood-congruence happens when one's mood or state of mind serves as a cue for memory retrieval.

natural concepts: Natural concepts are concepts that resist formal definition but instead are described by characteristic features.

nondeclarative knowledge: Nondeclarative knowledge is the knowledge of implicit memory, which cannot be overtly stated.

primacy effects: The primacy effect refers to the improved memory for words, or other stimuli, occurring at the beginning of a list or earlier in time.

priming: Priming can occur in recognition tasks, where cues facilitate quicker recognition performance (compared to recognition without cues).

proactive interference: Proactive interference occurs when earlier information interferes with the acquisition and retention of subsequent (i.e., newer) information.

procedural memory: Procedural memory is one's stored knowledge of how to perform certain tasks or actions.

prototype: A prototype is the characteristic member of a concept category.

recall: Recall refers simply to remembering, or producing spontaneously, the information requested (e.g., as must be done for an essay test).

recency effects: The recency effect refers to the improved memory for words, or other stimuli, occurring at the end of a list or more recently in time.

recognition: Recognition is the ability to recognize correct information, as on a multiple-choice test, or features of a particular item, such as whether something has been seen before.

rehearsal: Rehearsal is repeating information in order to retain information.

relearning: Relearning requires that material actually be relearned, for example, learning again a list of forgotten names.

repressed memory: Repressed memory is the psychic defense mechanism of hiding from oneself memories or knowledge that is painful or threatening.

retrieval: The process of moving the information out from memory storage and essentially reversing the encoding process so that the information can be used.

retroactive interference: Retroactive interference occurs when new information interferes with the retrieval of previous (i.e., "old") information.

retrograde amnesia: Retrograde amnesia is the loss of knowledge (or recall ability) for events prior to any event (i.e., past memories) that disrupts ongoing neural activity (such as a sudden blow or a mild electrical shock to the head).

schema: A schema includes the knowledge, beliefs, and expectations about a particular concept.

script: A script is a schema that is about a particular event or sequence of events, such as familiar activities.

semantic encoding: Semantic encoding of a stimulus is the process of converting (i.e., coding) information in terms of its root meaning so that it may later be retrieved from long-term memory store (LTS).

semantic memory: Semantic memory deals with general knowledge information, such as specific facts, that constitutes the bulk of our long-term memory store (LTS).

sensory store: The sensory store holds direct impressions of sensory events for short periods of time.

short-term store (STS): The short-term memory store (STS), also commonly referred to as "short-term memory," is considered a briefly lasting repository for information that has been transferred from the sensory store, retrieved from long-term memory, or temporarily stored while being actively processed (by working memory).

state-dependence: State-dependence happens when one's mood or state of mind serves as a cue for memory retrieval.

storage: The retention of encoded information in memory.

visual encoding: Visual encoding refers to the process of converting (coding) visual information about how a stimulus appears so that it may later be retrieved from long-term memory store (LTS).

working memory: Working memory typically refers to the active, conscious processing of information that recruits short-term memory for storage purposes and manipulates or transforms information therein.

■ CHAPTER NINE: COGNITION II: LANGUAGE AND THINKING

algorithm: An algorithm is an often rigorous, cognitively demanding strategy for problem solving that employs a procedure or formula guaranteed to produce a correct solution.

analogy: An analogy is an inference that two things or ideas that are similar in some ways share other qualities as well.

anchoring: Anchoring is a heuristic whereby one uses some value (such as a given value, or a value used in previous situations) as a starting point when trying to solve a judgment task.

artificial intelligence (AI): Artificial intelligence (AI) refers to the use of computers to imitate human perception and cognition.

availability heuristic: The availability heuristic entails using information that is most easily, or readily, brought to mind—that which is mentally most "available"—to solve a judgment task.

choice: Choice is the selection of an option or action from among an available set of options and actions.

convergent thinking: Convergent, or "analytic," thinking is focused, deliberate, and directed thinking that starts from a broad perspective or pool of ideas and narrows down to a single perspective or idea.

deductive reasoning: Deductive reasoning begins with general principles and applies these to particular cases.

deep structure: Deep structure refers to the underlying meaning of a sentence, as opposed to the mechanical or symbolic aspects that are actually produced (surface structure).

divergent thinking: Divergent thinking characterizes undirected thinking (e.g., brainstorming) that begins from a relatively narrow perspective or idea and branches out into a broad array of perspectives or ideas.

expected utility: Expected utility provides a measure of the utility ("usefulness") one can expect to receive by choosing an option, and is the benchmark for decision optimality.

framing effects: Framing effects refer to situations where logically equivalent choices are presented in different ways.

functional fixedness: Functional fixedness is a mental set where one cannot imagine new uses for familiar objects.

grammar: Grammar is a set of rules applied to a language.

heuristics: Heuristics are general solution strategies, like "rules of thumb," that are less cognitively demanding than algorithms, but that do not always yield a correct solution.

ill-defined problem: A problem lacking at least one of the following: certainty in the given information; the valid operations on this information; or the goal or desired end state.

inductive reasoning: Inductive reasoning, or "inference," begins with specific facts or experiences and concludes with general principles.

inference: Conclusions or judgments that are derived from statements that are known or assumed to be true, rather than from directly observed evidence.

insight: Insight is the perception of a problem in a new way.

judgment: Judgment refers to a particular type of inductive reasoning that involves determining the likelihood of certain events occurring.

language: Language is the mechanism by which we communicate our internal thinking to others through the manipulation and understanding of a symbolic system.

language comprehension: Language comprehension is the understanding of the meaning and purpose of language produced by another person.

language production: Language production is the use of language to construct a meaningful message.

means-end analysis: Means-end analysis is a process of repeatedly comparing the present situation with the desired goal and working towards the final goal by reducing the difference between the two.

morphemes: Morphemes are the most basic unit of a language that conveys meaning.

phoneme: Phonemes are the basic units of sound, and the smallest linguistic unit.

productive thinking: Productive thinking involves producing a new organization of a problem's elements.

representativeness heuristic: The representativeness heuristic is the basing of one's judgments largely on the degree to which the object is similar to a category prototype, or typical member of the class.

reproductive thinking: Reproductive thinking applies past solutions to new problems.

semantics: The semantics of language are the rules for deriving meaning.

set effect: A set effect is a tendency to solve new problems by applying past habits and assumptions.

surface structure: The surface structure of a sentence refers to the actual sentence (structure) that was produced, as opposed to abstract representations or meanings in a sentence.

syntax: Syntax is the portion of grammar that dictates valid ways to form grammatical structures.

utility: Utility is a personal measure of value or liking.

well-defined problem: A problem characterized by certainty in the given information, the valid operations on this information, and the goal or desired end state.

■ CHAPTER TEN: MOTIVATION, EMOTION, AND STRESS

affiliate: The preference, or need, to affiliate is the desire to be physically close to others of one's own species.

aggression: Aggression is any behavior intended to harm another, whether instrumental in nature (harming another to achieve a goal) or hostile (harming for the sake of hurting, in and of itself).

anorexia nervosa: Anorexia nervosa is an eating, or body-image, disorder that primarily affects women and is characterized by extreme illusory perceptions of being overweight and severe weight loss due to the individual's usage of self-starvation and other means in an attempt to correct the perceived obesity.

approach: In terms of a conflict-level analysis of motivation, approach motivation is the state of attraction toward a desired goal.

arousal: Arousal refers to an overall level of physiological activation, such that arousal theories of motivation hypothesize that there is some optimal level of arousal that results in maximum performance for a given individual in a given situation.

avoidance: In terms of a conflict-level analysis of motivation, avoidance motivation is the status of aversion felt toward experiencing a particular undesirable state or event.

bulimia nervosa: Bulimia nervosa is an eating, or body-image, disorder that is characterized by patterns of "binge" eating (overeating) followed by "purging" (induced vomiting) so as not to gain weight.

Cannon-Bard theory: The Cannon-Bard theory of emotion lies in contrast to the James-Lange theory of emotion, and asserts that an emotional stimulus simultaneously triggers bodily changes and conscious awareness of the emotion being experienced.

coping: The coping response to stress entails actively restoring one's physical and psychological balance by removing the stress-causing threat through three choices of action: confrontation; compromise; and withdrawal.

defense mechanisms: Defense mechanisms (e.g., repression, denial, and rationalization) are the behavioral strategies or responses individuals may use in an attempt to alleviate or reduce, rather than cope with, anxiety.

displacement: The defense mechanism known as "displacement" involves directing one's frustration caused by one source toward some other, less retaliatory, target in the form of aggression.

drive: The term "drive" refers to the motivational force that energizes goal-directed behavior and is hypothesized to motivate not a single specific behavior but an entire class of behaviors that are all connected to the same basic need.

effectance motives: Effectance motives (e.g., activity, exploration, and curiosity) constitute an individual's ability to autonomously function within, and have an effect on, his or her environment.

emotions: Emotions are subjective experiences, or "feelings," that are not under conscious control and influence thoughts, perceptions, and behavior.

extrinsic motivation: Extrinsic motivation refers to motivated states that arise due to factors (e.g., incentives) outside of (i.e., extrinsic to) the individual's sense of self, and self-guided activity or autonomy.

frustration: Frustration is the subjective feeling, or experience, that results from having one's access to a goal or need fulfillment blocked.

general adaptation syndrome: General adaptation syndrome, attributed to H. Selye, is a three-staged (alarm, resistance, and exhaustion) physiological and psychological pattern of symptoms thought to be characteristic of the typical response to stressor events.

homeostasis: Homeostasis is the tendency of an organism to maintain a consistent internal, psychological and physiological state.

instincts: Instincts are innate, goal-directed sequences of behavior that are more complex than simple reflexes, but are impervious to the influence of learning and experience.

internal conflict: Internal conflict is the subjective experience often felt when one simultaneously prefers incompatible goals or demands.

interpersonal conflict: Two people are said to be in a state of "interpersonal conflict" when one person opposes what the other desires.

intrinsic motivation: Intrinsic motivation refers to motivated states that arise due to incentives arising from one's own sense of self (i.e., within oneself), and self-guided activity or autonomy.

James-Lange theory: The James-Lange theory of emotion lies in contrast with the Cannon-Bard theory of emotion, and proposes that emotions are experienced in the following sequence: (1) an emotional stimulus is presented, causing one to experience (2) physiological reactions, which are (3) consciously experienced as an emotion.

motivation: Broadly speaking, motivation refers to the processes involved in energizing and directing goal-oriented behavior. The study of motivation entails determining factors that define goals, influence the initiation of goal-directed behavior, and determine the persistence and vigor of such behavior.

need: A need is a physiological (or psychological) requirement of an organism, such as for a resource, or for balance among bodily processes that is necessary to the healthy/optimal function of the organism.

obesity: Obesity is the condition of being severely overweight (as defined by body mass index, or BMI, standards).

primary motives: Primary motives are biological motives that provide a natural or innate source of goal-direction and promptness of behavior.

Schachter-Singer theory: The Schachter-Singer theory of emotion proposes that emotional experience requires two factors: (1) a state of physiological arousal, and (2) a cognitive interpretation or labeling of that state as an emotion.

secondary motives: Secondary motives are the learned cognitive, social, psychological, or environmental factors that influence or provide motivation.

set point: A person's set point is his/her person-specific ideal level of weight.

sexual dysfunction: Sexual dysfunctions (e.g., erectile dysfunction in men) are abnormalities in sexual desire, arousal, and response.

sexual response cycle: The sexual response cycle is a four-stage (excitement, plateau, orgasm, and resolution) classification system used to characterize the typical sequencing of events in human sexual activity.

sexual scripts: Sexual scripts are culturally sensitive, gender-specific guidelines for appropriate sexual behavior and conduct in sexual encounters.

stress: Stress (from *stringere*, or "to stretch," in Latin) refers to the strenuous process of adjusting to a demand or set of demands, thereby producing negative emotional and physiological effects.

stressors: Stressors are the events or situations that disrupt (or threaten to disrupt) an organism's homeostasis and, therefore, are the cause (rather than the effect) of stress.

Yerkes-Dodson law: The Yerkes-Dodson law suggests that the effects of arousal will vary with the nature of the task and performance in question, with the optimal level of arousal to motivate good performance on simple tasks being greater than for complex tasks.

■ CHAPTER ELEVEN: HUMAN DEVELOPMENT

accommodation: Accommodation occurs when new information produces a reorganization of existing knowledge and the acquisition of new responses.

adolescence: Adolescence is the stage between childhood and adulthood, roughly from twelve to eighteen.

assimilation: Assimilation occurs when new information is incorporated into existing knowledge and is dealt with through existing behaviors.

attachment: Attachment refers to the close, affectionate, and enduring relationship between an infant and those who provide for him or her.

authoritarian parents: Authoritarian parents are strict and firm, relying on punishment to establish obedience in their children and authority in themselves.

authoritative parents: Authoritative parents are firm, yet understanding; they reason with their child and promote compromise.

circular reactions: Circular reactions are seemingly meaningless repetitions of chance events that catch an infant's eye.

concrete operational: Concrete operational children are much less egocentric and are more objective about the world around them.

conservation: Conservation refers to the understanding that changes in the appearance of objects do not necessarily imply changes in properties.

conventional level: At the conventional level (beyond ten years of age), reasoning reflects not only the pressure to conform for personal gain but also a loyalty to codes of behavior based on a sense of belonging to a family or society.

critical period: The critical period lasts for six weeks after the embryonic stage begins; it marks a time when specific changes and growth must occur if development is to continue normally.

developmental psychology: Developmental psychology seeks to describe the typical patterns of change—physical, emotional, social, moral, and intellectual—that occur over the life span.

egocentric: Egocentric refers to the inability to conceptualize a world existing outside him- or herself that is affected by the actions of others.

embryonic stage: The embryonic stage begins when the cell mass implants, and for six weeks the cells differentiate in both structure and function.

fetal alcohol syndrome: Fetal alcohol syndrome refers to congenital problems in children as a result of alcohol consumption during pregnancy.

fetal stage: The fetal stage begins when a basic form of each structure is present, about two months into the pregnancy, and lasting until birth.

formal operational stage: In the formal operational stage, thinking becomes more abstract, systematic, and probabilistic.

gender roles: Gender roles are the behavior patterns considered appropriate for one gender or the other.

gender schemas: Gender schemas are generalizations about gender-appropriate toys, activities, likes, dislikes, occupations, and so on.

germinal stage: The germinal stage is the first prenatal stage, beginning with conception.

gerontologists: Gerontologists are psychologists and sociologists who specialize in the study of older adults (those sixty years of age and older).

holophrases: Holophrases are single words used to convey whole thoughts (or words meant to be "whole phrases").

identity crisis: An identity crisis is a period when one reevaluates oneself with an eye toward entering the adult world.

insecure attachment: Insecure attachment is not lack of attachment, but rather an avoidant (tends to avoid or ignore) or ambivalent (becomes distressed upon separation but rejects the caregiver upon return) relationship.

maturation: Maturation is growth due to aging rather than learning that is relatively independent of the environment.

menopause: Menopause is the result of a dramatic decrease in the production of female hormones, and may bring physically uncomfortable sensations and psychological stress.

object permanence: Object permanence refers to the ability to recognize the existence of objects when they are no longer visible.

permissive parents: Permissive parents are more concerned with appearing congenial, giving their children greater freedom and little real discipline.

placenta: The placenta is the protective organ that surrounds the embryo and facilitates nourishment and waste elimination.

postconventional level: The postconventional level (adulthood) is a stage of moral reasoning in which individuals are guided by concern for the rights of the individual rather than loyalty to the group.

pragmatics: Pragmatics refers to the social rules of communication of a language.

preconventional level: In the preconventional level (age four to ten years), children's reasoning does not reflect an awareness of rules as a system with inherent benefits to those who use it.

preoperational stage: The preoperational stage is divided into two substages: the preconceptual phase (two to three years of age) and the intuitive phase (four to five years).

puberty: Puberty is sexual reproductive maturity that begins during early adolescence.

reflexes: Reflexes are inborn, coordinated motor behaviors.

secure attachment: Secure attachment describes a pattern in which infants feel comfortable leaving their caregiver to explore and are happy and receptive when the caregiver returns after a brief absence.

sensorimotor stage: The sensorimotor stage lasts from birth until around two years of age, and is composed of six substages, during which children's understanding of the world is based totally on their sensory and motor interactions with it.

telegraphic: Telegraphic sentences contain only the minimum number of words important to expressing the underlying idea.

temperaments: Infant temperaments are demonstrations of stable patterns of reaction to objects and events.

teratogens: Teratogens are harmful substances in a mother's blood that can be passed into the child's

bloodstream and affect the course of prenatal development.

theory of mind: The theory of mind is the realization that others are their own beings, with their own interests, thoughts, likes, dislikes, desires, intentions, and so on.

universal grammar: Universal grammar is a genetic language-acquisition device, or an innate human predisposition for learning language.

zygote: A zygote is the one-celled organism that forms when an egg is fertilized by a sperm cell.

■ CHAPTER TWELVE: PERSONALITY, INTELLIGENCE, AND INDIVIDUAL DIFFERENCES

central traits: Central traits are usually, but not always, detectable in overt behavior.

compensation: Compensation is a state of overzealousness in attempting to overcome real or imagined personal deficiencies.

ego: In psychoanalytic theory, a person's ego is the aspect of the self that is largely visible and abides by the reality principle, effecting compromise that will satisfy some of the id's demands while not violating too many of the superego's constraints.

extraverts: Extraverts are typically outgoing and interested in participation in external events and involvement with others.

five-factor model: The five-factor model of personality purports five primary dimensions of personality: extraversion; agreeableness; conscientiousness; emotional stability (conversely, neuroticism); and openness to experience.

four humors theory: The four humors theory, adapted by Galen and based on the ideas of Hippocrates, asserts that the human body produces and requires the proper balance of four humors, or bodily fluids, to function optimally: bloody, yellow bile, black bile, and phlegm.

g: The letter *g* is a general intelligence measure introduced by Charles Spearman, based on the positive correlation among scores on various mental aptitude tests.

id: The id, latin for "it," is a personality that Freud described as completely selfish and motivated by the pleasure principle.

introverts: Introverts are unsociable, withdrawn, and concerned with their private worlds.

libido: The libido, according to Freud, is the psychic energy of unconscious motivation that originates in biological growth.

perceived self-efficacy: Perceived self-efficacy is a feeling of competence and self-control based on learned expectations of success in prior situations.

pleasure principle: The pleasure principle is the drive to seek physical pleasure and satisfaction.

reciprocal determinism: Reciprocal determinism is the theoretical proposition that persons and situations interact in a mutually influential way.

s: The letter *s* is Charles Spearman's notion of "specialized intelligence," or intelligence in a specific domain of knowledge or activity.

secondary traits: Secondary traits are behavioral traits that are elicited in particular situations, but not general situations.

self-actualizing tendency: The self-actualizing tendency is a biological urge that propels individuals toward "realizing" (i.e., achieving) their full potential, as defined by an innate (genetic) blueprint for one's life's potential.

self-concept: Self-concept is the way one thinks of oneself.

superego: The superego is the moral component of personality that guides and shapes the primitive id, inducing guilt when one has behaved selfishly or badly, and permitting a sense of pride when one has behaved well. The superego is sensitive to social and cultural definitions of morality.

trait approach: The trait approach to personality psychology attempts to describe specific features or characteristics that individuals may exhibit to differing degrees.

traits: Traits are characteristics that are relatively stable personality tendencies such as "generous," "ambitious," "aggressive," and "shy."

triarchic theory of intelligence: Sternberg's triarchic theory of intelligence describes three kinds of intelligence: componential (ability to learn, acquire new knowledge, and use it effectively), experiential (ability to adjust well to new tasks, use new information, and respond effectively in new situations), and contextual (ability to select optimal environments for one's efforts).

type approach: The type approach to personality psychology is a qualitative approach that attempts to categorize people into specific personality classes (e.g., Type A personality versus Type B).

■ CHAPTER THIRTEEN: PSYCHOLOGICAL ASSESSMENT AND TESTING

achievement tests: Achievement tests measure knowledge that has been gained in a particular area.

alternate-form reliability: Alternate-form reliability is a measure of the equivalency between different forms of a test or scale.

aptitude tests: Aptitude tests are designed to measure a specific capability, usually one's capacity for learning particular skills or performing certain tasks.

construct validity: Construct validity refers to the degree to which a given psychological construct (e.g., intelligence, happiness, and so on) is actually measured by a test that claims to measure that construct—e.g., the degree to which an intelligence test actually measures intelligence (and not some other construct).

content validity: Content validity refers to the degree to which a test accurately and completely represents the informational content presumed to be covered by the test; a test is "accurate" when it covers only specified informational subjects, and is "complete" when it covers all of the informational subjects it claims to cover.

criterion validity: Criterion validity refers to the degree to which a test of a given construct corresponds with a pre-established, often well supported, test of that construct (e.g., the degree of correspondence between a new test of anxiety and a commonly supported test of anxiety).

giftedness: Giftedness refers to those individuals who have unusually high Intelligence Quotient (IQ) scores.

Intelligence Quotient (IQ): The Intelligence Quotient (IQ) is the score given by the Stanford-Binet intelligence test that attempts to scale an individual's intellectual ability with his/her age.

internal consistency: Internal consistency is a measure of test reliability that attempts to demonstrate the degree to which one portion of a test corresponds with another portion of the test (e.g., the degree to which the first five questions on a test correspond with the last five).

learning disabilities: Learning disabilities are defined as a lack of ability to apply or display one's intelligence.

mentally challenged: Mentally challenged individuals are those who possess mental retardation, a condition that is classified in varying degrees by both intelligence-quotient (IQ) scores lower than 70 and notable behavioral deficits.

MMPI: The MMPI (Minnesota Multiphasic Personality Inventory) consists of 550 "true-false" items and is the best known objective technique for assessing personality.

objective tests: Objective tests present specific questions or statements that are answered by selecting one of a set of alternatives (e.g. true or false).

objectivity: Objectivity is a property describing tests that are fair and unbiased.

projective tests: Projective tests are so labeled because the respondent is assumed to project (impose) his or her own needs and character onto an ambiguous test stimulus—one that can be interpreted in different ways—in developing a story or description.

reliability: Reliability implies test "consistency," such that a reliable test produces a similar value or score each time a person takes it.

test-retest reliability: Test-retest reliability refers to a measure of test reliability that is gauged upon a test's degree of measurement consistency across multiple testing occasions (i.e., a test yields the same or similar score for the same individual across multiple test sessions).

Thematic Apperception Test (TAT): The Thematic Apperception Test (TAT) is a projective measurement technique in which a respondent examines and tells stories about each of a series of pictures.

validity: Validity implies that a test measures what it is designed or intended to measure.

Wechsler Adult Intelligence Scale (WAIS-III): The current (third) edition of the Wechsler Adult Intelligence Scale (WAIS-III) uses fourteen subtests—seven verbal and seven performance (nonverbal)—to generate three intelligence-quotient (IQ) scores: a verbal IQ (VIQ), a performance IQ (PIQ), and a full-scale IQ (FSIQ) that represents overall level of performance.

■ CHAPTER FOURTEEN: PSYCHOLOGICAL DISORDERS

affective disorders: Affective disorders usually entail a restricted range of abnormalities in emotional behavior and behavioral change.

antisocial personality disorder: The antisocial personality disorder ("psychopathy" or "sociopathy") is present in people who consistently violate the rights of others—they lie, cheat, steal, manipulate, and harm others—with no evidence of guilt or remorse.

anxiety disorder: An anxiety disorder is a condition in which chronic anxiety interferes with normal adjustment and functioning; this is the most common class of psychological disorders in North America.

biopsychosocial model: The biopsychosocial model is essentially a combination of the three component approaches in its name: the biological or medical, psychological modeling, and the sociocultural approaches.

bipolar disorder: Bipolar disorder ("manic depression") involves cycling between the two extreme poles of manic and depressive emotionality.

cognitive disorders: Cognitive disorders refer to problems in cognitive functioning, such as certain thinking abilities or memory processes.

conversion disorders: In conversion disorders, a psychological conflict is "converted" into a distinct, debilitating physical symptom or handicap.

delirium: Delirium refers to the general inability to think clearly, including "cloudy" consciousness, confusion, and disorientation.

dementia: Dementia involves the loss of specific cognitive functions or intellectual capacities.

diathesis-stress: The diathesis-stress approach to determining the causal origin of psychological disorders supposes that an individual has a biological predisposition, or "diathesis," towards developing a particular psychological disorder that is later triggered by some environmental event.

dissociative disorders: Dissociative disorders are rare conditions in which part of an individual's personality becomes dissociated (separated) from the rest, and he or she cannot reestablish the associations.

dissociative fugue: A dissociative fugue involves a sudden loss of personal memories and identity, and the assumption of a new identity in a new locale.

dissociative identity disorder (DID): The dissociative identity disorder (DID), commonly called multiple personality disorder, involves the appearance of more than one distinct identity within the same person.

DSM-IV: *The Diagnostic and Statistical Manual of the American Psychiatric Association*, Fourth Edition, abbreviated DSM-IV, is currently the primary classification system of abnormal behavior.

generalized anxiety disorder: Generalized anxiety disorder is characterized by an individual's feeling of persistent anxiety that cannot be readily attributed to any particular object or situation.

hypochondriasis: Hypochondriasis refers to a chronic psychological condition in which one unjustifiably feels that he or she suffers from severe physical problems, such as cancer or AIDS.

major depressive disorder: A major depressive disorder is diagnosed when one is overwhelmed with grief or guilt, unable to resume or enjoy normal living and activities, and immobilized by lethargy or apathy for an extended period of time.

mania: Mania is characterized by hyperactivity, euphoria, talkativeness, and impulsive behaviors.

narcissistic personality disorder: People with narcissistic personality disorder are highly self-absorbed, obsessed with fantasies of success, and very demanding of others' attention and love.

negative symptoms: Negative symptoms refer to "normal" behavioral/psychological characteristics that are noticeably absent from a schizophrenic patient's mental activity, such as lack of motivation or sociability.

obsessive-compulsive disorder (OCD): Obsessive-compulsive disorder (OCD) is a condition involving irresistible recurring thoughts and urges to perform certain rituals.

panic attack: A panic attack is a sudden, unpredictable experience of intense fear.

personality disorders: Personality disorders reflect a failure of the personality itself to develop, adjust, and learn.

phobias: Phobias, or phobic disorders, are characterized by experiencing intense, irrational fear associated with a particular condition or target.

positive symptoms: In schizophrenia, positive symptoms are maladaptive symptoms, such as hallucinations and delusions, that appear in addition to normal mental activity.

posttraumatic stress disorder (PTSD): Posttraumatic stress disorder (PTSD) is frequent among veterans of war and victims of terrorism and natural disasters, and is manifested as a pattern of panic attacks that are traceable to an original traumatic experience (e.g., war or natural disaster).

psychopathology: Psychopathology refers to a general pattern of disruptive thinking, feeling, and behaving that disturbs the person affected and/or those around him or her.

psychotic disorder: A psychotic disorder is a condition involving delusions or hallucinations—both of which are symptoms of a seemingly disconnected and malfunctioning mind.

schizophrenia: Schizophrenia is a pattern of behavior characterized by disordered thought, perception, emotion, judgment, and behavior.

somatization disorder: Somatization disorder involves numerous (often vague) complaints of physical illness.

somatoform disorder: An individual suffering from a somatoform disorder experiences vague, recurring, sometimes unrelated physical pains and dysfunctions for which medical examinations can find no physiological cause.

■ CHAPTER FIFTEEN: TREATMENT OF PSYCHOLOGICAL DISORDERS

antidepressants: Antidepressants are psychoactive drugs used in the treatment of depression by working to increase the levels of certain neurotransmitters in the brain, such as serotonin and norepinephrine.

anxiolytic drug: Anxiolytic drugs, such as Valium and alprazolam (Xanax), reduce the feeling of anxiety.

attribution therapy: Attribution therapy encourages clients to replace their negative thoughts and attributions with more realistic (positive) explanations.

aversive conditioning: Aversive conditioning applies the principles of classical conditioning by pairing an aversive stimulus (e.g., a painful electric shock or drug-induced nausea) with a behavior one wishes to eliminate.

client-centered therapy: Client-centered therapy is the humanistic system developed by Carl Rogers in which the therapist's goal is to help the client become a fully functioning human by supporting the client's innate potentials.

clinical psychologists: Clinical psychologists work with so-called clinical populations, individuals treated on an inpatient or outpatient basis for more severe disorders, including affective, addictive, and schizophrenic disorders.

counseling psychologists: Counseling psychologists work with the problems of "normal" adjustment—adjustment to demands of everyday life—rather than abnormal function. This includes, for example, stress management, relationship conflict, and behavior modification.

desensitization: Desensitization is a behavior therapy commonly employed in the treatment of phobias, involving a development of a "hierarchy of anxiety," a rank-ordered listing of phobic situations that the client progressively imagines until he or she has come to terms with each level of anxiety.

electroconvulsive therapy (ECT): Electroconvulsive therapy (ECT), also known as "shock therapy," is a dramatic and controversial treatment that employs electric shocks in an aversive conditioning program to treat severe depression.

Gestalt therapy: Gestalt therapy emphasizes the importance of helping an individual to contact and understand his or her "whole" self.

lithium: Lithium is a chemical used to minimize and prevent the mood disorders of depression and mania associated with bipolar disorder.

neuroleptics: Neuroleptics are drugs that alleviate symptoms of severe disorders.

psychiatrists: Psychiatrists are medical doctors that have completed specialized training in psychological disorders.

psychoanalysis: Psychoanalysis is a therapeutic system that emphasizes identifying and resolving an individual's unconscious conflicts.

psychopharmacology: Psychopharmacology is the use of drugs to achieve psychological change.

psychosurgery: Psychosurgery, also known as neurosurgery, involves surgical procedures to remove or destroy focused regions of brain tissue in order to cause behavioral change.

psychotherapy: Psychotherapy involves the treatment of psychological disorders through talking and other methods as a means to modify thinking, feeling, and behavior.

rational-emotive behavior therapy (REBT): The rational-emotive behavior therapy, developed by Albert Ellis, questions and redefines the irrational beliefs that may underlie disordered feelings and behaviors.

resistance: In the therapeutic setting, "resistance" refers to the client's conscious or subconscious reactance against progress being made during therapy and involves, for example, refusing to talk, forgetting

to keep appointments, or not paying the analyst's bill, in order to try to protect one's psychological defenses from being analyzed.

sedatives: Sedatives, such as alcohol, barbiturates, or tranquilizers depress central nervous system activity.

stress inoculation therapy: Stress inoculation therapy involves helping a client to reduce the stress he or she feels in certain situations.

transference: Transference is a process in which the patient may project his/her feelings about personal or past relationships onto the analyst in order to protect his/her ego (psychological defenses).

■ CHAPTER SIXTEEN: SOCIAL PSYCHOLOGY

altruism: Altruism is an unselfish concern for the welfare of others, often leading to giving assistance when not required, sometimes even in the face of danger to oneself.

attitude: An attitude is an evaluative reaction to a person, object, or event.

authoritarian personality: The authoritarian personality type includes such tendencies as superstition, anti-intellectualism, a tendency to stereotype, exaggerated respect for conventional authority, and ethnocentrism, a bias in favor of one's own and against others' ethnic groups.

bystander effect: The bystander effect occurs when the likelihood that any single individual will offer assistance decreases as the number of individuals present increases.

causal attribution: Causal attribution involves ascribing causes or reasons to behaviors.

central traits: Central traits are influential in modifying the total impression formed as well as the way each trait in the impression is interpreted.

cognitive dissonance theory: Cognitive dissonance theory asserts that self-justification is necessary because a mismatch between attitudes and behavior creates disharmony (dissonance), which produces psychological tension.

competition: Competition is where an individual attempts to attain a goal while denying it to others.

compliance: Compliance is the voluntary change of behavior because of a (usually explicit) request.

conformity: Conformity is changing one's behavior as a result of (often implicit) group pressure.

cooperation: Cooperation occurs when two or more individuals work together to achieve goals.

deindividuation: Deindividuation is a reduction in self-awareness and sense of individual accountability when in a group.

discrimination: Discrimination is the behavioral component of prejudice, treating people in unfairly different ways because of their perceived group membership.

door-in-the-face procedure: The door-in-the-face procedure involves asking for a larger favor than desired (which is likely to be denied), in hopes that by subsequently asking for a smaller favor—the one actually desired—one appears willing to compromise.

external attribution: External attributions are explanations for behavior that involve factors outside of the person involved, such as the environment and immediate task demands.

false consensus effect: The false consensus effect is the tendency to overestimate how common one's negative behaviors and prejudices are, assuming that they also describe the majority of other people.

false uniqueness effect: The false uniqueness effect is the tendency to see one's own positive actions, skills, and abilities to be relatively unusual, misjudging the likelihood that others are also good or talented.

foot-in-the-door phenomenon: The foot-in-the-door phenomenon involves asking someone for a smaller favor than desired, to which they are likely to agree, which increases the chances of subsequently obtaining from them larger favors (those actually desired).

fundamental attribution error: The fundamental attribution error is the tendency to overestimate situational influences (external attributions) in explaining one's own negative behaviors, while overestimating dispositional influences (internal attributions) in explaining the same negative behaviors in others.

group polarization: Group polarization is the tendency for like-minded individuals, when brought together in a group, to reinforce one another's existing opinions such that they become stronger.

groupthink: Groupthink is the tendency of group members to give higher priority to a sense of cohesiveness than to the quality of their work, which often stifles dissension and objectivity.

illusory correlation: Illusory correlation is the false impression of assuming a connection between events that does not exist.

ingroup bias: Ingroup bias is the belief that the members of one's own social group (the ingroup) are superior to nonmembers (the outgroup).

internal attributions: Internal attribution presumes the cause for behavior lies within an individual's motives or personality.

interpersonal conflict: Interpersonal conflict is the disagreement with (and often hostility towards) another person or people, stemming from the belief that one is opposed from reaching a goal by the other individual or group.

lowball approach: The lowball approach to compliance involves asking for a smaller request than is truly desired, and then increasing the cost (monetary or otherwise) of the request after a commitment is obtained.

person-oriented leaders: Person-oriented leaders provide less strict supervision, and are concerned with group members' input as well as their feelings.

persuasion: Persuasion is a form of social influence that occurs when individuals change others' attitudes.

prejudice: Prejudice is an unjustifiable negative attitude toward all members of a group.

proximity effect: The proximity effect describes the influence of physical nearness in increasing interpersonal attraction.

reference groups: Reference groups are categories of people to which one feels like one belongs, and to which one often compares oneself.

relative deprivation: Relative deprivation is a phenomenon where one believes that one is achieving, attaining, or receiving less than is expected by membership in the reference group.

self-handicapping: Self-handicapping is engaging in somewhat self-defeating or self-destructive behavior, in order to provide more acceptable reasons for failure.

self-serving biases: Self-serving biases are tendencies to perceive and judge our own actions in ways that preserve our self-esteem.

social cognition: Social cognition describes the way that people interpret information about, draw inferences about, and categorize others, as well as how this determines their own actions.

social comparison: Social comparison is the comparison of ourselves with others, using others' opinions and actions as a standard for judging our own.

social facilitation: Social facilitation describes a situation when the presence of others is arousing.

social identity: One's social identity is derived from group membership, such as that defined by characteristics including ethnicity, religion, citizenship, and so on.

social impairment: Social impairment describes a situation when the presence of others is distracting.

social judgment theory: Social judgment theory argues that attitude change is affected by factors like the original attitude—the attitude being changed or replaced—and the difference between it and the new or replacement attitude.

social loafing: Social loafing occurs if individuals reduce their effort when working in a group setting or among many others, compared to when working on the same task alone.

stereotype: A stereotype is a generalization about a group of people that distinguishes them from others.

task-oriented leaders: Task-oriented leaders are those who provide close supervision and direct the group through giving orders, discouraging group input and discussion.

Index

Collins College

OUTLINES

Fully Revised and Updated

Written by professors, teachers, and experts in various fields, the titles in the Collins College Outlines series provide students with a fast, easy, and simplified approach to the curricula of important introductory courses, and also provide a perfect preparation for AP exams. Each title contains a full index and a "Test Yourself" section with full explanations for each chapter.

BASIC MATHEMATICS
Lawrence A. Trivieri
ISBN 0-06-088146-1 (paperback)

INTRODUCTION TO CALCULUS
Joan Van Glabek
ISBN 0-06-088150-X (paperback)

INTRODUCTION TO AMERICAN GOVERNMENT
Larry Elowitz
ISBN 0-06-088151-8 (paperback)

INTRODUCTION TO PSYCHOLOGY
Joseph Johnson and Ann L. Weber
ISBN 0-06-088152-6 (paperback)

MODERN EUROPEAN HISTORY
John R. Barber
ISBN 0-06-088153-4 (paperback)

ORGANIC CHEMISTRY
Michael Smith
ISBN 0-06-088154-2 (paperback)

UNITED STATES HISTORY TO 1877
Light Cummins and Arnold M. Rice
ISBN 0-06-088159-3 (paperback)

WESTERN CIVILIZATION TO 1500
John Chuchiak and Walter Kirchner
ISBN 0-06-088162-3 (paperback)

ABNORMAL PSYCHOLOGY
(coming in 2007)
Sarah Sifers
ISBN 0-06-088145-3 (paperback)

UNITED STATES HISTORY FROM 1865
(coming in 2007)
John Baick and Arnold M. Rice
ISBN 0-06-088158-5 (paperback)

ELEMENTARY ALGEBRA
(coming in 2007)
Joan Van Glabek
ISBN 0-06-088148-8 (paperback)

SPANISH GRAMMAR
(coming in 2007)
Ana Fairchild and Juan Mendez
ISBN 0-06-088157-7 (paperback)